Contemporary Canadian Art

David Burnett & Marilyn Schiff

Contemporary Canadian Art

Hurtig Publishers Ltd.
in co-operation with
The Art Gallery of Ontario

Hurtig Publishers Ltd..
10560–105 Street
Edmonton, Alberta

Canadian Cataloguing in Publication Data

Burnett, David.
 Contemporary Canadian Art

 Bibliography: p.
 Includes index.
 ISBN 0-88830-242-8 (bound). —ISBN
0-88830-241-X (pbk.)

 1. Art, Modern—20th century—Canada.
2. Art, Canadian. I. Schiff, Marilyn, 1939–
II. Title.
N6545.B87 709'.71 C83-091275-4

Printed and bound in Canada
by D.W. Friesen & Sons Ltd.

Contents

Introduction / 7
Acknowledgements / 8

Painting in Quebec: Change and Revolution / 13
Toronto: Breaking the Mould / 41
Abstraction in Montreal / 63
A Broadening Scene: Toronto and London / 82
The Maritimes, Modernism, and the West / 111
Sculpture in the Sixties / 141
Representational Painting / 159
Alternative Modes / 181
Recent Sculpture / 213
Recent Painting / 247

Selected Bibliography / 293
Index / 298

Introduction

In 1940 the condition of the visual arts in Canada was at a low ebb. The audience for the arts, particularly for the work of living Canadian artists, was minute; public and private support for the arts was severely limited, and, with the exception of a very small number of people, the artistic community that did exist was dominated by inward-looking attitudes, resistance to change, and procedures that for the most part owed more to the styles and structures of the nineteenth century than to the twentieth century. To look now at the past forty years is to be struck by the astonishing changes in the character, the interest, the activity, and the quality of the visual arts in Canada. A situation once marked by an indifference to or determined rejection of what was occurring in the arts elsewhere has become one which stands aware of, and in many respects exists on a par with, what is happening anywhere. From an art history largely reflecting older European traditions, a creative Canadian art has arisen. The level of activity is marked by the growing number of professional artists, the development of museums, art galleries, and alternate spaces, the growth of private galleries, and the expansion of public, private, and corporate collections. It is a level of activity that has moved from being an exclusively private preserve into the public domain, supported in substantial ways by all levels of government.

This book is a survey of painting and sculpture in Canada from the Second World War to the present. We have given emphasis, in the main, to the leading radical developments and to the artists who have brought these about. Our aim has been to discuss the range of Canadian painting and sculpture that can be seen in the public galleries, alternate spaces, and commercial galleries. In this respect the book does not present a particular political or aesthetic thesis, but has been prepared as a guide to art for a broad audience. We have, however, taken a personal view of recent history and current developments. With several thousand artists working in this country, we have had difficult decisions to make about inclusions and exclusions, both of individuals and of groups of artists. We have decided not to include the art of the native peoples. We felt that to survey the arts of the native peoples without being able to develop their relationship to the cultural roots and traditions of those peoples would be to do so not only superficially, but improperly.

Given the extraordinary changes that have occurred in the arts in Canada over the past forty years, one of the most significant aspects of writing about art now must lie in raising an awareness of history and the roots of our current situation. It is still a situation resting on a limited range and depth of artistic traditions, and in which the proportion of artists in the early or mid-point of their careers is relatively high.

With Canada's topography and demographic patterns, artistic activity is divided among widely scattered centres, and the essence of that activity is inseparable from regionalist concerns. This is the reflection of a cultural, as of a political, reality. This does not simply mean — as it once did — an uncritical dependence on the once-new styles of Europe and the United States. Rather it represents the development of creative identities — open to the outside, but special to the places and contexts of their origins.

A fragmented or low level of interest in history is as much a sign of cultural vulnerability as it is of political and economic vulnerabilities. Clinging to nostalgic symbols will not diminish our vulnerabilities, nor will seeking to exclude the outside world. They can only be overcome by a critical awareness of the present, and such an awareness can only become critical through a knowledge of the past.

David Burnett
Marilyn Schiff

Acknowledgements

Every book is the result of the work and co-operation of many people. We have been particularly fortunate in the help and support we have had. In the course of our research we spoke with many artists. We are grateful to them for the time they gave us, for their interest, and for their help in assembling photographs of their work. We would also like to thank the many people in public galleries, private galleries, and corporate collections who assisted us in obtaining photographs for reproduction, as well as the private collectors who gave us the opportunity to see the works in their collections.

Our research was supported in the initial stages by a Canada Council Explorations Grant. We are most grateful for this support and that which we have received from Isadore Sharp of the Four Seasons Hotels and his administrative assistant, Nan Wigglesworth, and from Dr. Michael Braudo, Mr. and Mrs. Morton Cohen, Mr. and Mrs. S.J. Fagan, Mr. and Mrs. Nahum Gelber, Mr. Roger A. Lindsay, Mrs. Enid Maclachlan, Mr. and Mrs. Harry Malcolmson, Mr. and Mrs. Aaron Milrad, Mr. Samuel Sarick, Mr. Gerald W. Schwartz, Mr. and Mrs. A. Silverberg, Mrs. Carol Tanenbaum, Pende Holdings Ltd., and George Weston Limited. Three people in particular — Marcel and Susan Elefant and one person who prefers to remain anonymous — have given this project very special support which enabled us to see it through to completion. We thank all of them most warmly.

At the Art Gallery of Ontario our thanks go to William J. Withrow, Marie DunSeith, Mara Meikle, and Maia Sutnik. Our thanks also for research help to Louis Grachos. We are grateful to Mel Hurtig, who immediately agreed to publish this book. The task of seeing the book into print has rested heavily on its designer David Shaw and on our editors Olive Koyama and — with our special thanks — Sarah Reid.

Last, but not least, our thanks go to Jana and David Schiff for their patience during the time that this book was in the making.

Photo Credits

Agnes Etherington Art Centre: 301
Art Gallery of Hamilton: 244
Art Gallery of Ontario: 4, 5, 14, 33, 35, 41, 45, 46, 64, 73, 80, 85, 93, 104, 119, 120, 136, 143, 144, 149, 152, 153, 154, 155, 167, 175, 176, 178, 185, 193, 194, 204, 213, 223, 223a, 230, 260, 263, 272, 311, 315, 322
Art Gallery of Ontario, J. Chambers: Cover (top)
Art Gallery of Ontario, L. Ostrom: 23, 32, 58, 201, 209, 224a, 249, 252, 253, 263
The Gallery/Stratford: 227, 232
Glenbow Museum: 114, 266, 271
Montreal Musée des beaux-arts: 71, 74, 195
National Gallery of Canada: 3, 77, 81, 87, 95, 96, 97, 105, 122, 135, 141, 142, 183, 184, 187, 188, 205, 210, 245, 246, 247
Norman Mackenzie Art Gallery: 125, 220
Robert McLaughlin Gallery: 36, 37, 44, 72, 91, 298
J.P. Beaudin: 129, 267
Y. Boulerice: 6, 7, 11, 12, 13, 15, 17, 18, 20, 24, 27, 28, 29, 30, 31, 51, 53, 54, 55, 56, 57, 65, 134, 138, 140, 197, 198, 200, 226, 229, 233, 237, 259, 321, Cover (bottom)
D. Burnett: 1, 34, 82, 132, 137, 225, 286, 307, 308a
J. Chambers: 8, 10, 38
D. Cumming: 319
W. Eakin: 320
J. Evans: 139
N. Hohn: 241
R. Keziere: 240 (Courtesy Ydessa Gallery), 248
G. Lewis: 186
P. MacCallum: 212, 299
T. Moore: 39, 42, 48, 49, 50, 75, 90, 94, 107, 116, 123, 131, 216, 281, 288, 290, 309
J. Nolte: 279, 280
D. Rescheff: 60, 146
D. Tuck: 329
Courtesy of the Artist: 43, 47, 98, 145, 159, 170, 171, 174, 179, 180, 189, 190, 206, 207, 208, 231, 248, 250, 257, 275, 283, 297, 300, 303, 310, 318, 328

Contemporary Canadian Art

Painting in Quebec: Change and Revolution

The Radical Context

Art in Quebec in the 1930s was an activity at the fringes of a society forced inwards by the ravages of the Depression. With governments at all levels helpless to deal with the social problems of economic collapse, the immediate concerns for most people were with day-to-day survival. The maintenance of stability was reflected in the continued conservative power of institutions whether political, religious, or cultural. The painter Jean Paul Lemieux, then a teacher at the Ecole des beaux-arts in Quebec City, wrote in 1938 of the impression Quebeckers might make on an outsider, "They are a very quaint people, but they don't know the first thing about Art."[1] Change had to come from within, and Lemieux's complaint was levelled specifically against the conservatism of taste which infected even the best contemporary painters and against the hide-bound academicism of the teaching institutions and museums. Most of all his vision was directed at the gap between the reality of the present and an idealization of the future:

> A troubled era cannot produce untroubled art; contemporary painting is in transition, it is tortured, unsettled, looking for new formulas like humanity itself.[2]

But contemporary art is always in transition; the values of stability are our abstractions of the past. The issues faced by artists in Quebec were those of a society on the edge of unprecedented change. The art of the time, however, supported, if only by default, those elements in society which were either resistant to change or intended to direct it.

Beginning about 1940, changes occurred in painting in Quebec that were due not to art's separation from society but to its practical engagement with society. If art came to reflect an assessment of Quebec's isolation, it did so in response to the complex concepts of change inherent in society, from the notion of gradual evolution to that of radical change. And the changes in Quebec art came about not through agreements but through disputes and anger. The break from Quebec's tradition of isolation was led by John Lyman, Alfred Pellan, and Paul-Emile Borduas. They were in agreement in their opposition to the prevailing conservatism of taste, and the need to bring about recognition in Quebec of what had happened in advanced art elsewhere, particularly in Paris, over the previous thirty years. They were united in their assertions of the place of living artists, but they came to be deeply divided over the direction that art in Quebec should take.

Official recognition of the visual arts came principally through the academic societies, the art school system, and, to an extent, by decorative commissions from the Church. Ozias Leduc earned his living from Church commissions, and Borduas, after apprenticing with Leduc, was sent, at Church expense, to France to train as a painter of religious subjects. Through the first half of the twentieth century, France, or rather Paris, was the undisputed source of artistic taste whether as the temple of academic tradition or as the core of modernism. Many Quebec artists studied in Paris; some made their careers there. James Wilson Morrice, the major figure of early twentieth-century Quebec painting, lived most of his life abroad and his life and work displayed a freedom and daring that would have been unobtainable at home. Even Clarence Gagnon, the archetypal painter of the Quebec scene, lived in Paris from the end of the First World War to 1936. In 1927 Gagnon had bitterly expressed his feelings about the influence of the Group of Seven on Canadian art:

> Nothing can be done to change matters as long as the Group of Seven will fight and dictate to all other artists in Canada, nothing will happen to make things better.[3]

13

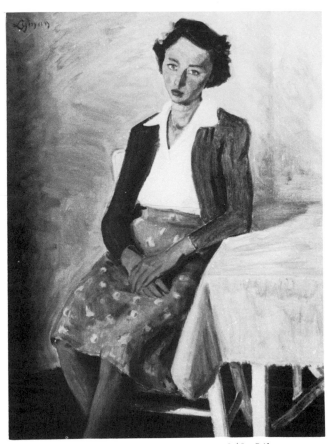

Fig. 1. John Lyman. *Young Girl in Blue*, 1948. Oil on canvas. 81.3 × 60.9 cm. Private Collection, Toronto.

in range and conventional in approach. Into this situation John Lyman, returning from Europe, introduced a vigorous advocacy of more recent French art and, as important, energetic organizational abilities.

Lyman, born in Montreal in 1886 of well-to-do American parents, had left Canada in 1907 to study art in Paris. He trained with Henri Laurens and Henri Matisse, became friends with the English painter Matthew Smith, and shared with him a lasting admiration for Matisse and the Fauve movement, an early twentieth-century style based on an aggressive use of drawing and pure colour. Lyman travelled widely in Europe, North Africa, and the United States, until in 1931 the Depression forced his return to Canada. The occasional shows he had sent back to Montreal, with their Fauvist "excesses," had been poorly received. His offence, both to the eye and the expectations of a 1913 Montreal audience, was succinctly described in a letter to the *Star*: "[His pictures] simply ruin the neutral tints of the Art Gallery's well-kept walls."[4] Through the twenties his palette became more subdued and after his return to Montreal his work, like *Young Girl in Blue* (1948) (fig. 1), is characterized by an effective sense of volume structured by shape and colour.

Lyman's work, his advocacy and knowledge of the School of Paris, and his determined activism gave him a prominent place in the Montreal art world. He wrote occasional articles and reviews and, from 1936 to 1940, a regular art column for *The Montrealer*, offering some of the most informed and cogent of Canadian art writing. Late in 1931, Lyman, André Bieler, and others founded the Atelier, a small art school patterned on the Parisian model. Although only open until 1933, the school offered opportunities for Lyman, Bieler, and other painters such as Marc-Aurèle Fortin and Goodridge Roberts (fig. 2) to show their work.

The Atelier was an initial step in the establishment of a forum for artists in Quebec who stood outside the academic societies but who also re-

Despite such opposition to the Group's evangelical promotion of a "Canadian school," throughout the mid and later thirties the strongest painting done in Quebec came principally from artists associated with the Canadian Group of Painters, the organization formed in 1933 on a nation-wide basis to succeed the Group of Seven. These artists, exclusively anglophones, came to be known as the Beaver Hall Hill Group, named from the studio they occupied on Beaver Hall Hill. But if the painting of Edwin Holgate, Albert H. Robinson, Mabel May, Sarah Robertson, Ann Savage, and, in particular, Lilias Torrence Newton and Prudence Heward was strong, it was limited

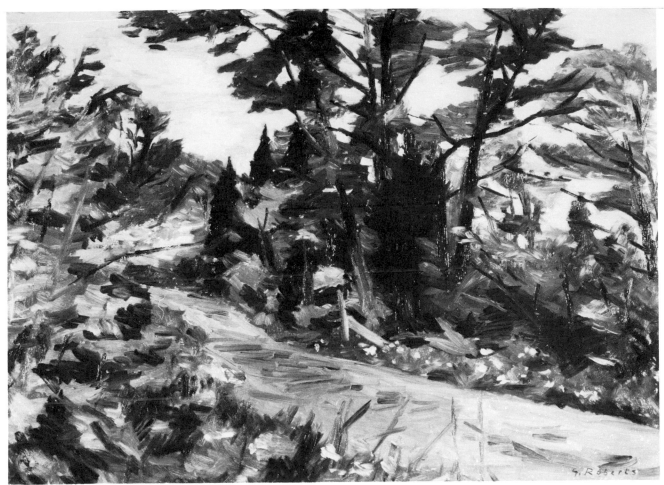

Fig. 2. Goodridge Roberts. *Laurentian Landscape*, 1952. Oil on masonite. 80.0 × 111.8 cm. Lavalin Inc.

jected the intentions and assumptions of the Canadian Group of Painters. In 1938 Lyman organized an informal association of artists who were not members of the Canadian Group of Painters to exhibit together as the "Eastern Group." Although the Eastern Group continued to exist until 1950, it was succeeded in 1939 by the Contemporary Arts Society—Lyman's most important act of organization. The Society's aims were to show the work of living artists—excluding any who were members of ("or partial to") any Academy—and to develop awareness of modern art movements. The Society's first exhibition was of major European artists, including Kandin-

sky, Derain, Pascin, and Modigliani. Its second, in December 1939, showed paintings by twenty-one of the Society's members, ranging from the School of Paris interests of Lyman and Goodridge Roberts to the more abstract work of Marian Scott (fig. 3) and Fritz Brandtner (fig. 4) and the surreal urban scenes of Philip Surrey (fig. 5).

The Society drew its initial membership, with the exception of Jack Humphrey from New Brunswick, from Montreal-based artists, among them Prudence Heward and Anne Savage from

15

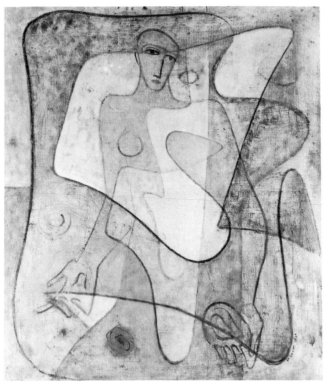

Fig. 3. Marian Scott. *Variations on a theme: Cell and Fossil, No. 6*, 1946. Oil on canvas. 71.1 × 62.2 cm. The National Gallery of Canada, Ottawa.

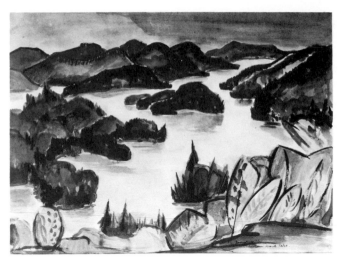

Fig. 4. Fritz Brandtner. *Sixteen Islands Lake (No. 1)*, 1942. Watercolour on paper. 44.5 × 59.4 cm. Collection Art Gallery of Ontario, Toronto, Purchase, 1943.

Beaver Hall Hill. The membership was predominantly English, although Paul-Emile Borduas was elected Vice-President. This imbalance, although gradually redressed, brought serious tensions and differences into the group, differences that became critical after 1943, when a group of young French artists who looked to Borduas for leadership were included in the group.

In mobilizing opposition to the status quo the Society became the catalyst for conflicting views of radicality. The very momentum the Society gave to art in Quebec was, in the end, what destroyed it. Lyman and the older, predominantly English-speaking artists, their thinking formed by the ideas of the School of Paris, sought to bring art in Canada firmly into the twentieth century. Theirs was a formalist view—a primary concern

with shape and colour—grounded in an historical notion of progress. A more extreme version of this approach was held by Alfred Pellan, the notion of *ratrappage*, of catching up with the rest of the world before being able to make an authentic, original statement from one's own ground. But for Borduas and the young artists who gathered around him, *rattrappage* was not enough. They sought an immediate expression through original art, based not only on aesthetics but also on an ideology responsive to the current conditions of Quebec society, a society they recognized as politically, intellectually, and spiritually repressed. By 1948 the Society was deeply split. In a move to heal the rift, Borduas was elected president, but he resigned almost immediately and the Society was formally dissolved in November. Nevertheless, it had provided a new direction for art in Quebec.

The return of Alfred Pellan from France in 1940 gave momentum to the radical movement. Pellan, like Lyman, had spent the formative years of his career abroad. An artist of precocious talent, graduating from the Ecole des beaux-arts in Quebec at eighteen, he had been the first painter

Fig. 5.
Philip Surrey.
The Crocodile, 1940.
Oil on canvas.
86.4 × 69.1 cm.
Collection Art Gallery
of Ontario,
Toronto. Gift from
the Albert H. Robson
Memorial Subscription
Fund, 1949.

Fig. 6. Alfred Pellan. *Instrument de musique*, 1933. Oil on canvas. 132.0 × 195.5 cm. Wellesley College Museum.

to be awarded a provincial bursary to study in Paris. He left for France in 1926, and was quickly accepted by the Parisian art milieu, exhibiting there regularly through the 1930s. His success counted against him when, in 1936, he was interviewed for a teaching post at the Ecole des beaux-arts in Quebec; the reflection of current French art in his work was judged undesirable for an instructor at the institution. He returned to Canada when Germany invaded France in 1940, and was immediately given a major exhibition of the work he had brought back, first at the Musée du Québec and then in Montreal at the Musée des beaux-arts.[5] The exhibition had an "explosive effect" on the artistic community, drawing enthusiastic and almost intemperate praise for a Quebec artist who not only knew Fauvism and Cubism and Surrealism first-hand, but himself painted in those styles (fig. 6).

Quebec artists had seen so little French art of the 1920s and 1930s that Pellan's brilliant eclecticism struck them as unprecedented invention. They knew no comparison for his sparkling colour and freedom of design, for his destruction of the illusion of depth, or for the daring of his dream-like images. His impact must be seen in the context of 1940. Pellan's easy transfer, back and

forth, between various adopted approaches and his synthesis of several sources in a single picture have in recent years been more harshly judged. We can now see, in a way not so evident to an audience in the forties, the open references to Matisse, Picasso, and Braque, and to the Surrealist mutations of Miró and Henri Masson. But to read his first ten years of mature work for his whole career is to distort his contribution; it allows him his importance but condemns him for not having been different.

In his 1947 essay *Projections Libérantes*, Borduas described Pellan's return as causing "a sudden, premature division of the [revolutionary] forces."[6] The older members of the Contemporary Arts Society found much of Pellan's work difficult because it ran counter to the values of the Parisian art which had formed their styles. In view of the impact Pellan's work had had on him in 1940, Borduas' assessment seven years later was less than generous:

> The work that [Pellan] brought from Paris bore the rich perfume of its place of origin. It was, all in all, a Paris fruit which he offered.[7]

The Society found an important ally in Father Alain Couturier, a French Dominican priest and painter who, unable to return to France from the United States at the start of the war, moved to Montreal in 1940. Couturier sought to encourage more Canadian painters to undertake church decoration, but also gave active support to the Montreal art community. He lectured at the Ecole du Meuble on religious art, and on modern art both there and to the Contemporary Arts Society. In 1941 he organized in Quebec and Montreal the *Indépendants* exhibition, showing eleven members of the Society, including Lyman, Borduas, and Pellan. In the exhibition catalogue Couturier asserted that France's leadership of modern art was grounded on its freedom of expression: "Free not only from realist dictates or academic conformity, but also from any political or ideological programme."[8]

Couturier's advocacy of the artists he chose for the *Indépendants* brought him into direct conflict with Charles Maillard, director of the Ecole des beaux-arts, and one of the staunchest advocates of entrenched conservatism. Maillard defended the teaching and institutional values of the school against

> certain disputes, which may have had a certain *raison d'être* in France thirty years ago, but from which we, in a young country where unity of action must be preserved, can spare ourselves.[9]

The running battle between Maillard and the advanced artistic community came to a head in 1945. Maillard continually criticized the teaching methods of Pellan, who had been appointed to the School in 1943. In 1945, he ordered Pellan to remove some of his students' pictures from an exhibition at the school. Pellan took them down, but rehung them covered with drapes. In the ensuing uproar, which included a student disturbance in the streets of Montreal, it was Maillard who found his situation untenable and who resigned.

Maillard's departure was a victory of the new, but it underlined a division of attitude among the radical French artists. If Pellan's appointment to the school had been a way to quiet opposition, it could also be seen as a way to change the conservatism of the art establishment from within. To others, in particular to Borduas, it was an unacceptable compromise to be associated with this bastion of reaction. More than that, Borduas could not accept Pellan's gradualist approach to change, the attitude of *rattrapage*.

Borduas' introduction to art and the profession of the artist had come through the most pervasive of Quebec's institutions, the Church. His first contact with art was the painting of Ozias Leduc in the church at Saint-Hilaire, where Borduas was born and where Leduc lived. Leduc had the vision of a mystic, iconographically expressed in his religious paintings, and deeply pervasive in his genre paintings and landscapes. To Borduas he

was a mentor, even when, later, Leduc's own convictions would not allow him to agree with the direction Borduas had chosen. Borduas wrote of him,

> I owe to him that rare permission to pursue one's own fate; when it became evident that I might stand for some values contrary to his hopes, no opposition, no resistance was felt: his precious and steady sympathy did not change....I owe to him...the freedom to pass from the spiritual and pictorial atmospheres of the Renaissance to the power of the dream which opens on the future.[10]

Borduas worked with Leduc in an informal apprenticeship until 1923, when, with Leduc's encouragement, he went to the Ecole des beaux-arts in Montreal. On graduation in 1927 he taught for two years for the Commission of Catholic Schools of Montreal; this gave him his second taste of establishment bureaucracy and politics— the Ecole des beaux-arts having been the first. Leduc urged him to undertake further study, and in 1928, with financial support from the Church, he enrolled for a year at the *Ateliers d'art sacré* in Paris, the school founded by Maurice Denis and Georges Desvallières in 1920 to encourage the development of religious art. Borduas then worked on church decorations in three locations in France before returning to Canada in the fall of 1930. Over the next few years he divided his time among his own work, teaching, and church painting. Only in 1937, with an appointment to the Ecole du Meuble in Montreal, did he become more involved with the advanced art milieu.

Borduas' work through the 1930s was inconsistent in quality and direction. There were some strong pictures, like the *Portrait of Maurice Gagnon* (1937) (National Gallery of Canada), and some vapid and awkward works. His involvement, however, with the Contemporary Arts Society and the ensuing contacts with other artists signalled a change in his work. Even if his understanding of Cubism in, say, the 1941 *Femme à la mandoline* (Musée d'art contemporain, Montreal)

is crude, it is marked by a tough determination to deal with the fact of painting itself rather than just the rendering of a subject. The turning point in his work came with the series of works on paper he made in 1942 (see p. 24). In their combination of Cubist composition and Surrealist imagery, these pictures owe a clear debt to the work of Pellan. But beyond that, and without Pellan's advantage of direct study of the modern European masters, Borduas' paintings have a powerful intuitive sense of Surrealism's meaning as it had been developed by Joan Miró, Max Ernst, and Henri Masson. The pivotal place that these works had in Borduas' art were, by virtue of his leadership for many young French-Canadian artists, crucial to the course of radical art in Montreal.

Pellan's concerns, aside from the dispute with Maillard, have always turned on the poetry of his own work, not on theory or direct action. Borduas, however, carried with him a driving need for debate and for action, a need to engage the issues rather than proceed around them. He was passionate and charismatic as a teacher, jealously demanding loyalty, swiftly provoked by opposition—particularly from those close to him. Through the 1940s and 1950s advanced art in Quebec was split and split again by his constant pressure. There were disputes with Lyman and Pellan, Jean-Paul Riopelle and Fernand Leduc. Though these disputes were sharpened by personal antagonisms, their grounds lay in Borduas' uncompromising pursuit of change, a pursuit often confusing to his colleagues, for Borduas was willing to shift position so as to assert a revolutionary point rather than consolidate an achieved one.

At the Ecole du Meuble Borduas gathered around him a group of young artists and writers who stood out against the formalism of the older members of the Contemporary Arts Society and the academicism fostered by the Montreal Musée des beaux-arts and the Ecole des beaux-arts. Their argument reached beyond aesthetics to an assertion of the liberating necessity of art, an assertion

that brought them in direct conflict with the established institutions and structures of Quebec society, in particular the repressive conservatism of the Duplessis government, and the domination of educational, cultural, and intellectual life by the Catholic Church.

Borduas' influence affected not only his own students, such as Riopelle and Marcel Barbeau, but others from the Ecole des beaux-arts, such as Pierre Gauvreau, Françoise Sullivan, and Fernand Leduc. This group met regularly to view and criticize each other's work and to argue and discuss art and philosophy and psychology. Their discussions and reading took them to Nietzsche and Kafka, Mallarmé and Rimbaud, Bachelard and, above all, André Breton and the Surrealist movement in France. Borduas' own major essays are less concerned with the specifics of aesthetic discussion than with the advocacy of the personal freedoms through which social change can be achieved. His espousal of anarchy, misunderstood or misconstrued by his opponents to mean a call for violence, was similar to the demands for individual freedom declared in the Russian anarchist Peter Kropotkin's life and writings. It was a proposal to free the full potential of the individual from the compelling weight of government and institutions. To Borduas the writings of Breton seemed to offer such a way, one that engaged the marvellous and personal world of the unconscious. Borduas' own writings are scattered with the desire for "magic," the magic at the core of our beings which positivism denies:

> The desire to know issues at first in magic. Science takes over knowledge in the course of things.[11]

And this means not just the magic of dreams but the magic of each individual freed from the compromises of rationality and pragmatism.

The group around Borduas became active both inside and outside the Contemporary Arts Society. In 1943 Maurice Gagnon, a colleague at the Ecole du Meuble, organized an exhibition of the work of twenty-three young artists, fifteen of them Borduas' students, at Dr. Max Stern's Dominion Gallery under the title *Sagittaires*. And in 1946 the first exhibition of the group which was to become known as the Automatistes was held: Borduas showed with Marcel Barbeau, Roger Fauteux, Pierre Gauvreau, Fernand Leduc, Jean-Paul Mousseau, and Jean-Paul Riopelle. The following year the group (without Leduc or Riopelle) showed again.[12] This exhibition was reviewed by Tancrède Marcil for *Le Quartier Latin* under the title *Les automatistes. Ecole de Borduas*, a title taken from one of Borduas' paintings, *Automatisme 1.47* (also known as *Sous le vent de l'île*, now in the collection of the National Gallery of Canada). Leduc and Riopelle were in Paris but kept in close correspondence with the group in Montreal. Riopelle in particular built on the contacts between André Breton and the Paris Surrealists and the Montreal group. There would shortly be a split between Borduas and Riopelle over differing interpretations of Surrealism, but prior to that came the publication of *Refus global*, the moment of greatest unity of and public controversy over the Automatistes.

Refus global was published on 9 August 1948 by the Henri Tranquille bookstore. Four hundred copies were run off on a duplicating machine. The little book had a jacket illustration by Riopelle, photographs of the the work of the Automatistes, and texts by Claude Gauvreau, Françoise Sullivan, Bruno Cormier, and Fernand Leduc, besides its central text, the essay *Refus global*. Though it was published under Borduas' name alone, *Refus global* was signed by fifteen other artists and writers.[13]

Some of the Automatiste artists had, in 1946–47, been in contact with the Communist party in Montreal, and Gilles Hénault of the party newspaper *Combat*, interviewed Borduas in 1947. In this interview, and in subsequent correspondence, Borduas made absolutely clear that the direction he saw for the Automatistes was outside politics, whether left-wing international politics or the politics of Quebec nationalism.

This is not to deny the social implications of his ideas, but at no point did he propose a political program. He said to Hénault:

Art, the only thing that concerns me, the only living thing, is an invention, not simply a more or less imperious new use of already known forms. [Art] is a real invention, totally new in its sensory form as well as in the matter it brings to the intelligence.[14]

And in a letter to the critic and journalist Josephine Hambleton-Dunn, Borduas wrote:

I find this desire to see in art the expression of a concern about the immediate social order in most of the English intellectuals with socialist leanings. I find it also to be particularly characteristic of Diego Rivera and behind him many Mexican painters. . . I consider all these works futile, illusory or crude.[15]

To Borduas social change lay in a change of attitude through the individual's realization of his potential. For him art was such a realization, but only if it was truly free, a creation without precedents. In more immediate terms, that spiritual freedom could only be attained through emotional and intellectual freedom, and here the question of education arose; and the control of education in Quebec was politically sensitive.

Despite his disavowals, the provocative phrasing of *Refus global* led to its interpretation as a politically scurrilous document. Borduas was, of course, far from alone in his opinion of the government and aspects of Church power. But the forceful language in which he expressed himself brought reaction not only from the vested interests of power but also from those more politically astute people who were working for a new order in Quebec.

Refus global—its very title indicates its impatience—begins with a description of the impoverished, colonial island that was Quebec,

A little people, that multiplied in the generosity of flesh, if not in spirit. . . spellbound by the annihilating prestige of remembered European master-pieces, and disdainful of the authentic creations of its own oppressed.[15]

A gradual awakening to the situation led to anger, but also to fear, "fear of being alone, without the God and the society which isolate you anyway," a fear of the new, a fear that leads to the anguish of a useless struggle. Faith in Christianity dulled expectations, rationalism and science were used to justify repression by the privileged classes. But the potential for the new exists, "Magic booty, wrested from the unknown, is at our feet. It has been gathered by the true poets." Borduas then moves on to exhortations of future possibilities,

Our duty is simple: To break definitively with all conventions of society and its utilitarian spirit! We refuse to live knowingly at less than our spiritual and physical potential. . .MAKE WAY FOR MAGIC! MAKE WAY FOR OBJECTIVE MYSTERIES! MAKE WAY FOR LOVE! MAKE WAY.

His attack on the Church and its control of education was explicit: "The religion of Christ has dominated the universe. Look at what has happened to it: the sister faiths turning into exploiting little sisters."

Reaction to the document was immediate. Voices of support were far outnumbered by responses that ranged from bitter invective to Gérard Pelletier's reasoned rejection of Borduas' attack on Christianity and its institutions.[17] For Borduas, the most serious consequence was that within a month of publication the Deputy Minister of Social Welfare and Youth, G. Poisson, ordered the Director of the Ecole du Meuble to suspend Borduas forthwith from his teaching post.

The years that followed were severely difficult ones for Borduas. Ill-health, family problems, loss of income, waning support, and despair led to severe depression. Maintaining his hold on the direction of the Automatistes became a battle in itself. Riopelle, in Paris, was taking a very different perspective from that of Borduas on Surrealism, and refused to support Borduas' 1948 essay,

En regard du surréalisme actuel,[18] in which Borduas wrote that French Surrealism had lost "the convulsive, transforming power through the conscious exploitation [by the best-known artists] of their personality." Borduas took Riopelle's refusal of support as a challenge to his leadership, and his reaction was bitter. As if to underline the weakness of Borduas' position, in 1948 Pellan, himself a target of Borduas' criticism, formed a short-lived group of like-minded artists, including Goodridge Roberts, Jacques de Tonnancour, Léon Bellefleur, and Albert Dumouchel under the name Prisme d'yeux. Pellan's aim was to offer an alternative to

Fig. 7. Paul-Emile Borduas. *La réunion des trophées*, 1948. Oil on canvas. 80.0 × 107.9 cm. Private Collection, Toronto.

the Automatistes, an alternative that stressed explicitly humanist values.

During the years following *Refus global* Borduas' reputation as a painter continued to grow. His work was shown in exhibitions in Canada and the United States, including a major show of the Automatistes at the Montreal Musée des beaux-arts in 1952. But his work seemed to lose direction and finally, in 1953, he decided that his only option was to leave Quebec for an extended pe-

23

riod; his plan was to spend several years in New York and Paris and, he hoped, Japan before returning to Canada.

He spent six months in Provincetown, Massachusetts, and in September settled in New York. There the work of the American Abstract Expressionists such as Jackson Pollock, Franz Kline, and Robert Motherwell had an immediate and profound effect on him. He recognized in the Americans' work an interpretation of pictorial space still more radical than in his own work. He saw in their paintings the destruction of both Cubism's flat illusionist space and the abstract Surrealism which he had developed. His own painting, particularly during the years in Paris (from 1955 until his death in 1960) shows an increasingly rigorous abstract structure.

The New Painting

In discussing the background of new art in Quebec, we marked 1942 as a turning point in the development of Borduas' art. In this year he made a series of about fifty paintings in gouache on paper. The gouache technique, of pigments mixed in water and gum, quick-drying and opaque, allowed him an immediacy and flow of gesture that he could not then achieve in oil paints. These compositions, such as *Cimetière Marin (Abstraction II)* (fig. 8), are abstractions rather than abstracts. Cubist in structure, with overlapping planes of colour developing a shallow illusion of space, they are Surrealist in imagination, mutated versions of three-dimensional reality. The looseness in the forms as they curl around one another suggest an underwater world, wafted around in the the currents, a "*cimetière marin*," a marine graveyard.

Over the next few years, working principally in oil paint, Borduas transformed and expanded the achievements of the gouaches. Some works remain openly representational, but most are abstractions in which a structure of forms, often referring to plants or fruits, appears to float in

front of a vaguely described landscape. This is the form of *Automatisme 1.47* (1947) and of *10.48*, also known as *Réunion des Trophées* (1948) (fig. 7). The space developed in this picture is, for all its Surrealism of mood and image, structured in Cubist terms. Borduas works from a thinly painted ground, building up the paint in layers from transparency towards the thicker, opaque levels which mark the forward plane of the picture. As in many Cubist pictures, he includes naturalistic clues, some apples, that heighten the tension between the autonomy of the picture and its origins in nature.

The Surrealist mood of the picture is developed through a rationally organized pictorial space. Although the forms first seem to float in front of an undefined ground, they are in fact progressively developed from background to foreground so that each plane is a development from the one behind it. This sense of structure remains consistent in Borduas' work from this point on, despite the difference in appearance between his Montreal period works and those done in New York and Paris. The changes that occur after the mid fifties result from the control of the surface and a reduction of illusionistic depth with interest spread equally across the picture surface. The notion of an image standing apart from its context gives way to what could be called an image of the whole. This is achieved gradually at first, as in *Persistence* (1955–56) (fig. 10), by embedding swatches of colour in a predominantly white field, as if the prominent columns of paint in *Réunion des Trophées* have become enclosed in the ground, like precious stones in rock strata.

In the works of Borduas' last years the paint becomes thicker still, trowelled on with a palette knife, developing a strong, simple opposition of tones and forms—black and white, brown and white, occasionally blue and white. A painting like *Composition noir et blanc* (1956) (fig. 9) is formed in dynamic tension between the contrast of tones, the emergent struggle of positive and

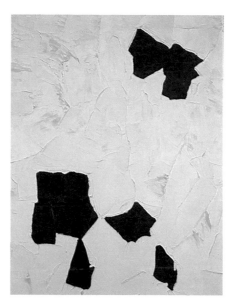

Fig. 9.
Paul-Emile Borduas.
Composition noir et blanc, 1957.
Oil on canvas.
150.0 × 116.0 cm.
Nahum Gelber, Q.C.,
Montreal.

Fig. 8. Paul-Emile Borduas. *Cimetière marin*, 1942.
Gouache on paper. 46.4 × 61.6 cm. Marcel
Elefant, Toronto.

Fig. 10.
Paul-Emile Borduas.
Persistance, 1955–56.
Oil on canvas.
60.9 × 101.6 cm.
Marcel Elefant, Toronto.

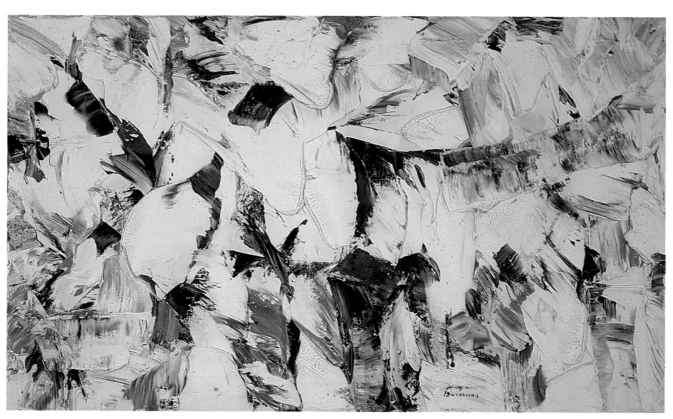

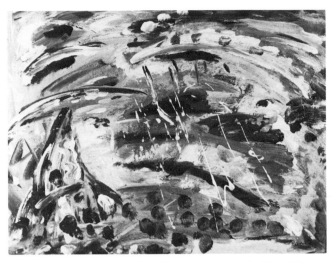

Fig. 11. Fernand Leduc. *Dernière campagne de Napoléon*, 1946. Oil on canvas. 50.8 × 66.0 cm. Artist's collection.

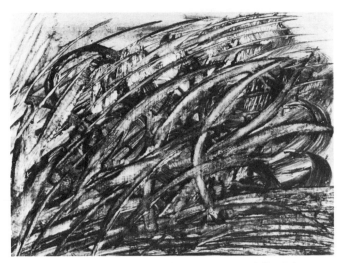

Fig. 12. Marcelle Ferron. *Les champs russes*, 1947. Oil on canvas. Edmonton Art Gallery.

negative shapes, seeking form from within the thickness of paint. A smooth area is surrounded by waves of piled-up paint; here a black edge cuts clearly from a white, there the colours encroach on one another. Nothing is settled. The black and white contrast like day and night, yet the turmoil in the paint surface itself and the streaks of grey and pink prevent an absolute distinction. The Surrealist creation of an alternative world has given way to one of reality, a constant struggle of formation and order in which the search for meaningful signs can never be finally settled. It is a paradigm of Borduas' own struggle that began in the desire to express the possibility of a new world and came to the realization that there are no solutions larger than the reality of making one form, one sign of lasting order.

The work of the young artists who had gathered around Borduas in the mid 1940s was, like his, directly affected by the Surrealist method of automatism, that is by an intuitive and spontaneous activity. Their paintings in the early years were generally small, dark in tone, and dense in structure. Some of the artists, like Leduc (fig. 11)

and Marcelle Ferron, or Jean-Paul Mousseau and Pierre Gauvreau (fig. 12, 13, 14) seem to develop their pictures, as did Borduas, from an organic or naturalistic base. In certain respects the most radical paintings, in the freedom of their automatic, intuitive gestures were those of Marcel Barbeau and Jean-Paul Riopelle. By 1946 both these artists were making pictures that all but eliminated the figure and ground structure on which Borduas still insisted (fig. 17, 18). And in this they were much closer to the way in which Abstract Expressionism in New York and the similar styles in Europe known as *l'art informel* or *tachisme* were developing.

Of this group of young artists Jean-Paul Riopelle was the most ambitious and the most talented. Since 1946 he has made his career in France, gaining a major reputation in Europe, the United States, and Canada, one of the few Canadian artists to be widely represented in public collections outside of Canada.

Riopelle visited New York in 1945 before travelling to Europe. The large-scale, "all-over" abstract works of Jackson Pollock which he saw

26

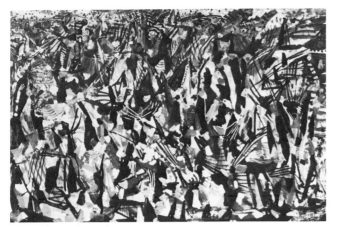

Fig. 13. Jean-Paul Mousseau, *Bataille moyenâgeuse*, 1948. Gouache on board. 71.1 × 110.5 cm. Artist's collection.

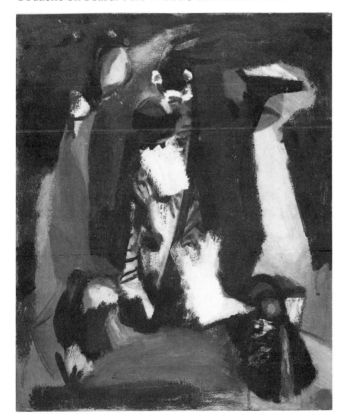

Fig. 14. Pierre Gauvreau. *Les plaines démontables: la fleur anthropophage*, 1947. Oil on canvas. 51.0 × 41.0 cm. Collection Art Gallery of Ontario, Toronto.

there had no parallel among European artists at that time. But the paintings that Riopelle began to make in Paris were similar in approach. They are thickly painted, indescribably complex in their weaving of colour and texture, worked with brush and palette knife, splattering and dripping with equal attention to each part of the surface (fig. 16). Without question some of the finest and most advanced paintings of their time, they are brilliant, often sparkling in colour. They have been described as being similar to stained glass or mosaic, but such a description ignores the fact that the energy of their making is caught, not constructed, by the paint itself; the light lies in the density of the paint.

In the later 1950s, the intensity and "all-over" character of Riopelle's surfaces begin to change. The individual strokes of paint become more broadly described, developing into a sort of drawing with paint, defining shapes which begin to emerge as forms from a ground. Into the early sixties these forms remained generalized and indistinct, but they gradually become more clearly separated, often openly descriptive. The shapes of birds and animals emerge; in recent years the owl has been a frequent subject in his paintings

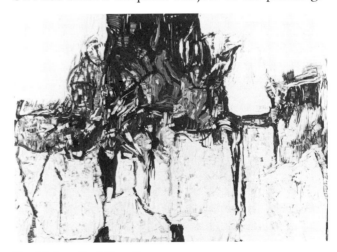

Fig. 15. Jean-Paul Riopelle.
Salut Gérard, 1970. Oil on canvas. 255.0 × 360.8 cm. Private Collection, Europe.

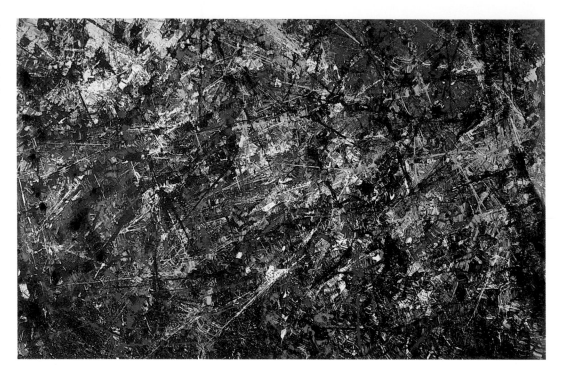

Fig. 16.
Jean-Paul Riopelle.
Composition, 1949–51.
Oil on canvas.
170.0 × 260.0 cm.
Private Collection.

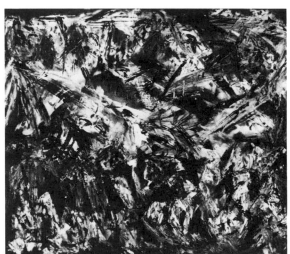

Fig. 17. Marcel Barbeau. *Le tumulte à la mâchoire crispée*, 1946. Oil on canvas. 76.2 × 88.8 cm. Musée d'art contemporain, Montreal.

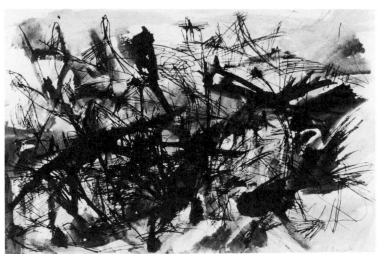

Fig. 18. Jean-Paul Riopelle. *Sans titre*, 1946. Watercolour. 30.5 × 45.5 cm. Private Collection.

and prints. It is as if Riopelle's sensibility has come full circle. Beginning with the automatism of European Surrealism the first stage of his independent work relates most closely to the emergent New York abstract expressionism. But over the years he has returned to a European sensibility. Even in the late 1940s and early 1950s, painting in Paris, as represented by artists like Nicolas de Staël, Jacques Bissière, Vieira da Silva, Hans Hartung, and others tended to maintain a figure-ground structure. Riopelle's work has come, over the years, to respond more closely to this (fig. 15).

Alfred Pellan and the Prisme d'yeux

The Prisme d'yeux group, which had been formed to counteract the Automatistes and their domination of the Contemporary Arts Society, held its first exhibition in February 1948 under the auspices of the Montreal Musée des beaux-arts. A manifesto prepared by Jacques de Tonnancour declared Prisme d'yeux to be "a movement of diverse movements, diversified by life itself."

Fig. 19. Jacques de Tonnancour. *Paysage de novembre*, 1958. Oil on masonite. 88.9 × 121.9 cm. Collection Marcelle Beaulieu, Montreal.

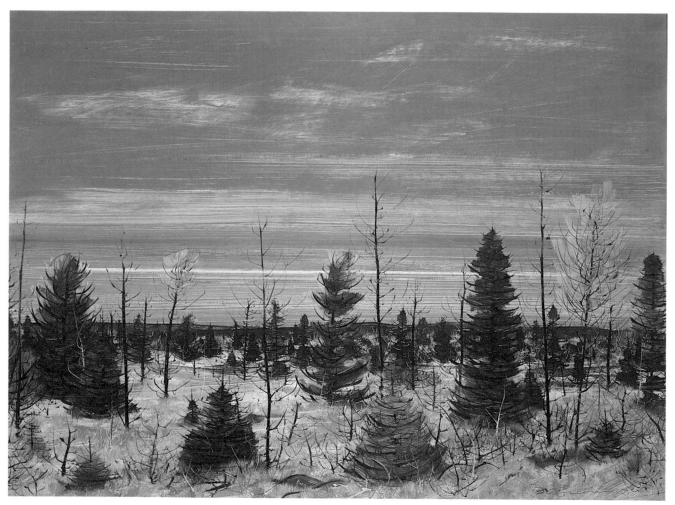

Its purpose was not only to accept differences of approach but to recognize the independence of choice made by individuals. The manifesto was clearly directed against the Automatistes:

> We seek a painting liberated from all contingencies of time and place, from restrictive ideology and conceived without literary, political, philosophical or any other interference which could adulterate expression and compromise its purity.[18]

The group lasted as an entity into 1949, by which time the Contemporary Arts Society had been dissolved and the furor over *Refus global* had weakened the position of the Automatistes. Prisme d'yeux gathered together a wide range of approaches, from the conservatism of Goodridge Roberts and Gordon Webber to the Surrealism of Albert Dumouchel (who was to become one of the most influential printmakers and teachers in Quebec) and Léon Bellefleur, both of whom were influenced by the work of Paul Klee. De Tonnancour began his career as a critic and subsequently became a student of Goodridge Roberts. Although he has worked both abstractly and representationally, his most characteristic and sensitive pictures are his landscapes (fig. 19), imaginative reflections on the Laurentian countryside.

The dominant figure among the Prisme d'yeux, however, was Alfred Pellan. He is an artist of striking virtuosity with a flowing drawing style, a boldness of colour, and a masterful facility for densely packing his pictures with varied incident. If the work he brought back with him in 1940 was a compendium of advanced European art of the 1920s and 1930s, the range of his imagination is epitomized by the pictures he began to make in the later 1940s. In *Femme d'une pomme* (1946) (fig. 23) the figure of a young woman stands divided within herself. On the left the free flow of her hair merges into two figures: above is a woman on a pedestal holding an apple; below, an inverted figure pointing to the root system of a seed. On that side she is related, goddess-like, to images of fruitfulness and growth, a figure uniting earth and sky. On the other side, however, the sky is filled with threatening and disturbing signs, mutations of the stars, a silhouetted figure enclosed in a corridor, an impenetrable wall and images of dismemberment. And below these is a womb-like form, dice and playing cards, and a foetus. The central figure reflects psychological tension, divided between timeless symbols of stability and generation, and of terror, chance, and destruction.

Pellan has always asserted the primacy of Surrealism in his work. In 1966 he said, "I have always been enamoured [with Surrealism], and I

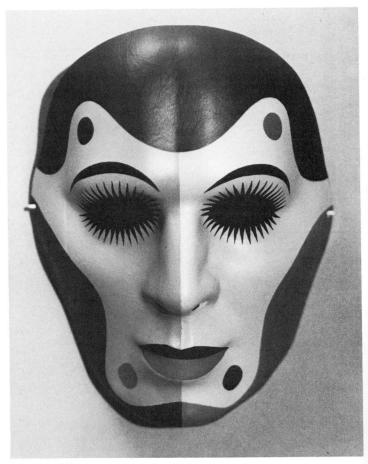

Fig. 20. Alfred Pellan. *Mask.* 1971–72. Acrylic.

still am, and I think I always will be a Surrealist."[19] His concern with Surrealism has been expressed at different levels, including several series of illustrations for Surrealist poems, those, for instance of the Québecois writers Alain Grandbois (1944) and Eloi de Grandmont (1946) and the French poet Paul Eluard's *Capitale de la douleur* (1948). But whereas the freedoms of Surrealism led Borduas to believe in the painted object as something independent of the specifics of thought, Pellan, in contrast, saw Surrealism as a method to open imaginative possibilities, to describe the world poetically with a freedom of transmission between inner and outer realities. Breaking through the surface of the exterior world, the painter could reform it into alternative worlds, poetically reconstructed in the imagination.

In the 1950s Pellan concentrated more on references to plant growth and to microscopic forms in his work, to a point, as in *Les carnivors* (1966) (fig. 24), where we seem to be looking at the indestructible and teeming character of life. His interests, however, have been as wide-ranging as his formal inventions. He has, for instance, taken up theatre costume design, and a 1971 project led him to prepare painted masks, which he then continued to produce simply for the delight of the invention (fig. 20).

Jean Paul Lemieux

From the founding of the Contemporary Arts Society the mainstream of Quebec painting has followed a modernist strategy, international in its roots and its development, placing painting in Quebec within the wider context of recent art. There is a tendency to concentrate on the most advanced aspects, but the situation is far from clear-cut, particularly among those artists who have stood apart from the groupings and regroupings which marked art in Montreal through the 1940s and 1950s; one may mention in this regard the work of such artists as John Fox (fig. 21) and Jean Dallaire (fig. 22).

Fig. 21. John Fox. *Untitled #1*, 1980. Acrylic on canvas. 204.5 × 196.9 cm. Lavalin Inc.

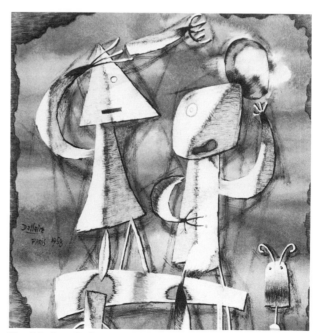

Fig. 22. Jean Dallaire. *Scarecrows*, 1958. Watercolour and gouache on board. 26.2 × 26.9 cm. Lavalin Inc.

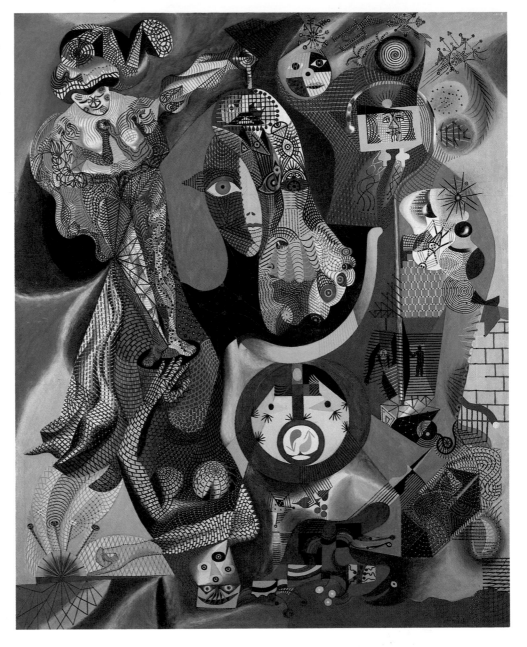

Fig. 23.
Alfred Pellan.
Femme d'une pomme,
1943.
Oil on canvas.
161.0 × 129.7 cm.
Collection Art Gallery
of Ontario, Toronto.
Gift of Mr. and Mrs.
Charles S. Band, 1956.

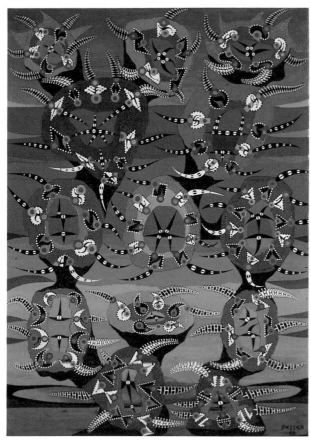

Fig. 24. Alfred Pellan. *Les carnivores*, 1966. Oil, silica on plywood. 66.0 × 46.5 cm. Dalhousie University Art Gallery, Halifax.

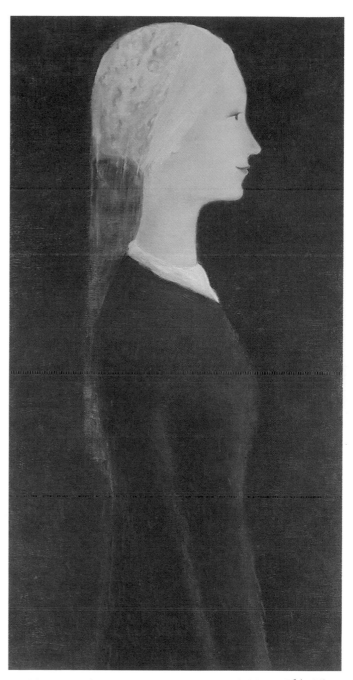

Fig. 25. Jean Paul Lemieux. *Jeune fille au voile bleu*, 1964. Oil on canvas. 102.9 × 51.4 cm. Mr. and Mrs. J. D. Hausner, Montreal.

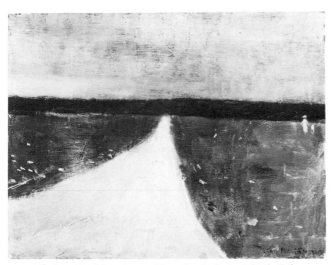

Fig. 26. Jean Paul Lemieux. *Chemin du bois*, 1975. Oil on canvas. 35.6 × 45.7 cm. Lavalin Inc.

Unquestionably the dominant independent figure on the Quebec scene over the past forty years has been Jean Paul Lemieux. Born in Quebec City in 1904, he taught briefly at the Montreal Ecole des beaux-arts and at the Ecole du Meuble before returning to Quebec City in 1937. He taught at the Ecole des beaux-arts there until his retirement in 1965. His involvement and interest in the generation of modern art in Quebec was marked both in his teaching and in a series of often strongly phrased articles which he wrote between 1935 and 1951. But the essence of his work lies in his response and attachment to Quebec life, to its landscape and institutions and, above all, to its people.

Until the 1950s Lemieux's work was characterized by a variety of styles, or rather by a searching for style. His paintings shift between the School of Paris and, in the best and most interesting pictures of this period, a naïve style filled with anecdotal detail, such as *Fête-Dieu à Québec* (1944). This unsettled direction and, in the 1940s at least, relatively small production were the result of a division within him between a passionate attachment to Quebec and an anger at the thoughtless disregard for the province's cultural values both historically and in the modern world.

The 1951 painting *Les Ursulines*, simplified but not naïve, direct and devoid of anecdote, signalled a major shift in his work. It took several more years, during which he spent some time in France, before he fully grasped the implications this painting had opened. In the late 1950s he began the landscape (fig. 26) and figure paintings on which his reputation is based. In certain respects, the simplification in his work took him back to the great masters of the Italian Renaissance, to Fra Angelico, to Piero della Francesca, and in the case of *Jeune Fille au Voile Bleu* (1964) (fig. 25), to the portraits of Domenico Ghirlandaio. But if these references are the basis for Lemieux's images, his vision of the people and the land of Quebec is at once unique and typical.

Les Plasticiens

Borduas' departure in 1953 was a fateful move for art in Quebec. But even from his self-imposed exile, his influence was pervasive. It existed in the minds of those he had taught and encouraged, in those with whom he had argued, and in the continuing example of his work. And there remained, right up to his death in 1960, the anticipation of his return. He wrote in 1959,

> How is the country? I am always thinking about returning one day—but I believe that that is still far off.[20]

The revolutionary character of art in Montreal in the 1940s and early 1950s was symptomatic of the demand for social change that, through the "Quiet Revolution," saw the collapse of the political system that the Duplessis regime had maintained, and the gradual loosening of the Church's control on thought and education. The revolution in the visual arts, both in its regard for events outside Quebec's borders and its assertion of freedom of thought and expression, symbolized the change that was to come in society as a whole. But

as that revolution gained hold there was, in painting, a vital shift of emphasis. The notion of the Surrealist, automatist expression was one of collective freedom through personal liberty, with art as an example of the potential existing in every individual. It assumed a direct, naïve, relationship between artistic expression and fundamental truths about the human condition.

In the 1950s there was a growing concern with the *language* of painting, with the recognition that it was not a natural language but a very specific construction independent from all other modes of expression. This was implicit in the perspective that Borduas gained from New York of painting in Montreal, and it is marked in two statements of Fernand Leduc. In 1943 Leduc wrote, "The artist is on the edge of society only when he is on the margin of life."[21] Many years later, recalling the formation of L'Association des artistes non-figuratifs de Montréal in 1956, he said its establishment

> was for us a way of bringing together artists who would compel recognition from society for a type of art which it rejected; who would force the museums to open their doors; who would force the powers that be to recognise the group.[22]

Clearer still was the attitude of a young critic and painter, Rodolphe de Repentigny who, in a 1954 article for *L'Autorité*, reviewed an exhibition of four young artists whom he called Les Plasticiens. He pointed out the difference of their approach from automatism and from "romantic Surrealism," by which he meant artists like Pellan and Bellefleur, and wrote,

> Every painting must have its own particular form to make a totality, resistant to and not assimilated by an ambience and where each part depends on the whole and vice-versa.[23]

Repentigny was, even if only for a tragically brief period, an important figure on the Montreal art scene. Born in 1926, he went to Paris in 1949 to study philosophy at the Sorbonne. He returned to Montreal in 1952 and began to write art criticism

Fig. 27. Louis Belzile. *Sans titre*, 1954–55. Oil on canvas board. 50.5 × 61.0 cm.

for *La Presse* and the short-lived journal *L'Autorité*. In 1954 he joined with Fernand Toupin, Louis Belzile, and Jean-Paul Jérôme (fig. 27, 28) to form Les Plasticiens. A master of the pseudonym, he painted as "Jauran," wrote under his own name for *La Presse*, and under the name "François Bourgogne" for *L'Autorité*.

Early in 1955 the four artists issued the *Plasticien Manifesto*, written by Repentigny.[24] Compared with *Refus global*, the manifesto is a temperate and technical document; "the Plasticiens make paintings because they like those things which are special to painting." They acknowledge a debt to the Automatistes, recognizing their place in the revolutions which have freed the arts from "servitude to a materialistic ritual." But for them Mondrian is the principal point of reference. It was Mondrian who insisted on the independent reality of painting. He argued that only by concentrating on the unique properties of painting could it become a disinterested object, one free to provide a passage for communication between the intuitions of the artist and the spectator.

In looking to Mondrian the Plasticiens—their name marking their exclusive concern with the

Fig. 28. Jean-Paul Jérôme. *No. 14*, 1955. Oil on canvas. Whereabouts unknown.

Fig. 29. Jauran. *Sans titre*, c. 1954–55. Oil on masonite. 38.5 × 34 cm. Private Collection.

abstract properties of painting—expressed their rejection of Surrealism and their attachment to the idealism of the European Constructivist movement which, from the 1930s, had spawned a wide range of approaches. Repentigny during his stay in Paris, and Belzile, who was there in 1952–53, could have seen not only the work of the original Constructivists but that of many others who had been drawn to Paris. Serge Poliakoff, for instance, was, from the late 1940s, making pictures of interlocking flat forms very similar to the paintings Repentigny began to make in 1953. In addition, the Plasticiens could work from paintings reproduced in magazines and from occasional exhibitions of modern European art in Montreal, such as an exhibition of tapestries made from designs by Victor Vasarely, Richard Mortensen, and others shown there in September 1954.

The paintings of the Plasticiens were neither original nor fully resolved, and their Manifesto is unclear as to the essential relationship they sought between abstract art and society. Their work was tentative and, in Repentigny's case, a deliberate testing of the relationship between theory and painting. His family had resisted his artistic ambitions and to receive their support for study in

Paris he had had to agree to stop painting. When he took it up again in Montreal—as "Jauran"—it was not so much because painting was his intended career, but in order to work through his ideas and understanding of geometric abstraction (fig. 29). His work, and that of his associates, still retains a Cubist version of pictorial space rather than a rigorously abstract space, but their rejection of the Surrealism of the Automatistes is complete. Most striking are the shaped paintings of Fernand Toupin, his "tableau-objets" (fig. 30). He began in 1955 to paint on shaped pieces of wood or masonite so that the edge of the picture becomes an active, if arbitrary, part of the painted design. The shaping of the pictures and the way they stand away from the wall assert their existence as objects rather than as illusions of the

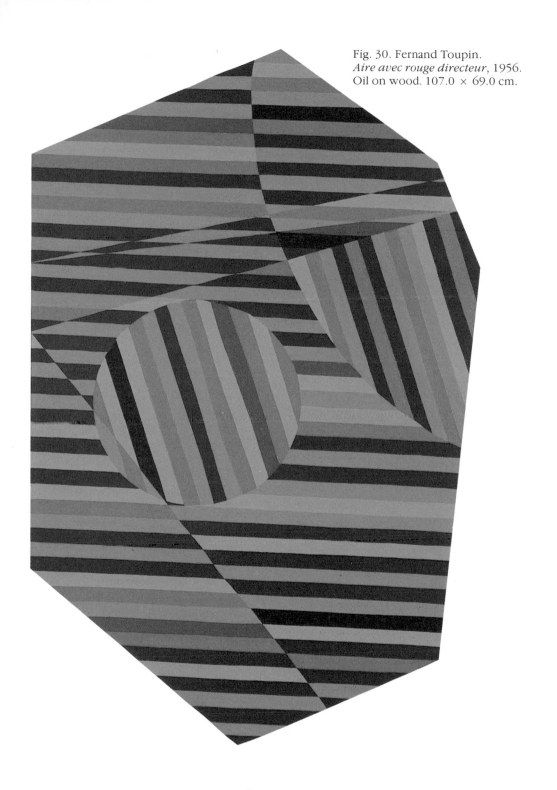

Fig. 30. Fernand Toupin.
Aire avec rouge directeur, 1956.
Oil on wood. 107.0 × 69.0 cm.

Fig. 31. Denis Juneau. *Rond noir*, 1958. Oil on canvas. 91.4 × 81.3 cm. Denis and Réjeanne Juneau.

natural world or of an imaginary surreal world. They exist as independent and self-referential objects. To break with the traditional shape and proportions of painting was not in itself unprecedented, but Toupin's abstraction, with its emphasis on the "tableau-objet" and the eccentricity of his shapes, looks forward to the developments of American hard-edge abstraction of the early 1960s, particularly the work of Frank Stella and Kenneth Noland.

The position taken by the Plasticiens was almost immediately (and more radically) developed by Fernand Leduc, Guido Molinari, and Claude Tousignant. The final act, as it were, of the Automatiste movement came in the 1954 exhibition *La Matière chante*, selected by Borduas and asserting continued opposition to the academic "Spring Show" at the Museum. The following year *Espace 55*, an exhibition at the Musée des beaux-arts in Montreal, was not only the occasion of a rift between Borduas and Leduc, arising from Borduas' criticism of current Montreal painting, but also marked shifts in the work of a number of artists away from automatism towards a more geometric structuring. At the same time the Plasticiens organized an exhibition of their own. These new directions found a centre of operations in a small gallery, l'Actuelle, opened by Guido Molinari in 1955, which was dedicated to showing only non-figurative work; and they were formalized in 1956 with the founding of the Association des artistes non-figuratifs de Montréal. Its constitution was written by Leduc and Pierre Gauvreau, both of whom had been Automatistes, and Repentigny, who had initiated the Plasticiens. Even within this group there were substantial differences in approach. The most radical direction became the subject of an exhibition early in 1959 at the Ecole des beaux-arts under the title *Art Abstrait*. It included work by Leduc, Molinari, Claude Tousignant, Jean Goguen, and Denis Juneau (fig. 31) as well as two members of the Plasticiens, Belzile and Toupin. The same year Leduc left for France and Repentigny was killed in a mountaineering accident. The radical leadership shifted to a smaller group, comprised of Molinari, Tousignant, Juneau, and Perciballi, who took the name *Espace dynamique* for a 1960 exhibition of their work at the Denyse Delrue gallery.

Notes

1. Guy Robert, *Lemieux,* (trans. John David Allan). Toronto: Gage Publishing, 1978; p. 45.
2. *Ibid.,* p. 44.
3. J. Russell Harper, *Painting in Canada: A History,* Second edition. Toronto: University of Toronto Press, 1977; p. 331.
4. *Ibid.*
5. *Alfred Pellan,* Musée de la province de Québec, juin 1940. Musée des beaux-arts de Montréal, octobre 1940.
6. *Paul-Emile Borduas, Ecrits/Writings 1942 – 1958,* François-Marc Gagnon (ed.), The Nova Scotia Series, Source Materials of the Contemporary Arts. Halifax: The Press of the Nova Scotia College of Art and Design, 1978; p. 93.
7. *Ibid.*
8. "Première exposition des Indépendants". Montreal, Galerie municipale au foyer du palais Montcalm, 26 avril au 3 mai, 1944.
9. François-Marc Gagnon, *Paul-Emile Borduas (1905 – 1960).* Montreal: Fides, 1978; p. 109.
10. *Ecrits/Writings,* p. 132.
11. *Ibid.,* p. 41.
12. At 75 Sherbrooke Street West, 15 February – 1 March 1947.
13. *Ecrits/Writings,* p. 45 – 54.
14. Gagnon, p. 208.
15. *Ecrits/Writings,* p. 45.
16. Gagnon, p. 261.
17. Gagnon, p. 247 – 248 and *Ecrits/Writings,* p. 71.
18. Ann Davis, *Frontiers of Our Dreams, Quebec Painting in the 1940's and 1950's.* Winnipeg: The Winnipeg Art Gallery, 1979; p. 27.
19. Reesa Greenberg, *The Drawings of Alfred Pellan.* Ottawa: National Gallery of Canada, 1980; p. 73.
20. Gagnon, p. 451.
21. Jean-Pierre Duquette, *Fernand Leduc.* Montreal: Editions Hurtubise HMH Ltée, 1980; p. 31.
22. *Ibid.,* p. 91.
23. *Jauran et les premiers Plasticiens.* Montreal: Musée d'art contemporain, 1977; n.p.
24. *Ibid.*

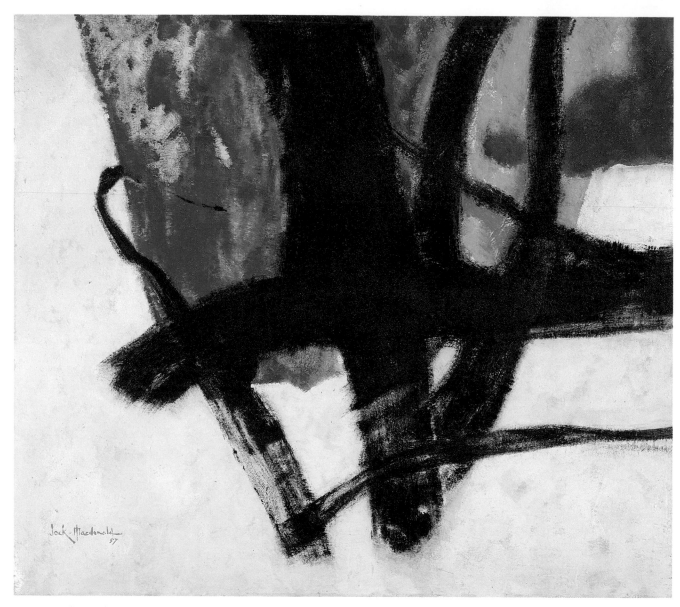

Fig. 32. Jock Macdonald.
Airy Journey, 1957.
Oil on board. 106.7 × 121.9 cm.
Hart House, Permanent Collection,
University of Toronto.

Toronto: Breaking the Mould

New art in Montreal emerged from an atmosphere of conflict, and the fragmentation of the forces for change within the artistic community was symptomatic of a society in dispute with itself. The various declarations of the Automatistes, the Prisme d'yeux, the Plasticiens, and Espace dynamique addressed, more or less directly, the issues of art as they expressed societal concerns; their polemics asserted interpretations of social realities. And if their debates were played out against a background of massive indifference or antipathy to the new, the climate of artistic dispute was grounded in the broader cultural introspection of Quebec society as a whole.

In Toronto indifference and antipathy also existed, but there was no parallel to the progressive debates within the avant-garde such as those that split the Contemporary Arts Society or that divided francophone artists between the Automatistes and the Prisme d'yeux. The contemporary art scene in Toronto was dominated by the Group of Seven and their successors in the Canadian Group of Painters. Opportunities for exhibition lay principally with the societies—the Royal Canadian Academy, the Ontario Society of Artists, and the Canadian Society for Painters in Watercolour. From the 1930s the strength of the Group lay in the wide public acceptance of their art in Ontario—the Group's own battles for recognition had been won in the previous decade—and their assertion of having founded a "Canadian School" of painting. Indifference to and ignorance of more recent developments in Europe ironically concealed that the roots of the Group's own style lay in late nineteenth-century European art.

The original Group of Seven had gradually added new members—A. J. Casson in 1926, Edwin Holgate from Montreal in 1930, Lionel LeMoine FitzGerald from Winnipeg in 1932 (although the Group was effectively disbanded in 1931)—and their shows had included guest exhibitors. The Canadian Group of Painters was formed to broaden and strengthen the principles the Group had established; the catalogue of the first exhibition of the Canadian Group of Painters, held at the Art Gallery of Toronto in 1933, stated that the new Group was "a direct outgrowth of the Group of Seven." But if its avowed intentions were nationwide, in reality Ontario remained the base of its influence and Toronto the centre of its operations.

In 1975, towards the end of his life, Jack Bush, one of the leading figures in Toronto painting from the late 1950s, recalled with some bitterness the power exercised by the Group of Seven,

> For the first time [around the mid 1940s] we saw what was going on in the rest of the world. This was something that the Group of Seven,...had never mentioned to us....They knew all about the Impressionists and so on and about the good American painters....They never once told us where their influence had come from. Suddenly they were indigenous to Canadian soil and all that nonsense.[1]

For artists who rejected both academicism and the Group's particular and limited assertion of "a Canadian painting," there were few guidelines: some exhibitions of current Montreal and European work, a heavy dependence on illustrations in books and magazines to find out what was happening in art in Europe and the United States. And for many artists who were doing commercial work there was little time or money for travel.

The Art Gallery of Toronto was dominated by academic taste. There were few art dealers in the city, fewer still who would show the most recent contemporary art, particularly by younger Canadian artists. Douglas Duncan's support of David Milne and Carl Schaeffer in the 1930s had represented a rare commitment to the careers of con-

temporary Canadian artists, but not until the 1950s was there any substantial expansion of his initiative. From the early forties there was some connection with recent Montreal painting through exhibitions; Borduas and de Tonnancour had a major two-man exhibition at the Art Gallery of Toronto in 1951, and Douglas Duncan gave Borduas one-man shows at his Picture Loan Society in 1951 and 1955. But only in the course of the fifties did any real interchange between artists in the two cities occur.

The Toronto home of Albert Franck and Florence Vale became an important gathering point for young independent painters like Harold Town, Oscar Cahén, Kazuo Nakamura, Tom Hodgson, and Ray Mead. Franck, a man of many facets and skills, worked as a picture restorer, and his knowledge of painting and printing techniques was a valuable resource to the younger artists. His deep attachment to Toronto was expressed in the series of paintings he made of the older houses and laneways of the city (fig. 92), recording an aspect that was disappearing in the urban transformation of the 1950s and 1960s. Franck initiated ways for artists to show their work, at one point even using his own home as a sort of gallery space. In 1950 and 1951 he arranged exhibitions of artists unaffiliated with the academic societies at the Eaton's College Street Gallery of Fine Art in conjunction with R. F. van Valkenburg, its manager. Gradually the number of galleries with a commitment to contemporary Canadian art grew. Avrom Isaacs opened the Greenwich Gallery in 1955 and the next year Barry Kerneman opened the Gallery of Contemporary Art, which was subsequently taken over by Dorothy Cameron, Kerneman's one-time assistant, and in 1959 renamed the Here and Now Gallery. Further the Park Gallery, the Roberts Gallery, the Laing Gallery, and, from 1962, the Jerrold Morris International Gallery all showed the work of younger Canadian artists.

The first attempt to show the range of abstract painting being done across the country was initiated by Alexandra Luke from Oshawa. In 1952 she organized the "Canadian Abstract Exhibition" of work by twenty-six artists. The exhibition, for which the term "abstract" was very broadly interpreted, included seven members of the future Painters 11 as well as Léon Bellefleur and Marian Scott from Montreal, Jack Shadbolt from Vancouver, and Lawren P. Harris from Sackville, New Brunswick. It was shown in six Ontario centres, in Montreal, and in Sackville with generally positive notices everywhere but Sackville.[2]

The following year William Ronald, not long out of the Ontario College of Art, initiated an exhibition which was to have lasting consequences on the development of advanced art in Toronto. His one ally on the staff at the College had been J. W. G. (Jock) Macdonald, who had had an extraordinarily difficult time himself with his more conservative colleagues. At Macdonald's urging and with the help of a scholarship, Ronald went to New York in 1952. He was immediately caught up in the excitement and energy being generated by the new painting there. Back in Toronto the next year, at a panel discussion at the Art Gallery of Toronto, he heard a critic, George Robertson, suggest that one way to break the difficulty artists were having in getting their work shown would be to get major department stores to sell original Canadian paintings—an idea which had as a precedent the Unaffiliated Artists Exhibitions at Eaton's College Street store in 1950 and 1951. Ronald, who had worked in the Robert Simpson Company design department, persuaded the company to agree to his organizing an exhibition of new paintings. The idea was accepted, and he asked seven artists—Jock Macdonald, Jack Bush, Oscar Cahén, Tom Hodgson, Alexandra Luke, Ray Mead, and Kazuo Nakamura to participate. Only Macdonald declined; he felt that he had no suitable work ready. Each artist was given one in a series of room-setting displays of contemporary furnishings in which to hang his or her work. The exhibition, entitled "Abstracts at Home," opened in October 1953.

At a session for a publicity photograph in conjunction with the exhibition, the artists discussed the possibility of continuing to exhibit together. Alexandra Luke suggested they meet at her Oshawa studio. The group got together there in November 1953 with four additional artists invited to join them; Macdonald at Ronald's suggestion, Harold Town and Walter Yarwood at Cahén's, and Hortense Gordon at Mead's. At this meeting the name Painters 11, put forward by Town, was adopted for the group; and Bush, then with the Roberts Gallery and the only one of the eleven to have a dealer, agreed to approach the gallery about a group show. The proposal was accepted and the first Painters 11 exhibition was held in February 1954. The opening of the show enjoyed unexpectedly good attendance, more perhaps out of curiosity than as a mark of the city's cultural starvation. Little work was sold, but the show received favourable notices. Pearl McCarthy of the *Globe and Mail*, acknowledging the group's insistence that they had not set out to assert a united sensibility, urged her readers to set aside the issue of abstract against representational art and to look at the individual works on their own terms. The exhibition was shown at the Robertson Gallery in Ottawa. In 1955 a second group show was held at the Roberts Gallery and at the YWCA (Adelaide House), in Oshawa.

Through its six-year life Painters 11 exhibited regularly and widely. An exhibition toured Ontario in 1955–56, and there were shows at the Riverside Museum, New York, in 1956, and the Park Gallery, Toronto, in 1957. In 1958 the group showed at the Ecole des beaux-arts in Montreal and the Alan Gallery in Hamilton, and this was followed by a national touring show in 1958–59, a 1959 joint exhibition with ten contemporary Quebec artists, at the Park Gallery, Toronto, and a show at the Stable Gallery, Montreal Musée des beaux-arts, early in 1960. The group formally disbanded in October 1960, but an exhibition already planned for the Kitchener–Waterloo Art Gallery opened in December that year.[3]

Fig. 33. Jock Macdonald. *Departing Day*, 1935. Oil on panel. 37.9 × 30.5 cm. Collection Art Gallery of Ontario, Toronto. Purchase with assistance from Wintario, 1979.

Their consistent program of group shows, and solo and smaller group exhibitions, and the support they received in the press kept Painters 11 in the public eye. From the beginning, attitudes, ambitions, and priorities within the group varied greatly. Its unity depended on desire for change and the recognition that change could only be effected by collective action. It was a unity strained but also fuelled by disagreements, yet bound by their rejection of the status quo. The artists' individuality is reflected in their decision not to work under a common manifesto, a point made explicit in the brochure for their very first exhibition:

There is no manifesto here for the times. There is no jury but time. By now there is little harmony in

Fig. 34. Oscar Cahén. *Animated Item*, 1955. Oil on canvas. 71.2 × 87.0 cm. Collection Mrs. M. Cahén-Egglefield.

the noticeable disagreement. But there is a profound regard for the consequences of our complete freedom.

A statement at the time of the 1957 Park Gallery show struck at reactionary opposition:

> In the war of sound (not sight) that surrounds painting today, we hear of a vast and conclusive return to nature, as if nature were a bomb shelter to be used in time of plastic trouble. We are nature, and it is all around us; there is no escape, and those who wish to go back have nowhere to go.

Dismissing the conservative assumption that a "return to nature" is the road to sanity, the group asserted;

> What might seem novel here in Ontario is an accepted fact everywhere else. Painting is now a universal language; what in us is provincial will provide the colour and accent; the **grammar**, however, is a part of the world.[5]

Although Painters 11 spanned the period from 1953 to 1960, the group was most active during the first four of those years. The tragic death of Oscar Cahén in an automobile accident in 1956,

Ronald's move to New York in 1954 and his resignation from the group in 1957, and Mead's move to Montreal the same year all diminished the group, and there was never any question of adding new members. Luke and Macdonald, discussing the 1958 exhibition with the invited Quebec artists, agreed it was "not a good show."[6] Macdonald, tracing his sense of disaffection back about a year and a half said, "No longer is there the old unity." He felt the group's high point was April 1956, when Painters 11 had exhibited with the American Abstract Artists at the Riverside Museum in New York. That exhibition was particularly well received, and very favourable critical comparisons were made between Painters 11 and current American painting.

In 1957 William Ronald had his first solo exhibition in New York, at the Kootz Gallery. Jock Macdonald attended the opening, and in conversation with Clement Greenberg suggested that the critic visit Toronto to see what other Canadian painters were doing. Greenberg's reaction was favourable, and at a meeting of Painters 11 Ronald proposed that Greenberg should be invited to visit the artists in their studios; his expenses would be shared amongst them. Luke and Macdonald were most strongly in favour of the plan, Town and Yarwood were so decidedly opposed that they refused to participate. The others decided to go ahead, and in June 1957 Greenberg spent half a day in the studio of each participating artist.

Some of the artists, particularly Luke, Macdonald, and Bush, found the criticism and encouragement from one of the leading critics of the day valuable. Greenberg was very direct in discussing their work, and although Macdonald's enthusiasm subsequently cooled, for Bush it was the beginning of a life-long friendship. Bush was the only artist visited who recorded in any detail the critic's comments on his work. In essence, Greenberg told Bush to seek out his own manner and stop trying to imitate the "hot licks" from New York. This response to Bush's work also reflected

Fig. 35. Jack Bush.
On Green Ground, 1960.
Oil on canvas. 198.1 × 208.3 cm.
Collection Art Gallery of Ontario, Toronto.

Greenberg's own growing disenchantment with the proliferation of Abstract Expressionism in New York. This critical perspective would lead him to support a very different approach to painting, one that he was to codify in his 1964 "Post Painterly Abstraction" exhibition in which three Canadian artists were included—Bush, and Ken Lochhead and Art MacKay from Regina.

Through the 1950s there was an increasing interchange between Painters 11 and the advanced painters of Montreal. Borduas, in particular, who had had regular showings of his work in Toronto from the early 1940s, was widely respected. The artists in Montreal and Toronto had common interests in their desire to break through the prevailing traditionalism and the indifference to change which protected it, but their ambitions for and approaches to advanced art were quite different. There was even some sense of playing down the Automatistes' moves toward abstraction; Hortense Gordon and Jock Macdonald had been making "automatic"—that is, freely intuitive—pictures since the 1930s.

No events in Toronto paralleled the resistance to and the forced resignation of Charles Maillard at the Ecole des beaux-arts, or the public furor raised by the publication of *Refus global*. But through the 1950s the cooler abstraction and theoretical concerns of the Plasticiens and Espace dynamique had taken painting so far from representational values that open confrontation was avoided rather than heightened. By contrast the work of Painters 11 was aggressive, challenging in colour and drawing and scale. The paintings' references, actual or implied, to images of the everyday world raised a more immediate public reaction of shock and discomfort both to the perception of art and to general concepts of reality. The relative strength of the Societies and the widespread influence of the Group of Seven and the Canadian Group of Painters comprised a substantial reservoir of opposition within the art world itself that, unwillingly perhaps, acted as a stimulus to dispute. Events were kept on the boil

by the high profile of some of the members of Painters 11—particularly Harold Town—by their involvement in the media, and by the support they received from writers, from Pearl McCarthy of the *Globe and Mail* and most of all from Robert Fulford of *Saturday Night*. Even though this energy was being generated by a very small group of people it was vital in raising an awareness of contemporary activity in the city and laying the basis for the rapid expansion of the visual arts in the mid 1960s.

In Toronto through the 1950s and early 1960s the visual arts experienced the ferment of extraordinarily rapid change from values rooted in the late nineteenth century to attitudes allied with the leading edge of advanced painting—in particular with what was happening in New York. In New York—and to a lesser extent in Montreal—the gradual assimilation of European abstraction and surrealism had brought American painting in the 1940s and early 1950s through a dynamic but progressive change. In Toronto the shift from a pre-Cubist approach to Abstract Expressionism occurred within just a few years. In Europe and the United States, new work, no matter how difficult it seemed to be, could be recognized within the broader patterns of change. The Canadian audience's lack of awareness of the larger perspective of developments in modern art made change appear to be spontaneous and unprecedented. Hence the cliché that a Canadian artist must receive recognition abroad before being taken seriously at home. But to accept a good outside opinion as a certificate of quality, is really no more than a way to ease the insecurity of making our own judgements.

Painters 11 and their Work

The members of Painters 11 varied widely in age, background, and experience. At the time of their first exhibition in 1954 Hortense Gordon, the oldest member of the group, was sixty-seven; Kazuo Nakamura and William Ronald were both

twenty-eight. Hortense Gordon and Alexandra Luke had a substantial amount of work behind them; Bush was, in a more modest way, established as an artist. Macdonald was by far the most experienced of the group, and had already had a major impact on the development of modern painting in Canada as artist, teacher, and advisor to a number of people, first in the West and, after 1947, in Toronto. Of the younger members Town, Ronald, and Cahén were artists of remarkable, even prodigious talent. Unlike the Automatistes the group had no clear leader; the meetings, called primarily to arrange plans for exhibitions, were "tempestuous," and became forums for debate and argument on the directions and priorities of each artist. Their exhibited work represented widely differing stages and accomplishments, the most powerful and most ambitious coming from Ronald and Town. These years saw the development of Macdonald's final and grandest statements; for Cahén they showed the promise of a major career that was not to be realized, for Hodgson they were the time of his most innovative work, and for Bush they saw the early moves towards his real artistic strength.

At the time of the formation of Painters 11 Macdonald had nearly twenty-five years of mature work behind him. His experience was rare not only because of the work he had produced, what he had seen, and the people he had worked with, but in his struggle to survive as a serious and advanced artist in Canada during the 1930s and 1940s. The integrity of his commitment, the example of his enthusiasm, and the support through his teaching made him a pivotal figure in Canadian painting from the 1930s to his death in 1960.

His commitment to painting as a direct expression of spiritual values through abstraction was formed in the 1930s in Vancouver. His closest colleague was Fred Varley, an original member of the Group of Seven. In 1927 the two men decided to share a studio and from 1933 to 1935 they ran their own school, the British Columbia College of Art. Through Varley Macdonald had been drawn

Fig. 36. Jock Macdonald. *The Ram*, 1946. Watercolour on paper 16.5 × 24.8 cm. Robert McLaughlin Gallery, Oshawa. Purchase, 1979.

into a circle actively interested in theosophy and related approaches to spiritual and scientific matters; the writings of P. D. Ouspensky, in particular the *Tertium Organum*, had been a vital influence on him.[7] In 1935 he began a series of abstract works, the "modalities," which were related to the theosophic notions of "thought-forms" (fig. 33). Grace Pailthorpe, an English physician, Freudian psychologist, and Surrealist, arrived in Vancouver probably in 1943 and in response to her ideas and knowledge Macdonald made his first "automatics" that year. In the following decade he developed them in a brilliant series of watercolours (fig. 36).

The determination for freedom, the excitement of experiment, and the atmosphere of commitment that existed within Painters 11 seemed to spur Macdonald to push his own work with a boldness and scale he had rarely attempted before. He began to use the new techniques that the younger painters were working with; Town introduced him to the lucite medium, which, unlike oil alone, gave his paint greater fluidity and quicker drying properties. In this medium he made the paintings that must count among his best such as *Airy Journey* (1957) (fig. 32) and *Legend of the Orient* (1958), paintings simple in form, free in

gesture, forceful in colour. These stand out from others of his late paintings, in which there appears a more deliberate searching for forms, for the creation of an "other-worldly" landscape. In his late work two very different notions of abstract painting meet. Macdonald's earlier work presented the exterior world as an opaque surface that could be made transparent by the revelation of a spiritual, and hence more fundamental, reality. This approach met, in Abstract Expressionism, an attitude that depended on the equivalence between the painter's activity and the physicality of the surface. Macdonald's late work began to reconcile the declarative nature of this expressionism with his earlier "spiritual" approach.

In 1945 Alexandra Luke attended the Banff School of Fine Arts where she was deeply impressed by Macdonald's "automatics" and the spiritual conviction of his teaching. She began to read Ouspensky and her painting, which up to then had been naturalistic in a style allied to that of the Group of Seven, showed an immediate response to Macdonald's automatism. Subsequently she attended Hans Hofmann's summer school in Provincetown, Massachusetts, every

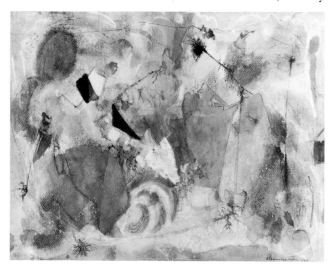

Fig. 37. Alexandra Luke. *Untitled*, 1950. Mixed media, collage on paper. 50.4 × 63.2 cm. Robert McLaughlin Gallery, Oshawa. Gift of Mr. and Mrs. E.R.S. McLaughlin, 1971.

year from 1947 to 1952. The opening of Luke's work to the abstraction Macdonald had developed was strengthened and redirected by her contact with Hofmann; his teaching was the critical factor in her later paintings (fig. 37). Hortense Gordon also made the trip to Provincetown to study with Hofmann in the late 1940s. Based on her appreciation of the painting of the School of Paris, however, she had already begun to work in an abstract manner in the late 1930s.

The works of Oscar Cahén and Jack Bush during the years of Painters 11 mark two contrasted situations. The death of Cahén in 1956 cut his mature career as a painter to just nine years and makes the full potential of his talent impossible to calculate; Bush's real achievement as a painter must be measured from after the group's disbandment in 1960. At the time of his death, Cahén had established an important reputation amongst those who followed the visual arts in Toronto. Within the Painters 11 group, Mead and Hodgson, in particular, have attested to the importance his example had for them as individuals and for the discussions of the group as a whole; and the influence of his bold use of colour, particularly in his handling of close harmonies, can be marked in Bush's work of the mid 1950s. He had also become well known as a graphic designer and an illustrator, a point of particular note within the context of Painters 11 as several of its members—Bush, Mead, Hodgson, Yarwood, and Town—worked full-time or on a freelance basis as commercial artists.

Cahén was born in 1916 in Copenhagen of a German father and a Danish mother. His father was a writer whose published opposition to the Nazis necessitated the family's escape from Germany. Cahén was living in Prague when, through the Munich Agreement of 1938, the Sudetenland was handed over to Germany. He went to England and, because he held German citizenship, was interned as an enemy alien at the outbreak of war in 1939. With many others in his situation he was shipped out of England in 1940, by chance

rather than choice being brought to Canada (it seems he was originally destined to be sent to Australia). On arrival he was again interned, this time near Montreal, but his release was obtained through contacts who knew of his training and abilities as an illustrator. He worked as an illustrator in Montreal, and in 1946 he moved to Toronto where he, Yarwood, and Town became close friends.

Cahén's mature career as a painter dates from his arrival in Toronto. His paintings dating from the late 1940s are often on religious subjects and emphasize tortured and despairing figures. They reflect in style the deep impression made on Cahén by the work of the American, Abraham Rattner, and the Englishman, Graham Sutherland, both of whom were then painting religious pictures reflecting their responses to the destruction of war. The influence of Sutherland's spikey and despairing figures remained evident in Cahén's paintings of the very early 1950s, even as the heavy dark figures of his work of the late 1940s gave way to sharp, abstracted forms. Gradually, however, his palette brightened, his design became broader and freer and his compositions were built from bold, interlocked coloured shapes. By 1953 he was making strong abstract pictures, simple in shape and form, strong in colour, and striking in their range and key: orange against red, green against turquoise (fig. 34).

In the last three or four years of his life, his work gives evidence of following several approaches simultaneously; some pictures were wholly abstract, others figurative or still-life abstractions, some were built from meshed planes of colour, while in others complex areas of drawing are surrounded, enclosed, and defined by the planes of colour. Cahén worked with equal ease in watercolour, gouache, and oil paint and moved with facility between figurative work and abstraction. His work, however, was not gestural in the sense of the broad, sweeping brushwork of contemporary American Abstract Expressionism, but more closely structured along the lines of contem-

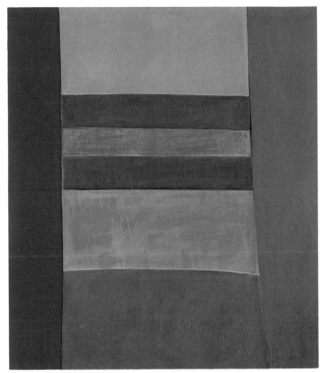

Fig. 38. Jack Bush. *Hard Red*, 1965. Oil on canvas. 237.5 × 209. 6 cm. Marcel Elefant, Toronto.

porary European and British painting. It reflects, to the extent that we can estimate it, a talent that was not and could not be restricted to one particular mode of approach.

In many respects Jack Bush's career epitomizes the changes that occurred in Toronto painting from the 1930s to the 1970s. The success of his work is largely to be measured by the last fifteen years of his life. It is the result of a long struggle; a struggle that took him from the conventions of Canadian painting (established and sustained by the Group of Seven) through Abstract Expressionism to the large-scale colourfield paintings that brought him national and international recognition. His example and ambition have provided a significant lead to many other artists, particularly to those whose careers were getting under way in the later 1960s. For some this has gone no further than imitation, but

for others his example has been the catalyst for their own independent development. His detractors have focused on his friendship with Clement Greenberg, seeing his work as part of a "Greenbergian system" and a diminishment of Canadian art by American influence. Bush became convinced that he must challenge, directly, the major painting of his time—and this, he felt was being done in the United States by artists like Kenneth Noland and Jules Olitski. To argue against Bush's choice is to denigrate both his freedom to choose and the contribution he has made to painting in this country.

Bush's earliest paintings with their heritage from the Group of Seven, show that he worked within the dominant mode of Toronto painting at the time. Through the later 1940s, however, he began to experiment in a number of directions, and by the beginning of the 1950s he was producing small abstract paintings of abutted planes defining a shallow Cubist space. The hesitancy of these early pieces changed, through the mid and later 1950s, with his contact with New York Abstract Expressionism, reflecting the interest that such work was arousing in Toronto. The broad gestural work of Franz Kline and Robert Motherwell and the dark drama of Clyfford Still are echoed in Bush's canvases of this period. But gradually (and here the advice of Greenberg was important) he began to move toward structured relationships of colour areas, breaking the dependence on gesture without returning to a Cubist type of space. Colour became both the shape and the drawing. *On Green Ground* (1960) (fig. 35) is a bold and simple structure of thin paint uniting gesture, form and colour. This picture, with its loosely painted ground and strong, clear, imposed shapes, anticipates the pictures Bush was to do in the last few years of his life. But in the intervening years he worked on various series of geometrically structured pictures, structures whose function was to carry colour. In 1962–63 he developed columnal or sash-like forms, building a tension between the perspective pull of the

shapes into the canvas and the power of the colour shapes to hold to the surface plane. These were followed by a major series of large scale paintings like *Hard Red* (1965) (fig. 38), where a column of horizontal colour bands is set against vertical columns of a single colour. The paint is even thinner, staining the canvas to a dry, suede-like texture. Despite the geometry of the picture, this emphasis on texture, along with the softness in the edges of the bands, permits the colour to predominate over the formal arrangement; a characteristic that often appears strained in the more aggressively structured pictures of the later 1960s.

In the work of his last years, Bush returns to a much more open contrast between figure and ground and to a more deliberate gesture of drawing with colour. The tightly locked flat planes give way to a freedom in texture and design, a challenge in contrasts. He began, in the very early 1970s, to lay down a mottled ground across the whole canvas by rolling and brushing acrylic paints, wet in wet, over which he drew opaque colour-shapes in broad gestural sweeps. In his final works, like *Mood Indigo* (1975) (fig. 40), the ground is even more loosely brushed, suggesting an atmospheric energy over which the contrasting swatches of colour are laid, as if with the single sweep of a wide brush. These paintings seem to break free—as in the 1950s the gestural paintings had broken free from his earlier figurative work— from a sense of restriction to reach for a direct and personal expression, a challenge not to some formula of painting, but to an intuitive resolution of the variety of his uses of colour.

The radical character of Painters 11 came principally through the younger members of the group, with Town and Ronald, and with Hodgson, Yarwood, and Mead. These five, though clearly, even fiercely, independent, were united by the explosive energy of the surfaces of their paintings and by their unwillingness to concentrate their approaches on a single line of research as Bush in his way and Kazuo Nakamura in his were beginning to do.

Fig. 39. Kazuo Nakamura. *Structure*, 1962. Oil on canvas. 43.6 × 57.0 cm. Private Collection, Toronto.

Nakamura took a wholly different direction from the others, standing apart not least by virtue of the quiet reflectiveness of his paintings. His early works were landscapes—sensitive and openly representational pictures—as well as abstract constructions of space (fig. 39). Through these he sought to understand the structure of our perception and representation of the world. Since the mid 1960s he has concentrated explicitly on the relationship of geometry in nature to the structuring of our perceptions. "Bases of all shapes," he has written, "are geometrical forms; therefore, the evolution or cycle of man's environment must be based on the cycle of geometric forms."[8] It is interesting to contrast Nakamura's approach to that of Macdonald, whose creative inspiration was also drawn from the landscape. Macdonald wrote,

The artist is a reflector of the creative spirit in

51

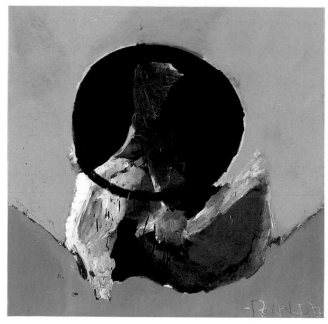

Fig. 40. Jack Bush. *Mood Indigo*, 1976. Acrylic polymer on canvas. 197.5 × 197.5 cm. Jack Bush Estate.

Fig. 41. William Ronald. *Exodus II*, 1959. Oil on canvas. 152.4 × 152.4 cm. Collection Art Gallery of Ontario. Toronto, Purchase, Membership Endowment, 1960.

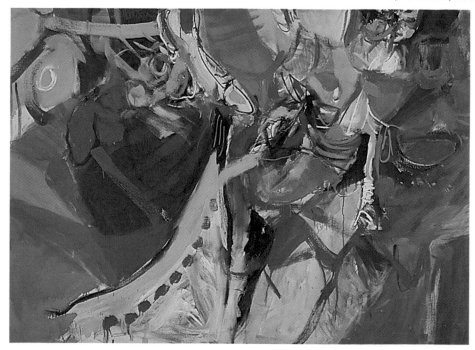

Fig. 42. Tom Hodgson. *Black Leotard*, 1959. Oil on canvas. 152.4 × 213.6 cm. Dr. Michael Braudo, Toronto.

nature. To be able to reflect this creative essence is definitely an astonishing power in the artist.[9]

For Macdonald this was discovered in the transparency of nature, in a revelation of the unseen; for Nakamura it exists in recognizing the equivalence between the structures of nature and our perceptions.

The reference to landscape is apparent in Ray Mead's paintings; bunched and layered *taches*, or daubs of colour, are suspended as if from a horizon, an approach similar to the abstraction of Nicolas de Staël. The centralized images, still retaining landscape or garden references, subsequently open out to broad planes of colour, such as in *Beaurepaire Summer* (1958) (fig. 44) and in the works of the early 1960s. These changes reflect Mead's contact with the very different approach to abstraction being developed in Montreal by Molinari, Tousignant, and Jean McEwen, reinforced for him by Yves Gaucher's *Webern* prints, which he saw in 1963. Soon after that, however, Mead began to concentrate on drawing and photography, only to return to painting again in the early 1970s.

For Tom Hodgson, too, landscape references were an important starting point for his pictures. Unlike the ordered structures that Mead built, however, the surfaces of Hodgson's pictures were energetic, accumulative, and gestural: thin paint, thick paint, graphic elements, colour drawing, collage. The paintings are rich and complex in incident, piling up references and associations with a direct subjective response to immediate experience (fig. 42). This raw energy made a special mark in the exhibitions of Painters 11 and reviews frequently made special mention of Hodgson. That energy and lack of compromise was at its peak during the 1950s and was not sustained beyond the existence of Painters 11. In the early 1960s he began to concentrate on a realistic style of figure painting and exhibited his work only rarely. More recently, he has returned to making abstract collages.

Yarwood's work in the 1950s was, like Hodg-

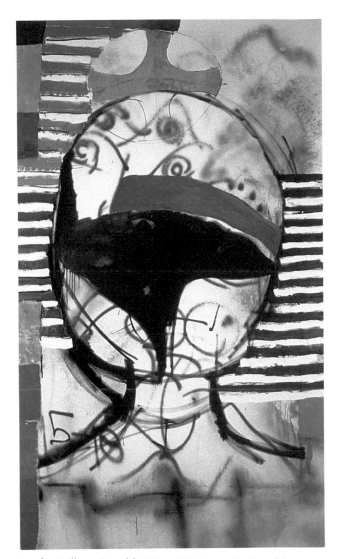

Fig. 43. William Ronald. *Prime Ministers Series – Pierre Elliott Trudeau*, 1979–81. Oil on canvas. 304.8 × 182.9 cm. Collection of the Artist.

son's, affected by the energy and directness of New York Abstract Expressionism, in particular the work of Franz Kline (fig. 46). With the dissolution of Painters 11 he too, switched the direction of his work, abandoning painting to concentrate on sculpture.

The revolutionary core of Painters 11, in its attack on the public satisfaction with the status

53

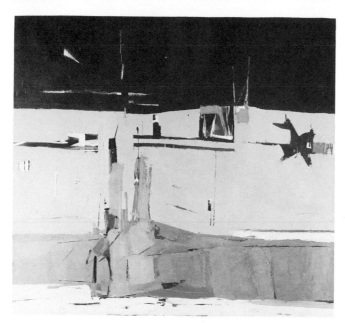

Fig. 44. Ray Mead, *Beaurepaire Summer*, 1958. Oil on canvas. 122.0 × 132.4 cm. Robert McLaughlin Gallery. On permanent loan from the Ontario Heritage Foundation.

quo and in the talent and aggressiveness of its work, lay most clearly with William Ronald and Harold Town. Between them, in the forcefulness and the clash of their personalities, the differing attitudes to change in art in Toronto polarized. It was Ronald's initiation of the *Abstracts at Home* exhibition that precipitated the formation of Painters 11. He was also quite clear that the centre of new art existed in New York and only by building contacts with the art there would the isolation of art in Toronto be broken. Ronald moved to New York in 1954, shortly after the first Painters 11 exhibition, and quickly became involved with the radical scene there. Macdonald was convinced of the importance of this environment for Ronald. He wrote in 1955, "It is a pity Ronald had gone—he won't return from New York I am sure—a very big error to do so."[10] It was Ronald who played an important role in getting the American Abstract Artists' invitation to the Toronto group to exhibit in New York in 1956, and he again who pressed for the group's accept-

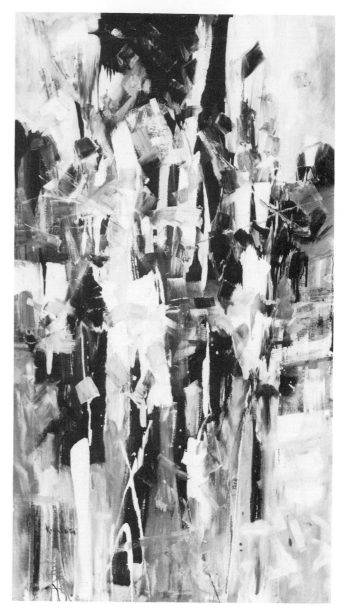

Fig. 45. William Ronald. *In Dawn The Heart*, 1954. Oil on canvas. 183.2 × 101.3 cm. Collection Art Gallery of Ontario, Toronto. Gift from the J. S. McLean Canadian Fund, 1955.

ance of Greenberg's 1957 visit. The same year he was taken on by Samuel Kootz whose gallery showed the work of radical contemporary artists. Ronald's success in New York drew him further away from events in Toronto, and he officially

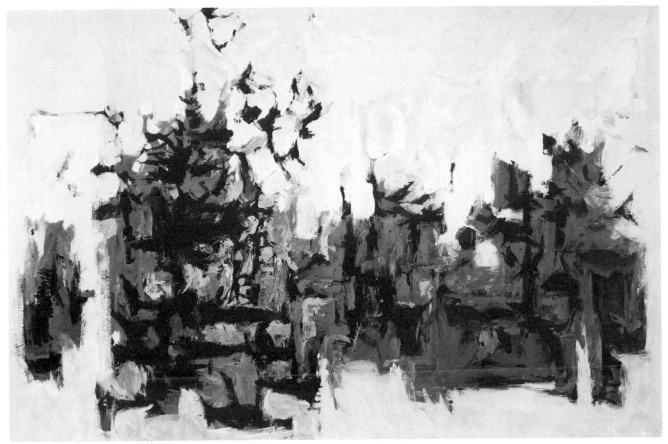

Fig. 46. Walter Yarwood. *The Lost Place*, 1956. Oil on canvas. 99.1 × 149.9 cm. Collection Art Gallery of Ontario, Toronto. Gift from the J. S. McLean Canadian Fund, 1957.

broke with Painters 11 in 1957, sealing his commitment to working in the United States by taking out citizenship in 1963.

Ronald returned to Toronto in 1965, initially only to organize an exhibition at the David Mirvish Gallery. He moved into the Anglican rectory on Ward's Island in Toronto Harbour and signalled his return by painting a massive mural there, covering the walls and the ceiling. This was a period of intense personal and professional difficulty for him. His success in New York brought with it pressure for continual performance and coincided with the shift of direction in new painting in the late 1950s and early 1960s from Abstract Expressionism to colour-field painting. The rapid rejection of the "hot," aggressive painting of the

1950s left him, as many others, isolated. For the next several years he turned away from painting to a career in broadcasting. For two seasons he hosted a program on the arts for CBC-TV called *Umbrella*, which gained Ronald the reputation of "the most hated man on Canadian television" because of his aggressive and opinionated manner. In 1968 he became one of the hosts of the radio program *As It Happens* and continues to do radio and television work. After several years away from painting he returned to it with a major mural commission for the National Arts Centre, *Homage to Robert Kennedy*, completed in 1969.

Fig. 47. Harold Town. *Gateway to Atlantis #2*, 1957. Single autographic print. 45.1 × 60.3 cm. Collection of the Artist.

Fig. 48. Harold Town. *First Spring*, 1957. Collage. 99.0 × 99.0 cm. Private Collection, Toronto.

Ronald made his early reputation with large, brilliantly coloured and "big-attack" paintings, works like *In Dawn the Heart* (1954) (fig. 45) which take up the breadth of gesture that marked the work of American painters like Franz Kline and Robert Motherwell. Through the mid and later 1950s his most original and strongest paintings were those with a strong central image, like *J'accuse* (1956), and *Exodus II* (1959) (fig. 41). Rich in colour and vibrant in painterly energy, the forms seem to rip away from the ground, as if the activity of painting can barely be contained within the format of a picture. These tensions and pressures in Ronald's work project the type of conflicts that were present in so much current New York painting. They are tensions where the very energy and verve of the gestures of painting predominated over the description of forms.

Ronald's return to painting in the 1970s found him still attacking the canvas with paint, still with an impatience which prevented him from settling

into a single mode. The evidence of his undiminished attack is nowhere more apparent than in his largest and most complex statement, a series of eighteen canvases on the *Prime Ministers of Canada* (fig. 43), on which he worked progressively for five years, completing the series early in 1983. It is in many respects the epitome of Ronald as an artist, openly controversial in its subject matter as well as in the nature and variety of treatments he gives to the pictures.

In a number of respects the strongest figure to have emerged onto the Toronto scene through Painters 11 was Harold Town. He has remained a constant presence, though in recent years for many people it has been the presence of a man who holds strong views strongly rather than one whose work demands a close interest. Unlike Jack Bush, Town has not drawn younger painters to follow him, and his determined individuality has placed him outside the criteria by which the mainstream of painting is both identified and measured. Yet he has worked and continues to work with prolific invention and technical finesse, compiling one of the most remarkable bodies of work in recent Canadian art.

Media attention to Painters 11 was without question a major factor in the development of the art scene in Toronto from the late 1950s on. It

generated interest not only in the works but also in the personalities of the artists, and for someone with the wit, inventiveness of phrase, and outspokenness of Town, controversy was a magnetic attraction. But if media attention created publicity, it also created resentments which could run deep when the number of people actively involved in the visual arts was still very small. In the early 1960s the arts, however, were rapidly expanding not because of any avant-garde tradition but from the determined pressure of a small group of artists, the Painters 11, to show their work. Consequently, there were increasing opportunities for younger artists to show their work and a greater awareness of advanced art outside Canada. Value was assumed to reside in the continued generation of the new, and an artist became stamped by the degree of his innovation in relation to the most recent, or the most recently understood, turns within the international scene. Yet art lies in the acts of the individual, measured not against fashion but by the integrity of the work. Town, in not remaining an exclusively abstract artist, and in his exhaustive investigation of a particular idea, has been seen both as changing too much, or as not changing enough. The character of his work has meant only one thing, that to be a painter is to work obsessively at painting; to express one's interests, whatever they may be, in painterly terms.

During the 1950s Town's reputation was established with three related but distinct groups of works: the "single autographic prints," the collages, and the "fat paint" paintings. The "single autographic prints" (fig. 47) were begun in 1953 with a litho press he had acquired from Oscar Cahén and were worked on through to 1959. Abstract but evocative in image, they are complex in their layers of colour and illusion of texture, flat in design but with a transparency, as if we were looking through an accumulation of archaeological traces. They are brilliant examples of what has been the essence of Town's work: the integration of an astonishing technical range and a prolific

inventive capacity. The accumulation of colour, layer on layer, retains the essential flatness of the printing technique while Town's fine control over the process opens up an imaginative depth. The collages (fig. 48) too, have this relationship between surface and depth; they are not merely an application of materials to a surface, but a building up of transparencies. The collages frequently refer to artifacts that have attracted and delighted Town in the collections of the Royal Ontario Museum: "To me the Museum is like a miracle, like one of those Chinese boxes that open up, filled with miracles."[11]

Town's first one-man exhibition, of his prints, took place at Douglas Duncan's Picture Loan Society in 1954. The first showing of his paintings was at a group show, *Mayfair Artists* at the Eaton's College Street Gallery of Fine Art in 1948, the same year he left the design department of that company and began working freelance. A solo show of paintings and prints was held at the Gallery of Contemporary Art in 1957. Through the years of Painters 11 Town's paintings were, in broad terms, Abstract Expressionist—powerful images of sweeping gestures, loaded planes of colour, and complex masses of drawing. In contrast to the tension in Ronald's work between a centralized image embedded in a ground, or Yarwood's broad, heavy forms, Town's paintings are rich in variety and complex in event, open to a multiplicity of associations. Their variety reflects the range of Town's interests and opinions and his sheer inventiveness of form and incident. By the end of the decade the shapes tend to become broader and flatter, markedly so in the series of paintings called *Great Seals* (1961–62). In 1962 Town began another series, *Tyranny of the Corner* (fig. 49). This series reversed the normal historical procedure of starting a picture from the centre and working out to the edges. Town began by defining the corners and from these developing the rest of the picture, trying "to make all the elements of the painting that arrived later a trifle uncomfortable."[12]

If *Tyranny of the Corner* determined a strategy for approaching the whole format of a painting, the *Snaps* series grew from the development of a technique. The technique relates to the method fresco painters used to work out the compositional lines of perspective or architectural structures; a string stretched taut over the wall is snapped so that it leaves the impression of a straight line in the damp plaster. Walter Yarwood suggested Town use this method to line up the elements in his thirty-seven-foot long mural for the Robert H. Saunders Generating Station on the St. Lawrence Seaway. Subsequently Town began to make paintings with this technique, loading a length of string with paint and snapping it onto the surface of the canvas, like releasing the string of a bow. As he developed control over the technique he loaded more and more paint onto the string so that the later pictures of the series have a high build up of paint and strong sense of texture. These layers of "snapped paint" are extraordinary in their illusory effects of mixed colour, while they retain an emphatically flat surface. Town next began to work against this effect by masking out a design that would be painted in a solid colour (fig. 50). It is characteristic of Town's approach to challenge the assumptions even of his own work, to invent, and then press that invention to a point that seems incapable of resolution. In the *Parks* series, worked on at the same time as the *Snaps*, the basis of the pictures is again set up as a contrast, a strong, flat shape combined with clusters of thick paint. Very often there is a wilful eccentricity, curious but evocative shapes seeking to break loose from the surface, a densely textured snap painting with flatly painted geometric forms around its edges like a sort of doodling, and everywhere a broad sense of humour and iconoclasm.

The range and inventiveness of Town's work is astonishing. He refuses to be guided by anything except the need to create, to propose and compose and depose. The wholly abstract series like *Tyranny of the Corner*, *Snaps*, and *Parks*, must be taken alongside such representational works as the *Queen Elizabeth* drawings, the *French Postcards*, the *Silent Stars, Sound Stars, Film Stars,* the brilliantly erotic and satirical *Enigmas*, the fantasy of the *Vale Variations*,[13] and, in very recent years, the *Toy Horse*.

Town's work stands out from the mainstream, from the concerns with art and anti-art, with abstraction or a return to figuration, with the rejection of painting and the return to painting. But it constitutes the body of work of one individual, multi-faceted, broad in interest and invention, constantly testing, impossible to categorize. Town is an artist whose love–hate relationship with the Toronto art world—and its with him—cannot diminish the talent or the integrity of his work.

The importance of Painters 11 lies in the fact that through their persistence, their advocacy, even their notoriety, a group of singularly unlike-minded artists broke the pathetically limited view of the visual arts that prevailed in Ontario in the early 1950s. It has been shown time and again that the very intemperance of reactionary opinion works to the advantage of new initiatives; the very conservatism of the opposition worked for Painters 11, the reactions of shock and disgust drew attention to them. The wide range of talent and ideas offered by the group validated a range of future possibilities in creative avenues, in ambition, in the place and significance of the artistic enterprise. They were not the only artists in Toronto concerned with the new, but their collective voice was the crucial one at a moment when such action could force the issues from backroom studios into the public arena.

Fig. 50. Harold Town. *Snap #80*, 1972. Oil and lucite on canvas. 182.9 × 182.9 cm. Collection of the Artist.

Notes

1. "Reminiscences by Jack Bush" in *Jack Bush: A Retrospective*. Toronto: Art Gallery of Ontario, 1976; n.p.

2. *Canadian Abstract Exhibition,* YWCA (Adelaide House) Oshawa, 1952.

3. For the exhibition history of Painters 11 see *Painters 11 in Retrospect*. Oshawa: The Robert McLaughlin Gallery, 1979; pp. 70 – 73.

4. *Painters 11,* Toronto, Roberts Gallery, 13 – 27 February 1954.

5. *Painters 11 1957,* Toronto, The Park Gallery, 31 October – 16 November 1957.

6. Letter to Alexandra Luke. Paris, 11 January 1955. The Robert McLaughlin Gallery Archives.

7. P.D. Ouspensky, *Tertium Organum. A Key to the Enigmas of the World*. Manas Press, 1920.

8. *Kazuo Nakamura*. Oshawa: The Robert McLaughlin Gallery, 1974; n.p.

9. See Joyce Zemans, *Jock Macdonald: The Inner Landscape. A Retrospective Exhibition*. Toronto: Art Gallery of Ontario, 1981; p. 247.

10. See note 6.

11. See *Indications. Harold Town 1944 – 1975*. The Art Gallery of Windsor, 1975. Catalogue no. 19.

12. *Ibid.,* Catalogue no. 40.

13. The series *Vale Variations* is based on a drawing by Florence Vale, *Pyramid of Roses* 1965. See Natalie Luckyj, *Metamorphoses, Memories, Dreams and Reflections. The Work of Florence Vale*. Kingston: Agnes Etherington Art Centre, Queen's University, 1980. Catalogue no. 16.

Fig. 51. Fernand Leduc.
Microchromie 6 murs de Rome, 1974.
Acrylic on canvas.
130.0 × 150.0 cm.
Collection of the Artist.

Fig. 52. Guido Molinari.
Trinoir, 1955.
Oil and enamel on canvas.
54.6 × 66.0 cm.
Private Collection.

Abstraction in Montreal

There is an opinion, widely held, or at least often repeated, that art in Montreal during the 1960s was marked by a single approach. In comparison to art in Toronto, there was indeed a greater emphasis on non-representational painting. But more importantly there was a certain pattern in the earlier development of many artists, a pattern bound into the history of advanced painting in Montreal, which saw first the dominance of an expressionist, automatist painting and then a cooler, more precise abstraction.

Through the 1940s and 1950s artists in Montreal tended to form well-defined groups both in reaction to the continuing apathy around them and, as a community, to relate their work to their immediate circumstances. There was not an upsurge in commercial galleries or collecting or publicity equivalent to that in Toronto from the mid fifties, but in the 1960s the general climate of interest did change; the more widespread prominence of the individual careers of artists diminished the need for groups. It is important, however, to stress that even if the history of the previous twenty years shaped the context for the sixties, the essential developments arose from a generation of strong individual artists.

In the late 1950s and early 1960s bonding into groups was still apparent. Reaction to automatism was solidifying first through the Plasticiens and then through a small group within the Association des artistes non-figuratifs de Montréal, which included Fernand Leduc, Guido Molinari, and Claude Tousignant, who felt that the Plasticiens were not rigorous enough.

Fernand Leduc occupied a pivotal role in the development of Montreal painting from the early 1940s to 1959. He was the eldest of the group of artists that Borduas gathered around him, and his open dispute with Borduas in 1955 was an assertion not only of his independence but also of the validity of the direction which his work and that of the Plasticiens was taking. A student at the Ecole des beaux-arts, he had met Borduas in 1941 and become firmly committed to the Automatiste movement, maintaining contact during his 1947–53 stay in Paris through regular correspondence with Borduas. After six more years in Montreal (1953–59) he went back to France where he has continued to live, except for the years 1970 to 1973 when he taught at Université du Québec à Montréal and Université Laval. He has exhibited at regular intervals in Canada, but the impact of his work here has gradually diminished through his absence abroad; a situation that has not, for instance, affected Riopelle in that Riopelle's major international reputation has sustained Canadian interest in his work.

Leduc was deeply impressed by Borduas' 1942 gouaches, and the impact of these and the abstract surrealist approach became immediately apparent in his work. His automatiste paintings, such as *Dernière campagne de Napoléon* (1946) (fig. 11), like the work of other Automatistes, are small, heavy in tonality and energetic in gesture. Through the early 1950s the gesture becomes more ordered, the structure tighter, and the illusion of space flatter, so that by 1955 his paintings are composed of flat, interlocked shapes of strong colour. In the later 1950s his colours in pictures like *Jardin au Bresil* (1956) and *Delta* (1957) (fig. 53) are even more intense. The forms become irregular but sharp-edged, creating a complex activity of colour against shape. In comparison to the contemporary works of the Plasticiens Leduc's paintings are aggressive and forceful.

After his return to France in 1959, the uncompromising attack of his late Montreal work gradually relaxed. The sharp-edged forms are first coursed through by linear elements and then, from 1963, the planes of colour are described in broadly curving forms. At the same time the tones and hues are brought closer and closer in value

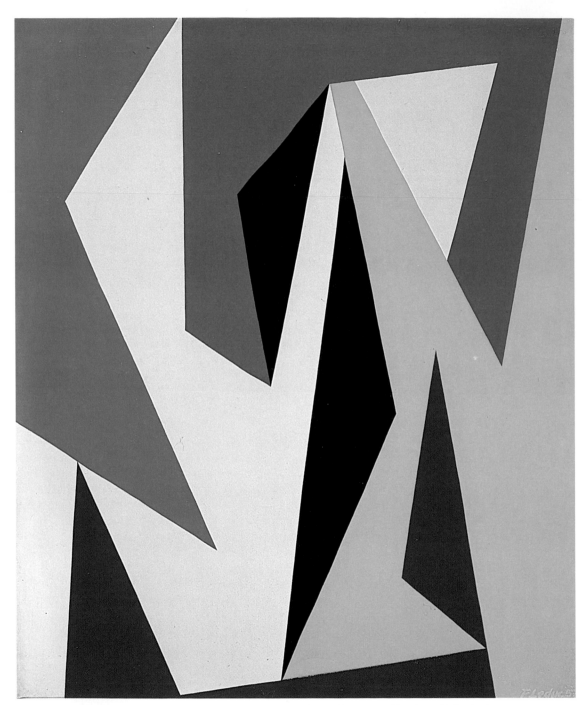

Fig. 53. Fernand Leduc. *Delta*, 1957. Oil on canvas. 91.4 × 76.2 cm. Collection of the Artist.

until in 1970 Leduc began the type of pictures he has called *Microchromie*, on which he has continued to work (fig. 51). They appear at first glance to be monochromatic—and in reproduction they can only be seen as monochromes—but beneath the top layers of paint is a structure of forms and colours similar to that in the earlier works. The distinctions in value of these sub-structures are so subtle that when covered by the final layers of colour they become effectively indiscernible. The eye, however, as it gradually adjusts to the surface, grows sensitive to the subtle shifts in value between the layers of colour, reading them not as descriptions of form but as emanations of coloured light. These effects are substantiated, paradoxically, by the way that Leduc constructs each picture as a group of separate panels. This construction emphasizes the painting as a physical object that must, in a sense, be overcome through the spectator's optical experience to reveal the work's true content, that of coloured light.

Tousignant and Molinari were moving along a path similar to Leduc's in the mid and later 1950s, in that their work was turning away from automatism. But their attitudes to the context of their work differed from his in two important respects. First, they were nearly a generation younger, so their involvement in the art scene in Montreal immediately post-dated the revolutionary moves of the Automatistes; they worked from it, rather than through it. Second, they had no special feeling for Paris as the guiding source for their work. Tousignant in fact spent six months in Paris in 1952–53, but found himself uninterested in the directions of current art there; Molinari's first trip to Europe was not made until 1968. The emphasis of new art had shifted to New York and it was a North American context—or at least a particular perspective of the history of painting whose direction, established by Malevich and Mondrian, had been radically advanced in American Abstract Expressionism—that they saw as relevant to their interests.

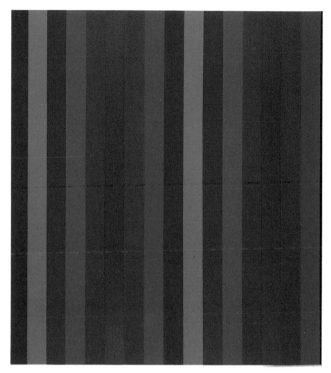

Fig. 54. Guido Molinari. *Bi-sériel bleu orange*, 1968. Acrylic on canvas. 228.6 × 198.1 cm. Private Collection.

Guido Molinari has been a dominant figure in art in Montreal by both the strength and quality of his work and his polemical and critical positions, vigorously and often provocatively argued. The very forcefulness of his stance in argument and in print has identified him for emulation and for attack in the continuing debates on the character and place of art that have been the mark of the Montreal art scene over the past forty years.

Molinari took evening courses at the Ecole des beaux-arts while still at high school. In 1951–52 he took a spring and two winter semesters at L'école d'art du Musée des beaux-arts, where he studied with Marian Scott and Gordon Webber. By the time he was twenty he had already gained a notable, even notorious, reputation as a painter and poet; Claude Gauvreau, the Automatiste poet, in a 1953 article, described his attitudes this way:

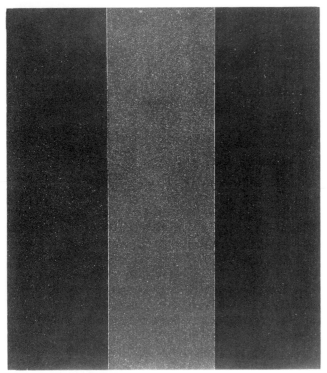

Fig. 55. Guido Molinari. *Quantificateur No. 6*, 1978. Acrylic on canvas. 249 × 218 cm. Private Collection.

Like Rasputin, mystic, German spy, first rate organiser of orgies, high class hypnotist, and corrupter of Czarism; like Arthur Craven, French poet and British heavyweight boxer; like Eluard, Surrealist man of letters and political dilettante: Molinari is a prophet of freedom and intellectual fertility.[1]

His early work, both in drawing and painting, was strongly marked by the freedom and directness of automatic methods. From 1953 to 1959 the greater part of his activity was in works on paper through which he gradually reconciled the intuitive element of expression with the pictorial discipline of a dynamic but unified objective statement. From time to time Molinari has returned to making drawings, as if to keep contact with the freedom of the subjective gesture that in his paintings is given over to the dynamics of colour stated in a strictly abstract form.

In an article written in 1955 Molinari defined his position in the dispute that had arisen between Borduas and Leduc.[2] He accepted Borduas's view of the radical achievement of New York Abstract Expressionism, but pressed it further, seeing the real achievement of modern painting from Cézanne to Mondrian to Pollock in terms of a continual reassessment of pictorial space. He wrote that no matter in what terms a work of art can be defined, its value lies in the spatial structure it creates, and the solution for current painting as he saw it, was to be found in the creation of space by "colour-light." The clarity with which he saw these issues was first given major form in painting in a remarkable series of black and white works of 1955–56. These paintings, which range from the relatively loose form of *Trinoir* (1955) (fig. 52) to the hard-edged *Angle Noir* (1956) (National Gallery of Canada), deal with the absolute contrast of tonal values—between black and white. They challenge the tendency for differences of tone to form spatial illusion; the optical tension between the black and white areas holding the surface of the pictures flat. They are remarkable pictures in the boldness and clarity of the position they state, both in the broad context of painting at that date and in being the product of an artist just twenty-two years old.

At the end of the 1950s, after the long search through the works on paper, Molinari began to concentrate on paintings. Freedom of gesture was transformed into a rigorously hard-edged structure of horizontal and vertical elements and black and white elements along with primary and complementary colours. By 1963 he had settled on a formal structure of juxtaposed columns of colour, hard-edged and evenly applied. Through this he came to realize the spatial character of colours, the way they act and react with each other depending on their positions and juxtapositions. In the works on paper the form and gesture had been subjective; now with the development of a rational, objective formal structure in the paintings, the subjective character of the work lay

wholly in the spectator's experience of colour. *Sériel bleu orange* (1968) (fig. 54), for instance, can be described in a series of formal relations; a sequence of eight colours is repeated twice across the canvas, the outer colours, blue and orange, being juxtaposed in the centre. Within that structure we could describe the relationships between the colours in many different ways, but such attempts at rationally analyzing the picture are overtaken by the dynamics of the colour experience itself: the shifting and mixing, the expansions and contradictions that lie only with the direct perception of the work itself and which exist as a subjective reality transcending the formal structures and the capacity of verbal description. There is, he has said, no space *in* painting, *"space was something created by the spectator."*[3]

Molinari worked on the coloured-band paintings through the 1960s, but from the end of the decade and into the mid 1970s he used a variety of formal structures, including triangular and square forms. In these, he was more often dealing with large planes of colour, usually just two in any one picture, so that the weight or mass of each colour becomes as important as the contrasts of hues. In the mid 1970s he began a shift whose direction was fully realized in the *Quantificateur* paintings begun in 1979. For these he returned to a formal structure of vertical elements, now in much wider bands. The striking change, however, was in the reduction of colour to dark values in which very subtle shifts of value slowly appear to the spectator. The aggressive character of the earlier work is given over to an extended contemplative experience resting not on the immediacy of chromatic effects but on the mass of colour, on the relationship between the quantity as well as the quality of the distinctions between one part and another (fig. 55). The changes that the *Quantificateur* paintings make are wholly consistent with Molinari's belief in the continual establishment and destruction of the formal language of painting, a process that must examine a proposition, fulfill its potential, and then redefine its premises to dis-

cover a new synthesis. Such changes represent neither a change of style nor of principle, but are the result of a rigorous and critical process of work.

During the 1950s Molinari and Tousignant worked closely together. Their pictures show both artists driving towards a radical structure of painting and rejecting the alternatives that they saw around them. Tousignant studied at the Ecole d'art du Musée des beaux-arts from 1948 to 1951. In Paris (between October 1952 and May 1953) his disappointment with current French art—Matisse and Hans Hartung were the exceptions—was both a sign and an incentive to make his work relevant to the situation in Montreal. His interest in automatism, like Molinari's, was with an "all-over" tachist form, rigorously abstract, related more to New York approaches than Parisian ones. His first exhibition in 1955 was of the "tachist" paintings. This was followed, the next year, by a show at L'Actuelle of a group of hard-edge colour paintings which must count as some of the most demanding and severely minimal paintings being done anywhere at that time. During the course of the exhibition he painted *Monochrome orangé*, a picture just over four feet square, of an absolutely even orange colour. *Le lieu de l'infini* (fig. 56) is a black rectangle enclosed top and bottom by horizontal red bands. These paintings were made with an industrial enamel paint that gave a smooth, hard surface. The clarity in the statement of these paintings is matched by the directness with which he has described the project of his work. In a 1959 catalogue statement he wrote,

> The reason for my work is to fulfil the universal givens relative to the activity of painting itself, that is to say the objectification of reality in relation to my subjectivity.

He rejects all prior twentieth-century painting, with the exception of Mondrian's, as "regressive and decadent," and continues,

> What I want to do is to purify abstract painting, to make it even more abstract . . . [then] only painting

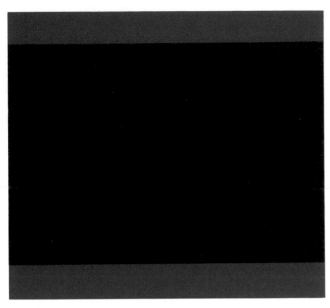

remains, emptied of everything alien to it, to the point where it is sensation alone, where it is understandable to all.

The formal rigour and reductive simplicity of Tousignant's paintings of 1956, along with Molinari's black-and-white pictures of 1955–56, are among the most striking statements on the nature of painting then being made. They are radical in both concept and execution; their place within North American painting as a whole still awaits full recognition.

In the early 1960s Tousignant's painting became looser, the hard-edged forms and dense, smooth primary colours giving way to a softer abstraction. But in 1962, in response to the work of Barnett Newman, he re-evaluated the boldness of his 1956 works and began again to paint with a reductive hard-edged structure and strong, fully

Fig. 56. (above). Claude Tousignant. *Le lieu d'infini*, 1955. Oil on canvas. 128.2 × 149.8 cm. Collection of the Artist.

Fig. 57 (below). Claude Tousignant. *The Blue and the Black*, 1972. Acrylic on canvas. Diptych, each 259 cm diameter. Collection of the Artist.

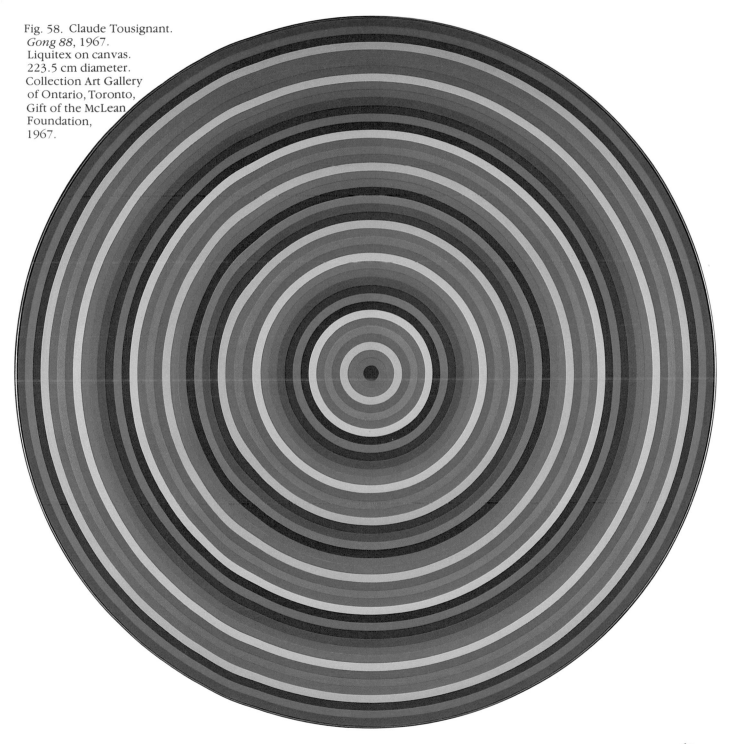

Fig. 58. Claude Tousignant.
Gong 88, 1967.
Liquitex on canvas.
223.5 cm diameter.
Collection Art Gallery
of Ontario, Toronto,
Gift of the McLean
Foundation,
1967.

saturated colour. In formal terms he began to concentrate on the circle, and in 1965 he developed paintings made with rings of colour, the *Chromatic Transformers*, in which the dynamic of the form is matched by the dynamics of the colour structure. These paintings were followed by other series of circular paintings—*Gongs* (1966) (fig. 58) and *Chromatic Accelerators* (1968). The formal structure of these paintings is based on a strict evaluation of sequences of colours, but they are perceived as a dynamic experience of coloured light.

At the beginning of the 1970s Tousignant turned away from the optical complexity of the rings to a simple monumental structure based on two related circular paintings using just two colours (fig. 57). They are monumental in their address to the fundamental distinctions between left and right, between symmetry and asymmetry. But they deal, as his work always has, with the point where "only painting remains, . . . painting [as] sensation alone."[5] And in his most recent works, like *Monochrome noir (Thanatos)* and *Monochrome jaune* (1981) he has returned to large-scale works of a single colour, emphasizing their autonomous objective character by building them on deep stretchers so that they stand out clearly from the wall.

The attention paid to the work of Molinari and Tousignant in the later 1950s and increasingly throughout the 1960s was based on at least four different reasons. First, they were the artists doing the most radical and demanding painting of the day; second, the images of their work were rigorous, clearly defined with a powerful, immediate visual impact. Third, the directions they took were supported by theoretical positions that were as forceful and lucid as the paintings they were making. And fourth, they could be seen to have emerged directly from developments of the avant-garde in Montreal; if they looked to New York rather than Paris, the meaning of their work was nevertheless stated in terms that pushed forward the debates which gave painting in Montreal

its special identity. But we cannot simply place them as representatives of a *style* (minimalism, optical painting or whatever) any more than we can place the work of other artists as either adhering to their style or rejecting it. To reduce all this to a "look" or a style is not only to miss the point of Molinari's and Tousignant's work, but also to neglect the much wider range in the contributions from other artists in the city.

In Montreal in the 1950s, the pattern of development for many artists was to begin with a form of automatism and then to develop tighter, more emphatically flat and rigorously abstract surfaces. No matter that the final appearance of these artists' mature work was a rejection of it, automatism

Fig. 59. Ulysse Comtois. *Tual*, 1962. Oil on wood. 36.0 × 32.0 cm. Lavalin Inc.

was their starting point. This pattern is true of Ulysse Comtois and Jean McEwen, for instance, and of Rita Letendre and Paterson Ewen.

Comtois has worked both as a painter and a sculptor. He made his first sculptures in 1960 and concentrated on sculpture throughout the decade, his major series in the first half of the 1960s being brightly painted. In the 1970s, he shifted emphasis back to painting. His works from 1951 are small, dark paintings very similar to the type of automatist work of Marcel Barbeau and Marcelle Ferron of a few years earlier. By the late 1950s the structure of the paintings had become flatter and more geometrically organized, although their paint texture was still loose and heavy, as with

Tual (1962) (fig. 59); only in Comtois' sculptures of the mid 1960s did the paint really become smooth and "hard-edge."

Comtois attended the Ecole des beaux-arts in 1948, but remained only for one year, preferring to be associated with the Automatistes. The pattern of Rita Letendre's early career was very similar: study at the Ecole des beaux-arts, but more importantly, becoming part of Borduas' circle. Her early work, too, was dark in tonality and loose in paint texture, but in a number of respects it was more vigorous in character and more individual in gesture than that of many of the young artists of the group. Her work from the mid fifties to the mid sixties showed the development of a

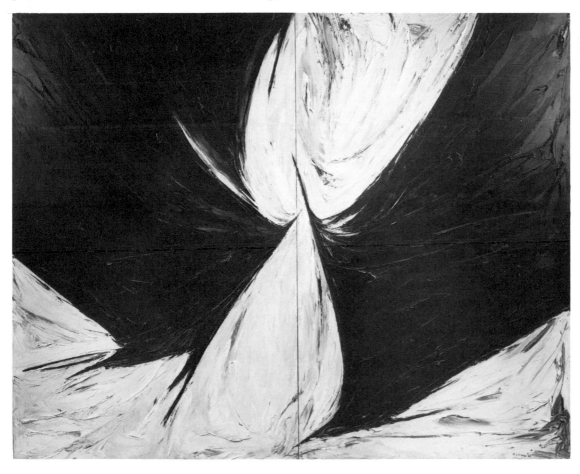

Fig. 60.
Rita Letendre.
Rencontre, 1964.
Oil on canvas.
243.8 × 304.8 cm.
Collection of
the Artist.

Fig. 61. Rita Letendre. *Sonar*, 1973. Acrylic on canvas. 102.0 × 152.0 cm. C·I·L Inc.

more regular and geometric structure, still thickly painted (fig. 60). In the mid sixties she settled on a form of bands of hard-edge colour emanating from the tip of a spearing shape, like the shock waves of a force through a resistant field. The bands spread right to the edges of the canvas, implying their continuation beyond it. It is a dynamic form open to constant variation in combinations of colour and in changes of scale. Crucial to the development of this approach was her first very large-scale work, a twenty-four by twenty-one-foot exterior mural *Sunforce* (1965) at California State University in Long Beach. She found,

while working on it, that the intensity of the light flattened out the effect of the painting, and realized that the energy of the work had to come through colour rather than texture of paint or detail of gesture. This shift from gesture and complexity to simple forms led her subsequently to develop the characteristic flat, wedge-like shapes in which the emphasis of the painting is that of colour itself (fig. 61).

Letendre has worked on canvases of many different sizes and proportions, on silkscreen prints and on other exterior murals, the largest being a sixty- by sixty-foot composition *Sunrise* (1971) on an exterior wall of the Neill-Wycik Building of Ryerson Polytechnical Institute in To-

ronto. If the form of her painting has changed
from gestural and expressionist to hard-edge, the
essential character of her work has not altered,
the vigour and energy have been formally con-
tained but not compromised.

The very swiftness and attack of Letendre's
painting stands in contrast to Jean McEwen's ap-
proach. McEwen was self-taught and, although
working full-time for a drug company, he was
actively involved in the radical art scene in Mon-
treal and exhibited regularly from the 1950s. His
first one-man show was at the Agnès Lefort Gal-
lery in 1951. His work, too, began as automatist in
character, but in 1955 he began, almost literally,
to build his pictures up on a firm but simple
geometric structure. *Les pierres du moulin* (1955)
(fig. 62), with layer on layer of paint, is indeed like
the surface of a wall, a structure of stones and
mortar stained and patinated by age. His paintings
were subsequently developed in a variety of
forms, typically with vertical divisions, some-
times simply marking off two planes, sometimes
with a broader central band. In all cases a complex
succession of colour layers was brushed, dripped,
and rubbed onto the surface.

Unlike many of the Montreal artists who re-
acted against the automatist manner with flat and
tightly formed structures, McEwen took a differ-
ent direction. He had been deeply impressed by
the painting of the American, Sam Francis, which
he had seen during a stay in France in 1951–52,
and by the sensuous colour surfaces of Mark
Rothko and Clyfford Still. He was drawn to their
evocative atmospheric surfaces, to the emphatic
texture of paint in Still's work, to the illusion of
depth implied by Rothko's veils of transparent
colour.

As the illusion of depth in McEwen's paintings
draws the spectator into them, so their scale ori-
ents and mirrors the spectator through his or her
reference to space—left and right, up and down,
front and back. For a time in the mid 1960s, this
notion of mirroring the spectator, of relating to
him physically and psychologically by means of

Fig. 62. Jean McEwen. *Pierres du moulin #3*, 1955. Oil on
canvas. 201.9 × 127.0 cm. Lavalin Inc.

the division of the painting's surface, seemed to
be more important than the colour depth and
textures of the earlier works. McEwen seems to
have switched his point of reference from Rothko
to Barnett Newman, at the same time changing his
technique from oil paint to acrylics so as to
achieve a smoother, less transparent surface. But
in 1968, after three years of working in acrylics,
he returned suddenly to using oil paint and to the

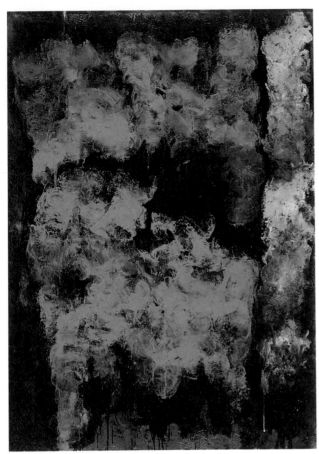

Fig. 63. Jean McEwen. *Les cages d'îles*, 1974. Oil on canvas. 177.8 × 127.0 cm. Lavalin Inc.

Comtois, Letendre, and McEwen explored three different alternatives from automatism that maintained an independence each from the others and from the directions Molinari and Tousignant were taking. And we can continue to extend these individual directions, with Edmund Alleyn, for instance, and with Paterson Ewen. After attending McGill University at the end of the war, Paterson Ewen went to the Ecole des beaux-arts from 1948 to 1950, studying with Lismer, Marian Scott, and, in particular, Goodridge Roberts. But by 1950 his interests were being drawn more towards the Automatistes. He participated in the discussion sessions Borduas led, and his work began to unite automatist methods with the figurative tradition in which he had been trained. Figurative elements, however, gradually disappeared in favour of the freedom of gesture. From the end of the 1950s and through the 1960s he painted several series of pictures that investigated the relationship between gesture and particular formal structures, a characteristic that is not lost even when the surfaces and their design becomes "hard-edged." *Life Stream* (1969) (fig. 65), is part of a series of paintings which for all their apparent reductive character, are procedurally but not conceptually objective. The pictures have the appearance of clock-like divisions, the flow of the segment like the trace of a pendulum. The gesture of the movement of Ewen's hand and arm was set down with strips of masking tape, transforming the subjective and intuitive action of drawing into an objectively featureless form.

In 1968 Ewen moved to London, Ontario. He found the atmosphere for work in London not only very different from Montreal but freeing and stimulating. He had become disenchanted with painting, with a sense of a loss of directness which seemed to have led him into working to a formula. *Life Stream* and other pictures which he had seen as anti-art statements rather than formalist structures had, nevertheless, settled into a certain pattern. He now realized that they could lead in an altogether different direction. He saw the

complex surfaces he had made before. There is, however, a subtle shift of emphasis: the formal structure emerging through soft, impalpable veils not so much as shapes but as coloured atmospheres. The dense textures of the earlier pictures are freed to a greater range of colour (fig. 63). As we look at the whole range of McEwen's work, we can see that the flat acrylics of the mid 1960s were not a diversion, but an alternative way to investigate the problem of dividing a coloured field to engage the spectator with it. What at first seemed to have been a step into formal rigidity became, in the result, a means to greater freedom.

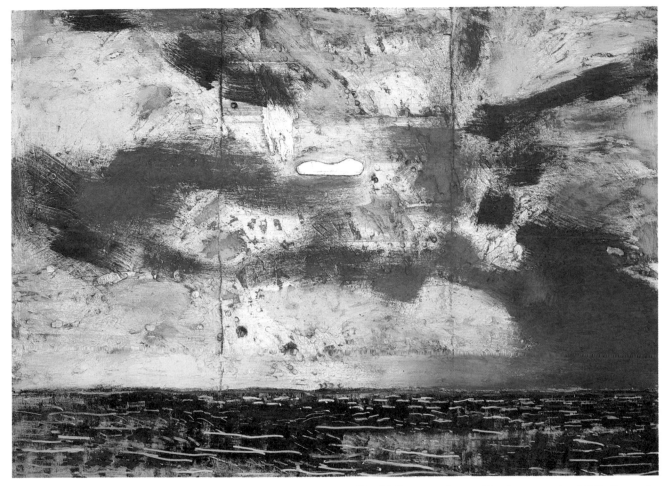

Fig. 64. Paterson Ewen. *Cloud over water*, 1979. Gouged plywood, acrylic, and metal. 243.9 × 335.3 cm. Collection Art Gallery of Ontario, Toronto, Purchase with assistance from Wintario 1980.

lines as "traces or vibrations in space," calling up interests in natural phenomena—in meteorology and geology and astronomy—that he had had as a boy and a young man.

In 1970, chance gave Ewen the breakthrough in technique and style which he had sought. He was hand-gouging a sheet of plywood, intending to make a large woodcut print, when, with the form cut and the paint rolled on, he realized that there was no need to proceed with the print—the finished work already existed. He took up painting again, with this totally new approach, moving away from the abstract formalism of his previous work to subjects of meteorological effects— wind, rain, snow, hail. Hand-gouging soon gave way to electric-powered routing; he added materials to some pictures: wood, leather, strips of metal. The paintings have a roughness which responds precisely to the raw and fundamental nature of the subject matter. There is a sort of ironic reversal of the approach to landscape subjects; Ewen, no longer concerned with representing "essential form," is dealing with the forces that

Fig. 65. Paterson Ewen, *Life Stream*, 1969. Oil on canvas. 173.0 × 198.0 cm. Canada Council Art Bank.

shape the land, forces which, aesthetically indifferent, are nevertheless those that give form to what we appreciate as natural beauty (fig. 64).

Ewen, a member of the Association des artistes non-figuratifs de Montréal, had exhibited regularly in Montreal through the later 1950s and 1960s, but had otherwise gained little recognition. His move to London and the change in direction of his work, a change essentially to "things already known," has given him a very different place in contemporary Canadian art. His work is now known and sought after, his list of exhibitions in Canada and abroad greatly expanded, and he was chosen Canada's representative at the 1982 Venice Biennale.

The complexity of the situation in Montreal through the 1960s is perhaps most forcefully indicated by the fact that two of the city's most significant painters, Yves Gaucher and Charles Gagnon, developed their work with little contact with the milieu of the Automatistes and the Plasticiens. Superficially Gaucher's work presents special difficulties because its geometric rigour and minimalist appearance have invited comparisons with the work of Molinari and Tousignant. The direction of his work, like theirs, has arisen from affinities with New York rather than European painting, but it has been developed from very different sources and interests within the context of Montreal art. Within the broader context of North American art during the 1960s, reductivism of form, geometric structures, and planes of smoothly applied colour were used by a wide range of artists for many different purposes. They represent not so much the characteristics of a style, as a particular syntax of the painterly language whose use must be understood within the context of each individual's work.

At the Ecole des beaux-arts from 1954 to 1956 Gaucher studied both printmaking and painting. In 1957, after a period of expulsion from the Ecole for insubordination, he returned to study printmaking with Albert Dumouchel, continuing his studies there until 1960. When he began working independently he did so exclusively as a printmaker, turning his attentions to painting only in 1964. He made his first major series of prints *En Hommage à Webern*, in 1963. The reference is to Anton von Webern, the early twentieth-century Viennese composer who, following Arnold Schönberg, was one of the musicians to develop serial music, a system based on permutations of a tone-row. Gaucher had heard a concert in 1962 which included compositions by Webern. "[The music] challenged every single idea I had about sound, about art, about expression, about the dimensions all these things could have." He said it "seemed to send little cells of sound into space, where they expanded and took on a whole new quality and dimension of their own."[6] It was the affective experience and not an attempt to transpose the music to a visual form that led to the formal language of the *Webern* prints: relief prints of lines and squares, some coloured, others left white and in both positive and negative relief (fig. 66).

Gaucher's wide appreciation of music is ex-

tended by his philosophic interests; a student of Oriental teaching and philosophy, he has also been deeply impressed by John Dewey's *Art as Experience*. He accepts, in particular, the relationship Dewey draws between life's rhythms and the constitution of experience not as a series of discrete events but as tensions held in a dynamic harmony. Art is a particular response to that desire for experience and its balance.

Gaucher's paintings from 1964 through the end of the decade are severely reductive; a limited structure of short horizontal lines is set in coloured fields, fields that in some pictures are immutable greys, in others strident primaries. The dynamics of the pictures develop not in the forms as such, nor in the illusion of optical colour mixing, but from a slowly perceived totality of an

Fig. 66. Yves Gaucher. *En Hommage à Webern 2*, 1963. Relief impression on laminated paper. 56.5 × 76.2 cm. Courtesy Mira Godard Gallery, Toronto.

Fig. 67. Yves Gaucher. *Jericho 3: An allusion to Barnett Newman*, 1978. Acrylic on canvas. 281. 9 × 451.2 cm. Collection. Germaine Gaucher.

Fig. 68. Yves Gaucher. *Gris et Bleu*, 1972. Acrylic on canvas. 203.0 × 229.0 cm. Rothman's of Canada Ltd.

articulated light-filled field. In the grey paintings, for instance, the short horizontal lines vary in tone both from each other and from the field. Some, by their contrast with the field, are immediately perceived, others, much closer in value to the field, are apprehended more slowly, sometimes so slowly that the spectator remains uncertain whether they are not, in fact, retentions in the retina of the more forceful contrasts. Gradually a sense of rhythm develops, growing more substantial with the concentration of the spectator. Gaucher has described the lines within the field as "signals," marking something apprehended directly within experience, not through description.

In 1969, after spending five years on these paintings, Gaucher turned from their subtleties to pictures of bold juxtapositions of horizontal bands of colour (fig. 68). It was a courageous move in that it brought Gaucher's work, superficially, close to the paintings of Molinari and the American painter Kenneth Noland. Molinari had been working through most of the 1960s on

paintings with vertical bands of equal width in serial relationships of colours. Noland had moved through series of targets and chevrons to horizontally striped paintings, the stripes in widths which varied in relation to their position in the context of the whole. Gaucher too used bands of varying widths but, unlike Molinari, who used geometric minimalism to diminish shape in order to emphasize the quantity and quality of colour, Gaucher accepted the values of colour as given by their shape and scale. In 1976 he extended this particular challenge a stage further by dealing with "the complex problem of the diagonal" (fig. 67). It is an issue in which he alludes to Barnett Newman's painting, *Jericho*. Gaucher takes up directly the challenge of other painting, daring simplified comparisons in order to state an individual position. If large-scale geometric colour painting was the dominant mode of the time, it had to be faced and an expansion of its options achieved.

Distinctions of style, or the common ground of style, are only channels for the essential exchange between an individual artist and an individual spectator. Historically, the exchange has been concerned not only with the perception of art in relation to nature, but also with the perception of art in relation to other art. While a number of artists may share common ground, the value of their work for the spectator arises only in the conviction of their individual achievements. And there is no question that the further art is removed from references to the natural world, the greater is the demand made upon the spectator for the completion of the work.

In regard to these issues, the work of Charles Gagnon in Montreal and of Michael Snow in Toronto is of special interest. For their approach to art and its perception is *critical* in their consideration of the relationship between the work and the spectator. Gagnon has not been professionally involved in what might be called the "development" of advanced art in Montreal, and although he has been a widely respected figure, he has by choice and temperament pursued his

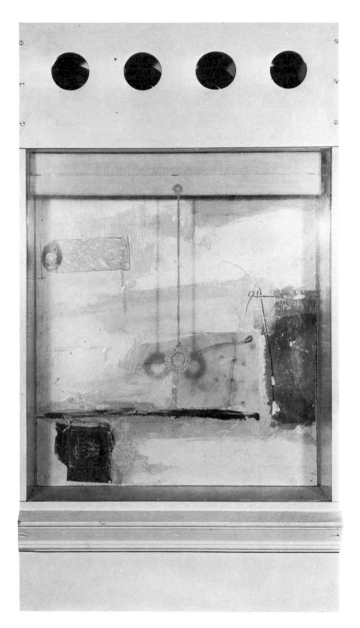

Fig. 70 (above). Charles Gagnon. *Cassation/A Summer Day*, 1978. Oil on canvas. 167.6 × 203.2 cm. Artist's collection.

Fig. 69 (left). Charles Gagnon. *Box #6 – The Window*, 1962. Mixed materials. 94.0 × 50.8 cm. Collection of the Artist.

freedom and energy of American Abstract Expressionism. He left Montreal in 1955 to live for five years in New York, returning in 1960 to take studio space with Gaucher and McEwen.

Since childhood, Gagnon has been interested in photography, an interest which is inseparable from his activity as a painter, and which he has further extended into film-making. In the early seventies and again at the end of the decade, Gagnon concentrated on photography and film-making to the exclusion of painting. These apparent gaps have made his work appear problematic (in a way similar to the assessment of the work of Joyce Wieland). For many people the measure of a painter's success demands not only a regular pace of production but also a pattern of solo exhibitions with sufficient shifts of manner to make it possible to determine the progress of a "development." But this is not Gagnon's way; it is the whole body of his work that counts and that work is among the most consistent, thoughtful, and provoking of any produced in this country.

While in New York Gagnon spent much time

work slowly and in relative isolation. As a result, his work is not particularly well-known beyond Montreal; the full range of his achievement only received major national exposure in a retrospective exhibition in 1978. Uninterested in the concerns of the Plasticiens, he was struck by the

Fig. 71. Charles Gagnon. *(Steps) December*, 1968–69. Oil on canvas. 203.2 × 274.3 cm. Musée des beaux arts, Montreal.

photographing, documenting his observations of the city, not its grander views or the frenetic energy of its inhabitants, but the detritus of urban civilization: the neglected and discarded, the peeling walls, the trash cans, the marks and scribbles that accumulate on walls and hoardings, those small corners of the city that reveal its archaeology. It is an archaeology of the discarded, images of the gaps between the events by which we act out our lives. But the emphasis of the photographs is such as to underline the continuity of our world, the viewfinder of the camera selecting arbitrary sections from the continuity of vision. It is a way to describe reality, not as the passage from one event to another but as a total fabric of whose seamlessness we are only occasionally aware. It reflects the way most of our lives are concerned with a playing out of events; we spend little time considering what we are. In a different context Gagnon has said, "To me, the most interesting thing about Zen is the idea of the void."[7] The photographs are in a way an ironic commentary on the materiality which fills our lives; we can represent the trap of the world through its trappings but we cannot represent, in photography or any other way, the purity of the void.

Gagnon's paintings at the time reflected these photographic observations through an Abstract Expressionist mode of shapes and marks, sometimes deliberately shaped, sometimes formed by chance and accident. This notion of forming something, of what it means to form something, was more specifically developed in the collage and box constructions begun shortly after his return to Montreal. One of the most telling of these early pieces was the *Box No. 6—The Window* (1962) (fig. 69). At the back of the box is a painting, abstract but suggestive of a landscape. In front of this is a window blind, partially pulled down, and above it, a strip of wood with four circular openings behind which are mirrors in which the spectator catches glimpses of himself looking at the work. The traditional notion of painting as a window onto the world and the metaphor of the eye as a window into the soul are drawn together. Through the painting we look into an illusion; an illusion of ourselves is reflected. And, imposed between this inescapable circularity of our understanding and the illusions of our judgements, is the window blind. Even if, in our imaginations, we pull down the window blind and conceal the illusion of the landscape, we still view ourselves reflected in the mirrors; our actions cannot free us from illusion.

Gagnon works with the illusiveness and allusiveness of vision and reality in a number of ways; he makes pictures, for instance, which seem to be more about the act of framing than the creation of something to be framed. He makes the act of painting not so much the formation of an image as a metaphor for a process of containment, forcing a gap into our visual field, creating a void in preparation for an illusion. In *(Steps) December* (1968–69) (fig. 71), the painting is composed of a firm black frame within which is a large field of broad criss-crossed strokes. This field gives a brilliant sparkling effect, reminiscent of the pearly-silver of a movie screen with the projection lamp turned on, but no film running. We are waiting—but for what? For the start, perhaps, of an illusion

that will give us an image of the natural world. The painting is a gap in our visual field and attention, a pure anticipation of events—despite the fact that the events we anticipate are themselves illusions. The painting is a screen against the world, a reflector of contents the spectator alone can supply.

In the paintings of recent years Gagnon has worked with several forms: *Splitscreens*, appearing rather like the rolling of a film or television picture whose horizontal hold has gone out of kilter, or the *Cassation* series. The word "cassation" is apposite, meaning "annulment;" in some countries there are Courts of Cassation which are courts of appeal. In *Cassation/A Summer Day* (1978) (fig. 70) a rectangular form is painted within another rectangular form, as if either the smaller is surrounded by a frame on three sides, or one painting has been placed in front of another. Nothing separates the inner from the outer shape except the act of painting itself. The technique and the curious juxtaposition of colours (how can we reconcile these with our experience of the world outside painting?) emphasize that our attention is drawn to a surface made of paint. Its capacity to affect us is wholly dependent on two things, our belief in the capacity of painting to produce illusions of meaning, and our willingness to allow that capacity to operate.

Art in Montreal in the 1960s cannot be seen as simply representative of a particular line. The fact is that the breakthrough made by Borduas and the Automatistes was of inestimable importance, and artists in Montreal have either had to work through that or deliberately stand apart from it. Ewen broke free altogether, Gagnon distanced his concerns, Gaucher asserted his independence by challenging in his own way the concerns of colour abstract and hard-edge painting. The result has been the variety and individuality that mark the health of any creative community. This variety of concerns would become even more assertive in the 1970s when a younger generation of artists arose whose early independent work did not have to draw on the heritage of Automatism.

Notes

1. Pierre Théberge, *Guido Molinari*. Ottawa: National Gallery of Canada, 1976; p. 10.
2. *Guido Molinari: Ecrits sur l'art (1954 – 1975)*. Pierre Théberge (ed.). *Documents d'histoire de l'art canadien no. 2*. Ottawa: National Gallery of Canada, 1976; pp. 15 – 17.
3. In *Sculpture '67*. Ottawa: National Gallery of Canada, 1967.
4. Claude Tousignant, "Pour une peinture évidentielle," *Art Abstrait*. Montreal: Ecole des beaux-arts, 1959; pp. 28 – 29.
5. *Ibid*.
6. David Silcox, "Yves Gaucher," *Canadian Art Today*. William Townsend (ed.) *Studio International*, 1970; p. 27.
7. Philip Fry, *Charles Gagnon*. Montreal: Montreal Museum of Fine Arts, 1978; p. 49.

A Broadening Scene: Toronto and London

Toronto

In the later 1950s the shape, the face, and the character of Toronto underwent massive changes. The economic boom was reflected in major building projects and urban expansion. The population of the city grew by over forty per cent in the decade after 1956,[1] and the constitution of that population was radically altered by the increase in immigration. The Toronto of the 1940s that Harold Town had described as a "crabbed place...Orange and Puritan,"[2] was beginning its move towards becoming a major North American city. Economic expansion and the social and cultural shifts it brought were reflected in progressively heightened activity in the arts, all the more extraordinary in view of the unfertile ground from which it sprang.

A 1927 exhibition of the *Société Anonyme, Inc.* at the Art Gallery of Toronto, with the work of Mondrian, Duchamp, and Kandinsky amongst others, had elicited the comment in *The Canadian Forum* that "abstraction is not a natural form of art expression in Canada,"[3] a comment apparently proved true by events through the 1930s and 1940s. And such reaction to the new—in phrases that have barely altered since the outrage greeting the first Impressionist exhibition in Paris in 1874—has continued periodically to mark the reception of new art in Toronto. In 1955 the city's mayor, Nathan Phillips, in response to an exhibition of two very young painters, Michael Snow and Graham Coughtry, said, "These pictures are something I wouldn't want my children to see. I'm not a connoisseur, but from an ordinary man's point of view, these pictures are not desirable."[4] Twenty-seven years later, in spite of all that had happened to make Toronto the most active artistic centre in Canada, Gail Christie, then Mayor of York, led a campaign against continued funding of some of the country's major artist-run galleries, on the grounds that the work exhibited there was "a scam." The period in between is pitted with other incidents of reaction, among them the public debate over the placing of Henry Moore's *The Archer* outside the new City Hall in 1966 and the closing of the *Eros-'65* exhibition at the Dorothy Cameron Gallery which led to Dorothy Cameron's conviction on charges of exhibiting obscene pictures.

Despite these periodic assaults, the position of contemporary art had, by the mid 1960s, been firmly secured in a number of ways. One of these was the development of the commercial gallery system and a major commitment within it to contemporary art. Avrom Isaacs, who had run a framing business since 1951, opened the Greenwich Gallery in 1955, changing the name to the Isaacs Gallery in 1959 and moving to his current Yonge Street location in 1961, all the while supporting living Canadian artists. The brief but important existence of Barry Kerneman's Gallery of Contemporary Art between 1956 and 1959 was succeeded by the Here and Now Gallery opened by Dorothy Cameron in the fall of 1959. (The name was changed to the Dorothy Cameron Gallery in 1962 when she moved to new premises on Yonge Street.) Two years after she closed in 1965, her gallery space was taken over by Carmen Lamanna who has consistently shown some of the most advanced art in this country. And other galleries either continued their existence or opened in the early 1960s: the Roberts Gallery, Laing Gallery, Gallery Moos, The Jerrold Morris International Gallery, Mazelow Gallery, Pollock Gallery, Galerie Dresdnere, and Gallery Pascal. David Mirvish's gallery, which was open between 1963 and 1978, had particular importance in broadening Toronto's awareness of contemporary developments through its exhibitions of recent American and Canadian avant-garde art. This expansion in the number of galleries reflected both the faith of

the dealers and the growing range of collectors, both corporate and private. More people were prepared to buy the new art of Canadian artists, their interest and enjoyment adding to the excitement of the developing art scene.

From the first exhibitions of Painters 11, the new art had been widely and positively supported in the media and by the 1960s some artists were being raised to "star" status and sought out, as the Toronto critic Barrie Hale has described, for "'personality pieces,' for their views on sex and society and the family and the creative process."[5] The Art Gallery of Toronto (it became the Art Gallery of Ontario in 1966), for so long the bastion of the academic societies, underwent a major shift in direction during the sixties, both in the range of its exhibitions and in the development of its collections of contemporary Canadian and American art, a lead given by the curatorial staff and the Junior Women's and the Women's Committees.

The most important changes, however, were those brought about from within the artists' community by a sequence of action and reaction. As Harold Town has said,

What Painters Eleven did, was introduce the idea that there was another kind of painting possible other than the horizontal format or the traditional portrait and that maybe artists could get together again and do something. . . . That art could become something that artists could manipulate rather than just waiting. . . [Painters 11] gave the younger artists . . . something to aim at, to denigrate, to disparage, to try and supersede.[6]

Although the age difference between the younger members of Painters 11 and those whose careers began in the later 1950s was small, the work of Painters 11 was seen as a point of departure. And it is important to stress that the younger generation were not the inheritors of a gradually unfolding tradition of change, but that they began their work in response to the radical breach Painters 11 had opened up in the early 1950s.

The strongest group among the younger generation of artists at this time were those who became associated with the Isaacs Gallery. They were not joined by ideology or theory but by friendship, an interest in jazz, and a common appreciation and enthusiasm for what had been happening in New York art. Music was a major force in the lives of many of the artists; Michael Snow supported himself for a time during the 1950s as a professional musician, and the "jam sessions" at the First Floor Club led to the formation around 1962 of the Artists' Jazz Band. The personnel of the Band, which still plays, varied but the core membership through the decade consisted of Graham Coughtry, Gordon Rayner, Nabuo Kubota, and Robert Markle. Michael Snow, who had been a member of the Band since the beginning, rejoined the group on his return from New York in 1972.

Interest in music overlapped another unifying interest of the group—neo-Dadaism. *Neo-Dada* can be used as a catch-all term for a wide range of exhibitions and events and cross-media performances that arose simultaneously in the United States and Europe in the late fifties. (Its spirit, more determinedly political, reappeared in the late sixties with the writings of Herbert Marcuse as its text.) In the United States the musician John Cage and the artists Robert Rauchenberg and Jasper Johns were developing new forms of concert and theatrical-type performances. And Allan Kaprow, moving through the 1950s from Abstract Expressionist painting to "environmental" sculpture, undertook the first "happening" in 1958; "Happenings are events which, put simply, happen. . . they appear to go nowhere and do not make any particular literary point."[7] Happenings had a brief, bright existence on the New York scene, their impact essentially over by 1963.

In Toronto the first happening was organized by Dennis Burton, Rayner, Coughtry, and Murray Jessel, a CBC writer, in 1959 at Burton's studio. Over the Christmas seasons of 1961–62 and 1962–63 there were events, subsequently known

as the *Elves' Art Exhibitions*, at the Isaacs Gallery, with the artists, their wives, and friends making Dada-like objects. The Isaacs Gallery was also the venue in the first half of the decade for a series of concerts. Of these the most important were arranged by Udo Kasemets who, having attended John Ashley's and John Cage's *Once* performance at Ann Arbor, introduced Cage's music to the city. Unable to find professional musicians who would perform at the concerts, he turned to the Artists' Jazz Band, whose members were only too eager to participate. The activity generated by these events reached, as critic Barrie Hale has described it, "a kind of apotheosis" in 1965, with a "happening" at the Art Gallery of Toronto attended by more than two thousand people and orchestrated by Dennis Burton, Richard Gorman, Gordon Rayner, Harold Town, and Walter Yarwood.[8] The neo-Dada events that had begun as spontaneous actions by a handful of people became, with this 1965 "happening," an occasion symbolizing the participation of the whole art community.

Characteristic of much of the advanced art in Toronto was the way that pictorial issues were "worked through" by figurative and referential means rather than by pure abstraction. This was as true of the work of Harold Town as it was of the work of Dennis Burton, Michael Snow, Joyce Wieland, John Meredith, Gordon Rayner, Graham Coughtry, Robert Markle, and Tony Urquhart— though not necessarily in an exclusive way. This established a sharp distinction between advanced art in Toronto and in Montreal, a distinction in the essential meaning of painting. It is a distinction that can be made between painting as an *event* and painting as *research*. By painting as *event* we mean that the surfaces of the pictures are spaces containing formal pictorial expressions arising directly from the complexity and variety of the artists' lived experiences, including their experience of other art, whether their own or their responses to the work of other artists. The work of Town and Tom Hodgson, Coughtry and Rayner, for instance, make implicit or explicit refer-

ences to the figure, to landscape, or, through collage, to the fact and materials of the natural and urban world. The painting refers, responds to, and reflects the immanence of personal experience through the very act of working, of making visible the process of a picture's production. In contrast—painting as *research*—in the work of the Montreal painters, Molinari and Tousignant and Gaucher, for instance, sets up a very different relationship between the painted surfaces and the spectator who views them. The appearance of their paintings is removed from the action of their creation; they stand as objects that do not permit the spectator to trace back, through the work itself, the process of its making. Their paintings are deliberately limited to the fundamental qualities of painting, to colour, to tone, to mass and to shape. The form of the paintings—the size and shape of the canvases, the internal divisions into bands or planes, the use of colour—maximizes these fundamental qualities. These qualities are transformed into a specialized sign language that, by sharpening the spectator's abstract perception of space, makes him aware of how his perceptions construct his world and how he bases his understanding of his world on that construction.

In the painting of events, however, the viewer's attention is directed towards various references to his or her world: references to environment, to feeling, to memory, to the erotic. Our thinking and understanding are shown to be based on our background knowledge of representations, whether in the events of our own lives, in painting and sculpture we have seen, or in popular images from magazines, films, and television.

These two approaches represent fundamentally different ways of thinking about painting. The distinctions between them go beyond the superficial separation between the abstract and the representational, a separation which the fragmentation or pluralism of art in the 1970s has served only to underline.

Several of the artists who joined the Isaacs Gallery in the mid fifties and later received their

initial training and encouragement from Jock Macdonald. Burton, Coughtry, Gorman, and Meredith were all his students at the Ontario College of Art, and Rayner felt the effect of his teaching through contact with Burton and Coughtry.

Coughtry and Meredith graduated from the College in 1953. Through his student years Meredith had commuted to Toronto from nearby Brampton and it was only in the early sixties that he moved to Toronto to share a studio with Richard Gorman (fig. 72). He visited his brother William Ronald several times in New York, but, in contrast to Ronald's strong public profile, Meredith has worked quietly and generally apart from engagement with other artists. At the time of his first one-man show (at the Gallery of Contemporary Art in 1958) he was producing abstract paintings: thick, textured vertical bands with wider, more smoothly applied planes on either side, reminiscent of a section through the stem of a plant. The plant-like and emerging figure forms became gradually more explicit until he had developed a personal vocabulary of images that defy specific associations (fig. 73). Part plant, part animal, part landscape, part figure, and often reminiscent of the patterns and brilliant colours of Asian art, Meredith's paintings seem to describe a personal mythology of a dynamic world in the process of change and formation. In the Japanese-titled works of the early seventies the energy of the painting and the colour had become the subject of the pictures, engulfing and dissolving all but the remnants of formed images.

In contrast to Meredith's complex and private symbolism, Graham Coughtry has worked for the most part with one of art's most traditional subjects—the human figure—his interpretations leading to some of the best painting in recent Canadian art. In common with many of the artists of his generation Coughtry was drawn towards the work of the American Abstract Expressionists, in particular, that of Willem de Kooning. Coughtry has described the impact de Kooning's painting, especially his *Woman* series, has had on him:

Fig. 72. Richard Gorman. *Green Lady*, 1964. Oil on canvas. 152.7 × 203.7 cm. Robert McLaughlin Gallery, Oshawa.

The thing about de Kooning that has always been important to me is the way he turned the image into an actual way of painting, spread it all over the canvas, and still retained traces of what the image was to begin with; it's a marvellous combination of seeing and then having an emotional response that is translated into a way of painting.[9]

Coughtry's admiration of de Kooning centres on the balance de Kooning maintains in the tense contradiction between representation and abstraction, the balance between the naturalistic description of the human figure and the sheer energy of painting itself. But in essential ways, Coughtry's approach to the equation reverses de Kooning's. De Kooning all but destroys the figure—that is, both traditional representation and the modern conventions of pin-up girls—by attacking the conventions in the very act of painting. De Kooning vehemently rejects the approach of traditional painting which seeks to persuade the viewer that the painting really *is* the figure. Coughtry takes the opposite approach: he reasserts the tradition of figure-painting so that the human forms arise out of the action of painting rather than barely surviving it. Still, his procedure is intuitive and not classical, it is in the act of

Fig. 73. John Meredith. *Seeker*, 1966. Oil on canvas. Triptych, 177.8 × 366.4 cm overall. Collection Art Gallery of Ontario, Toronto, Purchase, 1967.

painting that decisions on the image are made, decisions whether a painting will contain a single figure, or two figures locked together, or, perhaps, no figures at all. Coughtry has said, "Colour comes before anything else; in the beginning the painting is conceived as a colour idea, and then, after that, comes the image."[10]

Coughtry's 1959 painting, *Emerging Figure* (fig. 74) epitomizes this; an Aphrodite-like figure arises from the water, her arms held in gestures that seem part physical protection, part modest concealment. In this picture, as in all Coughtry's pictures, the form emerging through the paint is a figure, not a person; the features are undefined, the differentiation of the figure from its environment incomplete. Sometimes, as in his *Corner Figure*, the image, as in so many of the contemporary English painter Francis Bacon's pictures, seems despairing, pressed foetus-like into the corner, undifferentiated as an individual, undifferen-

tiated even as to sex. But this lack of personality can indicate not only despair but also desire. Coughtry was drawn to Ovid's story of Salmacis and Hermaphroditus in which the two lovers were dissolved into one being by their sexual union. This is the subject of *Myth No. 2, The River* (1962), the beginning of a major series of two-figure paintings, and a theme to which he has returned time and again. The first group of paintings made between 1962 and 1964 and including *Two Figures* VI (1962) (fig. 75) was a major achievement of expressive equivalence, drawing together the dynamics of painting and sexual energy, with the loss of individuality becoming the unity of the painting. Everything revolves around the figures who seem, literally, to gather the paint to themselves. They are the subject and the object of the painting, they form its compositional horizon, they define its space.

After working on several series of these paintings for four years, Coughtry found himself at an impasse. He left Toronto in 1967 for Ibiza in the Balearic Islands—a place he had visited regularly

Fig. 74.
Graham Coughtry.
Emerging Figure, 1959.
Oil on canvas.
149.9 × 152.4 cm.
Musée des beaux-arts,
Montreal. Saidye and
Samuel Bronfman
Collection of Canadian
Art.

Fig. 75 (above).
Graham Coughtry.
Two Figures VI, 1962.
Oil on canvas.
182.9 × 172.7 cm.
Collection Mr. and Mrs.
Harry Klamer.

Fig. 76.
Graham Coughtry.
*Reclining Figure
Moving #1*, 1974–75.
Oil on canvas.
198.1 × 243.8 cm.
Private Collection,
Toronto.

since the mid fifties—and stayed there four years. He did no painting, but he drew and taught and played jazz. When he returned to Toronto in 1971 he continued to teach and he started to paint again, working from drawings he made from a movie of his daughter playing in the sea. Eventually these drawings led to the *Water Figure* series. In the early paintings of this series, the figure is clearly defined, but it is gradually lost to the flow and movement of the surf/paint until, by 1973, the subject had become the water alone.

Coughtry had, early on, been interested in Eadweard Muybridge's photographic sequences of figures in action. His paintings have always been concerned with the figure in movement, and through movies he found he could both study and objectify the movement of the figure. His working procedure is to make a movie, select single frames from it, photograph them, and then make scores of drawings from the photographs before starting a painting. His process of painting is similarly one of continuous working and re-working. The original naturalistic image is by these means isolated and worked through many stages of abstraction, as he seeks to equate its dynamic impression to the activity of painting (fig. 76).

Coughtry's single-minded concentration on painting the figure throughout his thirty-year career, is a rare feature in Toronto painting, Gershon Iskowitz's dedication to landscapes being the other most striking example. The variety of approaches and interests in the work of Dennis Burton and Gordon Rayner is perhaps more characteristic.

Burton graduated from the Ontario College of Art in 1956. In the following year he joined Coughtry in working for the graphic department of the CBC. He left in 1960, to concentrate on his painting, as his instructor Ben Shahn had urged the previous year when Burton had taken a summer course at the Skowhegan School of Painting and Sculpture.

With so little original recent painting to see and so little advice to depend on, there was for this generation of painters in Toronto—as for some of the Painters 11 just a few years before—a certain innocence as to how a personal but modern direction in painting could be established. Like so many others, Burton looked closely at the American magazines, particularly *Art News*; his attention was drawn to Robert Motherwell and Willem de Kooning. His first attempt at abstract painting came after he and Rayner saw the 1956 Hart House exhibition of Painters 11; they went back to their studios and started to make abstract pictures. The next year Burton and Rayner went to see recent American paintings at the Albright-Knox Museum in Buffalo: it was the closest place to see paintings by artists like de Kooning, Jackson Pollock, Robert Motherwell, Mark Rothko, and Clyfford Still. Visits to New York followed, and by late 1958 Burton had developed a personal approach to abstraction, influenced in particular by de Kooning and Jack Tworkov, and seeking to deal with the issues between a tightly organized structure and a free, gestural handling of paint.

He found his ambition to work full-time on painting impossible to sustain; he went back to freelance commercial art work and began teaching part-time at the YMCA and then at the New School of Art when that opened in 1965. In 1970 he was offered the chairmanship of the painting department at the Ontario College of Art, a post he held for nine years until he moved to the Emily Carr College of Art in Vancouver.

Throughout his career Burton has moved between abstract and figurative work, but the core of his work is in the erotic "garter-belt" paintings of 1964–68. Eroticism was a subject in his work as early as 1957, with *The Game of Life* (1960) (fig. 77), an abstraction of genitalia and other parts of the human body, somewhat reminiscent of Adolph Gottlieb's pictograms, being one of his best-known early works. In the "garter-belt" paintings, the eroticism becomes more explicit and focused. Working from "skin" magazines and drawing from models, Burton began the long

Fig. 77. Dennis Burton. *The Game of Life*, 1960. Oil on canvas. 137.2 × 197.5 cm. The National Gallery of Canada, Ottawa.

series of pictures to which Kay Kritzwiser of the *Globe and Mail* gave the title "Garterbelt-mania."[11] There was, particularly at the beginning, a desire to shock, but more important was the desire to deal with his own reactions to the subject and the challenge of coming to terms with a whole series of conventions: the conventions of past painting of the female figure, the developing conventions of current painting (particularly post-painterly abstraction), and the conventions of the erotic magazines. There is a curious parallel in Burton's paintings between the mechanics of underwear—conceal/reveal—and the mechanics of painting and its design. Burton's approach co-

incides with that of other artists elsewhere, particularly the British Pop artists Allen Jones and Anthony Donaldson. Jones' first "thigh and groin paintings"[12] were made in 1964, and Donaldson has spoken of the importance to him of "Recognition, both inside the painting under its own terms and outside through associative references [to the painting's image]."[13]

The strongly abstracted forms of Burton's early paintings, like *Mother, Earth, Love* (1965) (Art Gallery of Ontario) had become more explic-

Fig. 78. Dennis Burton. *Niagara Rainbow Honeymoon No. 1—The Bedroom*, 1967–68. Oil on canvas. 152.4 × 152.4 cm. Winnipeg Art Gallery. Donated by the Women's Committee, 1968.

itly representational by 1967–68, and there was a more deliberate juxtaposition of the symbols of art and nature, as in *Niagara Rainbow Honeymoon No. 1—The Bedroom* (1967–68) (fig. 78) with its references to the sleazy and the exploitative. The erotic paintings then abruptly ended. In 1968 Burton began a series of collages, two years later a series of calligraphic paintings, and then, in 1972, he went back to abstract paintings, working again through the example of the American Robert Motherwell. His interest in erotic subject matter, however, has not been lost, as a series of drawings exhibited in 1982 showed.

Unlike Burton and Coughtry, Gordon Rayner did not have a formal art school training, but the visual arts figured prominently in his family background. His father and uncle were commercial artists, and his father and grandfather had painted. Rayner trained for a career in commercial art, first with his father and then with the company of Wookey, Bush and Winter, and worked full-time in the trade for seventeen years. Jack Bush and Rayner's father had worked together at the Rapid Grip and Batten Company, and his contact with Bush brought Rayner indirectly into Painters 11's discussions on contemporary art. His own work, however, was developed in the context of his friendship with his peers, in particular Burton and Coughtry.

Rayner, like Burton and Coughtry, took the model of the American artists, particularly de Kooning and Motherwell, as the standard to follow. Beyond that there was the influence of music, of the art and thought of the East, of surrealist and symbolist and existential writing, of Samuel Beckett and Antonin Artaud and the new American writers like Norman Mailer and Jack Kerouac. Of this group of artists Rayner's work has been particularly reflective of the whole range of his immediate experience. His work does not concentrate on one subject, as does Coughtry's, nor on a series as does Burton's, but it has a vitality and responsive inventiveness which shows through one picture after another. This variety of subject matter and style has been criticized—certainly it makes awkward art history—and there have been times when he has been drawn into approaches that seem out of place. This is particularly true of his enthusiasm in the late sixties for the paintings of the American abstract painter Morris Louis and for the ideas of the critic Clement Greenberg. It was Jack Bush, who maintained close contacts with Greenberg and the type of American abstract painting Greenberg espoused, who encouraged Rayner's interest in abstract colour-field painting. Rayner could not, however, settle into the sort of systematic approach that the aesthetic of this work demanded. He reacted to it finally with the iconoclasm of *Unrolled* (1969) (Art Gallery of Ontario)—a reference to Louis' series of paintings known as "Unfurleds"—which is a roll of canvas painted with "formalist" stripes, in the process of being unrolled. There is in this

90

Fig. 79. Gordon Rayner. *Flying Out*, 1980. Acrylic on canvas. 152.0 × 182.0 cm. Rothman's of Canada Ltd.

an irreverence (Louis *is* one of the best painters of our time) and humour which reflects the neo-Dadaist attitudes to which Rayner was one of the most committed of the Toronto artists. And it is this combination which leads to some of his best works, such as *Homage to the French Revolution* (1963) (fig. 80), the reverse of an old dining-room table, reworked.

Rayner, Coughtry, and Burton all received Canada Council grants in 1961 and all three used them to travel abroad. Rayner went to Europe and North Africa and in 1966–67 he travelled to Turkey, Iran, India, and Nepal, followed by a 1974 trip to Central and South America. The colour and patterns and vitality that this travel brought into his work are linked with influences from his

91

Fig. 80. Gordon Rayner. *Homage to the French Revolution*, 1963. Construction: painted wood. 179.1 × 114.3 cm. Collection Art Gallery of Ontario, Toronto, Purchase, 1964.

strong attachment to northern Ontario. By 1963–64 he had developed a pattern of living and working in Toronto during the winter and spending his summers at "Charlie's Place," a cabin in the Magnetawan district of Georgian Bay, where he has been going since childhood. His response to this northern landscape, touched by his interest and experience of the East, has led to his finest pictures, from *River Window* (1965) (Art Gallery of Windsor) to *Flying Out* (1980) (fig. 79), characterized by brilliance of colour and breadth of gesture.

The artist who most clearly sought to break

with the direction in which Toronto painting was going was Michael Snow. The very nature of abstract expressionism as a procedure for painting is that it is direct, intuitively developed in the process of its making, and left open to the spectator's response. Snow's work, in broad terms, is a critical extension of that procedure, one that encloses the process of making the work in the process of perceiving it. The analysis of a work by Snow depends on responding not only to the appearance of its surface—expanding our immediate perception through the associations and references of our individual experiences—but also to a continual questioning of the terms and meaning of the analysis itself. Looking at a work by Snow is a matter of both coming to terms with what we see, and coming to terms with the structure of our understanding and the language with which we can describe it. How do we perceive things? How do we describe them and name them? How relative is the intellectual framework we construct to describe the reality of the world in which we live? We are led by Snow's work not to the solutions to these problems—for they are insoluble—but to a recognition of the inescapable web of perception and description on which our understanding is based.

Lac Clair (1960) (fig. 81) is an "expressionist" picture, abstract in form but carrying the "personality" of the artist through the unique markings of its surface. This sense of "personality" is deepened if we know that the title refers to the island summer home of Snow's childhood. It is, it would seem, a quintessentially expressionist picture, personal in its origin and yet by its abstractness—its generality—open to any spectator. Yet to look closer is to become aware of a series of contradictions in the assumptions so easily held and so easily stated about the nature of painting. A painting is a bounded object, it has a definite form and a shape which make it stand apart from its surroundings. In *Lac Clair* the edges are further emphasized by strips of tape that are at the same time part of the image and a frame to it. And what

Fig. 81. Michael Snow. *Lac Clair*, 1960. Enamel on canvas, 177.8 × 177.8 cm. The National Gallery of Canada, Ottawa.

is the image? The painted surface, emphatic in its brushstrokes, is just painting, but the colour and the picture's title lead us to construct an illusion of and allusion to water; water which in itself is unbounded, flowing and searching for its own level but always contained—whether in a lake, an ocean, or a bucket. To look at the picture is to give ourselves over to an illusion; to describe it is to find terms that will relate to experience as we understand it in the natural world. This twisting between illusion and the description of reality is heightened by the title, *Lac Clair*. *Lac* or *lake* is the term for a particular type of paint, the insoluble product of a soluble dye and a mordant; "Clear Lake," as a painting material, therefore, seems a contradiction. We are faced in the picture with something that is objectively real, but that denies solution—rather than being clear it is obscure. *Lac Clair* can be taken as an ironic reflection on painting and its "meaning," in particular on abstract expressionism, then a prevalent inter-

est of advanced painting in Toronto. "I'm interested," Snow has said in another context, "in doing something that can't be explained."[14]

Snow was born in Toronto in 1929. He attended the Ontario College of Art, and after a brief period in commercial art he worked on animation at Graphic Films. Subsequently he freelanced on commercial films and as a jazz musician—he is an accomplished pianist and trumpet player. His first major show, with Graham Coughtry, was at Hart House in 1955 soon after his return from a year in Europe. This was followed in 1956 by his first one-man show at the Greenwich Gallery. Like the other young artists of the time he looked to New York and the Abstract Expressionists as the point of reference for radical art, but he also had an early and strong appreciation for Paul Klee, not only for his style and whimsical humour, but also for the process of art-making that Klee developed, a process in which the construction of an image was the development of its meaning. *Lac Clair*, ostensibly an expressionist work, turned back the current practice of Abstract Expressionism to become a criticism of its premises. In doing so the painting marked a turning point in the development of Snow's work.

Snow's *Walking Woman*, a subject that he worked on in many different forms and media between 1961 and 1967, was his way of extending critical meaning while engaging the potential of painting and yet questioning and breaking through the assumptions and traditions which surrounded it. The image of the series—the exclusive starting point for all his work during those years—is the silhouette of a young woman. He made a wide variety of paintings of the image, he made sculptures of it, he placed a cut-out version of it in various city situations in New York and photographed it in those surroundings (his *Four to Five* is a compilation of sixteen of these situations). The series, which culminated in eleven stainless steel figures made for the Canadian Pavilion at Expo '67, is one of the most significant single series of work in recent Canadian art.

The silhouette figure of the *Walking Woman* is a cropped one, without hands, feet, or the top of its head—as if it had just stepped out of a picture frame (fig. 82). The image, and Snow's use of the image, brought immediate comparisons with Pop Art, but Snow has reversed Pop Art's procedures; where Pop Art took everyday things, for example, advertisements, and represented them in an art context, Snow took an art object, a painted figure, out into the streets. Through the many variations on the figure, Snow set up a complex series of situations that alert us to the distinctions and assumptions about art and life, about illusion and reality. By a confusion of context he forces us to question the categories and distinctions through which we come to terms with images—with what we see and how we interpret our perceptions.

In 1964 Snow and Joyce Wieland settled in New York until 1972, when they returned to Toronto. While in New York they became involved in experimental film (the medium on which Snow's international reputation is now substantially based). Both Snow and Wieland had made their first films while working for Graphic Films in the mid fifties. Through the sixties film became for Snow an increasingly important medium; his use and interpretations of the medium have made a major contribution to experimental film.

Snow's observation that narrowing vision and attention intensifies perception lies behind a number of sculptural and photographic works such as *Sight*, *Scope*, and *Atlantic*. Perhaps his most intensive and innovative investigation of this is *Wavelength*, the major film he made in 1966–67. The film, shot in a New York loft space, comprises a forty-five-minute fixed zoom that begins with a view of almost the whole area of the room and ends by filling the frame with a photo-

Fig. 82. Michael Snow.
Walking Woman, 1965.
Oil on canvas. 58.4 × 27.9 cm.
Private Collection, Toronto.

Fig. 83.
Michael Snow.
Wavelength, 1966–67.
Still from film.

Fig. 84 (below).
Michael Snow.
Midnight Blue, 1973–74,
Wood, acrylic, colour
photograph, wax.
73.0 × 66.0 cm.
Canada Council
Art Bank.

graph of waves that is stuck onto the far wall of the room. Other events, or snatches of events, come and go, as do changes in film stock, lighting, and filters, but the movement of the zoom continues inexorably. The film is open to many levels of discussion, amongst them a critical examination of the creation and the process of art-making. The movement of the zoom acts as a curious closing-in on illusion, as if it were seeking to arrive at the vanishing point of a perspectival painting, only to reveal at its furthest point another illusion, the photograph of waves. The movement of the zoom is paralleled by an electronically-produced sound that changes progressively throughout the film from a very low to a very high pitch. The photograph on which the zoom ends (fig. 83), coinciding with the highest pitch of the sound, metaphorically reduces the whole process of the film to a recognition that all sensation is brought to the quality and quantity of waves, both of light and sound.

Four years after *Wavelength*, Snow made a long (more than three hours) film *La Région Centrale* (1970–71). The film was shot in an isolated mountain region of Quebec. The camera was mounted on an ingenious mechanical structure, designed for Snow by Pierre Abeloos, which allowed it to rotate through all the angles within a sphere, excluding only the mounting column of the structure and its placement in the ground. Every part of the vast landscape is captured by the camera, except for this rooted point—though we do, from time to time, see its shadow. The film records the relationship between seeing and movement but leaves—as does our own eyesight—a blind spot, a point deduced but not perceived.

In the 1970s Snow made a series of film and photographic works, many of them dealing with the process of art-making, its reality and illusion, and with perception and the circular way in which we say we know things and by which we form a structure for understanding the world. Time and again these works develop accumulated layers of illusion. Each is built on the previous one so that, as we follow them, we become trapped into accepting one layer of illusion as reality in order to describe the next. *Midnight Blue* (1973–74) (fig. 84) develops such a layering through a series of sharp contrasts in materials. A colour photograph of a burning candle and its shadow, set against blue-painted wooden boards, is glued to the actual boards, painted in a contrasting blue to form a sort of frame for the photograph. A blob of wax, presumably the residue of the candle, lies on a ledge in front of the photograph. An artificial perspectival structure is suggested by lines drawn on the vertical surface and the ledge. The work relates to the traditions of painting in its references to still life, to linear perspective, and to *trompe l'oeil*. We are faced not only with the mechanics of illusion, but also with references to the passing of time, the greatest illusion of all, in the photographic record of the burning candle and its real remains.

The scale and complexity of Snow's work is, to date, most fully described by his 1974 film *"Rameau's Nephew" by Diderot (Thanx to Dennis Young) by Wilma Schoen*. The film is very long—four hours and twenty minutes divided into twenty-five apparently disparate sequences. Snow is interested in the notion of passages, of the movements from one event to another. The references in the film's title form in themselves a complex linking of people and events. Denis Diderot, the eighteenth-century French philosopher, critic, dramatist, and co-editor of the *Encyclopédie*, wrote a book entitled *Rameau's Nephew*. Jean-Philippe Rameau was a much-respected musician and a contemporary of Diderot; his nephew Jean-François Rameau, a would-be musician, squandered his life and talent. Diderot's book was brought to Snow's attention by Dennis Young, then curator of Contemporary Art at the Art Gallery of Ontario. Wilma Schoen is an anagram of and pseudonym for Michael Snow. The film develops a complex interchange between appearance and the perception of events, establishing a structure of reason through the interaction and connections between sound and sight. Snow has written,

> My films are intended to be unique experiences, actual despite their being representational, but also because they're representational. That's what they work with. An aspect of them is that they provoke meanings.[15]

Snow's work stands apart from categories, styles, and movements, and yet it is involved in them all. At one level it has been a critical examination of various contemporary artistic movements from the 1950s to the present, at another level it engages the broader issue of what representation by artistic activity means. That it is complex and demanding is without question; that it is amongst the most important work of our times rests in our engagement with its complexity and demand.

In the summer of 1982, when Judy Chicago's *Dinner Party* was being shown at the Art Gallery

Fig. 85.
Joyce Wieland.
Time Machine Series, 1961.
Oil on canvas.
203.2 × 269.9 cm.
Collection Art Gallery
of Ontario, Toronto,
Gift of the McLean
Foundation.

Fig. 86.
Joyce Wieland.
What They Do at Sunrise, 1982.
Oil on canvas.
30.4 cm. diameter.
Courtesy of Isaacs Gallery,
Toronto.

of Ontario, a letter in the *Globe and Mail* pointed out that in the fervour of attention given to the *Dinner Party* the earlier contribution of Joyce Wieland, both in "collective creation" and in feminist issues, should not be overlooked. The situation decried by the letter is symptomatic of Wieland's career. Even now, after more than twenty-five years of work, there is a negligible amount of critical writing on her contribution in any medium. There may be any number of reasons for this, but the most evident is the difficulty she has encountered as a woman in being taken seriously as an artist, even amongst her peers. Her use of sexual imagery and the humour in her work were too easily attributed to role-playing. Further, her concern with nationalist and feminist issues has encouraged a view of her work related not simply to the issues in themselves, but to the particular form in which they were then expressed. The issues continue to be of importance,

97

Fig. 87.
Joyce Wieland.
Reason over Passion,
1968.
Quilt cloth assemblage.
256.5 × 302.3 cm.
The National Gallery
of Canada, Ottawa.

but the *terms* in which they are spoken now, and certainly the way in which they are expressed in the media, are very different to the *form* which they were given in the mid and later sixties. There is also the practical problem that a major part of her contribution has been in film-making, which perhaps has made her work less easily accessible. But in addition there is the difficulty faced by an artist who chooses, as Wieland has done, to work in a variety of media, each of which may interest a somewhat different audience. The impact of a continuous body of work can thus be fragmented, its direction and context made difficult to define and assess.

Wieland's interest in a wide variety of media has been a characteristic of her art from the begin-ning. In the later 1950s she painted, made collages and small wooden constructions, drew, and made films. Her first film, *Tea in the Garden*, was made in 1956 when she was working at Graphic Films, and she was also involved there with a number of co-operative ventures. Though she was at first reluctant to move to New York, she quickly be-came involved, particularly with the experimen-tal film-makers, and her years there proved to be both productive and rewarding.

By the early 1960s she was making large-scale paintings, sometimes humorous, often powerful in their sexual imagery. *Time Machine Series* (1961) (fig. 85), is centred on a form, cell-like, womb-like, and vaginal, suspended in an area of rich blue asserting the female role of generation.

And in her most recent drawings and paintings, one series shown at the Isaacs Gallery in 1981 and another in 1983 (fig. 86), she has taken up again the theme of life and generation with the female side delightfully but definitely in control. Wieland's work has in many ways brought into focus the physical, social, and psychological roles of women, both in subject matter and through artifacts traditionally made by women. She had worked with cloth in the late fifties and early sixties and, while in New York, she designed a quilt which her sister Joan Stewart made. Later her interest in traditional women's crafts and the notion of co-operative work often associated with them was united with a growing feeling of national identity in the large-scale quilts made in 1968 titled *True Patriot Love*, *Reason over Passion* (fig. 87) and *La Raison avant la Passion*, these last two companion pieces made in both official languages, their text being taken from a quote by Prime Minister Trudeau, "Reason over Passion, that is the theme of all my writings." These quilts were shown in a major exhibition in 1971 organized by Pierre Théberge, a curator at the National Gallery of Canada. This was the first major retrospective given to a woman artist at the institution. The exhibition, *True Patriot Love*, centred around the image and the heroic place in Canadian history of Laura Secord.[16] Wieland also showed a 1969 film, *Reason over Passion*, the record of the Canadian landscape that she made in a journey across the country.

Wieland's films on political themes were at their most intense and controversial in the years immediately after her return to Canada in 1972. *Pierre Vallières* (1972), made shortly after Vallières, a member of the FLQ, had been released from jail,[17] was shot as a close-up of his mouth as he talked, with English titles superimposed in the middle of the frame. The following year she made *Solidarity*, a film of a demonstration by striking women workers in Kitchener, Ontario. She had joined CAR (Canadian Artists Representation) on her return to Canada, and had become involved in

Fig. 88. Gershon Iskowitz. *Sextet*, 1965. Oil on canvas. 152.5 × 122.0 cm. Private Collection.

various of its political projects, including joining with the Cree Indians in Quebec in their protest against the James Bay hydro-electric project. Her most ambitious film, *The Far Shore*, was released commercially in 1976. In some senses it elaborates on the theme of *True Patriot Love* through a narrative treatment expressing a sense of heroic identity with the land, epitomized for her by Tom Thomson and the Group of Seven.

All these artists, united by their association with the Isaacs Gallery, their friendship, and their active engagement with the Toronto scene, formed the identifiable core of the avant-garde. But activity in the city was diversified. Any attempt to describe a "Toronto look" must include many

Fig. 89. Gershon Iskowitz. *Red and Blue Painting*, 1973. Oil on canvas. 172.7 × 203.2 cm. Private Collection, Toronto.

other artists, among them Gershon Iskowitz and Louis de Niverville, whose work developed essentially outside any artistic involvement with others and has been directed by intensely personal visions. For Iskowitz this has meant sublimation of the horror of the past through an interpretation of landscape in ebullient colour. De Niverville's work has centred on the expression of experience through the images of dreams and fantasies.

Iskowitz, a survivor of the Holocaust, arrived in Toronto in 1949. Through the war years in the ghetto of his Polish home-town, Kielce, and in Auschwitz and Buchenwald, he made drawings and paintings. Into the mid fifties his work continued to dwell on the past, on the memories of terror and despair and loss. Slowly these gave way to his concentration on the landscape, first around Toronto and Markham, and then further afield, particularly in the Parry Sound region. These early paintings, openly representational, were thickly painted and heavily drawn, but grad-

ually his paintings and watercolours changed from immediate descriptions to impressions of the light and colour of landscape, and, by the later sixties they were, in essence, colour abstractions (fig. 88). In 1967, with the aid of a Canada Council grant, he went to Churchill, Manitoba, where he took some helicopter flights. The shapes and colours of clouds and land and lakes as he flew low over the ground made an indelible impression on him. His work immediately began to reflect this experience in large-scale and brilliantly coloured paintings developed in layer on layer of oil paints. He has produced series after series of these joyful pictures, reflections of landscape through the sheer delight of colour. His paintings—and his approach to making them—stand outside any debates on painting's nature, outside the sophistication—and the sophistries—of art about art. His work relates simply and directly to the compulsion to make pictures, to the reality of his experience of landscape and a love of colour's capacity to give expression to a *joie de vivre* (fig. 89).

In contrast to Iskowitz's open and ingenuous work, de Niverville's painting is dark, shadowy, and disturbing. Iskowitz had little formal training; de Niverville, who like Iskowitz had drawn and painted compulsively since childhood, had practically none. He was deeply impressed by Saul Steinberg's little book *All in Line* and his work was largely developed through his study of this book and the work of those masters who impressed him. As a result, in his early work he struggled long and arduously with both the techniques of representation and the need to find his own voice. The outcome, in his work of the late fifties and early sixties, is a sort of naïve directness, with reflections of Matisse and Bonnard and, particularly, Henri Rousseau. Around 1967 he began to combine collage and painting, concentrating on this technique for about two years. With this he created mysterious spaces, surrealist in feeling, inhabited by curious organisms. He has said of *Pool* (1967),

This collage is my romantic concept of "the dawn of civilization." That very phrase conjures in me a naïve image of this monumental event taking place in one day. An actual morning with the sun about to rise and all these primeval creatures splashing about in the pool of life.[18]

Although he has continued to make collages from time to time, around 1972 his discovery of the airbrush technique brought another shift of style, allowing him to create pictures of a shadowy, disturbingly insubstantial presence (fig. 90). De Niverville has spoken of his choice to paint "strange feelings and imagery which somehow move and excite."[19] He has built up his images—evocative in their curious distortions of time and reality—from dreams, from childhood memories, from old photographs. Often he will invest inani-

Fig. 91. Louis de Niverville. *Millwood Mauve*, 1973. Oil on canvas. 101.6 × 96.5 cm. Collection Gallery Moos, Toronto

Fig. 90. Louis de Niverville. *The Oriental Doll*, 1978. Acrylic on canvas. 106.6 × 91.4 cm. Dr. Michael Braudo, Toronto.

mate objects with life-like qualities, as he did in *Millwood Mauve* (1973)(fig. 91), where the house takes on a vivid human quality, the awnings like eyelids, the door like sealed lips, restraining speech.

Iskowitz and de Niverville are just two artists who have made successful careers in Toronto without any sense of belonging to a "mainstream." The fact is that the list of artists outside any such "mainstream" is not only long, but deep in range and quality. Such a list would have to encompass the work of John Gould and Florence Vale; Mashel Teitelbaum and Eric Freifeld. The work of Freifeld, a teacher at the Ontario College of Art for over thirty-five years, has never been—could never be—in the "mainstream" of anything. Yet his influence on successive generations of students has directly or implicitly become part of the constitution of art in Toronto.

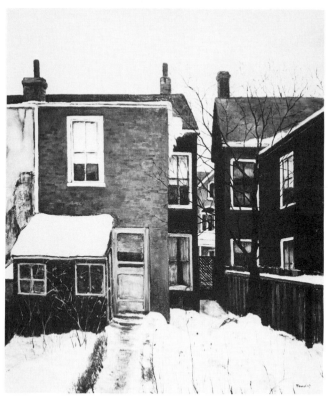

Fig. 92. Albert Franck. *Behind Robert Street*, 1963. Oil on masonite. 60.8 × 50.7 cm. Collection Florence Vale.

We must also be able to encompass the different views and feelings about the city apparent in the work of Freifeld, William Kurelek, Albert Franck, and Christiane Pflug, among others. Franck made affectionate records of the simple and generally unregarded aspects of the city (fig. 92), while for Pflug the city was both the stable ground of reality and a cage containing the individual within its buildings and hydro pylons and streets; her work expresses a deep ambiguity toward perceptions of the city's stability and its entrapping claustrophobia (fig. 169).

And there was the promise of Jack Reppen. Before his tragic death in 1964 at the age of thirty-one, Reppen had shown much potential for major work. Widely known for his sports cartoons in the *Toronto Star*, in the last three or four years of

his life Reppen produced paintings and collages strikingly original in their use of colour and texture. During a 1961 trip he had been deeply impressed by the traditional arts of Mexico and reflections of these began to appear immediately in his work (fig. 94). His painting was developing from strength to strength up to the point, late in 1963, that he became seriously ill.

There was a feeling in the later sixties that some of the spark had been lost from the Toronto scene. Increased knowledge of the latest developments in New York—of Minimalism and Kinetic Art, Op and Pop Art—was projected onto the situation in Toronto, and Toronto was found wanting. The most advanced art still seemed to be that coming from the Isaacs' artists, and some of them had been showing their work for ten years. It seemed difficult to identify the new, the successors to Painters 11 and the Isaacs group. Greater knowledge of contemporary American art made the comparisons between Toronto and New York sharper, and if New York as the source was not being followed then it seemed that Toronto was falling back. Perhaps there was also the desire to hold onto the high points of excitement generated through the rapid development of the previous ten years.

From today's perspective the situation can be read rather differently. In 1965 the artists associated with the Isaacs Gallery were just at the early stages of their mature careers; Coughtry was thirty-four, Burton and Meredith thirty-two, Rayner and Gorman just thirty, Markle (fig. 93) twenty-nine. There had not yet been time for them to influence or be rejected by a new generation of younger painters. And the strong influence that Jack Bush was to exert on the Toronto scene had not yet occurred. It was a period of growth, more through consolidation and development, than through rapid and violent change in which every new canvas seems like an unprecedented discovery. But, in fact, an independent artistic milieu was developing, a milieu clearly identified

Fig. 93. Robert Markle. *Falling Figure Series: Marlene III*, 1964. Charcoal on paper. 58.4 × 88.9 cm. Collection Art Gallery of Ontario, Toronto. Anonymous gift in honour of J.W.G. (Jock) Macdonald.

with Toronto. By 1965 a sense of maturity had been reached in Toronto. From that point the leadership of the new was no longer dependent on one small group of artists representative of the whole, but rather on the variety and range to be found in any major cultural centre. Art is made from the careers of individual artists, not by some amorphous process of change, not by a brief period of stardom, but in the process of work and living. Fashion is impatient, excitement demands its constant injections of "highs;" art is the process of the individual, of the commitment to work.

London

The connotations of regionalism are often those of a viewpoint that is inward-looking and limited; in art, regionalism implies concerns either unaware of or disinterested in events beyond certain horizons. But a different perspective of regionalism marks it as the grass-roots reality of art in Canada. The development of artistic activity in Canada has been regional in the sense of its concentration in relatively isolated centres, whether in the smaller cities or in the major urban centres of Vancouver and Montreal and Toronto. In recent years, despite greater communication and knowledge of events through travel, exhibitions, and magazines, regional concentration has

Fig. 94. Jack Reppen. *Yucatan Ruins*, 1963. Plaster, oil on canvas. 121.9 × 121.9 cm. Private Collection, Toronto.

changed relatively little. The case for regionalism—not as a deliberate restriction or by default, but as an active engagement with the reality of living in a particular place at a particular time—has been most strongly asserted by two artists from London, Ontario. It is a case which Jack Chambers and Greg Curnoe have made with their lives, their work, and their political activism, the latter given particular expression through the formation of CAR (Canadian Artists Representation). Curnoe has actively expressed his opposition to the infiltration of American cultural values and the power both contained and symbolized in that infiltration. He asserts the primacy and the realism of art as an immediate expression of the individual in response to the environment and context in which he or she lives and works.

Curnoe was born in London, Ontario, in 1936. He attended H. B. Beal Technical School and then studied at the Doon School of Art and the Ontario College of Art. His experiences at these two institutions left him deeply dissatisfied with what he saw as a contradiction between their perpetuation of the notion of "High Art Culture" and popular culture—the reality of culture as the facts and circumstances of living in a particular environment. A focus for his expression of this contradiction came through his interest in the writings and actions of the Dada movement, a focus developed through his friendship with Graham Coughtry and Michel Sanouillet, a writer and student of the Dada movement who was teaching at the University of Toronto. After three years in Toronto, Curnoe returned to London in 1960 and set up his own studio.

Early in 1961 he began to publish a magazine entitled *Region*, and in November of the following year he and six other artists, including Jack Chambers and Tony Urquhart, founded the artist-run Region Gallery which Curnoe managed for its one-year existence. He wrote at that time that "regionalism" was being used "as a collective noun to cover what so many painters, writers and photographers have used—their own immediate environment—something we don't do in Canada very much."[20] The value of work arose as an involvement with and response to everyday and immediate events, to sounds and places and people, to past events, and to the whole range of events and people's involvement in them that create the distinctive character of a place, rather than a concern with "art" as a distinct, self-perpetuating refinement of its own traditions. Originality does not arise from an individual adding another layer to the patterns of art formed in and for circumstances not his or her own; "I believe," Curnoe wrote in 1975,

> that the artists who are original, who break out of the colonial mould, are the ones who really affect our culture and inevitably they are original because they develop out of their whole background.[21]

He has distinguished between regionalism and provincialism: regionalism as the reality of individual and collective living, provincialism as the

Fig. 95. Greg Curnoe. *View of Victoria Hospital, First Series: Nos. 1–6 (August 1968—January 1969),* 1969. Marking ink and latex on canvas. 6 panels, each 289.6 × 228.6 cm. The National Gallery of Canada, Ottawa.

uncritical acceptance and extolling of imported cultural values. He consistently asserts these values in the subjects and references in his work. Specifically, he has worked directly through his own lived experience, through his surroundings and observations and interests, through his family and his friends. This has not meant for him a wholesale rejection of art from elsewhere, but it has meant the rejection of an uncritical imitation of outside values, an imitation that allows outside values—particularly American ones—to become the arbiter and modality of Canadian values.

The critical values of Dadaism, particularly as they are found in the work of Marcel Duchamp and the German artist Kurt Schwitters, with their assembly of "non-art" objects that reject the traditions of "High Art," have played an important part in Curnoe's work. He has approached these values through his own interests in popular culture, in comic books and advertisements and newspaper reports. Both British and American Pop Art drew their imagery and their style from similar sources, representing images that bear immedi-

ately on everyday life, breaking down the separation of the "art experience" from the reality of immediate experience. Curnoe has been criticized for his approach because to some people he has seemed to be dependent on an imported style, in particular an American style. This criticism, however, misses the point at several levels. It overlooks the interest Curnoe has always had in aspects of popular culture; in comic books, for instance, in their style and declarative messages, in their combinations of words and pictures. His art does not so much adopt a Pop Art style as it reflects his own interests and his assessment of the realism of cultural expression. The criticism is false if it rests on a coincidence of "style," for the circumstances of the rise of Pop Art in New York must be seen within the context of art and reaction there. The close cultural ties between Canada and the United States represent a reality that can-

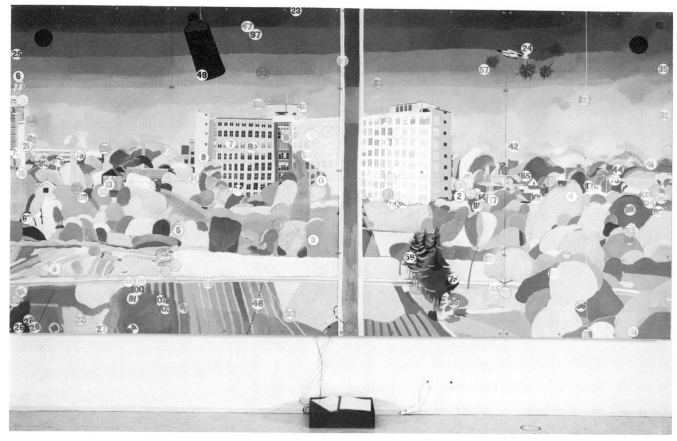

Fig. 96. Greg Curnoe. *View of Victoria Hospital, Second Series (10 February 1969—10 March 1971)*, 1971. Plexiglass, metal, stamp pad ink, wallpaper, oil, and graphite on plywood; loudspeakers, sound tape and tape recorder, and printed text (notebook, 8 pages), 243.8 × 487.0 cm. The National Gallery of Canada, Ottawa.

not simply be disregarded; they can be, as they have been in Curnoe's work, critically examined.

If the choice is between a hide-bound isolationism and an engagement with the issues, then Curnoe has taken the route of engagement.

The ambition of Curnoe's work and his approach are most fully shown in two related works, *View of Victoria Hospital, First Series: Nos 1–6 (August 1968–January 1969)* and *View of Victoria Hospital, Second Series (10 February 1969–10 March 1971)* (figs. 95, 96). The first

comprises six canvases, together reaching over forty-five feet, filled with a text done in rubber stamps. The text describes the view towards the Victoria Hospital in London from Curnoe's studio. The matter-of-fact description—"AGROUPOF LARGETREESOBSCURETHEHOUSESTOTHERIGHT"—is interspersed with declarative statements—"THISIS TRULYGREATARTBECAUSEITWASNOTMADEBYAN AMERICAN." The second work is a painting of a view of the hospital. A series of painted numbers is a key to events and thoughts recorded over a period of time and listed in a notebook which accompanies the work. In addition a tape recorder plays a tape of sounds recorded in the studio; these sounds are amplified through loudspeakers set into the plywood support of the

painting. These works, while totally personal in their immediate content (Curnoe's viewpoint, his thought, his perspective) are presented in techniques and styles and materials that do not belong to art history in the narrow sense, but to the cultural ambience in the more general sense.

Curnoe has been at the centre of the artistic community in London from the beginning of the sixties; with *Region* and the Region Gallery; with the 1964 formation, with a number of other local artists and friends, of the Nihilist Spasm Band; with his involvement with CAR since 1967. His studio has long been a gathering place for his friends, an informal setting for discussions on art and politics and philosophy, "a vital meeting place," as Pierre Théberge has written, "for a whole generation of artists."[22] Through Curnoe's suggestion, the artistic activity in London was given national identification in the exhibition *The Heart of London* organized by Pierre Théberge in 1968. The exhibition brought together the work of a remarkable group of artists: John Boyle, Jack Chambers, Murray Favro, Bev Kelly, Ron Martin, David Rabinowitch, Royden Rabinowitch, Walter Redinger, Tony Urquhart, Ed Zelenak, and Greg Curnoe.

The integrity of Curnoe's activism has come

Fig. 97. Greg Curnoe. *Homage to van Dongen (Sheila) No. 1*, 1978–79. Watercolour and graphite on paper. 152.4 × 243.8 cm. Hart House, Permanent Collection, University of Toronto.

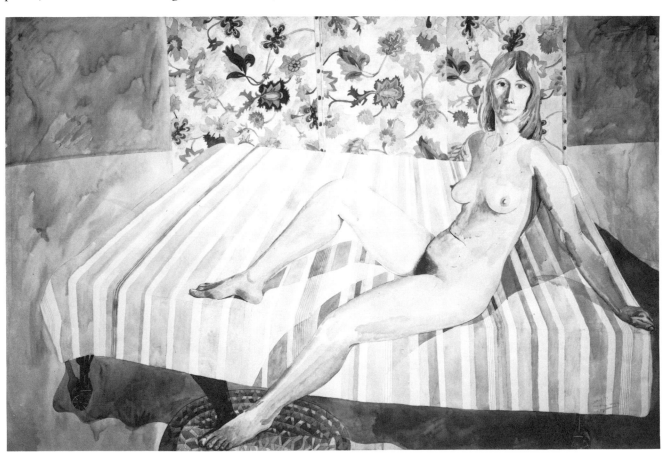

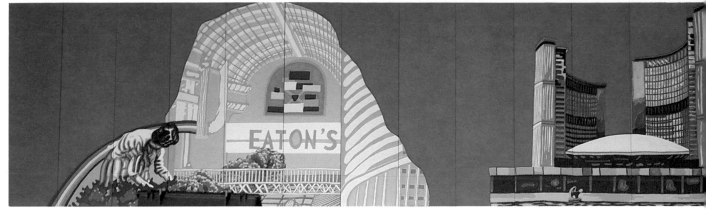

Fig. 98. John Boyle. *Our Knell*, 1980. Baked porcelain on steel. 2.2. × 15.2 m. Queen Street Subway Station, Toronto Transit Commission.

through his very strengths as a painter and printmaker. The sheer range of his inventiveness, the boldness of the text work of *View of Victoria Hospital, First Series. . .* displays this integrity. It shows also in the brilliant large-scale watercolour *Homage to van Dongen (Sheila) No. 1, 1978–79* (fig. 97), a tribute to his wife expressed through his respect for the Dutch painter Kees van Dongen. It shows in the series of prints and watercolours of bicycles and bicycle wheels that draw together his personal interest in bicycling, his respect for Marcel Duchamp, and his friendship with Sanouillet, the scholar of Duchamp's work.

Curnoe has tried to awaken Canadians from their apathy towards the American cultural and economic presence and alert them to the attitudes of institutions—artistic, political, and commercial—that have allowed or welcomed this presence. At the same time his insistence on the primacy of regional identity reflects a realism about the political, geographic, demographic, and cultural constitution of Canada.

John Boyle, a friend of Curnoe's and a member of the Nihilist Spasm Band, has taken a more determinedly nationalist view in asserting a Canadian entity against the encroachment of American influence. His work, like Curnoe's, is often closely identified with the immediacy of his surroundings, but he also attempts to raise our sense of national consciousness through the heroes of Canada's past—Louis Riel and Tom Thomson, William Lyon Mackenzie and Nellie McClung—presenting them in a style of glaring opulence, as if to bring their shadowy presence from the past into an insistent present. His most visible public statement is the mural *Our Knell* (fig. 98) commissioned for the Queen Street subway station in Toronto and installed in 1980. Using a technique of baked porcelain on sheets of steel, the mural presents Mackenzie and McClung in the context of major buildings in the area.

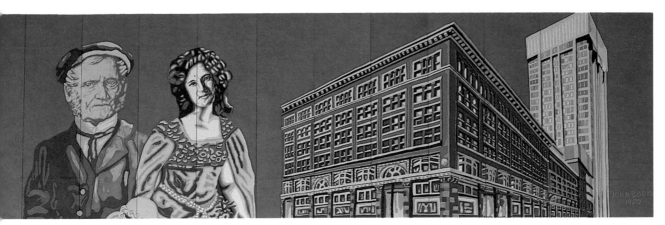

Notes

1. See Anthony H. Richmond, "Immigrants and Ethnic Groups in Metropolitan Toronto," Institute for Behavioural Research, York University, 1967.
2. Harold Town, *Albert Franck: Keeper of the Lanes.* Toronto: McClelland and Stewart, 1974; p. 12.
3. Dennis Reid, *A Concise History of Canadian Painting.* Toronto: Oxford University Press, 1973; p. 184.
4. *Toronto Painting: 1953 – 1965.* Ottawa: The National Gallery of Canada, 1972; p. 5.
5. *Ibid.,* p. 6.
6. Joan Murray interview with Harold Town, 11 July 1977. In Joan Murray, *Gordon Rayner Retrospective.* Oshawa: The Robert McLaughlin Gallery, 1978; p. 8.
7. Allan Kaprow, "'Happenings' in the New York Scene," *Art News,* May 1961.
8. *Toronto Painting,* p. 22.
9. Barrie Hale, *Graham Coughtry Retrospective.* Oshawa: The Robert McLaughlin Gallery, 1976; p. 9.
10. *Ibid.,* p. 15.
11. *Dennis Burton Retrospective.* Oshawa: The Robert McLaughlin Gallery, 1977; p. 23.
12. Lawrence Alloway in Lucy R. Lippard, *Pop Art.* London: Thames and Hudson, 1970; p. 65.
13. *Ibid.,* p. 62.
14. *Michael Snow / A Survey.* Toronto: Art Gallery of Ontario in collaboration with the Isaacs Gallery, 1970; n.p.
15. *Michael Snow: Works 1969 – 1978. Films 1964 – 1976.* Lucerne: Kunstmuseum Luzern, 1979; p. 13.
16. Laura Secord (1775 – 1868) in 1813 crossed through the American lines, driving a cow to avoid suspicion, to warn the British of impending American attack during the War of 1812.
17. The FLQ or Fédération pour le libération du Québec was an extremist movement seeking the independence of Quebec from Canada.
18. Joan Murray, *Louis de Niverville Retrospective.* Oshawa: Robert McLaughlin Gallery, 1978; p. 25.
19. *Ibid.,* p. 9.
20. Pierre Théberge, *Greg Curnoe.* Ottawa: The National Gallery of Canada, 1982; p. 13.
21. *Ibid.,* p. 17.
22. *Ibid., p.* 7.

Fig. 99
Jack Humphrey.
Bobby, 1939.
Oil on canvas.
61.0 × 50.5 cm.
Galerie Dresdnere,
Toronto.

The Maritimes, Modernism, and the West

Outside Montreal and Toronto—and they were hardly paragons of progressiveness—the situation of the visual arts between the wars was bleak. Even in well-established cities like Quebec City and Halifax there was little in the way of major professional activity. Elsewhere, activity is identified by the determination of a few individuals: Emily Carr in Victoria, LeMoine FitzGerald, and, for brief periods, Bertram Brooker and Fritz Brandtner in Winnipeg.

In the West the art schools constituted the bases of activity—the centres for discussion and the development of professional ambition—in the absence of well-developed and progressive public or private galleries. The strongest artistic community was in Vancouver, centred on the School of Art where Fred Varley and Jock Macdonald were teaching. And activity in the city was strengthened by the arrival of Lawren S. Harris in 1940. The summer art schools at Banff and Emma Lake were both founded in the later 1930s. The Banff School of Fine Arts, developed from an art camp established by A. C. Leighton in 1935, became an important gathering point for teachers and students from across the West. The Emma Lake Summer School began in 1936 as a more modest enterprise initiated by Augustus Kenderdine, then head of the art department at Regina College.

Despite the limitations on artistic activity in the West, there was a basis and a spirit of enterprise on which expansion in the 1950s grew. There was no comparable activity in the Maritimes. There were, of course, art schools; the Nova Scotia College of Art and Design had long been established in Halifax; Mount Allison in Sackville, New Brunswick, had been the first Canadian university to have an art school and the first, in 1941, to offer degrees in the subject. Nonetheless the atmosphere was one of deep conservatism, dependent on derivations of traditional European and British forms, and of virtual isolation from central Canada; even the activities of the Canadian Group of Painters did not extend far into the Maritimes. The two most significant artists and the two whose response and understanding of modern developments was the greatest, were Jack Humphrey and Miller Brittain. Both men were born in Saint John, New Brunswick, and both spent most of their careers there. They both trained outside Canada—Humphrey in the United States and Europe, Brittain in New York—but their work was essentially concerned with their immediate circumstances and surroundings. Humphrey broke the sense of isolation by regular travel, but Brittain did not and grew increasingly bitter at the disregard he felt his work suffered. With the exception of a positive review by Robert Fulford, his first solo exhibition in Toronto, at the Greenwich Gallery in 1957, was poorly received, fuelling Brittain's strong antipathy to the "Upper Canada Art Establishment," in particular to successive directors of the National Gallery and to the dominant position of the Group of Seven and their assumption of landscape as the quintessentially Canadian subject matter.

Humphrey, born in 1901, studied in Boston and at the National Academy in New York, and in 1929 he spent a brief but intense period with Hans Hofmann in Munich. He made regular visits to New York throughout his life, and for a time was in contact with the emerging scene in Montreal. He had joined Montreal's Eastern Group of Painters in 1938 and was a founding member of the Contemporary Arts Society, exhibiting regularly with them through the 1940s. Humphrey's cosmopolitan training and travels made him aware of a wide range of contemporary art, and his study with Hofmann gave him insight into the pictorial thinking of one of the most influential teachers of the day. That he was an able painter, if not an inventive one, is evident from the range of his

Fig. 100 Miller Brittain. *In Front of the St. John Liquor Store*, 1945–46. Oil on masonite. 45.7 × 55.9 cm. The Weston Group.

work, in particular the portraits of the 1930s; his best work sensitively reflects the people of Saint John and their surroundings (fig. 99).

After the war Humphrey's interests shifted somewhat from regionalist concerns, with the pictures he called *Outdoor Objects*. In Europe in 1952–53 contact with the type of abstraction being done in Paris by artists like Jean Bazaine and Alfred Manessier signalled a further change. It was a change described by Russell Harper in his book *Painting in Canada: A History* as creating a "disturbing dichotomy;"[1] Humphrey would make representational landscapes in watercolour and oils and then develop them into abstractions. It was a method of approximating the appearance of recent American and European painting, based not on a radical working from the principles from

which they sprang, but on an appropriation of their formal and stylistic procedures.

Miller Brittain was an artist of a very different cast, less concerned with responding to various aspects of modernism than with expressing views and feelings that were deeply, even agonizingly, experienced. He spent two years (1930–32) at the Art Students' League in New York at a time when the dominant concerns at the League were the rural and urban realisms marking the mainstream of American painting from the later 1920s to the 1940s. Brittain came into contact with painters like Raphael Soyer and Reginald Marsh who concentrated on urban scenes, reflecting the confusion, the squalor, and the promise of big-city life. Brittain's paintings in the 1930s and in the years immediately after the war are sharp, often brilliant, observations of the people in the streets and service clubs of Saint John. In their stubby awkwardness the figures are reminiscent of Brueghel the Elder, but Brittain's paintings have nothing of Breughel's grand moral perspective on the human condition; they concentrate on the small dark corners and incidents of everyday life, lit now and then by flashes of bright colour that contrast ironically with the atmosphere of drab struggle in the subjects themselves (fig. 100).

Probably at Humphrey's suggestion, Brittain joined the Contemporary Arts Society, and exhibited with it in 1940, 1941, and again in 1948.[2] He enlisted in the RCAF in 1942 and saw active service in 1944–45 as a bomb aimer. Commissioned in 1945, he was transferred to the Canadian War Art program until his discharge in 1946. His wartime experiences had a profound effect on his thinking and his art. His work between 1947 and 1951 was dominated by religious subjects, "It is a matter," he wrote, "of the Bible containing every human emotion, so that whatever I felt, I could find a story in the Bible to illustrate it."[3]

Brittain, struggling with a severe alcohol problem and the protracted illness of his wife, expressed in his work an increasingly introspective vision. Surrealist forms, attenuated, faceless figures set in ravaged or desolate landscapes, present a tortured vision broken just occasionally by moving and sympathetic portraits of his daughter. The isolation in his work, as well as reflecting a personal withdrawal, stands witness to Brittain's isolation from debate and from recognition. The issue is not *whether* Brittain was a great artist, nor whether major art can exist outside the major centres; the issue is that he *was* an artist, a witness and a voice in a generally hostile environment towards which he made no compromises.

The War Art program was the context in which a number of artists began their careers; for other artists it marked an important stage in their development. This was true of Alex Colville, Lawren P. Harris (who became head of the Mount Allison art department in 1946), and Donald C. MacKay (head of the Nova Scotia College of Art and Design from the end of the war to his retirement in 1971). It was true also of Bruno and Molly Lamb Bobak. Bruno Bobak was the youngest of Canada's war artists, Molly Lamb the only woman to receive official War Artist status. While Bruno Bobak was training at Central Technical School in Toronto, Molly Lamb was studying at the Vancouver School of Art with Jack Shadbolt. After the war—they had married in 1945—they settled in Vancouver where Bruno Bobak taught at the Vancouver School of Art. They travelled in Europe for a time in the late 1950s and then Bruno was appointed Artist-in-Residence at the University of New Brunswick, Fredericton. Later he became Director of the Art Centre.

Bobak's early work was indebted first to the "expressive realism" of Carl Schaeffer and then to the influence of British artists like Paul Nash, John Piper, and Graham Sutherland. This approach underwent a radical change in the late 1950s, after Bobak had seen the work of Oscar Kokoschka and Edvard Munch. Through the 1960s and 1970s his expressive figurative work set him outside the mainstream when figuration in itself was a mark of exclusion (fig. 101).

Fig. 101
Bruno Bobak.
Vancouver, 1962.
Oil on canvas.
116.8 × 142.2 cm.
Lavalin Inc.

Molly Lamb joined the army in 1942, shortly after graduating from the Vancouver School of Art, and in 1945 was appointed an official War Artist. She subsequently taught at her *alma mater* (1947–50), at the University of British Columbia, and then, from 1960, at the University of New Brunswick. Her work ranges in subject matter from flowers to parades and public gatherings (fig. 102). The contrast in her work between the fragility and anonymity of the individual and the strength and vitality of the group, in a curious way validates the individual even in its loss of separate identity.

Both Alex Colville and Lawren P. Harris took up appointments at Mount Allison in 1946, immediately after their discharges from the army. Col-

ville had graduated from the university just four years earlier. Harris, ten years older than Colville, had trained in Boston and Toronto. The two men represented totally different approaches. Harris had begun to make semi-abstract pictures before the war, but had retained a sharply realistic manner for his war work. In Sackville he moved back to his earlier abstract experiments and towards fully non-objective paintings and serigraphs (fig. 103). His isolation in this regard, however, was quite different in nature from Miller Brittain's, in part because of his contacts with artists in Toronto and elsewhere, and in part because of his institutional responsibilities to expand the showings of art in the region. The National Gallery, particularly under Alan Jarvis' direction, had es-

tablished a nation-wide program to circulate exhibitions, loan pictures, and arrange lectures in the smaller centres. These initiatives were further developed in the East with the formation of the Maritime Art Association and, more importantly, the Atlantic Provinces Art Circuit, which undertook to originate exhibitions from and amongst the various art galleries and universities in the Maritimes. By these means the opportunities to show a wide range of recent art from within the Maritimes and from across the country were expanded.

Vancouver

Beginning in the late 1920s, Vancouver had boasted a small but vital group of painters and writers. This intellectual circle had shown considerable interest in esoteric religion and philosophy, in theosophy, in anthroposophy, and in the writings of P. D. Ouspensky. The sense of mystic unity in natural, cosmic, and cultural terms proposed by their interests lies deeply felt in the work of Jack Shadbolt. Through their work and their teaching, Shadbolt and B. C. Binning were the dominant figures in Vancouver from the late 1940s. Both men had graduated from the Vancouver School of Art and returned there to teach, Shadbolt from 1938 until he entered the army in 1942 and then again after the war until 1966, Binning from 1934 until 1949 when he moved to the University of British Columbia where he continued until his retirement in 1974.

Shadbolt's broad embrace of modernist interests and his deep affinity for nature and its cultural representation contrasts with Binning's narrow range and more formally structured abstraction. Binning studied in London, first with Bernard

Fig. 102 (above). Molly Lamb Bobak. *Swimmers, Elk Lake,* 1962. Oil on canvas. 121.9 × 91.4 cm. Lavalin Inc.

Fig. 103 (below). Lawren P. Harris. *Chevrons No. 3,* 1974. Acrylic and latex on canvas. 117.0 × 137.0 cm. C·I·L Inc.

Meninsky and subsequently with Amédée Ozenfant and Henry Moore, and then in 1939 for a year at the Art Students' League in New York. Until 1948 he worked exclusively in drawings, taking subject matter that was simple and familiar—seashores, ships, waterside activity—as means to a formal end. The detail of his earlier drawings gradually gave way to more rigorous abstract structures (fig. 104), and in many works after 1953 all representational elements were eliminated. Such rigorous abstraction was, of course, still rare in Canada in the early 1950s, rarer still on the west coast—even Lawren S. Harris' work became looser, more directly responsive to the west-coast landscape after the later 1940s. But if the methods of Ozenfant and Purism guided the principles of

Fig. 104
B.C. Binning.
Squally Weather,
1948–50.
Oil on paper board.
81.3 × 102.9 cm.
Collection Art Gallery of
Ontario, Toronto, Gift
from the Albert H. Robson
Subscription Fund, 1951.

Fig. 105.
Jack Shadbolt.
Winter Theme No. 7, 1961.
Oil and lucite on canvas.
107.6 × 128.9 cm. The
National Gallery of
Canada, Ottawa.

116

Fig. 106. Jack Shadbolt. *Summer Icon No. 3 (Triptych)*, 1977. Acrylic, oil, and lucite on canvas. Three panels, each 152.0 × 102.0 cm. C·I·L Inc.

Binning's art, his pictures often retain a lightness, a whimsy reminiscent of the imagination of Paul Klee and Joan Miró. Later in the 1950s Binning became involved in a number of architectural projects—his initial appointment at the University of British Columbia was in the School of Architecture—among them several mural commissions for corporate buildings in Vancouver. There is, in the later 1960s, a certain loss to the character of his work as he moved into shaped canvases and paintings constructed on a modular principle with optional configurations, an apparent shift from his earlier purist abstraction to adapt to the approaches of current Minimal art.

Although his work is still relatively unknown outside British Columbia, Binning enjoyed a substantial reputation as a teacher. Jack Shadbolt too has been most influential as a teacher, but his complex and varied work has had wider exposure. His sources and interests are legion: the great masters of the past, Cubism and Surrealism, the American Regionalists. In particular he has had a deep regard for the art of the native people of the Northwest Coast, both their craftsmanship and their spiritual unity with nature and its forces, that forms the basis of their art.

Shadbolt's attendance at the Vancouver School of Art was the start of a long period of varied studies interspersed with periods of teaching. He marks his visit to the 1932 Chicago World's Fair as "my real initiation" to art, for it was there he first saw a range of major art—from the Italian primitives to Gauguin and Picasso, Cézanne and Matisse to the contemporary American realists Edward Hopper and Charles Sheeler and the Mexican painters Diego Rivera and José Clemente Orozco. In New York in 1933 he was especially struck by the Surrealist work that was then beginning to appear there. In 1937 he went to Europe, studying first in Britain at the Euston Road School and then in Paris with the Cubist

117

painter André Lhoté. He enlisted in the army in 1942 in hopes of being made a war artist. In 1944, however, when the appointment came it was not to a field post, as he had wished, but as an administrative officer of the Army War Artists in London. One of his duties was to sort and catalogue photographs documenting the army's advance through Europe. This visual evidence and his immediate observation of bombed-out buildings in London led him, in a very direct way, to recognize a process and meaning for abstraction: not as a particular phenomenon of art history, but as something real, both physically and psychologically:

> ...when the bomb blows the building apart it abstracts it, the pieces fall back together again and you get a memory image of what was there but vastly altered and psychologically made infinitely more intense than the original thing. So that was a process of abstracting.[4]

This thinking was reinforced by his renewed study, in Vancouver after the war, of Indian art. He was struck, in particular, by the "X-ray" type of image where the artist combines in a single figure its inside and outside appearance.

It was, perhaps, not surprising that immediately after the war Shadbolt's work should contain reflections on human and social concerns, that the experience of death and destruction should lead him to make images examining the everyday activities and the ways in which people build and are bound together. Gradually these concerns expanded from a response to particular times and experiences to man's more fundamental cultural expression of his place in nature. Through his interest in the figure of the *shaman* and in the myth of the eternal return in the cyclical process of nature, Shadbolt could unite his respect for great art of both the recent and the distant past, and his attachment to the richness of the west-coast landscape to form a personal "*lyrical* vision" (fig. 105). The need to work between art and nature, between the construction of art and the immanence of nature, seemed for a long time to him to be a dilemma:

> I have had a recurrent pattern [in my work] of going periodically to an architectonically designed structure. This inability to adhere to one major direction used to worry me as a sign of artistic weakness in myself.... Reflection has told me that, in fact [this duality] is me...and insight has suggested that it may be my strength, not my weakness, if I can contain it in a form.[5]

He has spoken of trying to reconcile or absorb that duality within an "enigmatic imagery," as if the enigma of the image would contain and express the ambiguities he felt. But in more recent years he has worked for the freedom that those ambiguities bring (fig. 106), allowing them to determine the construction of the picture.

The concerns and doubts that he once felt about the sheer variety of his work reflect on a rather different issue which is at the roots of his work, the issue of the international and the regional. Shadbolt has always felt that he had to seek out the possibilities that had existed in art in the past as well as those occurring in the present no matter where they were done. It meant a long, self-imposed apprenticeship. At the same time he recognized that the only meaningful development in his art would have to be discovered in his roots. The issue was this: for his art to be relevant to his own time he felt the need to understand the whole heritage of western art. At the same time his own expression had to arise out of the immediacy of his surroundings. International developments become meaningful only when they are taken into the artist's own context, "the real experience has to be brought back to one's sort of regional identity."[6] This is an attitude of special importance in the way it describes the foundations of a modern culture in Canada. Shadbolt's career, developing in the 1940s, forms part of the measure of art in Canada from a state of isolation to a creative engagement with international developments. This does not mean slavish approxima-

Fig. 107 E.J. Hughes. *The West Arm, Kootenay Lake*, 1973. Oil on canvas. 81.3 × 101.6 cm. Gerald W. Schwartz, Toronto.

Fig. 108 (below). Gordon Smith. *Rhada*, 1969–70. Acrylic on canvas. 117.0 × 117.0 cm. C·I·L Inc.

tions to international styles but to interpretations that show the commitment of the individual to the circumstances of his particular place. Only because of those bases, laid in many parts of the country in the 1940s and early 1950s, has the expansion and deepening of the cultural enterprise in the past thirty years occurred.

The sense of rooting in a particular place is also very apparent in the work of E. J. Hughes, but in his case the choice was to turn away from outside references. Hughes was born in 1913 and like Shadbolt and Binning, received his initial training with Varley and Macdonald at the Vancouver School of Art. He began his career in the 1930s principally as a mural artist, working with other British Columbia artists such as Paul Goranson and Orville Fisher. He enlisted in the army in 1940 and was appointed an Official War Artist in 1943, working in that capacity until 1946. His work, which had always been strongly drawn and

Fig. 109. Gordon Smith. *West Coast No. 1*. Acrylic on canvas. 165.1 × 228.6 cm. Scotiabank Collection.

simple in form, moved towards the more naïve approach to design and colour with which he has described the landscapes and seascapes around Vancouver Island (fig. 107).

Despite Shadbolt's and Hughes' contrasting, even conflicting approaches to painting, they are united in seeking, through colour and a fullness of surface, a response to the richness of the west-coast landscape. Their response to place is an immersion into its variety whether, as for Shadbolt, in a mystic sense or, as for Hughes, in a naïve

directness. A very different vision of landscape arises in the work of Gordon Smith and Toni Onley emerging in their work through an abstract pictorial structure rather than through an abstracting from nature. Even if there was always a disposition towards a sensibility of landscape for both these artists, for much of their careers the form of their work has been abstract.

Gordon Smith was fifteen in 1934 when he and his family came to Canada to settle in Winnipeg. He attended the Winnipeg School of Art, studying with LeMoine FitzGerald among others, and worked as a commercial artist before enlisting

in the army in 1940. After the war he taught at the Vancouver School of Art, where his interest in print-making led to the formation of the silk-screen department in 1946 and the lithography shop in 1950. After ten years at the School he moved to the Faculty of Education at the University of British Columbia. His earlier work was of an abstracted figuration, but through the 1960s and into the 1970s it became strictly abstract and hard-edge; strong colour designs delivered a sense of movement through colour and shape, a form of the Op Art which dominated so much art through the 1960s. During these years Smith worked principally in silkscreen, a technique that lent itself to the smooth application of colour and the sharp distinctions between one area and another which heighten the effects of optical movement. By the end of the 1960s the forms, while retaining their hard-edge abstraction, became increasingly complex, as if searching for a new structure, a new definition of space challenging the unity of the coloured shapes (fig. 108). The break came in the early 1970s with pictures that, while retaining a marked degree of formal abstraction, introduced more loosely applied and textured colour, opening up a landscape-like illusion of space. They are, reminiscent of the abstract landscapes that the California painter Richard Diebenkorn had begun to do in the later 1960s.

Since the early 1970s Smith's work has characteristically, but not exclusively, been concerned with seashore or sea-line subjects: paintings built up with strong horizontal divisions, sometimes introducing explicit references to natural features, at other times holding strictly to geometric divisions, but always with a looseness of texture implying a coloured atmosphere which transcends the restrictions of geometry in the forms (fig. 109).

Toni Onley's interest in landscape, given through subtle tonal arrangements of low-keyed colour, also came as a return from abstraction; in his case, from a more vigorous expressionism. Onley was born on the Isle of Man in 1928. His

Fig. 110. Toni Onley. *Polar 19*, 1962. Oil and collage on canvas. 114.6 × 129.2 cm. Lavalin Inc.

training was in architecture and his early work as a painter was in landscape, reflecting his interests in the English watercolour landscape tradition. His interest in landscape was reinforced when he came to Canada in 1948, and went to study with Carl Schaeffer at the Doon School of Art. He first went to British Columbia in 1955, and he settled in Vancouver in 1960 after spending three years in Mexico. Onley had begun to make pictures in an Abstract Expressionist manner in Mexico. Dissatisfied with the results, he destroyed many of them by cutting them into pieces. But he then recovered the fragments and began to make collages from them, using the shapes as the basis for further painting. He began to exhibit these collages at the New Design Gallery in Vancouver and the Dorothy Cameron Gallery in Toronto. Gradually they became more tightly organized. The group title of the *Polar* series (1962) refers to the dominant polarity in the works which draws in and concentrates the activity on the centre of the canvas (fig. 110). The energy of the expressionist works led to abstract paintings very spare in im-

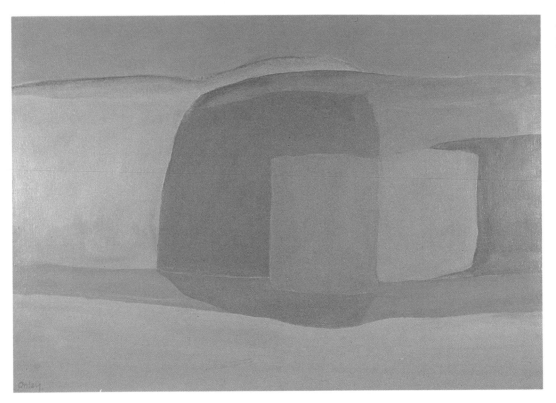

Fig. 111.
Toni Onley.
Mirage, 1966.
Acrylic on canvas.
94.0 × 124.0 cm.
C·I·L Inc.

age and restricted in colour—dependent primarily on a tension between shape and tone—and then, from 1965, to paintings containing direct references to landscape, but a landscape of severely restricted elements, reduced in colour to just a few generally pale hues—a sensibility of landscape rather than a description (fig. 111). The subtlety of the work points more to Giorgio Morandi and to Oriental landscape painting than to the immediate and overpowering presence of the west-coast landscape and the traditions of landscape painting; "I had," he has said, "to paint my way out of a forest of Mickey Mouse trees."[7]

As Onley turned away from the density of landscape—a refined and stylish simplification whether the source in nature is from Mexico or the high Arctic or the British Columbia coast— and Smith turned to the simple division between sea and sky, so Takao Tanabe has looked towards the Prairie plains and away from the Rockies and the forests of the coast. But for him, as with Onley and Smith, concentration on landscape painting has been a development of relatively recent years. Tanabe was born in 1926 near Prince Rupert, moving to Vancouver in 1937. As a Canadian of Japanese origin he and his family were forced to register under the shameful requirements of the British Columbia Security Commission. His parents and the younger children of the family, including Takao, were interned in the interior of British Columbia. After two years he was released to join his elder siblings, who were doing farm work in Manitoba. In the late 1940s he studied at the Winnipeg School of Art, with Joe Plaskett, who had replaced LeMoine FitzGerald as head of the school. In the early 1950s he also studied with

Fig. 112. Takao Tanabe. *Prairie Hills 4/77*, 1977. Acrylic on canvas. 139.7 × 177.8 cm. Canada Tungsten Mining Corporation, Ltd.

Hofmann and Reuben Tam at the Brooklyn Museum Art School and then, in 1952, returned to Vancouver where he remained until 1967, a period broken by a two-year stay in Japan (1959–61) before going to New York for six years. When Tanabe returned to Canada in 1973 it was as head of the art department at the Banff School. (He had worked as a labourer at the School in the early 1950s.) Up to that point the main body of his work had been non-representational, but his interest in landscape painting, which had begun in the late 1960s, now led to a concentration on the subject. He has, since that time, been making paintings of a serene simplicity, contrasting land and sky essentially unbroken by vertical intrusions. These can be paintings of powerful mood, often dark and threatening, concerned less with the description of particular features—they are rarely specific in location—than with the sense of the land's vastness. What features there are come not from formal elements but from the way that light builds the structure of the land, the sun catching the edge of a hillside, or forming a pale pool of light in the otherwise featureless plain (fig. 112).

Maxwell Bates and Calgary

The Banff School of Fine Arts, a summer school, attracted many amateurs, but with its fully professional staff it also became a meeting point for aspiring professionals from across the West. Jock

123

Fig. 113. Ron Spickett. *Flight No. 5*, 1967. Oil on canvas. 77.0 × 138.0 cm. C·I·L Inc.

Macdonald taught there in 1945; his advocacy of abstraction and of "automatic" methods of drawing cut across the more common grain of academicism and the dominance of naturalistic landscape pictures. The course, for instance, of Alexandra Luke's work and thinking was radically altered by her contact with Macdonald at the School. The following year Macdonald moved to Calgary to head the art department at the Provincial Institute of Technology and Art (later the Alberta College of Art attached to the Southern Alberta Institute of Technology). After one year, glad to get away from the "isolation" he felt in Calgary, he left and was succeeded by Illingworth Kerr, born in Saskatchewan but trained at the Ontario College of Art. Even in his brief stay Macdonald made an important contribution, and established life-long

friendships with Jim and Marion Nicoll and with Maxwell Bates.

Bates, born in 1906 in Calgary, was trained as an architect but he painted throughout his life. As with so many Canadian artists between the wars whose interests reached beyond art as a genteel accomplishment, Bates spent the early part of his career abroad. In the 1920s he was active in the Calgary Arts Club, the city's only real forum for artists, but he encountered conflict over his interest in showing abstract art—the Club had already been forced to operate in an informal, almost clandestine way after opposition to an attempt to introduce life drawing. Bates left Calgary in 1931 to travel in England and on the Continent. He was still in England when war broke out. He joined the army in 1939, was captured in 1940, and spent the rest of the war as a prisoner, returning to Calgary and his architectural practice in 1946. His return coincided with Macdonald's year of teaching at

the Provincial Institute of Technology, a period that began the strengthening of modern interests in the city. Bates became the focal point for these interests, the centre of what came to be known as "The Calgary Group," drawing its membership principally from teachers and recent graduates of the Provincial Institute. It was a group that included John Snow, best known as a colour lithographer, Marion Nicoll, Ron Spickett (fig. 113), and, before he left for Regina in 1954, Roy Kiyooka.

Bates had a personal but eclectic talent; the range of his work reveals references at many levels to the major modern European masters. Even before the war, however, he had been drawn towards German Expressionism, which remained the dominant, if not the exclusive, direction of his mature painting. It was a direction strengthened in 1949–50 by his year at the Brooklyn Museum Art School studying with the German Expressionist painter Max Beckmann and with Abraham Rattner. The approach of the German Expressionists—socially responsive themes set down with strong, often deliberately awkward drawing and rich colour, thickly and roughly applied—is reflected throughout Bates' career. His style varies considerably from a sophisticated version of modern modes to a child-like directness; from paintings of precise realism to dark and macabre works of figures hiding behind masks which yet reveal them (fig. 114).

Bates suffered a stroke in 1961. After his partial recovery he gave up his architectural practice and moved to Victoria where, in 1962, he began painting again. He was able to work for another sixteen years until in 1978 he suffered another stroke. He died two years later. The work of his last years shows no relaxation of the energy of his previous work.

In certain respects Bates' career represents a type for many artists of his generation. It is simple now to point to the sources on which he drew and show how the basis of his work was part of the *lingua franca* of modern painting that he

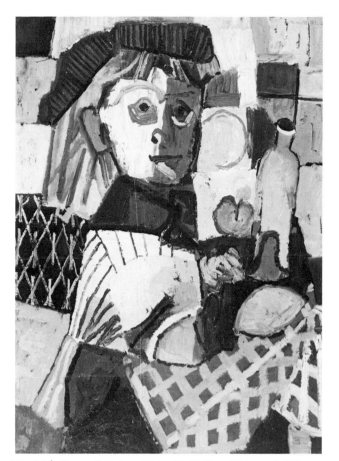

Fig. 114. Maxwell Bates. *Girl with Yellow Hair*, n.d. Oil on board. Glenbow Museum, Calgary.

adopted but did not invent. Artistic activity in the Calgary he left in 1931 and the city to which he returned in 1946 was severely restricted in both quality and quantity. With few exceptions the art being made was an amateur version of landscape and still-life subjects. From the start, Bates broke this pattern, working from illustrations of paintings and later studying the range of modern styles in the original. In his own work he sought an approach which was singular and imaginative; he produced paintings of a raw expressive strength, sometimes explosive, sometimes derivative, sometimes bad, but never dull.

Fig. 115. Marion Nicoll. *Prairie Farm*, 1968. Acrylic on canvas. 97.0 × 160.0 cm. C·I·L Inc.

Marion Nicoll's turn to abstract painting in the later 1950s was in itself a radical step.[8] Nicoll was an instructor at the Provincial Institute when Jock Macdonald taught there. She was deeply impressed by his notion of abstraction and began to make "automatic" drawings following his lead. Later she met the American artist Will Barnet, who led the Emma Lake workshop in 1957. Through his influence she began to paint formal abstractions (fig. 115) and the next year went to the Art Students' League in New York specifically for Barnet's classes. There is in this a certain innocence but at the same time a powerful and demanding drive, a drive to absorb the unprecedented notions and the instruction offered by Barnet. Artists like Bates and Nicoll may not, in the larger sense, represent the form of art history, but they are its fundamental material.

Regina and the Emma Lake Workshops

The development of modern art in Toronto and Montreal came about in an atmosphere of reactionary opposition. That resistance was strengthened by the fact that artistic traditions in those cities had established, even if on their own terms, a certain place for the visual arts in the cultural fabric. The introduction of the new was recognized on both sides as a matter of displacing existing modes, challenging not only the prevailing aesthetic but also opportunities to exhibit and to teach.

In the Prairie cities the situation was very different. The number of people actively engaged in the visual arts—no matter in what direction of interest or at what level—was limited and the audience proportionately small. Because there was no body of vested interests the younger artists in the 1950s had a freedom which did not exist in the East. Moreover, the developments in Abstraction and Surrealism and Expressionism, emerging a bit later than in the larger centres, were firmly part of the language of advanced art. In this context, a handful of young artists gathering in Regina in the 1950s established a climate of new art, the repercussions of which are still an active part of art on the Prairies.

In 1950 Kenneth Lochhead from Ottawa, then just twenty-four years old, was appointed director of the Regina College School of Art, a position he held until 1964. Two years later an exact contemporary of Lochhead, Arthur McKay from Nipawin near Prince Albert, became an instructor at the School. Lochhead had studied at the Pennsylvania Academy of Art and the Barnes Institute in Merion, Pennsylvania; McKay had studied at the Provincial Institute of Technology in Calgary (while Jock Macdonald was there), as well as in New York, Paris, and the Barnes Institute. Roy Kiyooka, born in 1926 in Moose Jaw, Saskatchewan, also attended the Provincial Institute, and was for a time part of the so-called "Calgary Group" centred around Maxwell Bates. After a year (1955) in Mexico at the Instituto Allende he too was appointed an instructor at the Regina College School. Douglas Morton, born in Winnipeg in 1926, moved to Regina in 1954. He was not associated with the College, for he worked full-time in a family business, but he was actively painting and closely involved with the other young artists at the College. Ted Godwin, born in Calgary in 1933 and another graduate of the Provincial Institute, moved to Regina in 1958,

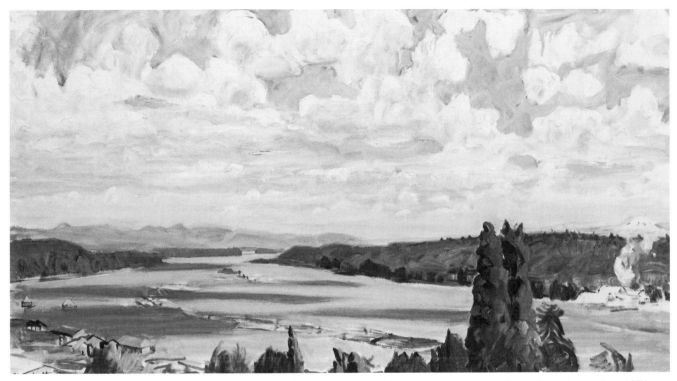

Fig. 116. Joe Plaskett. *Fraser River from Sapperton*, 1970. Oil on canvas. 68.6 × 114.3 cm. Gerald Schwartz, Toronto.

the same year that Ronald Bloore, then thirty-three, was appointed Director of the Norman Mackenzie Art Gallery established in 1953 at Regina College. Ron Bloore was both a painter and an art historian, a graduate of the University of Toronto and Washington University with additional study at the Fine Arts Institute in New York and the Courtauld Institute of Art in London. The seventh member of this circle, Clifford Wiens, was not a painter but an architect.

These artists were drawn together by their common interests in art and their determination to break through the isolation of the conditions in which they found themselves. If the College was the focus of their activities, the initiative to reach beyond it came with the establishment of the Artists' Workshops at Emma Lake, an initiative which has had profound effects on the shape and development of art in western Canada, particularly in Saskatchewan and Alberta. In 1936 the University of Saskatchewan assumed responsibility for the Emma Lake summer school, and Augustus Kenderdine remained its director until his retirement in 1947. Lochhead proposed that the summer school be extended to include a program in which working artists might meet under the leadership of a major invited artist. To spend two weeks with a major artist in an informal working environment would offer an opportunity for close contact with modern trends and ideas which never could have arisen, for example, on a brief trip to New York. The proposal was approved and in 1955 Jack Shadbolt led the first workshop. The second was led by Joe Plaskett (fig. 116), and then in 1957, at the suggestion of Shadbolt and George Swinton, an invitation was sent to Will Barnet of the Art Students' League in New York. Barnet's workshop set a pattern for

inviting group leaders from outside Canada, mostly from the United States.

For many artists the most significant early workshop was that of Barnett Newman in 1959. In itself the invitation was an act of foresight, because at that time Newman had not received in the United States the sort of recognition that was being accorded to other artists of the "First Generation Abstract Expressionists." The invitation came from McKay, acting Director of the School (Lochhead was away for a year) after discussion with Kiyooka and Bloore. Robert Murray, McKay, Bloore, Morton, Kiyooka, and Godwin have all attested to the importance of Newman's presence.[9]

The sense of excitement generated by Newman was sustained in the following year when Bloore organized an exhibition at the Norman Mackenzie Art Gallery of new work by Lochhead, McKay, Morton, Godwin, Clifford Wiens, and himself. Kiyooka, who had been closely associated with the others, had left Regina in 1959 for Vancouver and was not included. Richard Simmins, then Director of Extension Services at the National Gallery and Bloore's immediate predecessor as Director of the Norman Mackenzie, decided to put the exhibition on national tour, but he insisted on the exclusion of Clifford Wiens. It toured as *Five Painters from Regina*, and so it is the "Regina Five" (not the Regina Six or Seven) who have been written into the history of recent Canadian art. The importance of *Five Painters from Regina* lay not only in the national exposure it gave to the five individual artists, but also in the recognition it brought to an emerging contemporary scene on the Prairies. The purpose of Bloore's exhibition was not to assert the establishment of a group in an exclusive sense, but to make a statement of a particular approach to painting occurring in Regina at a specific moment in time. The name "Regina Five" and its repetition has tended to perpetuate a sense of exclusive unity and overlooks the contributions others— Kiyooka and Wiens for instance—had made to the

Regina scene and the much wider activity generated by the Emma Lake workshops. Further, this grouping of artists began to break up in the 1960s: Lochhead went to Winnipeg in 1964, Bloore to Toronto in 1965, followed by Morton in 1969. In 1982 Godwin moved to Calgary, leaving only McKay in Regina.

If Newman's visit in 1959 marked the real establishment of the Emma Lake workshops, the core of their direction and future influence came in the years 1962 to 1964, with the visits of Clement Greenberg, Kenneth Noland, and Jules Olitski. Barnett Newman declined Lochhead's invitation to return to Emma Lake in 1962, suggesting that Greenberg be invited instead. It was a significant choice, built on by the presence of Noland in 1963 and Olitski in 1964, and it established an orientation towards a particular modernist sensibility which, originating in New York in the early 1960s, continues to flourish on the Prairies, particularly in Saskatoon and Edmonton.

After his stay at Emma Lake, Greenberg wrote a long article in *Canadian Art* reviewing his impressions of the art he saw on an extensive, if rapid, trip across the Prairie provinces.[10] His concerns reflected, at least in part, his view of painting in the United States at that time, which he had made clear in various articles and was to codify in his major *Post-Painterly Abstraction* exhibition in 1964. It was a view opposed to the mannered expressionist painting of the successors to early Abstract Expressionists, the work he labelled "The Tenth Street Touch;" a view that identified a newly developing form of colour abstraction painting. The Greenberg visit also brought immediate results. One of the landmark exhibitions of the post-painterly, *Three American Painters: Noland, Olitski and Louis* was shown at the Norman Mackenzie in 1963 and two of the three Canadian painters Greenberg included in his *Post-Painterly Abstraction* show were Lochhead and McKay.

Of the painters whom circumstance had drawn together in Regina in the late 1950s, it was Ronald

Fig. 117.
Ronald Bloore.
Painting, 1960.
Oil on Masonite.
121.9 × 121.9 cm. Galerie
Dresdnere, Toronto.

Bloore whose work was the most resolved. His intellectual rigour and the clarity of vision that informed his work placed him in a special position within the group. In the catalogue of *Five Painters from Regina* he wrote of his work,

> I am not aware of any intention while painting with the exception of making a preconceived image function formally as a painting. By this I mean that the appearance of each work has been consciously determined in my mind before executing it, and the general concept is not significantly altered by the requirements of material limitations.[11]

In the context of North American painting around 1960, when free-flowing, intuitive expression through action was still painting's main currency, Bloore's rigour was striking and remains constant through the various series of works he was making, some with "an all-over, activated surface," others with what he described as "symbol-like elements" (fig. 117). His colour then, as now, was severely restricted: one, perhaps two colours in a painting and a predominance of white, so that in many paintings the image is formed by ridges of low relief which alone must carry shape and

Fig. 118.
Ronald Bloore.
Untitled, 1966.
Oil on masonite.
121.9 × 243.8 cm.
Norcen Energy
Resources Limited.

Fig. 119 (below)
Arthur McKay.
Microcosm, 1960.
Oil on masonite.
182.6 × 122.0 cm.
Collection Art Gallery
of Ontario, Toronto,
Purchase, 1982.

drawing and the articulation of light. The "symbol-like elements"—stars, sun/mandalas, arches, geometric shapes such as linked triangles—do not intend a specific iconography but are signs immediately recognized, and carry with them a long and venerable pre-history in art. By these he engages the traditions of marks and signs, recapitulating ancient vocabularies, not to present a specific content of mystery but to relate to the mystery contained in all men's attempts to come to terms with the world by setting down records.

Bloore's interests have always drawn him to the art of the distant past. He has often repeated the view that nothing worthwhile in painting has been done since Cimabue (the great thirteenth-century painter), asserting that what can be achieved fundamentally in painting had been realized by the beginning of the fourteenth century. His own paintings, from the earliest extant works to the more recent *Byzantine Light Series*, dwell on the radiance that can be achieved in painting (fig. 118).

The resolution apparent in Bloore's work between his approach to the activity of painting and the results achieved, was an important example to the artists around him. Art McKay's work around 1960, in particular, developed in important ways

Fig. 120. Ken Lochhead. *With Green Centre*, 1965. Acrylic on canvas. 208.0 × 203.0 cm. Art Gallery of Ontario, Toronto.

Fig. 121. Arthur McKay. *Untitled*, 1978. Enamel on masonite. 121.9 × 121.9 cm. Olga Korper Gallery, Toronto.

from his response to Bloore's work. At that time, apparently at Bloore's suggestion, he began to use enamel paints on masonite, applying the material and then dragging across or scraping the surface of the paint to leave a variety of thicknesses. His "all-over" pictures, like *Microcosm* (1960) (fig. 119), have an illusion of depth belied by the thinness of their surfaces. In 1961 he began to make paintings with a centralized circular form set into a square picture format. The paint in these was also scraped down to produce a thin but variable surface and the illusion of an indefinite but pervasive depth. While the circular, mandala-like shape has become the one by which McKay is best known (fig. 121), he has worked also with squares and rectangles, as if to draw attention to his concern with the autonomous formal activity of painting and away from the symbolic connotations of shape.

It has long been suggested that McKay's work has been linked with the use of hallucinogenic drugs. Simmins, in the *Five Painters from Regina* catalogue of 1961[12] referred to McKay's "deep interest in the controlled LSD and mescaline experiments [which] helped modify his vision and his understanding of the solitary individual living with the lonely crowd," leaving the impression of an effect on his work. Dennis Reid in his survey book on Canadian art in 1973 wrote that McKay "had been introduced to the hallucinogenic drug LSD and mescaline through the pioneering controlled experiments then being conducted at the University of Saskatchewan" prior to his year in New York in 1956–57, experiences that "would have opened for him the expanding yet effortlessly contained 'all-over' cosmic images of Jackson Pollock."[13] In 1974 Barry Lord in his history of Canadian art was even more explicit, suggesting that McKay's painted images were derived from, and their growth retarded by, the use of drugs.[14]

McKay has vigorously rejected Lord's statement on two grounds: first, that the essential point of departure for the work he began to make in 1960–61 came through his contact with Newman at the Emma Lake workshop of 1959, and, second, that his taking LSD occurred early in 1962, that is, *after* the launching of the *Five Painters from Regina* exhibition. Experiments undertaken at the University of Saskatchewan in relation to psychiatric and alcoholism treatments had begun in 1952–53 but had been reduced by the end of the 1950s. Drs. Hoffer and Blewett of the Psychology Department of the University of Saskatchewan in Regina, spurred, it would seem, by the interest generated by the *Five Painters from Regina* exhibition, invited artists to participate in experiments on perceptual change. McKay had been interested in hallucinogenic experiments for some years but his direct experiment with LSD occurred only in 1962 and had severe medical and psychological consequences from which he suffered for many years. In 1964 the use of LSD for experimental purposes was banned by the Federal Government.[15]

Kenneth Lochhead's early work was surrealist, with automaton-like figures set into a wide space, an approach strengthened by his move to Regina. "The prairie landscape," he has said, "became a fitting background for the arrangement of figures."[16] He was impressed by John Ferron, the American painter who led the Emma Lake workshop in 1960, and he began to turn to a freer, more abstract mode of painting, further influenced by the work of Franz Kline and Willem de Kooning (fig. 122). By 1962, however, he was working with flat areas of colour, a minimalist post-painterly abstraction. One of the finest of these pictures is *With Green Centre* (fig. 120), which, for all its flatness, retains a witty iconic character. In the early 1970s he made a series of airbrush paintings, impressive in scale and swift in the movement of colour, but lacking the joyfulness which is the real character of his work. In very recent years, Lochhead has returned to painting landscape representationally, making pictures that reflect his delight in vision and its transformation into oil paint. The work draws away from the ambition of "high art" in Clement Greenberg's sense—and Lochhead was impressed by Greenberg—but it is direct and truthful to the relationship between his art and his life. Nearly twenty-five years ago he wrote,

> Through my association with Regina painters, such as Art McKay, I have enlarged my scope of understanding that "expressive life can be beautiful." With this attitude I have happily, although often blindly pursued myself.[17]

In recent years Ted Godwin has also moved towards landscape painting. Of his work in 1960–61 he said that he was

> . . . exploring, finding and making a cohesive order out of the organic accidents that I have willed to take place on the canvas. While I have explored organised forms I find the naturally evolved organic forms have more meaning for me.[18]

From the looser abstract paintings of the 1960s he moved in the early seventies to what have been

Fig. 122. Ken Lochhead. *Minotaur*, 1960. Gesso and oil on board. 182.9 × 121.9 cm. The National Gallery of Canada.

described as "tartan" paintings, overlapping layers of vertical and horizontal colour bands transparently applied on a dark ground (fig. 123). They give an effect reminiscent of light flashing over the surface of water, an effect retained but made more explicit in Godwin's recent paintings of the tree-lined lakeshores of the North.

Roy Kiyooka and Doug Morton, like Art McKay, were also profoundly impressed by contact with Barnett Newman. Through the 1950s the more gestural activity of Kiyooka's work was

Fig. 123 (above left).
Ted Godwin
Red Shoo.
Acrylic on canvas.
200.7 × 185.4 cm.
Private Collection,
Toronto.

Fig. 124 (above right)
Douglas Morton.
Green, 1969.
Acrylic.
182.9 × 196.8 cm.
Private Collection,
Toronto.

Fig. 125 (below).
Roy Kiyooka.
Structure, 1958.
Duco on masonite.
121.9 × 182.9 cm.
Collection of the
Norman Mackenzie Art
Gallery, Regina.

134

Fig. 126.
Roy Kiyooka.
Thalassa Series, 1967.
Acrylic on canvas.
125.7 × 142.2 cm.
Norcen Energy Resources
Limited.

gradually reduced (fig. 125). A picture like *Relief Painting with Incised Circles* (1961), reminiscent of some of Barnett Newman's earliest paintings, is based on a slowly developing and contemplative sense of order, a juxtaposition of positive and negative forms as if cut from chaos. Through the early 1960s he developed a "hard-edge" but sensuous form of colour painting, as in *Thalassa Series* (1967) (fig. 126), that for all its precision retains a strong organic sense. His move to Vancouver in 1959 to teach at the School of Art was important for the development of painting in that city, in particular for the contemplative interpretation he brought to his appreciation of advanced painting in New York. He stayed six years in Vancouver before moving to Montreal, but later returned to Vancouver and turned away from painting to concentrate on photography.

In the 1960s Morton's work also moved from a looser, expressionist form to a hard-edge colour painting. But rather than being based on a dominant image or a simply divided field, his pictures were built up from series of flatly interlocking shapes engaging the whole pictorial field (fig. 124). It is in this form that he continues to paint, although since the late 1960s he has become increasingly engaged in teaching and administration, first at the University of Saskatchewan in Regina where he was Head of the School of Art from 1967–69, then at York University, where he remained until 1980 when he was appointed Dean of Fine Arts at the University of Victoria.

135

Emma Lake and Saskatoon

The stimulus of the Emma Lake workshops and the successful national identification of activity through the *Five Painters from Regina* exhibition had considerable impact on the development of the arts in Saskatchewan. Contact with major New York artists and the atmosphere of engagement in the development of serious new art drew artists to the province and introduced a level of professional activity rarely found in relatively small and isolated urban centres. Emma Lake became an important developing ground not only for those artists who lived and worked in Saskatchewan, but for many who have made their careers elsewhere. There was, however, in the later 1960s a shift in the centre of activity from Regina to Saskatoon; many members of the original Regina group had moved away by the end of the decade, and the University in Saskatoon took over administration of the Emma Lake workshops. The community of artists in Saskatoon, although small, has been and remains particularly strong and stable, a supportive community with a continuing diversity of work, even among the senior artists— William Perehudoff, Otto Rogers, and Eli Bornstein, (primarily abstract painters); Ernest Lindner, Reta Cowley, Wynona Mulcaster, and Dorothy Knowles (as representational artists).

The large-scale colour paintings by which Perehudoff is known are a development of the more recent part of his career. After study in Colorado Springs and at the Ozenfant School of Fine Arts in New York in the late 1940s and early 1950s, he returned to Saskatchewan to work as a commercial artist. He painted consistently, both landscapes and abstracts. His participation in the Emma Lake workshops, particularly those led by Greenberg and Noland, marked a turning point for him, and through the 1960s he experimented with a range of colour painting reflecting his respect for Noland, Olitski, and Bush, and seeking an independent statement. His best work is that which retains, even in abstraction, a sense of landscape, a transformation of the light and colour of the Prairie into an enveloping atmosphere articulated by slim horizontal or vertical elements (fig. 129). When the work loses that relationship it becomes too reminiscent of the formal structures of, say, Noland or Bush—the formal structures and not the expressionist tension that Bush developed in his later paintings when he challenged the conflict between the figure and its ground.

Landscape is also at the base of Otto Rogers' art, but his approach to it differs greatly from Perehudoff's. For Perchudoff there seems to be an attempt to mediate between the openness of landscape and the firmly bound, formal structure of the painting. In Rogers' pictures the distinction is sharply impressed; even in works where the references to the panorama of the Prairies and the height of the sky are openly descriptive, there is no ambiguity towards the emphatic painterly quality of the surface. His approach, in fact, is textural rather than atmospheric. The emphasis is on the "madeness" of the painting. He is concerned with the relationships between parts that, despite their diversities, must achieve unity. For Rogers the reference to the landscape is spiritual: the diversity of all the elements in the landscape, its different textures, is transcended by a unity which for Rogers is unequivocal. "I saw in this environment a part of the creation and without hesitation I loved its Creator."[19] As his view of the world is of its immanence, so his paintings hold the illusion of space through colour to surfaces emphatic in their material presence (fig. 130).

Greenberg, in his article on art in the Prairies, wrote, "Landscape painting is where Canadian art continues (excepting for Borduas, Bush and McKay) to make the most distinctive contribution."[20] This has traditionally been the case on the Prairies, its roots laid by artists like Kenderdine and A. C. Leighton, Inglis Sheldon-Williams and Walter J. Phillips, and continuing in the present with young artists who began as abstract painters and have turned to landscape. But if there is a continuity of tradition it is one that has been reinterpreted

through the experience of recent expressionist and colour-field painting. It was a reinterpretation developed first by established painters whose views were changed by contacts made at the Emma Lake workshops.

The doyen of painting in Saskatchewan is Ernest Lindner. Born in Vienna in 1897, he immigrated to Saskatchewan in 1926 and began to teach at the Technical Collegiate Institute in Saskatoon in 1931. He became head of the art department in 1936 and remained on staff until 1962. A fine and sensitive draughtsman, his approach to landscape was essentially traditional. But with his retirement from teaching, the freedom to concentrate full-time on his own work, and the spur of encouragement from Greenberg and Olitski, he has, in the last twenty years, produced the finest work of his long career. He has moved away from painting wide vistas to concentrate on the details of the Prairie landscape, on decaying tree-stumps and the denseness of the northern bush (fig. 127). At the same time what had been difficult before— social attitudes in Saskatchewan in his early career all but forbade the use of the nude model— became open and possible for him in the 1960s, and he has worked more frequently with the

Fig. 127. Ernest Lindner. *Fungi*, 1964. Tempera on board. 89.0 × 74.0 cm. C·I·L Inc.

Fig. 128. Wynona Mulcaster. *Prairie Pasture*, 1982. Acrylic on canvas. 88.9 × 144.8 cm. Collection of General Foods, Canada.

137

Fig. 129 (above). William Perehudoff. *Andante #2*, 1976. Acrylic on canvas. 139.7 × 297.2 cm. The Westburn Collection.

Fig. 131. Reta Cowley. *Untitled, September 27*, 1978. Watercolour on paper. 57.1 × 74.9 cm. Mr. and Mrs. H. Konopny, Toronto.

Fig. 130. Otto Rogers. *Light Above*, 1979. Acrylic on canvas. 152.0 × 168.0 cm. Rothmans of Canada, Ltd.

figure, often combining the nude figure with his closely observed landscape elements.

The more prominent form of landscape in Saskatoon—found in the work of Wynona Mulcaster, Reta Cowley, and Dorothy Knowles—derives from the traditional form of the wide vista, emphasizing the qualities of the Prairie breadth of land and height of sky. For Mulcaster and Cowley (fig. 128, 131) the more traditional approach to the landscape altered in the 1960s with a change of emphasis, from depicting landscape through paint to exploring the possibilities of the paint to make the landscape. Knowles, who has always painted landscapes as well as portraits and still-life, was, in the early 1960s, also making abstract paintings, paintings that, if current in their mode, were unsatisfactory to her. At the 1962 Emma Lake workshop Greenberg encouraged her to stop working in this way and concentrate on her landscapes. Subsequently Noland and Olitski advised her on a freer handling of paint, so that the monumentality of the subject is built through colour and texture rather than through the attempt to illustrate the vast and pictorially intractable Prairie landscape (fig. 132). Her success in particular has established national recognition for current landscape painting on the Prairies, giving strength to the development of the genre not simply as a tradition but as an active and valid definition of regional concerns.

Fig. 132.
Dorothy Knowles.
Sunlight on the Hills,
1967.
Acrylic on canvas.
146.0 × 177.8 cm
Private Collection,
Toronto.

Notes

1. J. Russell Harper, *Painting in Canada: A History* (second edition). Toronto: University of Toronto Press, 1977; p. 307.
2. See Christopher Varley, *The Contemporary Arts Society, Montreal 1939 – 1948.* Edmonton: The Edmonton Art Gallery, 1980; pp. 40 – 42.
3. *Miller Brittain — Painter.* Owens Art Gallery, Mount Allison University, Sackville, N.B., 1981; n.p.
4. *Jack Shadbolt: Early Watercolours.* Victoria, Art Gallery of Greater Victoria, 1980; p. 8.
5. *Jack Shadbolt,* Vancouver Art Gallery, 1969; p. 24.
6. Interview with the artist, Vancouver, 24 February, 1982.
7. Ted Lindberg, *Toni Onley: A Retrospective Exhibition.* Vancouver: The Vancouver Art Gallery, 1978; n.p.
8. Roy Kiyooka and Art McKay were both trained in Calgary. McKay left in 1949; Kiyooka in 1954.
9. See John D. H. King, *A Documented Study of the Artists' Workshops at Emma Lake.* MA Thesis, University of British Columbia, 1971.
10. Clement Greenberg, "Clement Greenberg's View of Art on the Prairies." *Canadian Art,* Vol. 20 (March / April 1963); pp. 90 – 107.
11. *Five Painters from Regina.* Ottawa: The National Gallery of Canada, 1961; n.p.
12. *Ibid.*
13. Dennis Reid, *A Concise History of Canadian Painting.* Toronto: Oxford University Press, 1973; p. 270.
14. Barry Lord, *The History of Painting in Canada. Towards a People's Art.* Toronto: New Canada Press, 1974; p. 10.
15. This information based on discussion with McKay in 1982 and on correspondence and documentation supplied by the artist.
16. *Five Painters from Regina,* n.p.
17. *Ibid.*
18. *Ibid.*
19. *Otto Rogers: A Survey 1973 – 1982.* Saskatoon: The Mendel Gallery, 1982; p. 36.
20. Greenberg, *op. cit.*; p. 98.

Sculpture in the Sixties

The development of modern painting in Canada has been conditioned by its short history, by the limited number of artists concerned with advanced art, and, until recently, by the narrow range of support in exhibition opportunities, in audience, and in progressive public and private collecting. Compared to sculpture, however, painting has been much better served. Any development in sculpture comparable in extent or quality to that in painting occurred only after 1960. Prior to that there had been very few sculptors of any substance. There was nothing that could really be considered to constitute a tradition, nothing either to follow or against which to react. Nor was there evidence indicating a real awareness of or interest in what had been occurring in European or American sculpture since the turn of the century. Few galleries were showing sculpture, and there was almost no discussion of sculpture in books or articles. Even in recent years there has been no general survey of sculpture in Canada comparable to surveys of painting in books by Russell Harper and Dennis Reid.[1]

What has happened in sculpture since 1960 has been substantial in range and depth.[2] The proportion of working artists who devote most or all of their activity to sculpture has increased substantially, opportunities to exhibit have expanded, and though major private collections of sculpture are still quite rare, public gallery collections of sculpture have grown, and commissions from corporations and public agencies have increased. Several factors occurring around 1960 contributed to the change of attitude towards sculpture. A number of artists who had begun their careers as painters started to make sculpture. In 1958 the federal government's Department of Public Works instituted a program to commission works of art, including major sculpture, for building projects across the country. In 1962 the National Gallery held a juried sculpture show, and a second followed in 1964. Among the few people determined to encourage the showing of sculpture, Dorothy Cameron in Toronto was a pioneer; the two-part show of sculpture at her Here and Now Gallery in 1964 and her organization of *Sculpture '67* for the National Gallery in 1967 brought public attention to the existence and the validity of new sculpture in Canada. The sculptural works commissioned for Expo '67 in Montreal further marked the legitimacy of new sculpture. The change in attitudes at the beginning of the decade were, in fact, noted by Robert Fulford, who began a 1963 article for *Maclean's*, "Whether they like it or not, Canadians will see a great deal more sculpture in the next few years than they've seen in the last few."[3]

In some ways the changes in sculpture since 1940 have been even more radical than have those in painting, to the point of invalidating previous definitions and assumptions. If painting has challenged its history and altered its form beyond recognition it has done so, in general, within the parameters of its frame and the flatness of its surface.[4] Sculpture, by its use of an almost unbounded range of materials, by its appropriation of industrial techniques, and by its redefinitions of sculptural space and the relationship between the object and its audience, has radically redefined the terms for its discussion.

The traditions of sculpture have rested on two fundamental approaches; the cutting and shaping of relatively dense materials such as stone and wood, or the moulding of a material—such as plaster—whose form is then transferred into a durable material such as bronze. But now wood, stone, metals, fabrics, plastics, fibreglass, and so on, may be cut, carved, sewn, assembled, tied, moulded, forged, welded, cast, thrown, nailed, glued, riveted, machined, or simply "found." This recent expansion of material and technical limits has cracked the traditional spatial codes. Sculpture has traditionally been *centripetal*, that is, a three-dimensional object of concentrated

material mass presented for viewing from one or more vantage points. Now the sculptural object may be broken open, spread, scattered, and extended, engaging space that can be walked into and through, not just around. Today, much sculptural work must be discussed in terms more usually reserved for architecture, landscape, or theatre. Now we must cope with and distinguish between sculpture and environmental art, site-specific work, and installations, even between sculpture and certain forms of painting. Sometimes the distinctions are difficult to make, sometimes the very character of the work renders the attempt invalid. Perhaps the most complex issue to be faced is the purpose of imposing a non-functional three-dimensional object into a world filled with manufactured functional objects. When sculpture was exclusively an object of material mass, and figurative in appearance, its point of reference was constant: it was inanimate and thereby distinct from human beings, but it was distinguished from other inanimate objects by its imitation of the human figure. The spectator established an immediate relationship to the figurative sculptural object through its likeness to himself. In non-figurative sculpture, the spectator must first reconcile the sculpture as an object related to other objects in the world. What is it? What does it do? Why is it there? Second, without being able to depend on simple responses to familiar appearances or iconography, he must recognize an expanded range of reactions to intellectual, to emotional, and to behavioural stimuli.

Many Canadian artists who developed as sculptors in the late 1950s and early 1960s began their careers as painters, and some have continued to work in both genres. Walter Yarwood, a member of Painters 11, only began to concentrate on sculpture around 1960; David Partridge and Henry Saxe were painters before working exclusively as sculptors. Ulysse Comtois, a member of the Association des artistes non-figuratifs de Montréal and associated in particular with the painters of *Espace dynamique*, also made his first sculpture in the 1960s and still works both as a painter and a sculptor. Similarly other artists, for instance Gerald Gladstone and Peter Kolisnyk, have continued to work both as painters and sculptors. Françoise Sullivan, who began to make sculpture in 1959, has followed a career of clearly marked periods when she has concentrated on particular forms of expression. Molinari, Tousignant, Bloore, and Town, known primarily as painters, have all made sculpture.

The classic case of the relationship between painting and sculpture in recent art is found in the work of the American artist David Smith, acknowledged as the most significant figure in sculpture since the war. Not only did he begin his career as a painter, but his sculptural work, in casting and welding, paralleled the surrealist and abstract concerns of radical American painting of the 1940s and 1950s. Later, with the *Voltri-Bolton* sculptures of found materials and the stainless steel *Cubi* structures, he came to establish not only the forms and techniques, but also the issues that have shaped so much of post-war sculpture. The freedom that marked Smith's work—and hence the freedom influential on succeeding generations—was developed as much out of the innovations in painting as from the traditions of sculpture itself.

By 1967, new sculpture's presence in Canada was both apparent and in some circumstances unavoidable. Dorothy Cameron's *Sculpture '67* took place on the plaza in front of Viljo Revell's new Toronto City Hall. She chose to present 54 artists from the 225 whose work she viewed; of those 54, well over three-quarters were making abstract pieces and were concerned, broadly, with the major current issues in international sculpture. It was the first time that such a range and scale of work, with its difficulties and demands, was brought into an open public forum— an indication of the remarkable change that had occurred in sculptural activity in Canada in a period of something less than ten years.

Fig. 133. William McElcheran. *Public Space*, 1981. Bronze. 25.4 cm high. Madison Gallery, Toronto.

Figurative sculpture continued through the 1950s and 1960s in the work of artists like Anne Kahane and John Ivor Smith, Elizabeth Frink, William McElcheran, George Wallace, and John Fillion. They expressed a determination for a continuing relationship with the long traditions of sculpture and for the meanings those traditions carried in humanist or religious terms. The religious aspect is explicit in Wallace's work, not simply in form but in the assertion of the relevance of those values and their traditions to contemporary society. McElcheran's work (fig. 133) expresses the relationship between the individual and the crowd. His suppression of individuality through an anonymity of appearance, and through the humour of the crowd's teeming and frantic clamour, reflects our desire for identity, our need to assert our individuality even in the depth of the crowd.

In more recent years there has been an upsurge of figurative work among serious sculptors, for instance in the work of artists like Colette Whiten, Mark Prent, and Don Bonham. But, even in abstract sculpture, the reference to the figure, if

Fig. 134. Louis Archambault, *Le second couple hieratique*, 1970. Prototype in plywood painted white. 381.0 × 93.5 × 52.0 cm.

way, in the extreme simplicity and geometry of Guido Molinari's *Hommage à Samuel Beckett* (1967) in an identification of scale and uprightness reflecting an individual awareness of our bodies' disposition in space. In both cases we are confronted by objects to which we are reconciled by reference to ourselves. But the *direction* of that reference is reversed. In Archambault's sculpture we give ourselves, as it were, *into* the forms we look at, in Molinari's we reflect from the forms an awareness of our own bodies.

As a member of Painters 11 Walter Yarwood contributed to the emergence of modern painting in Toronto in the late 1940s and early 1950s. From 1960 on he began to work exclusively in sculpture, transforming the freedoms that he had developed in his paintings into a concern with the potentials of materials in three-dimensional space. By 1965 he was making aluminum column pieces in a wide range of scales, casting and shearing and picking at their surfaces with acid (fig. 135). The contrast between the sharp geometrically formed aluminum blocks and the opening out of their masses by the acid relates, perhaps, to the attacking gesture of the brush on the canvas. But instead of working within the arbitrary shape of the canvas, in the sculptures the shape and scale of the columns are developed directly through the activity of working into the surfaces.

David Partridge, like Yarwood, turned away from painting to concentrate on sculpture, though the effect of his work remains much more explicitly pictorial than Yarwood's. He has worked with a particular technique—hammering nails into a piece of wood, sometimes sheathed in metal, to form relief structures in organized patterns with undulating surfaces. The varied relief patterns may be read as a reference to landscape, transformed through a "non-art" material into elegant designs. Partridge has developed considerable flexibility with the technique; his works range from small sketch-like pieces to massive structures such as *Metropolis* (1977) (fig. 136) in the Toronto City Hall.

not always the figurative, remains, although often interpreted in the broadest sense. It remains explicitly in the sculpture of Louis Archambault such as *Le second couple hieratique* (1970) (fig. 134); even with the extreme reduction of features and details there remains a certain sense of movement, a certain response to essentially human acts and relationships. It remains, in a very different

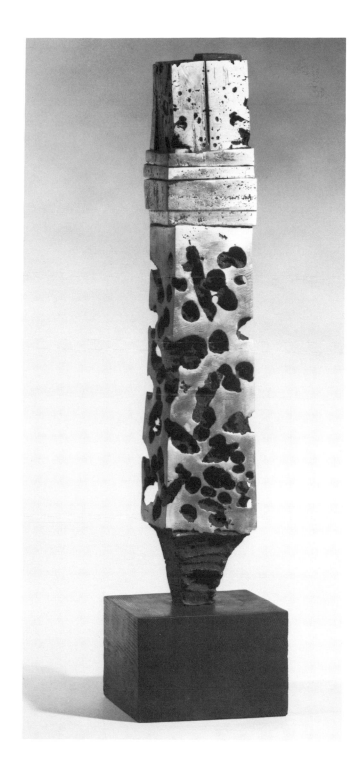

Gerald Gladstone, in contrast to Yarwood and Partridge, has continued to work both in sculpture and painting, in figurative and abstract modes, and in a variety of sculptural techniques, from cast figures somewhat reminiscent of the Russian sculptor Ossip Zadkine, to welded steel constructions (fig. 137) and metal forms cast into blocks of lucite. He has also undertaken a number of major commissioned works in Canada and abroad including, a twenty-eight-foot fountain sculpture, *Solar Cone*, for the Winnipeg Airport which stands as a companion piece to a similar scaled work by Walter Yarwood.

Ulysse Comtois is among the few members of the Association des artistes non-figuratifs de Montréal who have worked extensively as sculptors. His paintings followed the familiar pattern from automatism to more structured and rigorously abstract work of the later fifties while maintaining emphatic surface textures and "expressionist" forms even with their bands of colour. His first sculptures, done in 1960, were crude welded pieces; in 1964, these gave way to more unified forms, principally in wood and mostly painted. The painting, strong in colour and generally in bands or stripes, emphasized and developed the shapes of the forms. Soon after, he began to integrate surface design more fully with structure by making complex twisting forms from pieces of laminated wood, and by 1967 he had developed his most successful sculptures, the variably-shaped aluminum columns. These are sets of similarly shaped forms, packed on top of each other to form a column linked by a concealed upright member or members around which each element can rotate in a horizontal plane. The elements of the densely packed column can be moved into an almost endless sequence of variations; in *Column* (1967–68) (fig. 139) an upright member supports seventy stacked aluminum plates. These sculptures, similar to certain forms of the British sculptor Kenneth Martin, refer back to certain

Fig. 135. Walter Yarwood. *Tower*. Metal. 78.7 cm high including base. The National Gallery of Canada, Ottawa.

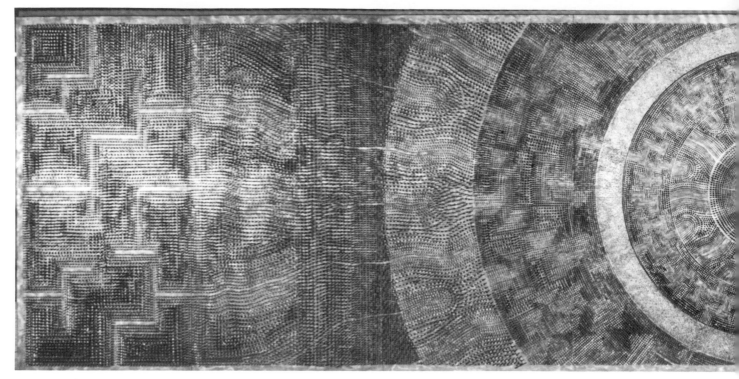

Fig. 136 (above). David Partridge.
Metropolis, 1977. Nails in wood. 228.6 ×
975.4 cm. Collection of the Corporation of
the City of Toronto.

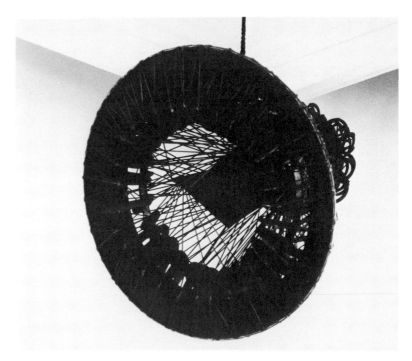

Fig. 137. Gerald Gladstone.
Welded Steel Sculpture, c. 1965. Welded steel.
58.5 (diameter) × 48.3 cm. (depth). Private
Collection, Toronto.

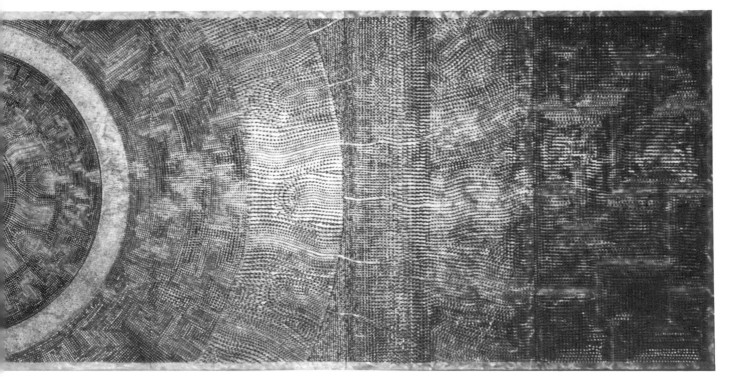

sculpture of the Russian Constructivists, notably Vladimir Tatlin and Alexander Rodchenko with their capacity to be moved into various shapes. Comtois worked on this type of sculpture for about seven or eight years, but by the mid 1970s he was once more concentrating on painting.

If Yarwood, Gladstone, and Comtois developed ways to make sculpture relate to contemporary developments in painting, Françoise Sullivan's work marked an interchange, in formal and dynamic terms, between painting and sculpture, dance and performance. She became part of the group around Borduas in 1941 when she was sixteen, and was one of those who signed *Refus global*. Her interests and studies were in both dance and the visual arts, though through the 1950s she concentrated on dance. She married Paterson Ewen in 1949 and by 1960 had had four young children, which curtailed her opportunities to continue professionally in dance. In 1959 she turned her interest to sculpture, studying first

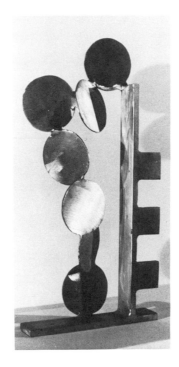

Fig. 138.
Françoise Sullivan.
Sans titre, 1966–67.
Aluminum.
53.5 × 27.0 × 5.0 cm.

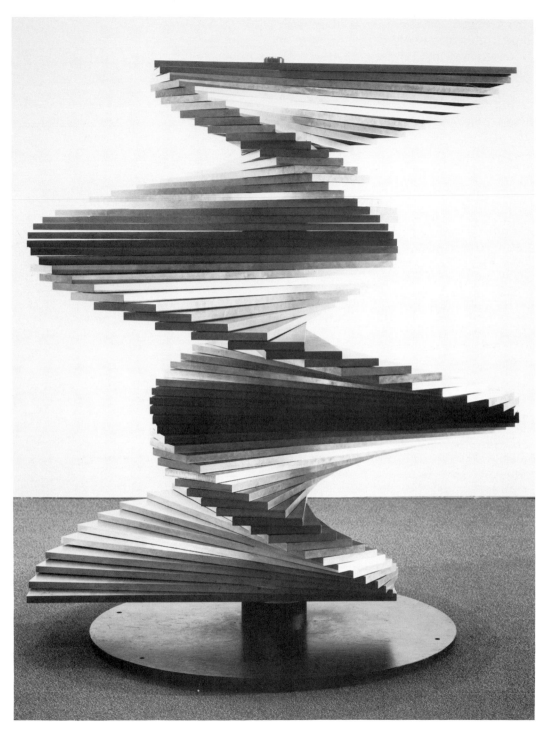

Fig. 139.
Ulysse Comtois.
Colonne 67–68, 1967–68.
Aluminum,
191.0 × 162.0 × 22.0 cm.
The National Gallery
of Canada, Ottawa.

with Armand Vaillancourt and then with Louis Ar-
chambault at the Ecole des beaux-arts. By the mid
1960s she was making elegant large-scale works in
painted welded iron and aluminum such as *Sans
titre* (1966–67) (fig. 138). In the late sixties she
started to use the transparency and flexibility of
plexiglass, as if to trace the movement of a figure.
The formal elegance and visual dynamics of her
sculpture seem like a transformation of the pat-
terns of movement in dance into metal and plexi-
glass. In 1970 Sullivan began to concentrate on
works that were conceptual in approach, ex-
pressed through documentation and perform-
ances reflecting her earlier dance events. In 1980
she began to make objects that combined, in a
sense, the whole range of her concerns—paint-
ing, sculpture, and performance (fig. 140). The
multidisciplinary interest that has dominated so
much art through the 1970s has been a constant
factor throughout Sullivan's career, but devel-
oped sequentially, subtly linked, and deeply re-
flective of the stages and course of her life.

Sullivan's work states, in a very personal way, the
relationship between abstraction and representa-
tion, a relationship held together by formal and
creative links, held apart by her moves from one
medium of expression to another. With figurative
sculpture accounting for a declining proportion
of the work made through the 1950s and 1960s,
the development of sculpture came, in general
terms, to be divided between the strictly abstract
and formal and the organic. It is a division whose
roots are traceable to the 1920s in the different
directions established on the one hand by the
Russian Constructivists and on the other by Con-
stantin Brancusi; the Constructivists with their
rigorous pursuit of pure abstraction, Brancusi
with his extreme and elegant simplification of
human and animal forms. It is a division whose
effects on sculpture have been incalculable in the
contrast between sculpture as a formed object
and sculpture as an additive, constructive proc-
ess. The sense of the formed object, at once

Fig. 140 Françoise Sullivan. *Tondo 7*, 1980. Acrylic on
canvas and stones. 174.0 × 214.7 × 96.5 cm. Canada
Council Art Bank.

through its shape suggesting organic existence
and by its material emphasizing its objective exist-
ence, is clearly shown in the sculpture of Robert
Hedrick. Hedrick, a painter as well as a sculptor,
studied at H. B. Beal Technical School in London
and at the Instituto Allende in San Miguel in Mex-
ico before settling in Toronto. He became associ-
ated with the artists of the Isaacs Gallery and first
exhibited there in 1960. His bronze sculptures
maintain a fine tension between a swelling or-
ganic shape and a hard, polished surface (fig. 141),
between the tactile and sensuous attraction of the
form and the reflective qualities of the surface that
further soften and visually expand it.

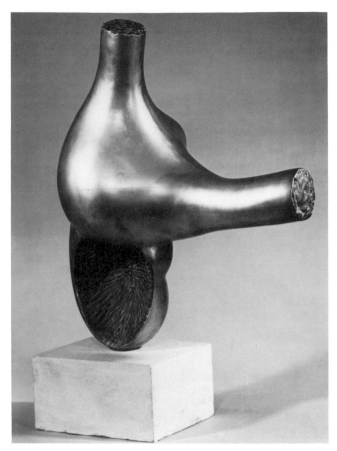

Fig. 141. Robert Hedrick. *Bronze Torso*, 1965. Bronze. 49.9 cm. high. The National Gallery of Canada, Ottawa.

This organic sense in a swelling form, stretching the tension between inside and outside, is even more explicit in Arthur Handy's *Aphrodite Yawns* (1967) (fig. 142) where the sexual connotations of the work are united in the most direct and simple way to sculptural form as an enclosure of space. Handy moved to Toronto from New York in 1960 and has worked principally as a ceramicist. He began a series of ceramic sculptures on the theme of *Aphrodite Yawns* in the mid sixties, culminating in the ten-foot-diameter fibreglass-and-polyester-resin version of 1967.

The sense of the organic is also central to the work of Maryon Kantaroff and Sorel Etrog, in Kantaroff's work through the sense of natural growth, in Etrog's more in the notion of the armature of the body and its movement. Etrog first showed his work in Canada at Gallery Moos in 1959; for a time he maintained studios in Toronto and New York, but settled permanently in Toronto in 1963. From his base in Toronto he has undertaken a wide range of public and private commissions in this country and abroad. His works, in a variety of materials but most characteristically in bronze, are abstractions reflective of the human figure, birds, or totem-like structures (fig. 143). One of his most frequently used formal devices is the "link" that he developed in 1964 as a means to suggest both the joining and articulating of the elements in the sculpture. It combines both the sense of a skeletal structure of bones and joints and a machine-like character of connecting rods and hinges, drawing a parallel between the organic appearance of the image and the process of its manufacture in metal. This parallel and its ambiguity remain even in his most recent and more rigorously abstract steel sculptures, soaring geometric planes linked by giant hinges

Much sculpture, even in abstract form, is a metaphor for the human body. But human form is only one aspect of a vast range of imaginative and poetic metaphors for space and our relationship to it, something which Gaston Bachelard has described in his brilliant study *The Poetics of Space*.[5] In a number of respects Bachelard's analysis could stand as a text for the work of Tony Urquhart. Urquhart held his first show, of paintings, at the Greenwich Gallery in 1956, while he was still a student at the Albright Art School in Buffalo. From the start his subject matter was drawn from landscape. When, in the mid sixties he began to concentrate on sculpture, landscape still remained the essential point of reference, even when in a piece like *Broken III* (1967), the form is wholly abstract. In this work tension is developed between the "pure" form of the circle and its breaking, with a clear-cut edge on one side and a

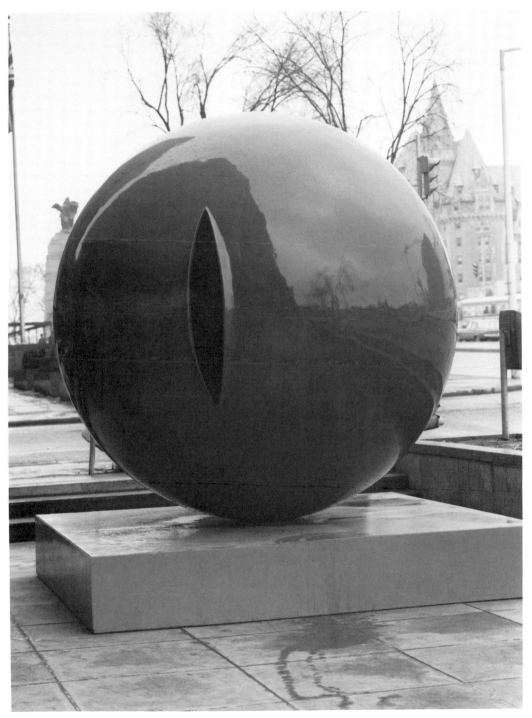

Fig. 142.
Arthur Handy.
Aphrodite Yawns.
Fibreglass and
polyester resin.
304.8 cm. diameter.
The National Gallery
of Canada, Ottawa.

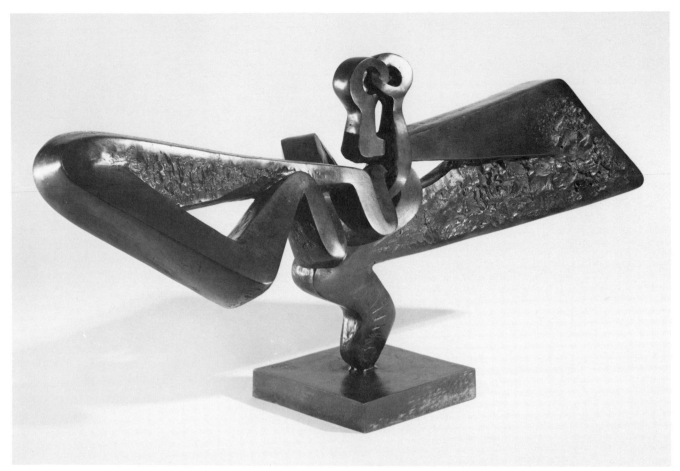

Fig. 143. Sorel Etrog. *Flight No. 1*, 1964. Bronze.
40.0 × 84.8 × 22.2 cm. Collection Art Gallery of Ontario,
Toronto, Gift of Sam and Ayala Zacks, 1970.

jagged one on the other. Urquhart described this
piece in landscape terms;

> There's that unexpected tear in the tidy outline;
> the creeping encroachment of landscape relief
> onto one geometric surface; the strong suspicion
> that nature, not man, is getting the upper hand![6]

In 1965 Urquhart began to develop box-like
sculptures, the first of which were simply blocks
of wood on which he painted landscape scenes.
Beginning in 1967 he began to make boxes with
doors that opened and elements that unfolded,
forms suggested to him in part by German altar
retables with their complex structures of paint-
ings, carvings, and hinged panels. Over the years
the boxes have become increasingly complex,
often with several sections opening to reveal a
variety of painting, textured elements, and addi-
tional materials (fig. 144). Their capacity for multi-
ple arrangements allows for shifting relationships
between one face and another, and between the
connections of inside and outside. The sculptures
develop a network of associations: the secrecy
and evocative character of boxes; revelations of
hidden interiors; the poetic linking of landscape
as exterior space and as inscape; the range of the
imagination, like the vastness of landscape being

held in the miniature construction of the box. A spectator might recall two lines from Noël Bureau's *Les mains tendues*,

He lay down behind the blade of grass
To enlarge the sky.[7]

Psychologically Urquhart's poetic imagination is timeless, but his sculptural approach is eccentric to the look of "mainstream" sculpture of the sixties and seventies. That look was abstract and formalist, the characteristics of the work of a wide variety of sculptors, for instance Hugh Leroy, Hayden Davies, Nabuo Kubota, Robert Murray, Robert Downing, and Kosso Eloul. The most determinedly formalistic direction comes from artists who have followed the constructivist theories of Charles Biederman, whose particular version, which he called "structurism," was exhaustively argued in his 1948 book *Art as the Evolution of Visual Knowledge*.[8] The most consistent advocate of structurism in Canada has been Eli Bornstein in Saskatoon (fig. 145), whose interest was developed by his first reading of Biederman in 1954. Structurist theory transcends distinctions between painting and sculpture and architecture to reflect idealist principles of culture and civilization. Bornstein has, through his teaching and writing, influenced a number of artists, including Ron Kostyniuk, to follow the structurist approach. Others, such as Gino Lorcini, came independently to espouse Biederman's ideas.

For Robert Downing and Kosso Eloul the nature of sculpture centres on the description of spatial volume through units of form. Downing has described his work as an investigation of the cube, a spatial unit to be cut, arranged, rearranged, and implied in the structuring of space through sculpture. Kosso is one of the best known and most experienced sculptors working in Canada. He studied in Tel Aviv and Chicago and served in the U.S. Navy and Israel's Haganah. He first exhibited in Canada, in Montreal, in 1964 and settled in this country that year, moving to Toronto in 1969. He came to Canada as an already

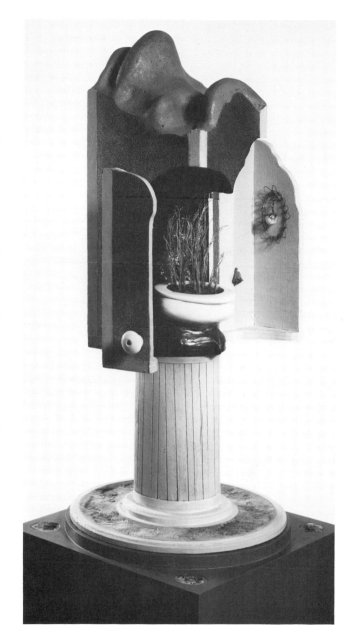

Fig. 144. Tony Urquhart.
Haven, 1975.
Mixed media on plywood.
81.3 × 35.6 × 35.6 cm.
Collection of the Artist.

Fig. 145. Eli Bornstein.
Double Plane Structurist Relief No. 8, 1969–72
Enamel on plexiglass and aluminum.
43.2 × 43.2 × 27.0 cm. Collection of the Artist.

154

mature artist with a long listing of international exhibitions behind him. He has continued to exhibit widely and has undertaken many major commissions in Canada, the United States, and Israel. His characteristic work consists of box-like units of painted or stainless steel, polished aluminum, and stone. The blocks are joined to one another, often at eccentric angles and in visually gravity-defying arrangements, an edge to a plane, one unit precariously balanced on another. Their unitary formation exhibits a strict modernism, but a cheerful disregard of the inherent logic of their structure and a delight in disorienting the spectator's expectations of objects in space. *Zen West '80* (1980) (fig. 146), was made for a sculpture competition at the Hakone Open Air Museum in Japan. It exists in an edition of two, one of which is in the collection of the University of Toronto.

Kosso and Sorel Etrog are unusual figures on the Canadian sculptural scene in that they began

Fig. 146. Kosso Eloul. *Zen West*, 1980. Stainless steel. 304.8 cm. high. Hakone Open Air Museum, Japan.

Fig. 147. Robert Murray. *Haida*, 1973. Cor-ten steel painted blue. 2.74 × 7.0 × 2.74 m. Department of External Affairs, Ottawa.

working here on a strong base of experience and exhibitions. For the majority of sculptors in the 1960s sculpture had not been a substantial part of their visual background or their training. The result was an explosion of activity, a rapid development in the quality and quantity of work, but little in the way of ground-breaking originality. The principal exception to this—an exception that has become less isolated through the work of sculptors whose careers were developing in the later 1960s—is Robert Murray.

Born in Vancouver in 1936, Murray studied at the University of Saskatchewan in Regina and at the Instituto Allende. Most significant, however, was his attendance at four of the Emma Lake workshops, in particular the one led by Barnett Newman in 1959. Newman offered him an assistantship and he moved to New York in 1960. He began as a very young artist, under Newman's guidance, to work immediately on non-referential large-scale public sculpture. His first commission in 1960, was for a piece to be installed at City Hall in Saskatoon. It brought him immediately to face the issues of sculpture in relation to architectural settings; to avoid the fate of so much recent public sculpture which either seeks to approximate itself to the architecture, or to "humanize" the architecture by contrasting with it. Murray's public sculptures—the Saskatoon commission has been

followed by many others in Canada and the United States—have the visual weight to stand with the architecture of steel and glass monoliths. Asserting their freedom and independence through contrasting planes, their discipline of viewing angles and shapes sustains and indeed guarantees their integrity as sculpture.

Murray's work through the 1960s and early 1970s was principally composed of sharply angled forms and flat, open planes of steel. In the early 1970s he began to use steel with an increasing degree of flexibility; large curved planes developed along with the flat ones, as for instance in *Haida* (1973) (fig. 147) installed outside the Department of External Affairs building, Ottawa. These curving elements have become increasingly more radical; plates of steel or aluminum bending in waves. His sculptures are invariably painted, often in reds and blues, with a hard, smooth surface which gives the mass of a work a strong visual unity, despite the environment and the contrasting shapes of the sheets of metal. In the more recent works, with their complex and shifting shapes (fig. 148), the colour becomes a way both to hold the unity of the mass and to open out the range of formal interest by the cast shadows and the subtle changes in colour warmth and tone.

Fig. 148. Robert Murray. *Kodiak*, 1975. Aluminum painted sienna. 209.5 × 505.4 × 270.5 cm. Courtesy Klonaridis Inc.

Notes

1. J. Russell Harper, *Painting in Canada: A History,* Toronto: University of Toronto Press, 1966; Dennis Reid, *A Concise History of Canadian Painting,* Toronto: Oxford University Press, 1973.
2. It is proper to note the contribution made by Mr. and Mrs. Spenser Clark who founded *The Guild* in Scarborough, Ontario, in 1932 with an ongoing commitment to support and encourage artists with a particular interest in sculpture and architecture.
3. Robert Fulford. *Maclean's* Vol. 76, no. 16 (24 August 1963) p. 23.
4. We realize, of course, that painting can be viewed not simply as a technique but as a strategy towards art-making and that the terms of painting can be extended well beyond the traditional terms that have defined it. Our point here is to make the comparison in relation to sculpture in its traditional terms.
5. G. Bachelard, *The Poetics of Space,* (1958) Boston: Beacon Press, 1969.
6. *Sculpture '67* Catalogue p. 40.
7. Bachelard, *op. cit.* p. 169.
8. Charles Biederman, *Art as the Evolution of Visual Knowledge,* Minnesota: (privately printed) 1948. Biederman's "structurism" is to be distinguished from the methodology of "structuralism" more recently developed, particularly by Claude Lévi-Strauss for a wide variety of cultural analyses.

Representational Painting

The terms *realism* and *representation*, as they are applied to art, are often used interchangeably. The results can be misleading or confusing, particularly as in other contexts the words carry quite distinct meanings. Representation describes the act of representing in some form an idea or an act of vision; realism has more abstract connotations, not only in art but in many aspects of life, and has familiarly come to imply the validity of a particular point of view.

Realism in art has been and continues to be a matter of context and a matter of perspective. Realism can be claimed for the gestural painting of Abstract Expressionism, in that it is a statement of the direct relationship between the artist's real, intuitive act and the unified pictorial results he produces. Minimal art—itself a rejection of Abstract Expressionism—can claim realism for its emphasis not on the act but on the fact of the art object. And in more recent years the increasing interest in representational painting—based on a common-sense vision of objects in the real world—has not only reclaimed the term *realism* for itself but has spawned a tankful of sub-realisms. The American critic, Gregory Battcock, in a 1975 book, lists, "Realism Now, Sharp-Focus Realism, Photographic Realism, New Realism, Hyper-Realism, the Realist Revival, *il nuovo realismo*, Separate Realities, Paintings from the Photograph, Radical Realism, Aspects of New Realism, Figures/Environments, Imagist Realism," to say nothing of the term "Super Realism," the title of the book of essays he was editing![1] This very proliferation of terms points, at best, to the variety of work being produced. At worst it is a mark of the trap of confusing representation and realism.

The mainstream of art in recent years has been largely directed into various forms of abstraction, or non-representation, or the non-referential (themselves notoriously unreliable terms, so susceptible to hair-splitting). But there has always been a consistent current of art that has dealt with direct allusions to objects in the natural world. And what, until a short time ago, was often dismissed as *rétardataire* and set outside the contemporary mainstream, is now being accepted more readily as part of the repertoire of new art. This recent enthusiasm for the representational reflects in part simply the fashion of the new and in part a renewal of reactionary sense of relief that the longed-for return to sanity may at last have come. Since the beginning of this century, a succession of art writers and artists have sought signs of a turn from the excesses of the avant-garde to the stability they assume to reside in representational art. But the notion that we are now "getting back to" representation is a false one, for every new form, no matter how it may refer to the past, adds to the complexity and fragmentation of the present. The influence, for instance, of photography, the movies, and television has radically changed the way that we view images and the references to the natural world they carry for us. And while judgements on the quality of formal abstract art are contained in our understanding of its own history, in representational art the arbiter of quality appears to lie outside the work, based on the accuracy of its approximation to the natural world. What is less readily recognized is that our standards of what is representational are continuously undergoing change. Witness our ready acceptance of the Impressionists' vision of landscape, against the shock it produced in audiences of the 1870s.

In Canada, recent practice of representational painting has been seen to centre on the Maritimes, with artists such as Alex Colville, Christopher Pratt, Mary Pratt, and Tom Forrestall. This, however, is too restricted a view, as shown by the work of Ernest Lindner in Saskatoon and Ontario artists such as Jack Chambers, Ken Danby, D. P.

Fig. 149. Hugh MacKenzie. *Holiday*, 1965. Egg tempera on board. 40.6 × 66.0 cm. Imperial Oil Limited.

Brown, Hugh MacKenzie (fig. 149), and, amongst young painters, Jeremy Smith (fig. 150) and Richard Robertson (fig. 151). The work of all these artists is characterized by immediate references to the natural or everyday world, and by a meticulous and sharply focused technique. But at this point the similarities end. The relative and differing strengths of all those artists lie not in their adherence to a single interest or aesthetic but in their individuality.

Alex Colville's work occupies a very special place in the context of contemporary representational painting. His importance has been widely acknowledged both in this country and abroad, bringing one leading German critic to call him "the most prominent realist painter in the western world."[2] Through his teaching and the example of his work he has had a significant influence on a number of the other realist artists; Christopher and Mary Pratt, Tom Forrestall, D. P. Brown, and Hugh MacKenzie, for instance, were among his students.

His work brings a particular but direct vision to the issues of life and death, to inter-personal relationships, to human concerns in the context of the worlds of nature and of animals, and to reflection on the responsibilities of civilized life. All of these are presented through Colville's close attention and attachment to the people and places he knows best, to his family and the places in which he has lived. These constitute the reality of his own life, and in turn form the basis for his observations and interpretations.

Born in Toronto in 1920, Colville moved with his family to Amherst, Nova Scotia, in 1929. His adult life has been spent in the small university towns of Sackville, New Brunswick, and Wolfville, Nova Scotia. He studied with the English post-impressionist painter Stanley Royle at Mount Allison University in Sackville, and returned to teach there after wartime service in 1946, remaining on staff until 1963 when he resigned to devote

Fig. 151 (above). Richard Robertson. *Shell and Cloth on Table*, 1982. Graphite and watercolour on paper. 104.8 × 80.0 cm. Private collection, Toronto.

Fig. 150 (left). Jeremy Smith. *Young Woman in Doorway*, 1982. Egg tempera on board. 172.7 × 78.7 cm. Private Collection, Sarnia, Ontario.

Fig. 152. Alex Colville. *June Noon*, 1963. Acrylic polymer emulsion. 76.2 × 76.2 cm. Private Collection, Düsseldorf.

himself full-time to painting. Colville had joined the army in 1942; in 1944 he was appointed an Official War Artist and spent the next year and a half in Europe. This experience was a profound one, shaping the fundamental issues on which his subsequent work has been based. In particular he recognized that although he was a witness to human and material destruction on an unprecedented scale, he was yet, by his work, separated from it. He was an observer immersed in experience in the only way he, or any of us, can know; "I and only I am experiencing this."[3]

The process of Colville's work is slow and precise. The initial idea for a picture, sparked, perhaps, by the pose of a figure, a setting, or a simple action, is set down in rough sketches, but it may be five or ten years before the sketches are transformed into a painting. When he decides to proceed, Colville invariably begins with a precise geometric plan, from which the picture's space and the poses and proportions of the figures are

determined. A further, often extensive, series of drawings follows, fixing in detail the disposition of the elements to be included. The geometric plan, appropriately scaled, is transferred to a pressed-wood board and the painted surface gradually built up to the final layers of small, precisely applied strokes. He has used a variety of techniques, including casein tempera and oil, but since 1964 he has worked exclusively with acrylic paints.

This long process is one first of withholding, then of authenticating; an idea is allowed to build slowly in the artist's mind and is then pursued with rigorous attention to detail. Through this process the image goes beyond being simply a record of an observed scene, to being a highly selective conceptual structure, a fact underlined by its emergence from the abstraction of its geometric plan. What at one level can often be described in simple terms, is revealed as a complex reflection on fundamental issues of existence. Compare, for instance, two pictures, separated by eight years, which bear on the same theme—the relationship between a man and a woman: *June Noon* (1963) and *January* (1971) (fig. 152, 153). The paintings are contrasted in season and setting, winter and summer, inland and seashore. They each contain the figures, male and female, turned away from each other, engaged with and attentive to their own concerns. The figures occupy contrasting positions in space, one close to the picture plane, one distant, but in both pictures the man is on the left, the woman on the right. Despite their separation, however, the relationship between them is strong; our attention to the figures reduces the distance between them. Colville, in subtle ways, brings them together; the line of sight between the figures in *June Noon* passes through the open flap of the tent, as if the man had just stepped out; in *January* the snowshoe tracks imply that the two figures were, at one point, standing together. The paintings bear on the fundamental relationship between a man and a woman. Colville has spoken of how the closeness

Fig. 153.
Alex Colville.
January, 1971.
Acrylic polymer
emulsion.
60.9 x 81.2 cm.
Collection Toronto
Dominion Bank.

and integrity of a relationship is based on the recognition of each other's individuality and the responsibility to care for that individuality. Separation here does not indicate indifference, but the value of difference. The figures (as so often in his work) are based on his wife and himself, but if the pictures refer, as they must, to his circumstances, their statement is universal.

Another issue—one brought home to Colville through his war experiences—is that an observer of events can never wholly be at one with his surroundings, but is alienated by his or her observation. The very precision of his work and, ironically, the fact that its precision removes the scenes from a narrative flow of time, drives home this point. This alienation has often caused Colville's work to be described in terms of threat, of a sense of an apprehended disaster. His frequent use of animals as subjects contrasts their simple

acceptance of the world with our unease. In *Dog and Bridge* (1976) (fig. 154) we feel menaced by the dog walking towards us, but the menace lies wholly in *our* minds, it is we who project our unease into the dog's intentions. "The idea," he has said, "of a bad animal is absolutely inconceivable to me, unless it has been driven crazy by people."[4] Colville originally planned this composition with a seeing-eye dog leading a blind man, a relationship in which the dog's presence would be interpreted sympathetically. Eliminating the blind man transfers the handicap to us, making us, as it were, blind to the intentions of the dog. Although we inhabit the same space as animals, we are essentially ignorant of their world.

We are in fact, beset by unnamed fears, a point made in Colville's picture *Berlin Bus* (1978) (fig. 155). The scene is, at first sight, banal—a girl running for a bus—but somehow such a descrip-

Fig. 154. Alex Colville. *Dog and Bridge*, 1976. Acrylic polymer emulsion. 86.3 x 86.3 cm. Mr. and Mrs. J.H. Clark.

tion does not fit. The girl seems out of place in the urban setting, her running action exaggerated, even frantic, against the apparent calm and solidity around her: the houses, the smooth movement of the bus, the notary's sign, the precisely rendered mosaic of the sidewalk. It is a nightmare in which the girl alone is aware of the illusion of stability around her. The picture is based on sketches made in Berlin in 1971, during Colville's first visit to Germany since the war, and carries a specific political and historical content as well as a personal one. Berlin, once the centre of Nazi power and the focus for its destruction, is now a symbol of the conflict between the East and the West.

Colville's work has often, but misleadingly, been described as "magic realism." Originally "magic realism" was used to describe a particular form of post-First World War German painting, the work of artists like George Grosz and Max Beckmann with which Colville's paintings have no real connection. And "magic" seems an inappropriate description for work that, drawn di-

Fig. 156 (above). Christopher Pratt. *Window with a Blind*, 1970. Oil on masonite. 121.9 × 60.9 cm. Norcen Energy Resources Limited.

Fig. 155 (left). Alex Colville. *Berlin Bus*, 1978. Acrylic polymer emulsion. 53.4 × 53.4 cm. Private Collection.

rectly from the circumstances of the artist's own life and reflecting his response to the reality of the world, touches the experience of us all.

To the extent that the bases of Colville's images are drawn from the circumstances and places and people of his own life, his work can be thought of in regional terms, as a response to his own time and place. But if his personal attachment is to a particular locality, his approach to his subjects transcends the personal and the regional. This must be stressed in relation to the loosely-used description of a "school" of Maritime realist painters. The principles and the sources for the development of Colville's art were not indigenous but stemmed from his appreciation of certain American realist art, the work, for instance, of Thomas Eakins and Edward Hopper. Colville has, of course, been an important inspiration for many younger artists, but the value of their work lies in its independence, not in any adherence to a common style, or even a common purpose. In essence, Colville's work does not permit followers—only imitators. The best of Colville's students are those who have developed approaches quite independent of his, both in purpose and technique.

When Christopher Pratt was at Mount Allison with Colville he was already, through his previous training and work, an accomplished painter with a clear personal style. The strong geometry of his compositions and their cool, detached tones have often—wrongly—been closely linked with Colville's work. Setting aside the differences of personalities, interests, and priorities, there is still a crucial distinction in their approaches. In Colville's work the essential character of the images exists in the spectator's sense of identity with a consciousness inside the image; the spectator is drawn into, almost literally projected into, the image. In Pratt's work the spectator's position is at the edge of the observed world, held away from it by its very structure. The tightness of his constructions, with their grids of horizontals and verticals, holds us at the picture's entrance. Even

when he includes a figure, the compact drawing and the atmosphere of quiet self-absorption make no gesture towards the spectator's presence. And whereas Colville's pictures always have a human or animal subject, Pratt's are often of architecture alone, a matching of representational and pictorial structures. Colville's work is centred on an often uncomfortable ambiguity between the observer and the observed, Pratt's on a sharp separation between the observer's world and the illusory world of the picture. A picture like *Window with Blind* (1970) (fig. 156) constructs contemplative pleasure through simple objects and their relationships to one another: a radiator and a window, a solid closed form and an open transparent one, a contrast between a sense of warmth and of coolness. In *Woman at a Dresser* (1964) (fig. 157) the enclosure between the figure and her surroundings dominates any sense that we, as spectators, are part of the picture's world. We see a reflection of wallpaper, rather than of a doorway or window that would hint at a means of access into the picture.

In Christopher Pratt's work the objects, even in their illusion of three-dimensionality, are sealed into an unyielding surface, in which not even the play of light and shadow is allowed to compromise its geometry. Mary Pratt, in contrast, is attracted precisely to the surfaces of objects, to their textures, to the fall of light, to the scatter of colour. She takes as her subjects the details of everyday life, objects around the home, a table ready for a meal, baked bread, a salmon lying on plastic wrapping as in *Salmon on Saran* (1974) (fig. 158). She has said, "I paint objects that are symbolic of nothing except a very mundane life. I am not moved, when I see them, by their moral or social implications, and nostalgia simply irritates me."[5] Through her concerns with the routine of daily life, the need to deal with the facts and practicalities of living, she rejects the unthinking and hypocritical assumptions about dealing with things "in depth;" "All these solemn 'in depth' people,...polishing up their own surfaces—

Fig. 157
Christopher Pratt.
Woman at a Dresser,
1964.
Oil on board.
67.0 × 78.0 cm.
C-I-L Inc.

dressing to be recognised for whatever ideas they had adopted."[6]

She works—as many artists now do—from photographs, in her case from coloured slides. Hers is a type of painting that has been called "pictorial phenomenalism,"[7] an approach similar to that of the contemporary American painters Audrey Flack and Janet Fish. Its essence lies pictorially in the emphasis of light on the surface of objects, an approach that recognizes reality in the immediate visual contact with objects. To paint that is to represent the primacy of that contact and affirm its reality. The use of the photograph is a confirmation of that immediacy, a way to see objects not first in a conceptual sense—how we use them and how we understand their use—but

rather as they are in their visual immanence, that is, as the direct embodiments of our perceptions.

Mary Pratt's paintings are the result of a sharply focused concentration on the details of immediate visualization. Her narrowing and intensification of vision contrasts with James Spencer's broad-ranging monumentality of subject and scale. His paintings of the Rocky Mountains, (like *Mountain* (1981) (fig. 159)) or the seashore are impressive representations of the vast and intractable elements of nature, the essentially unconquerable aspects of a socially and psychologically shrinking world. An approach to landscape painting with this grandness and on this scale recalls the American sublime landscape painting of the nineteenth century by artists like Thomas Cole

Fig. 158. Mary Pratt. *Salmon on Saran*, 1974. Oil on board. 45.7 × 76.2 cm. Private Collection.

and Frederic Church, but those painters sought through the exaggeration of scale and natural effect to project the New World as the new Eden. In Spencer's paintings there is no straining after effects; they are simple statements of nature's presence, a reminder of its power set in pictures whose own great scale diminishes us and humbles us.

Mary Pratt's use of photography is an empirical means of holding a moment of experience. Her paintings are made to value that moment, not as a suggestion of fantasy or of narrative, but simply for itself. Writing of photo-realist art, the American critic, Linda Chase, has said,

> Photo Realist painting is seeking to re-value things, and though it may appear that [the artist] is devaluing the traditions of art and the role of the artist, . . . it should be clear that he is rather re-evaluating these in terms of his particular historical position.[8]

This historical position is one in which we are supplied with information through photographs which have radically altered our notions of fantasy and narrative and the exotic.

Historically, art has in many ways fulfilled the desire for fantasies of the exotic; even the simple fashion in seventeenth-century Holland for not just representations of the home scene but also for "Italianate" landscapes was exotic to people excluded from all but local travel. We have, through the relative ease of long-distance travel and the transmission of information, lost much of that innocence and its attendant mystery. We have replaced it with new desires, with what the critic and novelist George Steiner has called the "Nostalgia for the Absolute,"[9] and with what can

be called the fantasy of the real, the most pervasive expression of which is the mass-media advertising transmitted substantially by photography. In recent years the fantasy of the real has seen the rise of a whole range of "realist" or "photo-realist" painting throughout the western world. Its attraction lies in its capacity to present the familiar with a selectivity of context and moment that has a fascination just beyond the reach of description.

It is a fantasy whose photographic immediacy can persuade us to accept it as natural. We find this in the paintings of American artists like Don Eddy, Don Hendricks, and John Salt, and of Canadian artists like Tom Forrestall (as in his *The Congregation* (1980) (fig. 160)) and Ken Danby. Danby's photo-realist technique, the familiarity of his images and their swift entrance into fantasy open up a longing for narrative. The photographic immediacy of Danby's paintings carries the connotations of an "image," an image of heroic concentration of an ice-hockey goalie in *At the Crease*, an image of anticipation in *Charter 1978* (1978) (fig. 161)—the characteristic moment in a story.

Fig. 159. James Spencer. *Mountain*, 1981. Acrylic on board. 55.5 × 80.5 cm. Art Gallery of Nova Scotia, Halifax.

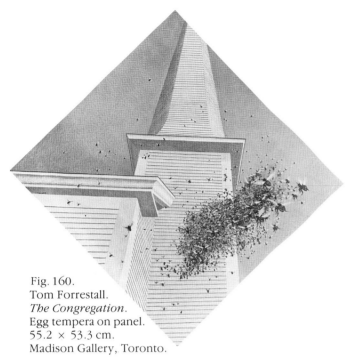

Fig. 160.
Tom Forrestall.
The Congregation.
Egg tempera on panel.
55.2 × 53.3 cm.
Madison Gallery, Toronto.

Other painters have used the impact of photography as a way of distancing their images, of forcing a critical gap between the information contained in photography and in the painted representation. This can be strikingly effective and evocative, as it is in the paintings of the young Toronto-based painter Michael Thompson, such as *Breathing In* (1981) (fig. 162). The Vancouver artist Robert Young approaches this issue at another level in his recreations, not of the the narrative circumstances of the original moment, but of only that moment preserved in the photograph; the photograph as a record, evidence of a reality that can never really be known but only built upon by giving it the form and value of painting.

Yet another approach to the relationship between photography and representational painting is developed in the landscape pictures of Leslie Reid from Ottawa. Her concern has been to break through the traditional means of landscape painting to express the fragile but still vital values of space. "I am painting," she has written, "out of a

Fig. 161
Ken Danby.
Charter 1978, 1978.
Oil on board.
71.1 × 101.6 cm.
Lavalin Inc.

170

Fig. 162. Michael Thompson. *Breathing In*, 1981. Acrylic on masonite. 76.2 x 182.9 cm. Private Collection, Toronto.

sense of loss, or is it relief at the familiar still being there?"[10] Her early paintings were hard-edge abstractions but, by the mid seventies, she was making paintings and prints that, in their response to the subtle changes in the colours of the atmosphere, appeared as monochromatic fields of light. At that time she was using photographs as points of reference but in the later seventies the form of the landscape as recorded in the photographs, began to appear directly in the paintings. In *Var III: Les Valises* (1980) (fig. 163), for example, it is as if the landscape is substantiated from the enveloping atmosphere by our contemplation.

In John Hall's work, the distancing and recreating are intended not to blur the realities of painting and photography but to make them collide. He began working in the early 1960s as an abstract painter, but he came to realize that the act of painting and the ordering of perception that it demanded made it necessary to impose the distancing effect of objects between himself and the image on the canvas. He was not concerned with creating an iconography; the objects he chose to work with, though directly related to aspects and events of his own life, were either well-known in

an everyday context or so deliberately evocative that their connotations were immediately evident. He built three-dimensional maquettes of still-life arrangements and based his paintings on them and on photographs of them—the use of the photographs adding another convention of distance, one that carries its own character as a source of visual information.

This technique—using objects and photographs, making maquettes, rephotographing, and then painting—raises rather than relieves tension. In *Twilight* (1980) (fig. 164) the particular combinations of objects, the mechanics of the still-life arrangements with straps and screws and metal plates, and the vivid illusionism of the painting are all the more disarming because of the magnification of the "real" objects in the painting. Our immediate recognition of what we see removes any mystery from the subject matter, but replaces it with a mystery of content. Why these objects in this combination? Why replace an arrangement of diverse objects, each with its own context and associations, with an illusion that seals the arrangement into a unified image? The act of paint-

Fig. 163.
Leslie Reid.
Var III: Les valises,
1980.
Acrylic on linen.
142.0 × 188.0 cm.
ManuLife collection
Toronto.

Fig. 164.
John Hall.
Twilight, 1980.
Acrylic on canvas.
111.8 × 111.8 cm.
Canada Council
Art Bank.

ing encodes the variety and fragmentation of the world into a unity by recasting those elements in a single material substance—paint—transformed by its own conventions of space and illusion.

John Hall establishes the independence of painting by challenging it through its very techniques. His illusionism brings his pictures into the world of objects and associations while his particular combination of references, his alterations of scale, his use of photographic images, distances them from any reality but the surface of the picture itself. In contrast, Gary Olson, who like Hall lives in Calgary, treats the surface of the painting as a barrier between himself and the spectator. Olson parodies and criticizes the procedures of abstract formalist art in its precious defence of painting as a flat and impenetrable surface. He uses the picture plane in *Peek-A-Boo* (1980) (fig. 165) as though it were a sheet of glass, spectators on one side, the artist pressed against it on the other.

Fig. 165. Gary Olson. *Peek-A-Boo*, 1980. Graphite on paper. 76.2 × 101.6 cm. Collection of the Artist.

The sense of regionalism in Colville's work arises as a result of his grounding his work in the immediate circumstances of his own life and the particular places in which he has lived, though he does not, in a strict sense, seek to portray those places. Regionalism, in a more determined sense is the basis of Jack Chambers' work. There is, as in Colville's work, a concentration on the circumstances and environment closest and most vital to him, but through them, particularly in the last ten years of his life, Chambers sought to express the spiritual transcendence that he believed could be achieved through a precise apprehension of the physical phenomena of his world. It was as if by perceiving his surroundings in their very fullness he could express the unity of the physical and spiritual.

Jack Chambers was born in London in 1931

Fig. 166.
Jack Chambers.
401 Towards London #1,
1968–69.
Oil on mahogany.
182.9 × 243.8 cm.
Norcen Energy Resources
Limited.

Fig. 167. Jack Chambers. *Regatta #1*, 1968. Oil, graphite, paper, plexiglass. 129.9 × 124.2 cm. London Regional Art Gallery.

and received his initial art training, as have so many London-born artists, at H. B. Beal Technical School under Herb Ariss and John O'Henly. He travelled widely in Europe through the fifties and studied at the San Fernando Academia de Bellas Artes in Madrid, from which he graduated in 1959. He returned to London in 1961.

His paintings of the sixties have a strongly mystic character but one wholly dependent on familiar settings and on those people most important to him, above all his family. These paintings often seem like dreams, vivid and yet somehow intangible, painted with a slightly misted tone, as if he were holding out of time the essence of a moment whose significance transcended the simplicity of its actual description. In the later sixties his paintings, like *Regatta no. 1* (1968) (fig. 167), were often divided into apparently disparate elements, fragments of experience poetically combined.

At the end of the sixties his approach to painting underwent a radical shift, signalled in the picture *401 Towards London No. 1* (1968–69) (fig. 166). This was a crucial work, not only professionally but personally, for it was while he was working on it, in the summer of 1969, that Chambers was told he had leukemia. The assemblage of images, the mixed and superimposed forms that had marked his work up to that point, gave way to a direct and immediate representation of vision itself. The change introduced by this painting and others of that year was the subject of his important essay "Perceptual Realism."[11] He developed the approach he described as "perceptual realism" from his own vision and from his wide-ranging reading, particularly of the writings of the modern French philosopher Maurice Merleau-Ponty, and from the spiritual writings of both western and eastern thinkers who gave expression to the notion of the "eternal present" the essence of the totality both in ourselves and in everything that surrounds us. He expressed this belief and the validation of painting through it in the following moving sentences:

> Perception redeems reality....You may feel that the objects in nature, nature itself, is easily loved. Your love for life is the celebration that life does not diminish or end. The certainty that this is so is perception. Perception is the reality of love. Love is the experience of certainty and knowledge and in our world it is light. So whatever makes us see more clearly approaches love and illuminates reality.[12]

During the seventies his paintings and drawings came even closer to the immediacy of his surroundings; his wife and children, the interior of his house, vases of flowers, the view from his window, aspects of the landscape in and around London. The paintings vary in the sharpness of their focus, the series of *Lake Huron* (fig. 168), for instance, have a brilliance and clarity of vision which overwhelms the spectator with the very fullness of their light. Other pictures of the last three years of his life, while equally focused,

contain a palpable atmosphere, as if the act of vision itself brings about the existence of objects. Chambers' notion of perception was that is was the means of revealing passage between two united worlds—the physical and the spiritual. While such unity is contained in every act of perception, Chambers, in his work, concentrated on images of those places and people most familiar, and hence most significant, to him. The simple facts of existence became not the background to special events but the true values of life.

His commitment as a painter was inseparable from his advocacy of the artist's role both in the immediate community and within society as a whole. The visual artist's place in society has, of course, long been recognized, in recent times through institutions such as museums and galleries and the activities of government-appointed agencies such as the Canada Council. But it is a place that keeps the artist under a system of patronage, rather than recognizing his or her efforts as "work" and rewarding it as the work of other members of society is rewarded. As a result of a dispute with the National Gallery of Canada over copyright and reproduction rights for some of his pictures, Chambers, in 1967, initiated in London, Ontario, a collective organization for artists. It was called the Canadian Artists' Representation (CAR), and Chambers was its first president.[13] Over the succeeding years he worked tirelessly for the formation of similar organizations across the country, through which to establish standards and fees for the use of artists' works for exhibition and reproduction purposes. Though he resigned as president in 1975, until his death in 1978 he maintained an active role within the organization. Chambers' organizational work, as well as the paintings and drawings and films he has left, comprise a very special contribution to the visual arts in Canada—a heritage that reaches far beyond the confines of London, his home.

The subject of David Blackwood's work is also regional identity, but in his case it is the past, not

Fig. 168. Jack Chambers. *Lake Huron No. 1*, 1970–71. Oil on wood. 152.4 × 152.4 cm. Jack Chambers Estate.

the present, which is the subject. His etchings recall the whalers of Newfoundland and the communities in which they lived. The lives of these people, set against the great animals they hunted, is the stuff of legends, but their reality was harsh and tragic. The people's strength depended substantially on their sense of community in the face of a hostile environment, and it is this characteristic that Blackwood emphasizes.

This attachment to a place and the simultaneous struggle with it can also symbolize the reality and identity of an individual. This was the case with Christiane Pflug and Toronto. Pflug immigrated to Canada from Germany in 1959 and settled in Toronto. Her work from then until her death by suicide in 1972 was almost exclusively concerned with her immediate surroundings—interiors of her house, views from its windows, views of Toronto from the Islands. Each work, whether a painting or a drawing, is a vivid recreation of this direct and immediate vision. The

Fig. 169. Christiane Pflug. *Interior at Night,* 1964–65. Oil on canvas. 172.0 × 140.0 cm. C·I·L Inc.

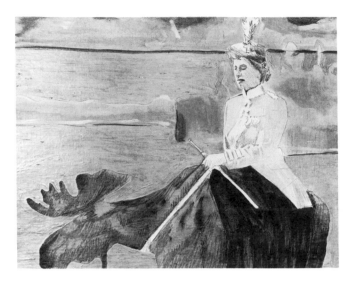

Fig. 170 (above). Charles Pachter. *Marsh Fantasy,* 1972. Acrylic and pencil on canvas board. 60.9 × 76.2 cm. Private collection, Toronto.

strongest and most poignant pictures are those like *Interior at Night* (1964–65) (fig. 169), that combine the inside and the outside, looking out of a window, the frame of her vision filled by the grid of the city—buildings, roads, hydro-electric lines. Her grasp of the familiar and of her surroundings, and her scrupulous recording of them is like an affirmation of reality, a basis of security. But at the same time this benign familiarity acts as a threat, as though trapping her within herself. The very clarity and naïve directness of her work underlines the uncertainty it represents—identity as an intense and tragic personal search.

The notion of identity in the work of Charles Pachter is broader. It is collective as well as personal, concerned less with representing his sur-

Fig. 171 (lower right). Charles Pachter. *Painted flag #5,* 1981. Acrylic on canvas. 213.0 × 183.0 cm. Collection of the Artist.

176

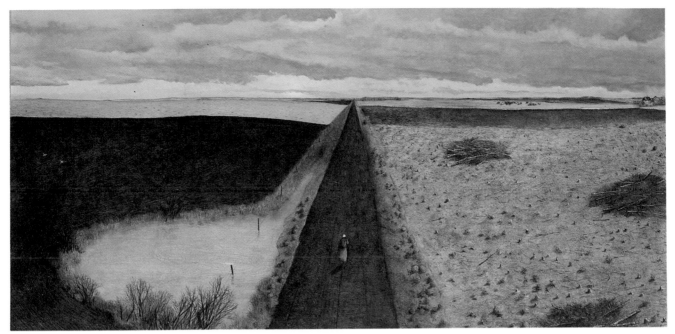

Fig. 172. William Kurelek. *Piotr Jorosz*, 1977. Mixed media. 60.7 × 121.5 cm. Art Gallery of Hamilton. Gift of the Polish Alliance of Canada and Wintario.

roundings for themselves than with focusing on images that symbolize identity: the streetcars of Toronto, the royal family, the flag, or the northern wilderness. Pachter returned to Toronto in 1971 after studying in the United States and teaching for a year in Calgary. The experience of living in the United States had sharpened his sense of national identity, and in several major series of works he concentrated on images that marked his feeling of place, and his response to the assumptions made about nationality and its symbols. Toronto streetcars were the subject of a series of prints made in the early seventies. At one level the streetcar is simply a graphic image, open to repetition and variation. Beyond that, however, as Pachter uses it, it becomes a symbol of a place in the way that images in Pop Art became symbols. In 1972 he said, "in a curious way, [the streetcar is] the embodiment of a world I know."[14]

In 1972, he began his *Queen and Moose* pictures, both paintings and prints. The choice of subject, as in *Marsh Fantasy* (1972) (fig. 170), was deliberately provocative. The provocation was not directed as an insult to the person of the Queen, but against the sort of unthinking, nostalgic assumptions by which nationhood is so often symbolized—here by both colonial heritage and northern wilderness. This issue of identity and its symbols is further made in a fine series of recent paintings of the national flag, such as *The Painted Flag #5* (1981) (fig. 171). In these a striking image for painting is combined with the official symbol of national institution—to say nothing of its place as the focus for collective national identity. The image that the flag represents is itself represented in the image of the painting, subtly combining a play between illusion and reality, symbol and fact.

William Kurelek's vision spanned "innocent nostalgia to apocalyptic vision." An intensely religious man of Ukrainian background, Kurelek became a passionate recorder of the Canadian scene, particularly the Prairies. His vision is a strikingly

Fig. 173.
William Kurelek.
Dinnertime on the Prairies, 1963.
Oil on masonite.
45.1 × 72.4 cm.
McMaster University, Hamilton.

individual mixture of the present, the historical past, and the timeless struggle of the individual with the fact of his existence.

Born at Whitford in northern Alberta in 1927, Kurelek moved with his farming family to Stonewall, Manitoba, in 1934. After graduating from the University of Manitoba in 1949, he spent several years in a largely fruitless search for guidance in the development of his art; first at the Ontario College of Art, then at the Instituto San Miguel de Allende in Mexico, and finally in England. In the end his essential artistic education came through his own vision and through practice. While in England, Kurelek suffered a severe mental breakdown. After two years of treatment he returned to Canada in 1959 and settled in Toronto, where he worked as a picture-framer for Avrom Isaacs. The following year he had his first one-man show at the Isaacs Gallery.

This show marked the start of his relatively short but remarkably successful and productive professional career. With the exception of 1961

he had at least one solo show in commercial and public galleries in each year from 1960 until his death in 1977. Though his output in that period numbered some two thousand works, it barely satisfied the demand from public galleries and private collectors for his pictures. Under this pressure of production, his quality of work is uneven, but he painted to a very particular strategy. The greatest demand was for what he called his "more pleasant, memory-recording type painting."[15] He could support his family with these, and, through them draw attention to his "religious works, which are didactic or moralizing."[16] It was in these pictures that he saw the essence of his art; they brought him into the tradition of moralizing religious art established in the sixteenth century by the Netherlandish painters Hieronymus Bosch and Peter Brueghel the Elder. As those artists had presented their particular convictions of Christian values in terms directly related to the worlds in which they lived, so Kurelek interpreted the heritage of religious belief into his own immediate

experience. Of *Dinnertime on the Prairies* (1963) (fig. 173) he wrote,

> The meaning of this picture is that our sins Crucify Christ just as much today, as 2000 years ago, and just as much in Western Canada, as in Palestine. The farmer and his sons doing the fencing may have had an argument just before dinner or one of them may have enjoyed a lustful thought. Or got an idea how to revenge himself on neighbours etc.[17]

The widespread affection for his work is expressed most often for his pictures that depict the landscape of the Prairies, its stories, and the homesteading life he knew as a child. *Piotr Jorosz* (1977) (fig. 172), for instance tells the story of one particular settler in the years before the First World War. Although Kurelek continued to paint western Canadian scenes throughout his career, his work after 1970 became increasingly centred on Ontario subjects. But he travelled extensively in Canada, making paintings of every region. These form a unique document, recognizing the vastness of the country, responding to its variety, and yet marking in every place the similarities of struggle and joy that comprise the lives of all people at all times.

Notes

1. Gregory Battcock (ed.), *Super Realism. A Critical Anthology.* New York: E.P. Dutton, 1975; pp. xxix, xxx.
2. Heinz Ohff, "Provinziell wie Caspar David Friedrich," *Der Tagesspiegel,* 25 August 1971; p. 4.
3. David Burnett, *Colville.* Toronto: Art Gallery of Ontario, McClelland and Stewart, 1983; p. 23.
4. *Ibid.,* p. 157.
5. *Some Canadian Women Artists.* Ottawa: The National Gallery of Canada, 1975; p. 55.
6. *Ibid.*
7. See Linda Nochlin, "Some Women Realists," in Battcock, *Super Realism,* pp. 64 – 78.
8. Linda Chase, "Existential *vs.* Humanist Realism," in Battcock, *Super Realism,* p. 90.
9. George Steiner, *Nostalgia for the Absolute.* Toronto: Canadian Broadcasting Corporation, 1974.
10. *Some Canadian Women Artists.* Ottawa: National Gallery of Canada, 1975; p. 69.
11. Jack Chambers, "Perceptual Realism." *artscanada,* Vol. 26 (October 1969); pp. 7 – 13.
12. *Jack Chambers. The Last Decade.* London: London Regional Art Gallery, 1981; p. 9.
13. On this aspect of Chambers' career, see Paddy O'Brien in *Jack Chambers. The Last Decade;* pp. 27 – 32.
14. "Charles Pachter," *Collins, Pachter, Tinkl.* Toronto: Art Gallery of Ontario, Extension Services, 1977 – 78; p. 8.
15. William Kurelek. "Reminiscences," in Joan Murray, *Kurelek's Vision of Canada.* Oshawa: The Robert McLaughlin Gallery, 1982; p. 70.
16. *Ibid.*
17. *Ibid.,* p. 24.

Fig. 174.
Iain Baxter.
Five Apple Trees, 1980.
Acrylic on canvas and
Polaroid prints.
240.0 × 200.0 cm.
Collection of the Artist.

Alternative Modes

In the later 1960s many artists in Europe and North America began to challenge seriously not only the style but also the morality of current art-making. They questioned the meaning of art in relation to political issues and social conditions. They charged prevailing art with hollow aestheticism, with collusion in preserving vested interests, with irrelevance to current circumstances. The questioning of established values became widespread through the media, within institutions, and in action in the streets. The May Rebellion in Paris in 1968, the youth movement across the western world, the deep divisions in American society over the Vietnam War, the rapid rise of the women's movement, a broadening sensibility to political corruption and repression; all these events were played out against a background of western industrial prosperity and consumerism, and all brought into question the assumed values maintained in social, political, and economic institutions.

The slogans of the May Rebellion "Culture is dead—create" and *"Vivre au présent"* emphasized the need for the arts to break with their own history; "If only the artist can realize that most of his output stamps him as a man of the past, an anachronism, this will be a great step forward."[1] Action groups were formed; in 1969 the Art Workers' Coalition formulated demands to the Museum of Modern Art in New York; Women Artists in Revolution (WAR) was established. Individual artists and small groups deliberately rejected "institutional art," art as a commodity item. The social criticism in the work of German artist Joseph Beuys in making sculpture from junk and refuse; the artist-as-object and masochistic actions of the Italian Vito Acconci and the American Chris Burden; the turn away from "fine art" objects to texts and the documentation of actions; the "uncollectable" land art of the Americans Robert Smithson and Michael Heizer; all were manifestations of rejection of the prevailing structure of the art world, of the assumptions, historically validated, it supported and the social and political system it reflected. The notion of art as its conception or its idea, as formulation rather than as product, as "anti-art," became, by the end of the 1960s, widespread as artistic action.

But gradually the work, even as it remained critical, came to be generative rather than revolutionary; anti-art developed its own status. A number of critics quickly seized on this as a mark of failure, as a sign that the artists had taken inherently untenable positions and that now everything was falling back into place. But the fact is that everything was changed, regardless that it was now part of the story of recent art. There could be no return to previous values that denied or overlooked the accumulation of actions and ideas. Les Levine, a Conceptual artist who came to Canada from Ireland in 1958, wrote in answer to the critic Robert Hughes' remarks on "The Decline and Fall of the Avant-Garde" in 1972,

> Conceptual Art, art that exists as ideas rather than as objects, was not only important, but totally necessary, to re-examine an art world that had lost its way in the boom of the mid-sixties.[2]

The re-examination Levine wrote of at that time set directions for art through the 1970s that vastly expanded the range of its possibilities for expression and the means and techniques by which those possibilities were examined.

In Canada, for a variety of reasons, the conditions of social criticism and unrest and the vociferous calls for change that arose in Europe and the United States did not strike with the same effect. Economic prosperity and an upsurge of national awareness, centred around the events of the Centennial celebrations of 1967, were matched by an unprecedented and generally welcomed involvement of government, both federal and provincial, in cultural activity. The growth of the universities, the development and building of museums

and art galleries, occurred at a rate and on a scale previously unmatched. In addition, the Canada Council, whose importance in cultural development began to take effect in the 1960s, came to play an increasingly important role, marked in particular in the visual arts by the formation of the Art Bank in 1972.[3] The political ascription of cultural values to national purpose and development was sealed in 1972 with the establishment of the National Museums Corporation and the extension of the government's "democratization and decentralization" policies of funding and access to cultural life. These decisions, implemented by government policies and agencies, decisively changed the character of cultural activity in Canada.

There was not, then, a fertile climate for the creative de-structuring and radical clamour that was occurring in the United States, in France, and in Germany. Modernism had been established in Canada only very recently, and the acceptance of the new in the late 1960s coincided with a willingness on the part of institutions to give it support. That support, developed to give particular emphasis to contemporary cultural expression, gave backing to the most current and often most difficult work. This coincidence of events, when Conceptual Art was being developed and when installation art and video and performance were beginning to emerge, made possible an unprecedented burst of artistic activity in this country.

Because their expression of ideas and development of techniques were essentially without tradition—whether of knowledge, of teaching, or of methodology—Conceptual Art and video and performance art emerged free from the conditions surrounding painting and sculpture. The work stood, for the most part, outside the art market system, but it did begin to receive support through some of the public galleries and through the rapid development of alternate-space galleries, that is, galleries or organizations developed and substantially directed by artists. At the beginning of the 1970s the Canada Council began to allot low-level funding to a few alternate spaces such as A Space in Toronto, founded in 1970, and Véhicule in Montreal in 1971. In 1973 it began to give stronger support, with the result that a network of such galleries emerged across the country. New developments in contemporary art were able to gain an audience in ways not possible in the early introductions of modernism.

The critical statement of art in the context of the public gallery and its audience was, in a way, codified by Garry Neill Kennedy in his 1978 work, *Canadian Contemporary Collection— Average Size—Average Colour* (fig. 175). With irony, with humour, and a literal statement of issues, he questioned not only the process of art-making, specifically that of painting, but also the support systems that present the art: the museum and its methodology of display and exhibition. For this work, made for an exhibition at the Art Gallery of Ontario, he analyzed thirty-two contemporary Canadian paintings hanging in the gallery. He determined the average size of those paintings and, by an accumulative analysis of all the colours used in them, mixed according to their proportionate use, produced a painting of their average colour. The painting of average size was hung on a wall painted with two coats of the average colour. In addition he showed the analytical documents for each of the thirty-two paintings: a colour photograph of each, and the systematic breakdown of its colour.

The work of art is shown to be an accumulation of factors; its production is the accumulation of intentions (willed or unwilled), it is made by an accumulation of materials (paint layers on canvas), it is accumulated through the collecting policies of the museum, where it becomes the subject of viewing, analysis, and opinion. Kennedy's work ironically de-structures the art object and its status by the accumulation of another layer, even if it is one that destroys the affective assumptions about a work of art by emphasizing its physical existence both as an individual object and as part

Fig. 175. Garry Neill Kennedy. *Canadian Contemporary Collection,* 1978. Photographs, pencil, and acrylic on board. 33 drawings, each 141.6 × 141.6 × 3.8 cm. Collection Art Gallery of Ontario, Toronto. Purchase with assistance from Wintario.

of a museum's content. It is a final twist in the process that this work should then become part of the collection it analyzes, itself open to scrutiny within the context of the museum system.

Kennedy's point was more sharply made in connection with his participation in the National Gallery's *Pluralities* exhibition in 1980. He had planned to adjust all the Old Master landscape paintings hanging on one floor of the gallery so that their horizon lines were at his eye-level. The gallery rejected the proposal, so he left the space allocated to him bare, except for a statement explaining his original idea and asserting that his work comprised all the space not allocated to other participants in the exhibition. The irony here lies not only in the original conception and its rejection, but also in the acceptance of the very negative revised idea; the rejective character of the work is bound into the system it criticizes.

Some of the most prodigious and inventive of all Idea or Conceptual Art done in Canada has stemmed from Iain Baxter and the N. E. Thing Company that he founded with Ingrid Baxter in 1967. In 1966 the Baxters and John Friel had developed the notion of the presentation of art not only through the anonymity of a chartered company but also with its connotations of capitalist enterprise, under the name of IT. The N. E. Baxter Thing Co. took over the idea. The company was formed specifically to establish a corporate rather than an individual creative identity dealing in the business of art. Its name changed in 1967 to the N. E. Thing Co. and "Ltd." was added in 1969 when the company became incorporated. In forming the company the Baxters acknowledged that they were dealing with a commodity,

Fig. 176. Iain Baxter. *Bagged Landscape with Water*, 1966. Inflated vinyl, air, water. 198.1 × 137.2 cm. Private Collection, Toronto.

art, that, like any other commodity, demanded a system of operation in a market arrangement.

The company undertook a diverse operation producing ideas, objects, and events. It responded, for instance, to the demand of any business enterprise not only to manufacture a product but also to package it. Out of this came a series of "bagged works of art" such as *Bagged Landscape with Water* (1966) (fig. 176), an assemblage of coloured vinyl bags filled with air and water, objects indistinguishable from their packaging, content contained in style. The style of the work existed also in the operations of the company as a

company, shown most fully in the 1969 installation at the National Gallery of the *N. E. Thing Co. Environment*. For this the ground floor of the gallery (itself housed in a converted office block) was transformed into the company headquarters of the N. E. Thing Co., with a range of offices, of personnel, products of the company, projects data, showroom, communications network, and so on. The company also developed a specialized language, a sort of high-tech jargon; "Visual Sensitivity Information" or VSI referred to material such as paintings, sculpture, architecture, and books; TRANS-VSI described the transmission of VSI from one place to another. The operations of the company were developed through a wide range of media: Xerox, Telex, telephone, mailings, maps, and photographs. Many of the company's projects existed as photographic documents. For example, the *1/4 Mile Landscape* (1968) was a series of photographs and a map of a section of California landscape bracketed by roadside notices. The first, reading "You will soon pass a 1/4 mile N. E. Thing Co. Landscape," was soon followed by another stating "Start Viewing," and, a quarter of a mile later, another read "Stop Viewing."

The company's last project was an exhibition at the Vancouver Art Gallery in 1977–78. Baxter's own activities and flow of ideas have continued undiminished and, maintaining the spirit of the corporate involvement and image, he has undertaken a number of projects with the Polaroid Company (fig. 174). His work (and that of the N. E. Thing Co.) has been widely acknowledged in the United States and Europe, both for itself and for the stimulus it has given to other artists. In Canada his work has been rather more grudgingly recognized, reflecting a somewhat humourless response to someone whose creative range of ideas is prodigious.

During the first years of the N. E. Thing Co.'s operations, the Baxters lived in Vancouver where Iain taught, first at the University of British Columbia (1964–66) and then at Simon Fraser Uni-

versity's Centre for Communications and the Arts (1966–71). His work has been extensively concerned with the means and meanings of communications, with the interchange of data, and with the relationship between the "personal" generation of ideas and their objective transmission. Though his ideas are presented in a witty, apparently light-hearted way, the seriousness of his comment on the structure and conventions of communication is evident.

The separation of the work from its originator has been an issue fundamental to much Conceptual Art. As the French artist Daniel Buren has declared, "The impersonal or anonymous nature of the work/product causes us to be confronted with an act (or idea) in its raw form; we can observe it only without a reference to any metaphysical scheme, just as we observe that it is raining or snowing."[4] And when Baxter said "Because of living so far away I really forced myself into dealing with the problem of information and sending it,"[5] his concern was not simply geographical but a comment on the nature of contemporary society as it is defined by its multi-layered systems of communications.

Baxter's interests coincided with those of a number of artists in Vancouver and, in the later 1960s, the city became a vibrant centre for Conceptual Art activities, for co-operative ventures, for video, and for performance art. From this point both video and performance began to develop as independent forms. Performance art, cutting across or through the separations of cultural disciplines, has appropriated aspects of ritual and theatre, poetry and dance, environments and installations. Challenging the conventions on which these other disciplines have been based, performance art has become responsive to immediate political and social issues, and directly and spontaneously sensitive to the issues of language and communication. And if the performance operates outside or across or against the traditional patterns and conventions of, say, theatrical presentations, the assumptions of the viewer too are

Fig. 177. General Idea. *General Idea's Going Through the Motions,* Performance, 1975.

challenged and he must reach deeply into his own experience and store of associations.

Performance in Canada can be traced back nearly twenty years, emerging first with the multi-disciplinary co-operative group Intermedia which operated in Vancouver between 1966 and 1970.[6] And Vancouver has remained an important centre for both performance and video art, in particular because of artist-run organizations such as Video Inn, formed in 1972, and Western Front, formed in 1973. Among the earliest developments in performance were those of Gathie Falk in Vancouver, the first in 1968, and the following year the first performance by the Toronto group General Idea (fig. 177). Subsequently Performance Art devel-

Fig. 178. General Idea. *The Unveiling of the Cornucopia,*
1982. Painted plaster board, plywood. 243.9 × 609.6 cm.
Courtesy of Carmen Lamanna Gallery.

oped rapidly in many parts of the country, although Vancouver and Toronto have remained the most active centres.

In certain cases performance has not been restricted to set events, but also to the development of a public persona, whether of a group, such as General Idea, or the duo of Eric Metcalfe and Kate Craig as "Dr. Brute" and "Lady Brute," or of individuals, such as the Vancouver artist Vincent Trasov who identified himself as Mr. Peanut, the advertising image of the Planters Company. Concealed in a papier-maché costume, Mr. Peanut was featured in magazines, and on radio and television. In 1974 he was entered as a mayoralty candidate in Vancouver. He was "like much art...an arrow pointing in an empty landscape...featured...not because he has 'done' something, but merely because of his existence as an available high-definition image."[7]

The Toronto-based group General Idea has most extensively worked for the notion of art not only as a public event but as part of society's cultural identity. In doing so they have in a deliberate way created art history, projecting a sort of archaeology of the future. General Idea, created in 1968, is comprised of three artists, A. A. Bronson (Michael Tims), Felix Partz (Ron Gabe) and Jorge Zontal (Jorge Saia), and projects its activities to 1984. In 1969 the three held the first Miss General Idea Pageant, projecting that and subsequent events towards their 1984 Pageant (fig. 177). They wrote of their project in *File* magazine, which they founded, that the date of 1984 represented "the collective historical vision of the future, seen through the eyes of the immediate past (which in many ways is the only past we have as a culture)." The reference to George Orwell's novel of faceless dictatorship and cultural control is evident. As A. A. Bronson has written, "History is a means of denying responsibility for the present. History is never made—it is written."[8]

In the way that the Baxters submerged their individuality into the anonymous N. E. Thing Co., General Idea is a collective projection, with the three pseudonymous individuals directing their work and activities to a complex and brilliant layering of collective cultural identity. They recreate a distant past, which we can know only in fragments, to reflect on contemporary culture—

that is, what makes up the features of the present—in order to project into the future when the identity of our present will be assessed. By these means they parallel and perpetrate the cliché of art and the artist—that art is something "allowed" by society for its own ultimate good, that society needs people who take it upon themselves to reflect society's values. The group has done this by paralleling the projection of their image through the mass-media techniques by which our culture is so often identified. They have worked through the devices of television in their video tapes, and through popular picture-type magazines (*File* magazine is modelled on *Life* magazine), and by their use of advertising techniques which create the image of "desirable" contemporary living. At the same time, they have created "art" in the form of "archaelogical" fragments (fig. 178) centred on the symbol of a urinating poodle for the Villa dei Misteri of their 1984 Miss General Idea Pavilion. By projecting the present as simply fragments of an unknown future, they eliminate arbitrary distinctions between Culture and culture. It is only in the future, based on the fragments of the past, that those distinctions can be made.

The notion that we do, somehow, have an overall view of our world and a sequential understanding of how our present has been constituted by the past, has been central to the work of Bill Vazan. His concern is with the different ways in which societies, past and present, seek to explain themselves to the world in which they live. His *Globe* series of photoworks (fig. 179), for instance, draws together the notion of a global view, but one constituted, of necessity, from a particular standpoint. Each is a group of twenty-four photographs, each photograph a section of the view as seen from a particular vantage point. He relates two symbolic levels; the grid structure of the work as an intellectually rational means of organization, the circular image as not only formally satisfying but also a charged symbol of complete-

Fig. 179. Bill Vazan. *Brick Maze Palatine Hill, Rome*, 1979. Photographs. 38.0 × 30.0 cm. Courtesy of the Artist.

ness, implying not simply a section of the world but the world as a whole.

Since the early 1960s Vazan has been involved with land-art works:[9] arrangements of rocks in park or landscape settings, patterns marked out in snow-covered fields, or by chalk markings. The works are essentially ephemeral—the markings disappear as the snow melts or the rain washes away the chalk—but recorded in photographs they comprise an archive of events. The works create or recreate archaeological sites or refer to geological features; the markings of *Ghostings* (1978–79) (fig. 180) at Toronto's Harbourfront, for instance, refer both to glacier striation marks and to Amerindian burial mounds, longhouses, and palisade enclosures. The references in the markings are to traces of the distant past, to the remains of human habitation, and to the devices and systems by which ancient peoples formulated their understanding of the recurring patterns in the heavens and in nature, and through which

Fig. 180.
Bill Vazan.
Ghostings, 1978–79.
Chalk on turf.
Site specific work
at Harbourfront, Toronto.
121.9 × 243.8 m.

they expressed the relationships between natural and cultural activity. Vazan projects these examples of the past as references for the present. They remind us that our view of present reality as something natural is relative only to our passing point of view; that our desire for transcendence, for a viewpoint that will reconcile all we perceive, is not essentially different from all such past desires for understanding.

Irene Whittome's work is also concerned with the accumulation of cultural material. Her works recall the mystery attached to objects surviving from the past, the mystery of artifacts as the visible but incidental survivors of their creators. Although born in Vancouver and a graduate of the Vancouver School of Art in 1963, she has lived in Montreal since 1968. She spent three years at l'Atelier Hayter in Paris. Unlike many artists of her generation whose work expresses a rejection or criticism of the concept of the museum, Whittome has openly accepted its validity. Her first major pieces were two groups of works under the title *The White Museum* (1975) (fig. 181), comprising a series of poles wrapped with string, with each element set into its own glass-fronted white-painted box. The objects reflect both the mystery of objects surviving from the past and the desire to collect and preserve them. The wrapping and box enclosures refer to our attempts to preserve and hence prolong the fleeting reality of our lives—the wrapping of mummies, the care, indeed the art, with which tombs and caskets were prepared. In the context of the museum these efforts are transposed into the ob-

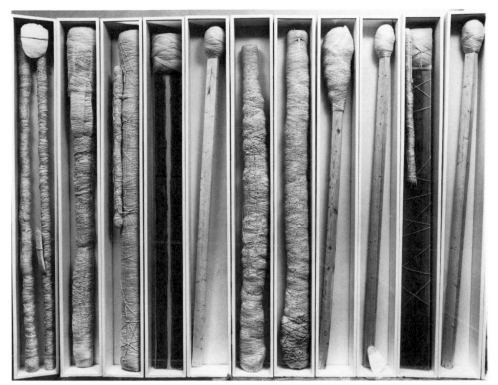

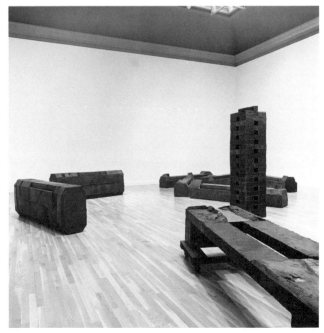

Fig. 181. Irene Whittome. *White Museum II* (detail), 1975. Wood, cord, string, jute, cloth, paper. Each 219.1 × 25.4 × 15.8 cm. Canada Council Art Bank.

Fig. 182. Irene Whittome. *Vancouver* (detail installation view), 1977–80. Mixed media. Courtesy Yajima Gallery, Montreal.

session with collecting the traces of past activity. The objects in Whittome's *White Museum* are similar in the process of their wrapping. They represent a class of things, part human in form, part the record of human activity. Together they recall the making of totemic images, whose value lies not simply in their presence as objects but as an accumulation of individual acts of propriation.

Vancouver, like *White Museum*, is a work developed by the process of accumulation, but its range, through the recreation both of the objects and of the site of archaeology, is greatly expanded. Whittome developed *Vancouver* piece by piece between 1975 and 1980 and arrived at an installation of twelve objects, several of them with multiple elements, made from a variety of materials, mostly wood and laminated cardboard, covered with encaustic, wax, and powdered pigment. Their surfaces are rough and aged in appearance, like objects recovered from the sea (fig.

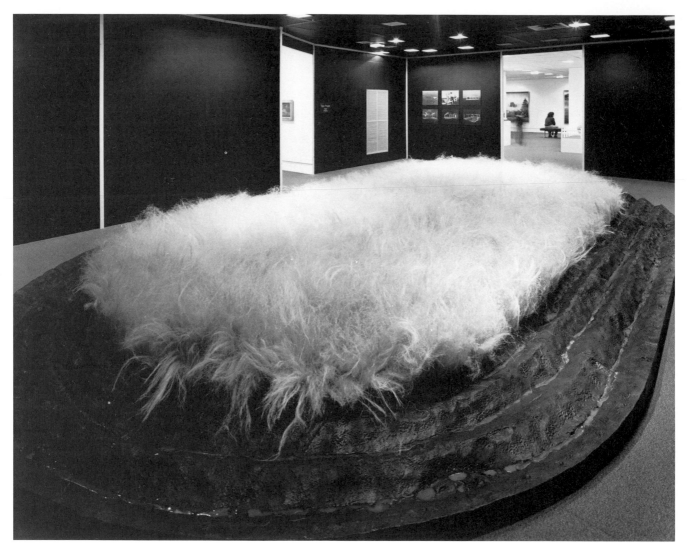

Fig. 183. Don Proch. *Field*, 1979–80. Cast epoxy resin and sisal. 4.6 × 7.9 m.

182). But along with individual objects—dugouts, an armchair, a tower—there are elements that refer to a whole site: there is a map; a watertable; and the element "Mountain ↔ Bridge ↔ Ocean ↔ Ocean ↔ Bridge ↔ Mountain," referring not simply to topographic features but to movement back and forth between them. The inclusion of a wagon and a dolly indicates both the physical facts of collection and the notion of carrying forward to the present the elements of the past. *Vancouver* has not only general references but personal ones referring to the place where Whittome was born and grew up. The work links two levels of time: the accumulation of the past symbolically condensed in artifacts, and the time span of the artist's own existence which is marked by the extended process of her techniques, techniques developed not simply to produce a partic-

ular form but to show, in its production, the commitment of her own time.

If Whittome's work is concerned with the transformation of nature to culture and the special status granted by the museum, Don Proch's is more directly concerned with the everyday activity of a region. His art "is about living and working in rural Manitoba."[10] For *Field* (fig. 183) begun in 1979, he marked out an oval area of a ploughed field, constructed a framework around it, installed a lighting system—and even a security guard—to make the *Field* "gallery." The oval area was then cast from plaster moulds into fibreglass for reconstruction in the context of a museum. The work is a sort of inversion of the notion of land art—with its alteration or sculpting of the landscape—by attempting to recreate the farmer's alteration or adaptation of the land. In so doing Proch seeks to bring the artistic enterprise to respond to the most fundamental and ancient relationship between nature and culture.

Ian Carr-Harris's works, essentially urban and social, often create "typical" situations—a domestic interior, an office, a movie theatre—but, detached from an occurrence of events, form what he has described as "static theatre." The spectator is both viewer and participant, both the active centre of the work and the focus of its disparate and physically separated elements. Many of the pieces raise a curious, disorienting division between the spectator's immediate experience and references to the past, through Carr-Harris's use of furniture styles of the recent past and texts using common phrases and clichés. It is a division reconciled by the spectator's personal synthesis of the past and the present into what he understands as constituting reality. In an early work like *Empire Piece* (1970–71) (fig. 184), the spectator is held outside the self-defining, self-reflecting arrangement. An old-fashioned projector projects onto a small wooden screen a slide that reads "Empire Piece." Both projector and screen are placed on wooden stands with elaborate mouldings and legs—though each stand has one plain

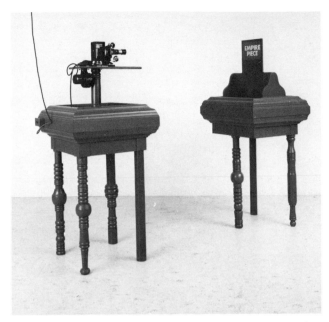

Fig. 184. Ian Carr-Harris. *Empire Piece*, 1970–71. Painted wood, projector, 35mm slide. 182.8 × 80.7 × 80.5 cm. The National Gallery of Canada, Ottawa.

leg, like a later addition—and the three-legged screen stand appears inherently unstable. Subsequently the installations have became more complex, involving a multiplicity of elements, including lighting and sound and sometimes film. In . . . *across town*. . . (1982) (fig. 185) the installation is physically centred around a sloping area of floor. A sound tape, amplified through speakers set around the floor, plays snatches of conversation at a party, focusing the description of an event in the empty arena. It is similar to the way a movie projector casts images onto a blank screen; here the emphasis shifts from pictorial images to language images. The traditional notion of the work of art—that the spectator focuses his attention on an object, in a sense gives himself over to the "event" of the work of art—is reversed. The discrete physical objects are focused on their reception by the spectator and his reconstruction of the information—whether visual, textual, or auditory—that they provide.

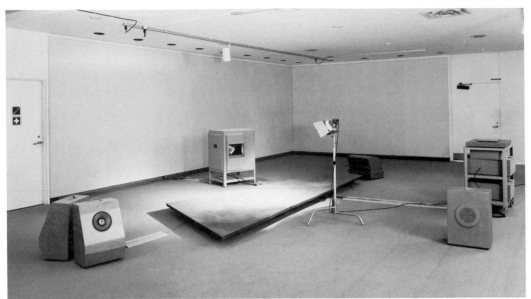

Fig. 185.
Ian Carr-Harris.
. . . *across town* . . . ,
1981. Mixed media
installation. Collection
Art Gallery of Ontario,
Toronto. Purchase,
1982.

The American art critic Lucy Lippard wrote in 1968 of conceptual art in terms of its "dematerialization," that is, where art was reduced often to a simple statement, say a text or a photograph, marking the fact of an action having taken place.[11] Sometimes there was no record at all, for the primacy of the work lay in its idea and in the rejection of the work of art as a special and valued object. More than that, for some artists the work became not construction but destruction, at its most extreme levels a masochistic attack by the artist on his own body. The American Chris Burden repeatedly dunked his head into a basin of water and breathed in until he was near collapse (all duly transmitted on video tape); the German Arnold Schwartzkogler's acts of self-mutilation led eventually to his death. But through the 1970s the totally rejective aspects of conceptual art shifted, and the work was prolonged, whether by documentation or three-dimensional constructions or by a greater degree of structure. The early happenings, for example, led to more elaborate planned and staged performances; video forged an identity separate from mass-media television; and installations developed their own forms related to but independent of sculpture and architecture.

All these aspects have thrust a different level of responsibility onto the spectator; his response and behaviour is brought much more openly into the active operation of the work. Occasionally the activity of the artist puts a very direct responsibility onto the spectator. In a performance by Max Dean, _____ . (1978) (fig. 186), the artist was bound, gagged, and blindfolded. He lay on the floor, attached to a winch by a rope around his ankles. The winch dragged him around unless and until its action was halted by sounds from the audience triggering a sensor. The responsibility for the artist's place, his orientation or disorientation, his comfort or discomfort, was the audience's, first to recognize its own power and second to decide to intervene in the work. Passivity meant the continuation of a spectacle of torture, speaking out stopped it.

The physical intervention of the audience in Dean's _____ . centres the work on the spectator's thought or felt reaction, given verbal expression and measured in quantity not quality. Stephen Cruise's installations (fig. 187) call up

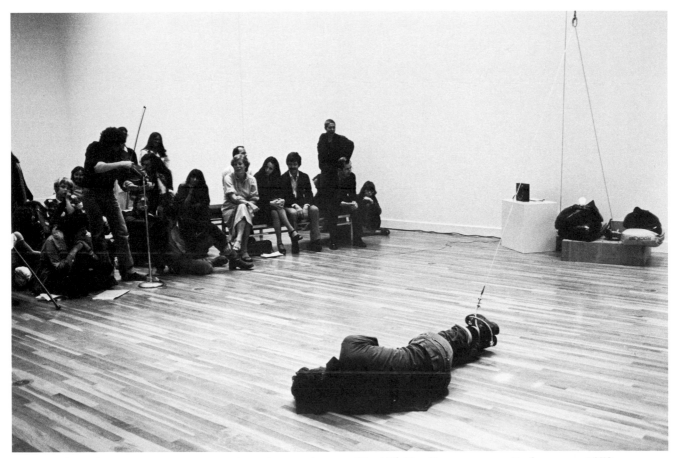

Fig. 186. Max Dean ———————. Performance, 1978.

more tightly focused responses to the relationship between conscious and unconscious reactions to transformations of the interior imagery of his dreams. In the context of art, we often reconcile the diversity of elements by seeking a unifying factor in the artist's intentions. But in fact the responsibility lies in our own self-recognition; we are at the centre of the diversity of the world around us. By evoking the state of dreams Cruise gives external form to a condition that, by our own experience, we recognize as having its only reality within us. He constructs his work through records of his dreams. "Dreams," he has said, "represent clearly the nature of things: a composition of separate parts having no fixed position. They exist, as we, only as a collected whole for

the time being."[12] Unlike the pictorial coding of surrealism, in which the imagery of dreams played an important part, Cruise's work brings out the reality of dreams' objects, with their actual textures, their "real" confusions of "real" scale, and their curious juxtapositions of elements which, centred in our minds, are real.

The issues of reality, of expectations and assumptions about reality, of the relativity of how we understand time and space, have been raised and challenged by artists in many different ways. Eric Cameron's video installation *Keeping Marlene Out of the Picture—And Lawn* (1977) (fig. 188) treats these issues with a wry humour and a

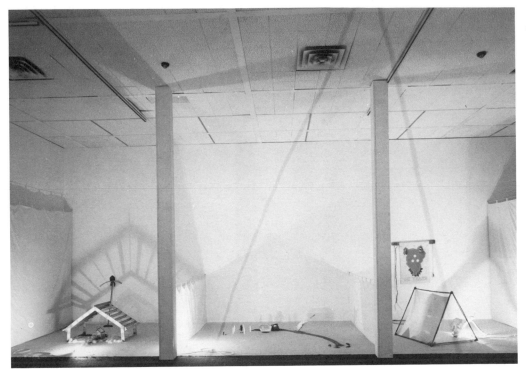

Fig. 187. Stephen Cruise, *Sharkey Sunrise* (detail), 1971–72. Metal, stone, wax, fur, feathers. 3.0 × 9.7 × 7.9 m.

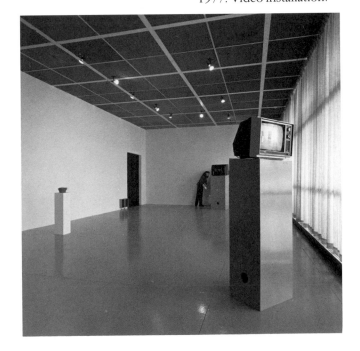

Fig. 188. Eric Cameron. *Keeping Marlene Out of the Picture—And Lawn*, 1977. Video installation.

fine balance of levels of illusion and reality. Three video monitors are set on pedestals and positioned so that we can never see more than one screen at a time. On a fourth pedestal is a pot containing a piece of sod. Stereo speakers amplify recordings of a woman walking across a wooden floor. The monitors show tapes of a room's interior and, intermittently, the woman, whose steps we hear. We can never grasp "the whole picture," because we have to move from one monitor to another, and can never be certain how to co-ordinate the woman's fleeting appearances with the notion of a unified time structure. We have to deal with the content of art not as a seamless artifice but as a series of gaps, broken physically by our own movement, visually by our response to the recorded movements of the woman, and psychologically by our attempts to develop a logical sequence. Our failure to do so is ironically underlined in two ways. First, the pot with the sod refers to a natural sequence of reality—the grass

grows and, in time, dies. Second, efforts to reconcile the fragmented information of the screens and speakers mirror the unstable reality of our actions in the present. We refer to the past— "What happened in the monitor we were just looking at?" and to the future—"Can we understand the whole by moving to another monitor?"

The physical engagement of the spectator in the work and the complexity of real and recorded time are central to the installation works of Noel Harding. Harding began in the late 1960s to make video tapes, first with a single monitor, then with multiple monitors, and from then in multi-media installations of considerable complexity. His *Once Upon the Idea of Two* (1978) (fig. 189), for instance, involves a film loop of an action— whose subject is a narrative about the shooting of the film—and an extension of the setting for that action into an installation. The spectator's presence is picked up by a TV camera and displayed on one monitor, while a second monitor continuously plays the action of the original film. The original film is concerned with the preparations for shooting a film, the various problems that arose, and the strategies used to overcome those problems. The work—which by its very nature defies sequential description—is, in one sense, always a work in progress, at any point unfinished, and at any point completed by the presence and participation of a spectator. It combines the permanent and objective character of art, developed through systems of illusion and always open to the temporal nature of its viewing.

In Harding's subsequent larger installations the formal exploitation of media and of the spectator's presence have been turned directly onto the apprehension of objects and their illusions. *Enclosure for Conventional Habit* (1980) (fig. 190) has three principal elements set parallel: a slowly moving conveyor belt or treadmill against whose movement several live chickens must walk in order to reach a food and water reservoir at one end; a tree in full leaf set onto a trolley and, with a bank of lights, carried back and forth by a pulley

Fig. 189. Noel Harding. *Once Upon the Idea of Two,* 1978. Mixed media installation. Courtesy Ydessa Gallery, Toronto.

system; and a wall of clear plastic behind which are the electrical mechanisms and devices that supply the power for the pulleys, lights, and so on. To view the work is to be surrounded by it; turn your back on one element and you are always facing two others. The work is open to multiple layers of reading, formally, emotionally, and morally. Each of the three elements has its own formal and conventional system to support the intrinsic energy contained in it. The displacement of the spectator's expectations—chickens in an art gallery, a tree that moves—encourages similar displacements in the conventions of life and behaviour. Politically, the work reflects on the strategies of conventions, the harnessing of natural energies and their channeling into conventions of behaviour, into routines and habits, some desirable, others a repression of our freedoms. Our very presence makes a response inescapable; our acceptance or rejection of the work's premise as art binds us, wittingly or not, to it. We cannot escape our own condition nor the conventions which we construct individually and collectively and to which we give expression—whether in

Fig. 190.
Noel Harding.
*Enclosure for
Conventional Habit,*
1980. Mixed media
installation. Courtesy
Ydessa Gallery,
Toronto.

relation to art or to any other aspect of life's experience—in action and opinion.

Harding's development of space in his installations is one in which the viewer is surrounded just by his presence—and by his existence—which he may seek to come to terms with or escape from by distancing his reactions, by constructing ways to objectify his individual experience. For other artists the enclosure of space impresses itself on the viewer, emphasizing the inwardness of experience and the reaction to it. The paradigm of this is Marcel Duchamp's *Etant données,* a piece on which he worked, in secret, for twenty years between 1946 and 1966 and which was only publicly revealed once it had been installed in the Philadelphia Museum of Art in 1969, nine months after his death. Unlike his *The Bride Stripped Bare By Her Bachelors Even* which was all transparency, *Etant données,* made in secret, is perceived in secret, for it can only be seen by a single viewer at any one moment.[13]

The installation works of Betty Goodwin en-

close the spectator in a space, setting up the spectator's awareness, through all the body's perceptions, of its orientation and extension in space. From 1969 she began to work with given objects, vests and tarpaulins, nests and notebooks. Each type of object became, for a period of time, her almost exclusive concern: the vests from 1969 to around 1974, the tarpaulins for about three or four years from 1974 on. In the process of transforming the vests and tarpaulins into art, Goodwin remains acutely sensitive to their original appearance and use, while at the same time flattening, that is, making pictorial, forms whose original purpose was to cover and enclose. The canvas tarpaulins, with their texture, their colour, their seams and patches, are presented like unstretched paintings hanging on the wall (fig. 191). In both these series of works, the artist presents with a fine sensibility common objects constituted as objects of aesthetic regard, without displacing them from their history.

For her *Rue Mentana* project (fig. 192), com-

Fig. 192 (above). Betty Goodwin. *Rue Mentana*, 1978–80. Installation.

Fig. 191 (left). Betty Goodwin. *Tarpaulin #4,* 1975. Tarpaulin, gesso, rope, and wire. 396.2 × 213.4 cm. Vancouver Art Gallery.

pleted in November 1979, she rented a ground-floor apartment at 1005 Rue Mentana in Montreal, and, with Marcel Lemyre as assistant and associate, made alterations to its internal appearance. She constructed new wall systems within the rooms and worked on the existing walls to suggest through them the history of the apartment. In some rooms she left the original wallpaper, in others she stripped it down to the plaster and then worked over the surfaces with graphite to bring out the minute marks and relief of the wall—an

attention similar to the emphasis she gave to the marks and tears and patches of the tarpaulins. In one room the additional wall system formed a passageway between it and the original wall structure. Another room was divided into three areas, a narrow passageway running down the centre, and a "cul-de-sac" on either side. The references to the original room spaces remained clear; the alterations heightened the spectator's awareness of both his or her own presence in the spaces and the sense of the lived-in past contained by the spaces. *Rue Mentana* recreated an environment, one that, in the indifferent and conventional spaces of its original layout, carried its history to the spectator's immediate physical and psychological awareness. The work was documented in photographs and opened for public viewing until March 1980, when it was dismantled and the apartment rented once more as a private home.

Fig. 193. John Massey. *A Directed View (The First Two Rooms),* 1979. Mixed media installation. 4.6 × 14.6 m. Collection Art Gallery of Ontario, Toronto. Purchase with assistance from Wintario and donation from Mr. and Mrs. Bram Appel.

Sensitivity to the space and place of a particular piece also marks the installation work of John Massey, in his case through an explicit focus on overlapping layers of media, scale, and image. Since his first exhibition in 1976, his work has been in building rooms (fig. 193) or adapting existing spaces. At first the rooms were arranged so that they were viewed rather than entered;

> one was held outside, looking through a window or partly-open door (as with *Fire Room* 1976), or kept at the perimeter of the piece by the sheer force or presence of the whole, a kind of theatrical "fourth wall" (as with *Embodiment*, 1976, or the more recent *A Directed View (the first two rooms)).*[14]

Subsequently he began to make installations that were models of large-scale spaces, *A Directed View (the third room) Some Other Union* (1980), being a model of his own studio, precisely rendered in scale and detail except for a full-size speaker set into one wall. A concealed tape loop plays through the speaker a variety of sounds—footsteps, typewriters—and a man and a woman reading texts for Cesare Ripa's *Iconologia*. (*Iconologia* was published in Italy in 1593 and became the indispensable source on iconography for artists in the seventeenth and eighteenth centuries.) The texts which we hear read relate not only to the activity of art-making—the everyday activity of the artist—but also to the conventions of meaning we have inherited which displace our everyday activity into forms of allegory and metaphor.

Two subsequent installations have referred to particular exhibiting spaces; *I Smell the Blood of an Englishman* (1981), to Massey's show at the France Morin Gallery in Montreal, and *Fee Fie Foe Fumm*, to an installation made at the Art Gallery of Ontario in 1981. This latter work (fig. 194) engages the whole space of the gallery with an element in each corner, three of them models of the corners themselves. In *Fee* there is a slide projection of a woman's lips in close-up and a tape of a woman speaking. *Fie* and *Foe* have speakers set into the model's walls. The fourth

Fig. 194. John Massey. *Fee, Fie, Foe, Fumm*, 1981. Mixed media installation. 18.9 × 13.7 × 6.1 m. Collection Art Gallery of Ontario, Toronto. Purchase, 1981.

corner, *Fumm*, has just two speakers set into the gallery's walls. A spectator entering the space causes a sensor to trigger the recorded tapes. The work layers the directness of experience of the space, its focused reflection in the models, and a return to the real space of the gallery through the sounds and texts heard from the tapes. The title (as did *I Smell the Blood of an Englishman*) refers to the giant's rhyme in "Jack and the Beanstalk." *Fee Fie Foe Fumm* connotes "little Jack, the giant-killer" showing his work in a major art institution, and *I Smell the Blood of an Englishman* was an ironic reference to an anglophone's exhibition in Montreal.

The concerns in Massey's work centre around

Fig. 195.
Rober Racine.
Lieux Cités/Cites
(detail), 1981. Mixed
media. Collection of
the Artist.

the conditions of seeing and thinking, of language and the conventions of expression, the situation of the artist in response to the context of his own activities, whether in the privacy of his own studio or in gallery spaces. Massey's work represents some of the most clearly focused of the investigations that many artists in recent years have undertaken in regard to the questioning of art and the artist, of art and the place of the spectator, and to the spaces and systems through which art is viewed. It questions also the conventions of art in relation to life, to the speech and objects, the sounds and space of immediate experience.

Many artists in recent years, for instance, Vincent Tangredi and Rober Racine, have shifted objects to statements, declarations, or texts. In part this shift dispenses with the art object which gathers to it an accumulation of descriptive words that seek to declare its truths or falsehoods. And in part it recognizes the inability of objects to engage directly in debates that are concerned with the experience of living. One of the most exhaustive textural projects is Rober Racine's *Dictionnaires A/Z* (fig. 195). He described the project in this way:

Dictionnaires A is the first presentation of a long series covering several years whose principal aim is the decentralization of the French language as it is found in the dictionary.

He went on to explain further the form in which the exposition of language would be declared:

> We are speaking, then, of an enormous research task which aims at the "spatialization" of History (language and its words), which, by essentially visual, environmental means and various installations, will permit free, bodily circulation around an abstract content; the dictionary of a language as a geographical site.[15]

The work of art in the normal sense is a centred and privileged object on which attention is focused, around which language gathers. What began, in Conceptual Art, as a statement of anti-art and a dematerialization of the object has, in many respects, returned to an object but in a decentred form, a form in which the many ways of communication and their place and meaning within our lives are engaged.

The Uses of Photography

One of the most pervasive developments in recent art has been the use of photography. Along with the expansion of mass-market photography and the influence of mass-media techniques on our images of reality and imagination, has come an increasing interest in the art of photography and in photography as art. Exhibitions of photography have become more frequent events in public galleries, and commercial galleries specializing in photography have emerged. A sensibility towards the history of photography has developed, and if good critical writing on photography is still rare, the proliferation of albums of photographers' work has brought an enormous range of material into easy access.

Since its development, photography has existed as documentation, where the interest is in the subject matter, and as art, where the interest is in the presentation of the image. The difference is primarily one of intention. In many ways the history of photography is inseparable from the history of painting and sculpture. The modern study of art history, for instance, has been substantially built around the development of photography; the comparative methods of art history, the gathering and ordering of evidence, and the communication of that evidence are all but inconceivable without photographic documentation. And the history of painting from the nineteenth century is deeply intertwined with photography. The particular visualization of photography—its framing device and one-point perspective—has been at the heart of painting since the Renaissance. In the seventeenth century the development in Holland of the *camera obscura*, a box-like instrument which projected an image onto a glass screen from which a tracing or grid-transfer could be made, helped formalize landscape and architectural rendering.

Photography itself developed in the mid-nineteenth century and was soon adopted by painters as an aid or as a creative device; the works of Delacroix and Degas are major examples. Some academic artists adopted photography as a technical tool, although the general reaction was one of scorn on purist aesthetic grounds and out of fear—photography seriously cut into the traditional bread-and-butter trade of portrait-painting. But "serious" photographers emulated the subject matter and the aesthetic of painting. In the twentieth century photography has influenced the way we perceive the world, our notion of what constitutes reality, our communication of information. For many artists in recent years these aspects, rather than the production of "fine art" photography, have determined their use of photography. As long as the dominant mode of advanced art was abstraction, photography, by its attachment to representation, had a limited role. But with the criticism of painting and its traditions by Conceptual Art, photography became a means to document a new range of activity and to break the "fine art" aesthetic. To the extent that the Conceptual and Idea art movements have built on approaches first developed by the Dadaists and Surrealists, it is important to recall the uses that

Fig. 196. Les Levine. *Northern Landscape (We are still alive)*, 1974. Coloured oil pastel on paper. 55.9 × 74.9 cm. Collection of the Artist.

Marcel Duchamp and Man Ray made of photography.

A number of artists—Snow, Gagnon, Vazan, Baxter and Massey for example—have used photography extensively in their work. Whether in the abstract work of Gagnon or in the work of realists such as Jack Chambers, Mary Pratt, and John Hall, photography has had a major effect on painters. Michael Snow, in particular, has influenced the way that photography has been used, and so has Les Levine. Levine has written,

> The camera is the extension of the eye. In *camera art* the mind is the tool, whereas in painting and drawing the hand is the tool. *Camera art* is a post-craft discipline.[16]

The place of the artist is not to create something,

> but to allow what is happening to be absorbed by you, the artist, in such a way that you can express it and clarify it. . . .The camera artist has to respond to the underlying cultural anxiety of our society. And somehow he has to shed light on that anxiety.[17]

In *We are still alive* (1975), Levine used drawings and photographs along with a text and video to document his visit to the Inuit community at Cape Dorset, a community economically dependent on its artists, its sculptors and its printmakers (fig. 196). The photographs are, in themselves, banal and matter-of-fact, but with their constant information the accompanying texts reveal the change in Levine's optimistic anticipation of visiting a community dependent on its culture, and his realization of what it actually means for a community to exist not through its culture but because of the demand created for its artifacts. The very "easiness" of the photograph, its indifferent documentation of appearance, stands in devastating contrast to Levine's gradually changing reactions and the interpretation of his observations.

In Vancouver in the late 1960s, Vincent Trasov and Michael Morris, acknowledging the importance of records and documentation of images, founded the Image Bank as an exchange and resource centre of image information through photographs. In Montreal a substantial number of mostly younger artists, centred around the alternate-space galleries Véhicule and Galerie Optica, became involved in a wide range of camera art projects. For some, like Robert Walker, the camera was used "only as a vehicle for communicating an idea or perception." And in Gunther Nolte's *Pagingwire* (1975) (fig. 197) the photograph was simply one element within the whole work. But for other artists, for instance, Suzy Lake, Serge Tousignant, and Pierre Boogaerts, the camera, although still primarily used as an instrument to record an idea, has become a way of giving value to the image itself. The distinction between the camera "as a vehicle for communicating an idea or perception" and as an instrument to create "an object of contemplation" is not necessarily as decisive or sustainable as it may appear.

Pierre Boogaerts moved to Montreal in 1973 from his native Belgium. His series, *Blue Cars and Sky Above Each of Them*, begun in 1976 and continued through to 1980, is composed of related pairs of images, a close-up of part of a blue car and the section of sky immediately above it.

Fig. 197.
Gunther Nolte.
Pagingwire, 1975.
Mixed media
installation. Collection
of the Artist.

The photograph reduces both elements to the common visual scheme—the photograph—and to a common colour. The camera is a recorder equally of the natural and the cultural—the sky as a giant metaphor for transcendence, the vehicle as a treasured symbol of materialist life-styles. This synthesis was more radically expressed in the *Street Corners (Pyramids) N.Y.* (1978–79) (fig. 198). In these, Boogaerts stood at street intersections in New York and shot upwards past the canyons of the buildings to the sky. The sequence of shots, joined together and mounted on masonite, appear from a distance like shaped-canvas abstract paintings. The extreme foreshortening of the buildings frames the sky, stamping it out as a flat and barely modulated shape. The immense but finite size of the buildings and the restricted but infinite depth of the sky are brought to a flat pattern, codified into an aesthetic object, and placed, as we expect of such objects, on a wall. The photograph compresses perception, flattens it, and displays it ambiguously between the photograph's own reality and the reality we *know* it describes.

The ambiguity of perception and the interpretation of vision—often by a contrast between the truth of the photograph and the intervention of the artist—is at the basis of Serge Tousignant's work. Tousignant, who began his career as a painter, stopped painting in 1967 to work first with folded-paper constructions and then with three-dimensional forms in steel and plexiglass, to develop more precise ways to reveal the relationship between perception and illusion. In the early

203

Fig. 198.
Pierre Boogaerts.
*Street Corners
(Pyramids) N.Y.
Lexington and 41ˢᵗ St.* (excerpt
from Part 10), 1978–79. Five
colour photographs. Each
30.5 × 69.9 cm.

1970s he began to use the camera in order to work more directly with and give order to the "givens" of perceived reality. *Environnement transformé no 2, St-Jean Baptiste P.Q.* (1976) is sixteen near-identical photographic images in colour offset. In each image the furrows of a cultivated field reach to a vanishing point in the top right corner. The repetition of the image denies a unified perspective, subjecting the illusionistic parts to a flattened whole. The environment is transformed by the distancing effect of the camera, which in turn is distanced by the formal arrangement of repeated images. Individual identity is lost to abstraction by repetition.

The relativity of perception in its dependence on rational constructions has been particularly finely shown by Tousignant in several series of photographs whose ostensible subject is sets of sticks and the shadows they cast. *Géométrisation solaire carrée* (1978) (fig. 199) is a group of nine colour photographs, in each of which four sticks set in different positions cast a consistent square shadow. The natural illusion is resolved by the camera and the intervention of the artist to form geometric abstractions. Nature, the artist's perception, and the camera join to form the illusion of "absolute" figures of rational description. Boogaerts and Tousignant both question not only our assumptions about vision, but also the procedures by which art gives formal structure to reality. They use photography for its formal capacities and its direct engagement with the world, and raise, in a different form, the tensions that painting, through its history, has sought to resolve.

Sorel Cohen has deliberately appropriated the history of both photography and painting in her series *After Bacon/Muybridge: Coupled Figures 1980* (fig. 200). Her photographs bear two immediate historic references, the first the series of photographs, studies of human and animal locomotion, that Eadweard Muybridge made in the 1880s. One of his series, men wrestling, became the basis of a number of paintings by the English painter Francis Bacon which avoid a resolution between their homoeroticism and physical aggression. Cohen's use of the dispassionate photograph relates to the studies of Muybridge, and through the entangled and often blurred figures she responds to the ambiguity of Bacon's paintings. Bacon's paintings are abstract in their settings and thereby hold a distance from a particular

time and space. Cohen, too, avoids a clear resolution of the figures but the setting is precise—functional and banal. Yet the very clarity of the environment only serves to heighten the uncertainty of our understanding of the figures.

This series of Sorel Cohen's combines the histories of painting and photography. It is at a different level that Geneviève Cadieux combines the immediacy of photography with the traditions of painting. In *Illusion #6* (1981) (fig. 201) she exposed photographs of a dancing figure onto photo-emulsion applied to sheets of plexiglass. These images were then worked on with pigments to achieve an evocative, atmospheric ef-

Fig. 199. Serge Tousignant. *Géométrisation solaire carrée*, 1979. Coloured photographs. 139.7 × 167.4 cm. Canada Council Art Bank.

Fig. 200. Sorel Cohen. *After Bacon/Muybridge: Coupled Figures, Russian Half-Nelson and Leg Scissors* (detail), 1980. Colour photographs.

Fig. 201. Geneviève Cadieux. *Illusion No. 6,* 1981. Photo emulsion on plexiglass, neons and pigment. 182.9 × 487.7 cm. Collection Art Gallery of Ontario, Toronto. Purchase, 1981.

fect. Neon tubes placed in front of the plexiglass cast a blue light, making it seem like sheets of steel, and contrasting strongly with the softness of the images of the dancer.

Suzy Lake lived for ten years in Montreal, as a student and then as a teacher, before moving to Toronto. From the early 1970s she has worked with "staged images for the camera, . . . images as visual information (anxiety, identity, vulnerability . . .), not as pictures."[18] By using herself as the model, she questions the true impartiality of that information. *A Natural Way to Draw* (1975) records the process of making herself up, set out in a storyboard of photographs and in a videotape. We follow through the photographs the issue of individual identity and the process of art, both fraught with unresolved tension between the natural and the artificial. A more recent work, again based on photographs of the artist, is a series *Untitled . . . Are you talking to me?* (1979) (fig. 202), in which she sets up a situation as if the artist and spectator were in conversation. She photographs herself adopting a variety of facial expressions and then prints the images from negatives that have been distorted by twisting and misshaping. In this way she makes the expressions part natural—they are her expressions—and part conventional, responsive to inner tensions that they both reveal and conceal, for we conceal more than we show. Photographically the result is dynamic, both in the image and in our recognition of the dramatic fragment of time that the camera preserves.

The information contained by photographs in their display and their withholding of information is also fundamental to Barbara Astman's work. Unlike Lake, however, Astman works with a carefully developed layering of surfaces. (Her interest in the illusion and layering of surfaces is not restricted to photography. A recent series of small sculptures was made by layering surfaces with pieces of once popular but now discontinued lines of linoleum, garishly coloured in imitation of marbles and stone veneers.) In 1979 she made a

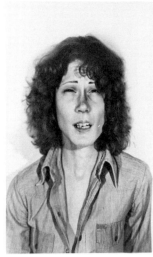

Fig. 202. Suzy Lake. *Untitled. . .Are you talking to me?*, 1979. Mixed media on paper. Private Collection, Toronto.

series of large colour photographs, in which images of herself standing against a red backcloth were overlaid with extracts from typewritten letters (fig. 203). The letters, although personal, are conventional in type and subject matter; they form a screen in front of the image of the woman, while the red drape against which she stands partially screens the darkness behind her. The visual impact of the photograph is immediate; gradually we separate its layers of information. Her own image is cropped so that we cannot fully read her expression, nor can we get more than the gist of the letters, for they are only extracts. She stands, vulnerable but elusive, between the dark ground and the written language, denying real understanding and leaving us literally and metaphorically capable only of reading between the lines.

Nothing could be further from the vulnerability in the work of Lake and Astman than the boldness of Becky Singleton's *"How to . . ."* series. The series shows billboard-sized images of a dispassionate but confident and powerfully feminine model demonstrating simple and everyday actions. The visual image is underlined by a cap-

Fig. 203. Barbara Astman. *Untitled "I was thinking about you,"* 1979. Mixed media on paper. 152.4 × 121.9 cm. Courtesy Sable-Castelli Gallery, Toronto.

tion, impressing an authoritative presence: this *is* the way to . . . (fig. 204). From icons to textbooks to advertising displays, we are used to such declarative messages. Yet by her particular choice of image and action Singleton reveals the ambiguities between "true" statements, questioning their meaning and our assumptions about the meaning of images and the meaning of language.

The meaning of images is indissolubly linked to the associations they raise with other images, in particular the authority vested by references to the art of the past, and the way that our knowledge of art history has been to such a great extent built up through photographic information. In Ian Wallace's *The Constructor* (1976) (fig. 205), photography is used in a way that challenges the traditional narrative of painting. Rather than working from the fixed image of painting, Wallace exploits the potential of photography to assert both the reality of the images and their existence in a moment of real time.

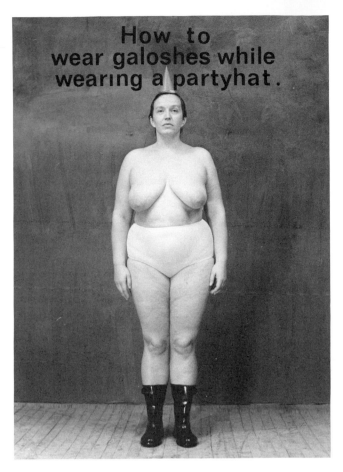

Fig. 204 (right). Becky Singleton. *How to wear galoshes while wearing a party hat,* 1981. Photograph. Collection of the Artist.

Fig. 205 (below). Ian Wallace. *The Constructor,* 1976. Black-and-white photographs covered in photo oils. Five photographs, each 175.2 × 119.3 cm. The National Gallery of Canada, Ottawa.

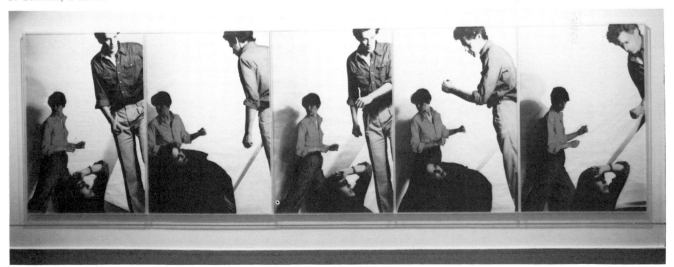

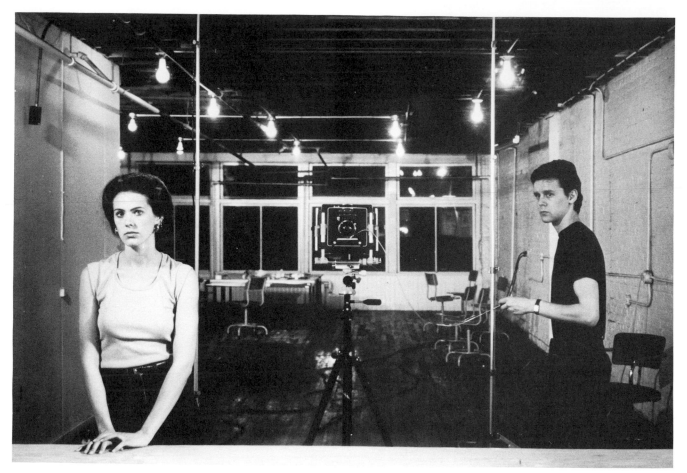

Fig. 206. Jeff Wall. *Picture for Women*, 1979. Cibachrome transparency and fluorescent light. 165.1 × 223.5 cm. Courtesy of the Artist.

For the past five years or so Jeff Wall, following the technique of advertising displays, has created large-scale Cibachrome transparencies, back-lit by fluorescent tubes set directly into a wall or into metal-frame boxes. In an essay entitled "To the Spectator" he describes his work as concerned with subject matter; "I am interested primarily in subject-matter, the art of subjects."[19] The subjects, their particular form determined by the limits of the camera, are staged situations with more or less direct references to images of past art. An immediately recognized reference draws a comparison, a reciprocal reading between the photograph and the original (itself a "staged" situation). If the precise reference is not apparent or available to the spectator, vague associations of familiarity may arise, a feeling of something "right" about the staging. In Wall's *Picture for Women* (1979) (fig. 206), there are references to Manet's *Bar at the Folies Bergère*, Velazquez' *Las Meñinas*, and Richard Avedon's portrait of Penelope Tree. In Manet's picture the mirror behind the girl opens up the space to reflect, imaginatively, our own space. In Wall's work the mirror is

in front of the subject, and the spectator must be excluded from any reconstruction of the space. In *Double Self-Portrait* (1979) (fig. 207) there is a reference to his own image in *Portrait for Women*, but the artist now confronts himself, simultaneously subject and object, divided and in a sense surprised by his own presence. The stagings of the image, in its references to his own work and that of other artists, acts like a construction of language by developing a code or convention of meaning that conceals or partially conceals the meanings from which it has emerged.

Fig. 207. Jeff Wall. *Double Self-Portrait,* 1979. Cibachrome transparency and fluorescent light. 162.5 × 215.9 cm. Collection Art Gallery of Ontario, Toronto. Purchase, 1982.

Notes

1. Michel Ragon, "The Artists and Society," *Art and Confrontation*. New York: New York Graphic Society, 1970; p. 28.
2. Gregory Battcock (ed.), *Idea Art: A Critical Anthology*. New York: E.P. Dutton & Co., Inc., 1973; p. 196.
3. On the Art Bank and federal government support of the visual arts, see "The Canadian Cultural Revolution," *artscanada*, Vol. 32 (Autumn 1975).
4. *Idea Art,* p. 179.
5. Marie Fleming, *Baxter.² Any Choice Works*. Toronto: Art Gallery of Ontario, 1981; p. 90.
6. For an outline of these developments in Canada see Peggy Gale, "History Lesson," *Performance, Text(e)s and Documents* (Actes du Colloque. Performance et Multidisciplinarité: Postmodernisme). Montreal: Les editions Parachute, 1981; pp. 93 – 100.
7. *Ibid.,* p. 95.
8. Peggy Gale (ed.), *Video by Artists*. Toronto: Art Metropole, 1976; p. 196.
9. He did one piece in 1957, *Montreal Island Raft Project.*
10. *Pluralities 1980.* Ottawa: National Gallery of Canada, 1980; p. 97.
11. Lucy Lippard, "The Dematerialization of Art," *Changing: Essays in Art Criticism,* New York: E.P. Dutton & Co., Inc., 1971; pp. 225 – 276.
12. *Pluralities 1980,* p. 46.
13. On Duchamp's *Etant Données* see Anne d'Harnoncourt and Walter Hopps, *Reflections on a New Work by Marcel Duchamp.* Philadelphia: Philadelphia Museum of Art, 1973.
14. Peggy Gale, "John Massey's Essential Realities," *Parachute* Vol. 24 (Automne 1981); p. 5.
15. Rober Racine, *Dictionnaires A.* Montreal: Montreal Museum of Fine Arts, 1982; p. 1.
16. *Camerart avec 24 artistes du Québec.* Montreal: Galerie Optica, 1974; p. 6.
17. *Ibid.,* p. 11.
18. *Viewpoint. Twenty-Nine by Nine.* Hamilton: Art Gallery of Hamilton, 1981; p. 20.
19. Jeff Wall, *Installation.* . . . Victoria: Art Gallery of Greater Victoria, 1979; n.p.

Recent Sculpture

Just as in the fifties painting in Canada brought a widened response to and engagement with new art, in the early 1960s sculpture appropriated, gradually and, on the whole, modestly, the techniques and directions of modern sculpture. Opportunities to show sculpture were limited, the interested and informed audience small. In practical terms, without the support of commissions and collectors, the technical demands, materials costs and even transportation costs meant that sculptors were faced with many more severe problems than were painters. By the end of the sixties, although the situation was by no means satisfactory, there was noticeably more acceptance of sculpture, more incentive in the form of commissions, and more collecting. And since then the character, the range, and the creative originality of sculpture in this country have expanded dramatically.

Internationally, the traditions of sculpture, limited in the range of materials and techniques, closed and dense in form, were broken apart. The demarcation between sculpture and painting, for so long clear and decisive was being challenged by both disciplines. In the 1960s Minimal Art, in particular, so altered the look, the procedures, and the relationships of the spectator to art objects that neither art's traditional appearance nor the language for its description could be sustained. The developments of installation art, site-specific and environmental works, further displaced the norms of previous art.

The American critic Rosalind Krauss has described the procedure of modern sculpture as being, in part, a "decentering."[1] Traditional sculpture, representational in form, evokes psychological responses from the spectator by mirroring his or her own body. A pose, the disposition of the sculpture's limbs, surface details are accepted as somehow expressive of "innerness," of the spirit contained within the sculpture's form. We all have notions of how our external appearance reflects our inner self and so we can project ourselves into sculpture's inert masses of carved stone or cast bronze. Krauss argues that the work of Rodin and Brancusi began to shift the emphasis from "innerness" to the surface, and that abstract sculpture has continued the process. Sculpture still prompts a response from the spectator, not as a projection into the sculpture's mass but as a broader awareness of the spectator's own body and its context. "Yet our bodies and our experience of our bodies continues to be the subject of [minimalist] sculpture—even when a work is made of several hundred tons of earth,"[2]—and even, we may say, where the work is so reduced *as an object* that its very existence is challenged.

In the work of Peter Kolisnyk (fig. 208), the distinction between sculptural activity and painterly activity is eliminated; the characteristics of painting and sculpture are both so reduced that, in essence, they coincide. The form is independent whether it stands free or fixed to a wall in a gallery space, or is set in a landscape or urban environment. What does change, however, is our response to space as it is delineated by the form. The work frames and articulates perception, its exactness of scale focusing our vision, so that we recognize that the experience is not just *in* the work, but in ourselves.

In Kolisnyk's work the sculptural element is reduced to a point where its purity as form and its literal existence predominate over the distinctions we make between sculpture or painting or drawing. Our experience is not substantially affected or qualified by knowing how or of what it is made. Knowing how it is made, however, is an essential aspect of Murray Favro's *Sabre Jet* (fig. 209), a scale reproduction of an F-86 Sabre. Built to just over half-size of the original, it represents a painstaking recreation of both the form and the construction methods of the original aircraft. The

Fig. 208. Peter Kolisnyk. *Three Part Ground Outline*, 1977. Steel and white lacquer. Each part 213.3 × 213.3 × 1.9 cm. The Gallery/Stratford.

Fig. 209. Murray Favro. *Sabre Jet, 55% Size,* 1979–83. Aluminum, steel, fibreglass, plexiglass, hardware. 236.2 × 632.5 × 624.8 cm. Courtesy Carmen Lamanna/Murray Favro.

Fig. 210 (above). Mowry Baden. *Ottawa Room*, 1980. Wood construction. 9.1 × 16.6 × 9.9 cm.

Fig. 211 (right). Robin Collyer. *We can build new belief systems*, 1976. Mixed media. 92.1 × 151.1 × 406.4 cm. The National Gallery of Canada, Ottawa.

original and its reconstruction can be described in material sculptural terms as to external form and the complex infrastructure—mass, shape, implied motion, and so on. But Favro, in recreating the acts of invention and of labour, gives monumental form to the collective conceptual and physical skills of those who originally made the aircraft. His work represents the response of his individual interest and commitment to the collective and anonymous work of the plane's builders.

In contrast to that of both Kolisnyk and Favro, in Mowry Baden's work the sculptural element is a material link between the individual and his experience of space. Baden's *Ottawa Room* (1980) (fig. 210) was constructed for a specific space in the National Gallery. Along two walls and across the diagonal of a room normally used to view pictures Baden built a wooden ramped walkway supported on trestles. The walkway led from the floor of one gallery to just below the floor level of the next storey. It was also canted sideways so that the disorientation of the participant to the room's space was exaggerated by his con-cern with keeping his balance. The traditional character of sculpture—an object defining itself by displacing space—is rendered irrelevant. The walkway appropriates the space of the room and although it conforms to its dimensions, it alters its neutral volume. The spectator is made aware of his inseparableness from the space in which he stands.

Fig. 212.
John McKinnon.
Shooting a Sitting Bird,
1981. Steel. 213.4 ×
213.4 x 457.2 cm.
Courtesy of the Artist.

Another direction in recent sculpture is the development of a narrative chain between diverse objects. Robin Collyer's *We can build new belief systems* (1976) (fig. 211), for instance, is made of four distinct elements: an electric fan, a small metal windmill, an aluminum cross joined to an electric motor, and a short text attached like an identifying label. The fan turns the windmill at 5 rpm and this is synchronized by its electric motor with the rotation of the cross. The text is a quotation from the American astronaut Ed Mitchell, "We can build new belief systems augmented and bolstered by scientific investigation."[2] Applied science—electric motors—brings the movement to the cross and the windmill and holds them in harmony. Technological intervention, motivating the cross and the windmill, brings an equiva-

lent rhythm to religion as a cultural system believed to be natural and the windmills as a cultural harnessing of natural forces.

It is the aspect of narrative that lies at the core of John McKinnon's work. A sculpture like *Shooting a Sitting Bird* (1981) (fig. 212) seems explicitly formal, an interwoven construction of distinct abstract elements. A description of the parts and their inter-relationships seems to bring the work into the range of formalist assemblage sculpture. But somehow the credibility of formal analysis is strained—and the title *Shooting a Sitting Bird* makes such efforts appear absurd. McKinnon has written of his works, "They are based on the idea of forming generalized images with a structural/ skeletal delineation that depicts open-ended narratives."[3] The narrative does not mean a fixed

story any more than the "structural/skeletal delineation" means a fixed formal statement. The combination of form and narrative gives the work many potential readings. The piece can be seen as a fragment, a snatch of movements and actions—approach, concealment, a shot, a bird on the ground. Yet metaphorically, the sculpture is a critical response to modernist formal sculpture and the traditions to which it is linked, as if its formal concerns and its self-referential character were a sitting target.

In ways quite distinct from one another the works of each of these five artists stretch or negate traditional notions of sculpture. The range that their work shows is further expanded, and in many different directions. We can look, for instance, from An Whitlock's use of commonplace

Fig. 213 (left). An Whitlock. *Magic Show*, 1974. Mixed media. 457.2 × 152.4 × 2.5 cm. Collection Art Gallery of Ontario, Toronto, Purchase, 1975.

Fig. 214 (above). John Noestheden. *Black Draft,* 1982. Wood and aluminum. Courtesy Olga Korper Gallery, Toronto.

materials—cloth, string, pins, rubber latex—abstract in form but organic in mood and associations (fig. 213), to John Noestheden's finely fashioned clusters of totemic objects (fig. 214). In each case the experience deflects emphasis from the object-in-itself to the experiencing spectator. In contrast, a whole range of sculpture, developed within the modernist tradition through the 1960s, has been concerned with abstract formal issues, no matter that they may suggest associations and references to figures or landscape.

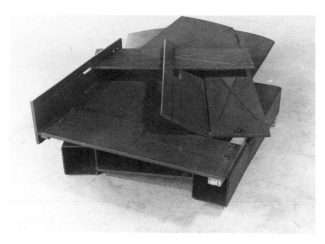

Fig. 215. Henry Saxe. *Radius,* 1982. Steel and aluminum 182.8 × 111.7 × 40.6 cm. Courtesy of the Artist.

Henry Saxe began his career making paintings that were abstract, structured by planes or bands of pure colour gesturally applied. His turn to sculpture in 1964 took two different formal directions. One led to works based on modular interlocked three-dimensional forms, theoretically open to infinite expansion. Some of these were spread across the floor, others attached to the wall, and one series, made of elements linked like a chain, could be rolled up or stretched out flat. The other direction included works in a variety of material forms: steel cable, steel rods, cut plates, sometimes even blocks of concrete. A recent work, *Radius* (1982) (fig. 215) is in massed planes of steel and aluminum. Distinct in shape and size, the elements are welded and bolted. The physical definition of space, emphasized by the heavy material, is opened up dynamically by the spectator moving around the work, synthesizing real and imagined movement as a model of space.

The different uses of steel planes by Robert Murray and by Saxe reflect, within abstraction, a particular range of modern sculpture. Murray treats the material as inherently flexible, accomplishing with curves, changes of direction, and asymmetry an easy, lyrical flow leading to a convincing unity. Saxe, particularly in his most recent

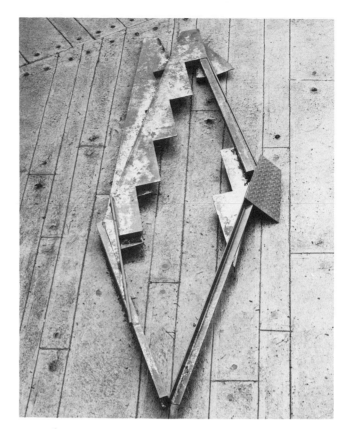

Fig. 216. André Fauteux. *Untitled,* 1978. Galvanized and painted steel. 12.7 × 294.6 × 114.3 cm. Mr. and Mrs. H. Konopny, Toronto.

work, uses more rigid elements—verticals, horizontals, and diagonals—but the structure of their order appears tense, even provisional, as if the abstract concept of the work is pressured by its material.

Another level of contrast can be drawn between two younger sculptors, André Fauteux and Patrick Thibert both of whom work around a basis of open steel frames rather than a construction of planes. Fauteux began working in steel at the beginning of the seventies. His first pieces were composed of a very few elements firmly organized on vertical and horizontal axes. His work has remained based on simple geometric shapes—circles, triangles, diamonds, rectangles,

but from the mid 1970s the variants on those shapes became more complex and the rigidity of their axes was modified, increasing the variety of its viewpoints (fig. 216). He was influenced by the English sculptor Anthony Caro[4] and by the paintings of Kenneth Noland. The critic Karen Wilkin has said that

> Noland's work offered him a way around Caro, a way of avoiding the tradition of collage sculpture, since the elements in a Noland painting never overlapped, but were arranged in parallel or concentric configurations."[5]

The visual unity of Fauteux's work lies in the way in which its asymmetries can always be resolved into the horizontal and vertical planes by reference to the sculpture's basic geometric forms.

In contrast, the work of Patrick Thibert has more rigidly defined structures, based on a limited range of views from each of which the essence of the whole structure is apparent. Thibert's *Trammel* (1979) with its post-and-lintel construction and its structure of enclosure has an architectural character. The title itself is suggestive; a *trammel* is, among other things, a type of fish-net trap, and the verb, *to trammel* means to hamper or confine movement. Within the doorlike structure of the sculpture suspended elements act as baffles as if to prevent egress. This ambiguity between an invitation to enter and a trap, between an element of security and its undermining, is true in a different way of *Fanshaw Cradle* (1981) (fig. 217). The flat and apparently secure plane of the top is supported by a rocking structure. The work lends itself to associations in themselves contradictory—the stability of a table, the rhythm of a teeter-totter.

Formalist painting has a particular strength in Alberta and Saskatchewan, and a similar situation exists in sculpture in those provinces, with artists like Doug Bentham in Saskatoon, Al Reynolds, Peter Hide (fig. 218), Catherine Burgess, Ken Macklin (fig. 219), and Clay Ellis in Edmonton. The participation in the Emma Lake workshops of

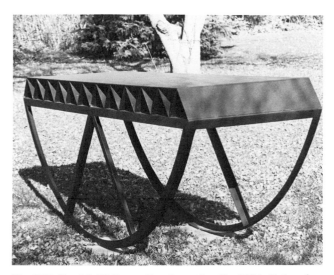

Fig. 217. Patrick Thibert. *Fanshaw Cradle*, 1981. Painted steel. 106.7 × 317.5 × 86.4 cm. Courtesy Olga Korper Gallery, Toronto.

the American sculptor Michael Steiner in 1969, and Anthony Caro in 1977, has established important individual contacts between these artists and the sculptors of the region.

Doug Bentham, in particular, has been responsive to the work of Caro, but he has developed a personal style directly attributable to the environment in which he lives and works. This is explicit in *Prairies* (1973), a major commissioned work for the National Science Library in Ottawa. A structure of sloped, overlapping, steel sheets some thirty-two feet long, it reflects the wide planes and ground rises of the Prairie landscape. Bentham later developed two contrasting series, *Opens* and *Enclosures*, the first a framework construction, the other more planar, both of which expand, through voids as well as solids, from the sloping expanse of *Prairies*. In both of these series the control of planes, the description of space by the definition of edges, the dependence of the work on a principal plane relate the works optically to a pictorial structure rather than to a tactile mass of surfaces and volumes. Working with Caro at Emma Lake opened for Bentham a whole range of new options. With the expanded

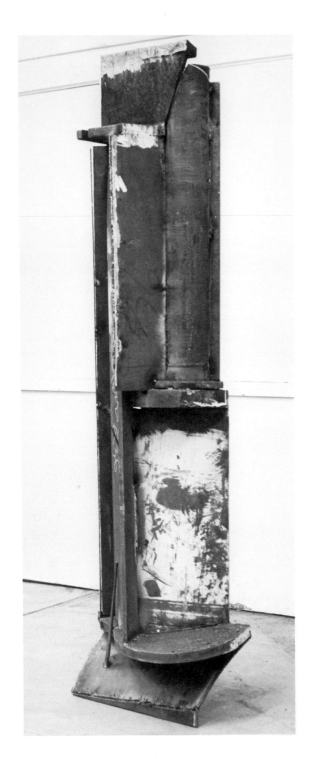

Fig. 218 (far left).
Peter Hide.
Triangle Trued,
1982–83. Welded steel.
259 cm high. Courtesy
Martin Gerard Gallery,
Edmonton.

Fig. 219 (left).
Ken Macklin.
Backyard Roxy, 1981.
Welded steel. Courtesy
Martin Gerard Gallery,
Edmonton.

Fig. 220 (below).
Doug Bentham.
Open Series, Sculpture V,
1977. Welded steel,
painted, 218.0 × 385.5
× 263.0 cm. Collection
of the Artist.

Fig. 221.
Al Reynolds.
Max's Sprawl, 1983.
Welded steel, 30.5 ×
35.6 × 76.2 cm.
Courtesy Gallery One,
Toronto.

Fig. 222 (below).
Catherine Burgess.
Peaseblossom, 1982.
Welded steel, 116.2 ×
130.0 × 58.4 cm.
Courtesy Martin Gerard
Gallery, Edmonton.

variety of his approach, both in pictorial forms and in sculptures more emphatically three-dimensional, has come a free and confident response to the character and potential of the different forms of steel (fig. 220).

Al Reynolds, whose earlier work was principally in wood, has more recently been making table-top metal pieces. His work, like Michael Steiner's, has been described as shaped and fashioned, as opposed to Caro's approach of selection and combination.[6] But Steiner casts from wax forms into bronze, while Reynolds works directly with the metal, bending, forming, cutting, and welding. His enclosed volumetric pieces are broken open on one side, the opening partially enclosed by graphic-like elements that maintain the integrity of the form while allowing for the definition and contrast of the inside and outside volumes (fig. 221). Against the elegance and

flexibility of Steiner's work, Reynolds' work has the toughness of direct contact with the material, without relinquishing a fine sensibility of shape or surface quality.

Anthony Caro's development of an open collage-type sculpture, more optical than tactile, more pictorial than three-dimensional, has had its effect on the work of Catherine Burgess as on that of many others. At the end of the 1970s, Burgess developed constructed masses using roughly hewn chunks of wood. In her recent work, however, she uses cut and pierced sheets of steel to define mass, not with solid blocks of material but through planar volume; shaping the edges and piercing the material to visually link all the elements (fig. 222).

The sculptures of Bentham, Burgess, and Reynolds formally structure space, whether by three-dimensional drawing or enclosure, or by a collage of elements. They construct solid forms and voids to arrive at unified shapes that stand as independent objects in space. The works of David Rabinowitch and Royden Rabinowitch, some of the most original and demanding in recent sculpture, exist within very different orders of approach. During the 1960s, the Rabinowitches were living in London, Ontario, where their work was first shown, and they were included in the National Gallery's *Heart of London* exhibition in 1968. Since the early 1970s they have both lived in New York and exhibited widely in North America and Europe.

The formal structure of a relatively early piece by David Rabinowitch, the *Eight Sided Pipe in 2 Sheets* (1967) (fig. 223), is simply described. Two sheets of steel are each formed into a five-sided trough and bolted together to form a single eight-sided unit. The viewer's perception of a single structure comprised of two equal elements is a procedure of abstraction from his experience of the whole work's mass, weight, relationship to the ground, length and depth and width, inside

Fig. 223. David Rabinowitch. *Eight Sided Pipe in 2 Sheets,* 1967. Mild steel blued. 243.8 × 30.3 cm. Collection Art Gallery of Ontario, Toronto. Purchase, 1981.

Fig. 223a.
David Rabinowitch.
*Metrical (Romanesque)
Construction in 5
Masses and 3 Scales #2,*
1977–78. Hot rolled
steel in 5 sections.
203.2 × 175.3 × 5.1 cm.
Collection Art
Gallery of Ontario,
Toronto. Purchase with
assistance from
Wintario, 1978.

and outside, seen from the total complex of the views he takes. These issues are further concentrated in *Rotational Sculpture of 4 Scales* (1969–74), a solid cylinder of cold-rolled steel seven feet long and six inches in diameter. Along its length four holes are drilled with four scales of bore, 3/16", 1/2", 3/4", and 1", the three smaller ones towards one end, the one-inch hole towards the other. The cylindrical shape, suggesting the rotation of the sculpture, defines one direction or dimension; its length gives a second direction or dimension at right angles to the first, and the drilled holes, at right angles to each of the other two, define the third direction or dimension. But the positioning and changes in scale of the bored

holes establish very specific relationships to the position of the spectator. The totality of the piece (a cylinder of steel drilled with four holes, placed on the ground) is given from every point of the spectator's view, but the totality of its perception is a multiple of separate acts.

Metrical (Romanesque) Construction in 5 Masses and 3 Scales #2 (1977–78) (fig. 223a) is much more complexly developed.[7] Five slabs of solid steel, six inches thick, each different in shape, are abutted to each other, their maximum combined dimensions enclosed within a fifteen-foot square. Three of the masses have holes of three different bores drilled in them. In the earlier pieces the overall shape, a cylinder or a pipe of a

223

certain section, can immediately be described. Here, although the overall dimensions describe a square, we do not perceive the work as a form within a form. Each of the five elements can be seen clearly from every vantage point, but differently; a new configuration of the whole is described from the perspective of the viewer and from the articulation of the drillings, which themselves refer both to the masses' surfaces and their depth. Roald Nasgaard has described the multiplicity of perceptions and the clarity of the whole as follows;

. . . it is not as if the world dissolves into an irreconcilable succession of unique appearances; the possibility of unity is known because at all times and in every position, all the facts of the sculpture's material composition are always fully available to the observer.[8]

Royden Rabinowitch distinguishes between "a sculpture with a wide range of views" and one "meant to be examined from many viewpoints."[9] In the first case the primacy of optical perception is assumed; in the second the total awareness of the spectator, not simply to a form but of himself as a body in space, is assumed. Space is not conceived as a void that may be filled by objects, but a reference to our perception of the world as comprising multiple and direct experiences of discrete elements. We organize those perceptions in rela-

Fig. 224. Royden Rabinowitch. *Barrel Constructions (Double curvatures at right angles 'F'),* 1963–64 (Remade 1983). Used whiskey-barrel staves. Six barrels in length. London Regional Art Gallery, London, Ontario.

tion to certain properties, for instance that of closed and open properties, the orientation and direction of planes, symmetry and asymmetry, top and bottom, left and right.

Barrel Construction (Double Curvature at Right Angles 'F') (1964–65. Remade 1983) (fig. 224) is one of a series of works Royden Rabinowitch made from the curved wood staves of barrels. Here the staves are laid adjacent to each other with the flat circular elements of the top and bottom set at each end. A reference to the original object as an enclosure of volume of a particular shape and uniformity remains, but it is a concept that stands distinct from the direct experience of the work as it is presented to us. It is, at one level, critical of the widespread sculptural practice of transforming found materials. That approach is substantially dependent on our holding a sense of ambiguity between the original "object" and the "object" into which the found materials are transformed. We shift between one concept and another.

Rabinowitch's work breaks open any such ambiguity. He denies any sort of pictorial transfer between the image of the original form and the sculpture. A "sculpture with a wide range of views" emphasizes the object apart from its context. A sculpture "meant to be examined from many viewpoints" sets the responsibility onto the spectator, who must take up a viewpoint and through that, at any moment, project himself and his perspective into the world.

A work like the steel floor sculpture *5 Right Limits Added to a Developed 6 Manifold* (1981) (fig. 224a) describes two types of elements: a manifold—an asymmetrical polygonal steel plate bent or creased to form a series of angled planes—and a number of "limits" variously shaped steel plates of different thicknesses—which are added to the manifold. The manifold rises up a few inches from the ground to a point, formed by the bending of the plate. *5 Right Limits* refers to the fact that, from the highest viewpoint, the additions and their greatest thickness lie to the viewer's right.

Fig. 224a. Royden Rabinowitch. *5 Right Limits Added to a Developed 6 Manifold*, 1981. Steel. 327.7 × 144.8 × 6.3 cm. Collection Art Gallery of Ontario. Purchase, 1981.

Rabinowitch develops the sculptures as "bodies," they have a "handed" character, a left and a right; they have a top and bottom, the bottom being the manifold, the top the "limits;" they can be open or closed, open by the manifold, closed by the limits; they contain all directions, horizontal, vertical, and diagonal; and they are asymmetrical through all these directions. Although a particular work may be described and titled as from one particular viewpoint, it is open to many viewpoints. Rabinowitch's sculptures exist separately and independently of us and, as Rabinowitch has written, they "always appear to be at a great distance."[10] We apprehend the works as bodies in space, as we are bodies in space, limiting the manifold of our experience by our particular viewpoint so that "our understanding of the world is based directly on our acting in it."[11]

Royden Rabinowitch's work is not so much about an object *imposed* in space as it is *of* space, of the content of space. In this, as in other ways, his work contrasts with that of many sculptors who are concerned with the nature of an object imposed in space, separated from other things perhaps, but attached by association to the natural, the organic, or the figurative.

Walter Redinger is one such sculptor. He has worked extensively with cast fibreglass, a material that determines no intrinsic form, that can be

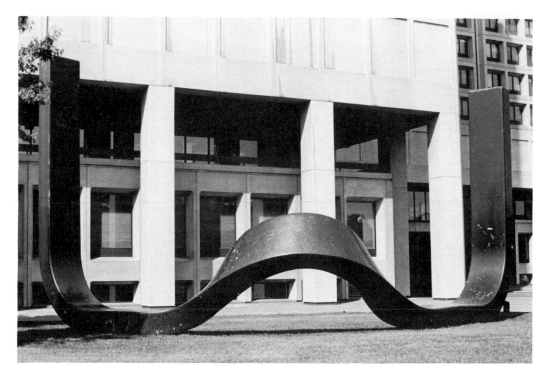

Fig. 225.
Hugh Leroy.
Untitled, 1973.
Laminated fibreglass
and blue pigment.
853.4 × 701.0 cm.
Department of National
Defence, Ottawa.

used to suggest the solidity of stone, the volume of welded steel, or a soft and viscous material. The surfaces can be made smooth or rippled and the edges sharp or gently rounded. An early piece like *Spermatogenesis no. 1* (1969) (Canada Council Art Bank) appears soft and semi-fluid, its mass reacting to gravity, its shape organically suggestive but undefined. Subsequent works have been made of multiple elements, groupings of shaped blocks that may stand piled up like an *inukshuk* or lie like fragments of an ancient structure. *1929–1984* (1973–74) (fig. 226) comprises thirty-two individual elements, but they seem like the elements of some machined structure, in which each form should have a corresponding element permitting construction into a unified totality. In this work, as in others, the fibreglass blocks are interspersed with steel frameworks, presenting an ambiguous assembly of machine-manufactured parts and skeletal forms dispersed amongst petrified objects.

Redinger, Hugh Leroy, and Ed Zelenak have been involved in a number of public works and have all chosen to work in fibreglass. The lightness and flexibility of the material, and its inexpensiveness in comparison to steel, have made possible the creation of ambitious works in a scale compatible with architecture and outdoor settings. Leroy's *Untitled* (1973) (fig. 225), placed on the east side of the Department of National Defence building in Ottawa, is made of laminated fibreglass painted blue. The vertical elements, reaching to twenty-three and twenty-eight feet and set in contrasting planes, are linked by a curving horizontal section. The flow of the piece responds to both the verticals of the buildings and the slope of the ground, yet its emphatic shape and colour assert its independence from them. Zelenak has undertaken a number of large-scale public works in Stratford (fig. 227), in Ottawa, Kitchener, Waterloo, and Scarborough, Ontario, and elsewhere. While his Scarborough piece

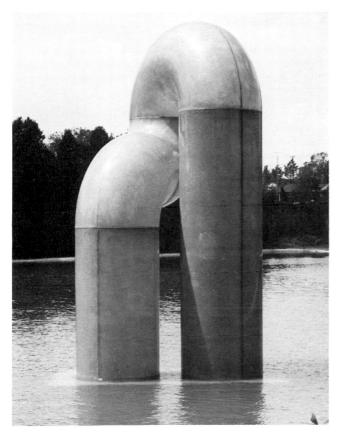

forms an arch, the others are variations on enclosed forms of curved or twisted fibreglass tubes; the title *Convolution* aptly describes the complexity of the piece in Waterloo.

The abstraction of Zelenak and Leroy is an assertion of the freedom of form to displace space, while the work of Fauteux and Thibert is articulated within the openness of space. In very different ways, the work of Mia Westerlund, Roland Poulin, and Claude Mongrain presents a more rigorous notion of the imposition of objects in space. All three artists explore the deliberate and essential relationship between the notion of

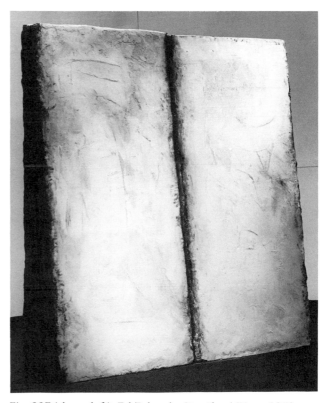

Fig. 227 (above left). Ed Zelenak. *Stratford Piece,* 1972. Cast fibreglass. 792.5 × 152.4 × 342.9 cm. The Gallery/ Stratford. Gift of Rothmans of Pall Mall Canada Limited.

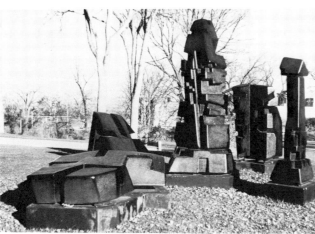

Fig. 226 . Walter Redinger. *1929–1984,* 1973–74. Fibreglass. Five sections, 320.0 × 701.0 × 579.5 cm. Canada Council Art Bank.

Fig. 228 (above). Mia Westerlund. *Muro Series IX,* 1976. Concrete and pigment. 199.5 × 190.5 × 32.0 cm. Collection of the Artist.

the sculptural object and the density of its material. All three have made extensive use of cast concrete, although in the early 1970s Westerlund was using fibreglass and polyester resin.

Westerlund, in giving up the flexibility of fibreglass for cast concrete, shifted emphasis from a sculptural presence to a pictorial interest in surfaces. She colours the surface of the concrete with pigment while it is still wet and sometimes embeds sheets of copper into it. She raises the concrete slabs vertically, developing a wedge form to give them stability and allowing them to stand freely in space (fig. 228).

Westerlund's change from fibreglass to concrete was from a material open to infinite possibilities, one in which scale does not bear an essential relationship to weight and mass, to one which is intractable, where weight and mass are critical. It was a move from a material whose commercial uses are generally superficial, coverings for machinery and the like, to one which is fundamental to the structure of urban development. Her response was to work with the given character of the material, but to make it stand independently as an object, and to use it not to bear weight but to carry the markings of her working, thereby emphasizing its unique existence. To some critics this emphasis on the pictorial has diminished the sculptural integrity of the fibreglass works, although Westerlund's more recent block-like forms have been well received.[12] In these, she cuts and grooves into the mass, opening up its density, revealing its intractability. But to see this simply as a shift from the pictorial to the sculptural is to miss the point of the development of the work, of the process of coping with the material, and of recognizing in the process its sculptural character.

To examine the development of Westerlund's work is to be made aware of her questioning of the process, and the difficulties of the decisions she has made. Roland Poulin's work thrusts the discomfort of decision-making onto the spectator. After leaving the Ecole des beaux-arts in Montreal in 1969, Poulin's first "structures" were made by laser beams. But after 1972 he began to work with solid material, sometimes wood but more frequently (in recent years exclusively) cast concrete beams. The sculptures are arrangements of the beams in square, rectangular, or, occasionally, triangular shapes. But if the beams frame regular shapes, they are not themselves regular or symmetrical in plan or in height.

In *Lieu* (1980) (fig. 229), the beams are laid two deep on three sides; the fourth side is enclosed by a single member, and the inner beam on one side stops short, breaking the regularity of the enclosed shape. We expect the outer square to be echoed by the inner space, but the experience of the work is ambiguous and unsettling. The square is broken by the shorter inner beam and the sculptural form is irregular because on one side there is only one beam. What actually and physically exists compromises our expectations of the inner shape and we see the concrete elements as an imperfect definition of that concept.

The tension in Poulin's work lies in the discomfort of the spectator and his need to adjust a concept of what he believes is described—a square, a rectangle, a triangle—to the actual appearance of the work. In Claude Mongrain's sculpture there is no simple synthesized concept;

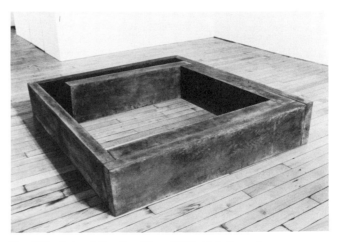

Fig. 229. Roland Poulin. *Lieu,* 1980. Reinforced concrete. 163.0 × 161.0 × 32.0 cm. Collection of the Artist.

tension arises directly from the materials and their arrangement. Mongrain assembles a complex and tenuous balance of common industrial materials—wood and concrete and steel—held by their own inertia, although sometimes elements are bound together with pieces of wire. The works of the mid 1970s, made with the sort of materials found on a building site, occasionally seem to parody structure. More recently, as in *Construction (Méditerranée)* (1979) (fig. 233), in white concrete whose shapes he cast himself, the balance of the work has shifted from an assemblage of order—however tenuous—out of the disorder of objects found in the world, to the construction of fragments that seem as if they could be part of some larger order. It is as if to say that we can only work with what we have, and our capacities are always partial and imperfect. The materials and their shapes—slabs, beams, columns—do suggest the ordered structure of architecture. The whiteness of the concrete, and such titles as *Construction (Méditerranée)* and *Construction: Italie* point towards the architecture of a particular history. We are the inheritors of that history but we are irrevocably separated from it.

The histories of sculpture and of architecture are, in many respects, inseparable. Sculpture could be the cause of architecture, to shelter a venerated object, or architecture the stimulus for sculpture, to articulate or decorate or give iconographic focus. Architecture, like sculpture, may impress us aesthetically as an object in space. In more recent years, however, many artists have seen the relationships between architecture and sculpture in terms of enclosures for living and working or occasions of interaction. In an installation like Betty Goodwin's *Rue Mentana* the sculptural and the architectural experience are indistinguishable. A different approach to this relationship occurs in the installations of Elizabeth Ewart (fig. 230). While they are specific to a particular site, and architectural in their formal structure, the definition of the work lies in the distinc-

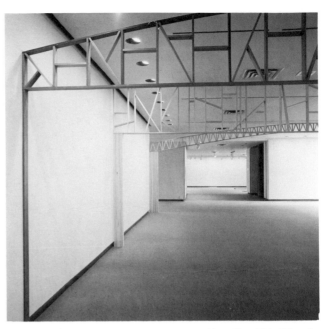

Fig. 230. Elizabeth Ewart. *Installation* (detail), 1981. Wood. 4 units, each 11.2 m.

tion—both of contrast and harmony—between the installation structure and the architectural space.

Melvin Charney works from a very different viewpoint, that of the collective social impact of architecture. Charney is an architect whose interests and activism have involved him in a wide range of projects responding to the relationships between people and building structures. Although his 1967 design for the Canadian Pavilion at the Osaka World's Fair was not executed, its innovations brought him substantial notice. His interests also include the historical and formal development and appearance of the urban environment, in particular, the relationship between buildings and the street and the interaction of urban living within that relationship. His installation *Une histoire d'architecture: Le trésor de Trois-Rivières* (1975) includes a structural façade and photodocumentation of vernacular architecture in Trois Rivières. His concern was not with the pretensions of architectural style but with the

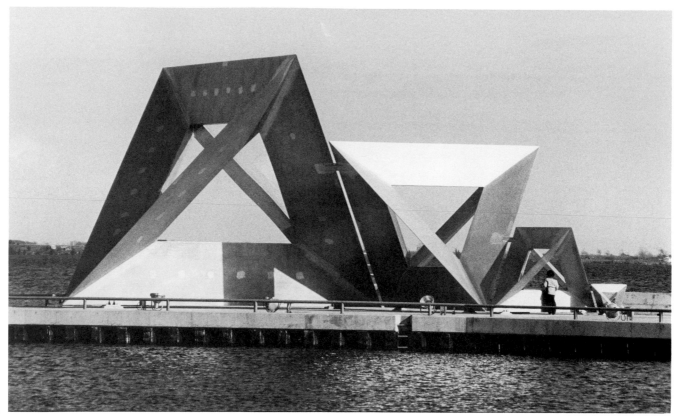

Fig. 231. Ted Bieler. *Tetra,* 1976. Aluminum. Four tetrahedrons: 10.1, 6.7, 3.4, 1.1 m high. Dedicated to the Kingston Tercentennial Project by the Government of Canada.

relationship of structure to the emergence of an urban landscape.

Charney's most controversial project was the 1976 Olympics event of CORRIDART, a collaborative project, of which he was the motivating and organizing force, involving many artists working along a five-mile stretch of Sherbrooke Street in Montreal. Constructions, documentation, and events celebrated the history of the street. It was ambitious, innovative, and original—and underfunded; even with the support of the artists it could not be properly realized. Then, without warning, before the games opened, Mayor Jean Drapeau had the whole project dismantled.

The more formal relationships between sculpture and architecture are developed in the work of Roland Brener and Ted Bieler. Bieler has been involved in a number of architectural projects, one of the most unusual and innovative being his collaboration with the architect Eberhard Zeidler for a hospital at Whitby, Ontario, where the design of the building was developed as a sculptural entity. In addition he has undertaken a series of commissions for public buildings, including *Tetra* (1976) (fig. 231) for Portsmouth Harbour in Kingston, Ontario, and *Canyons* (1978), an aluminum relief work at the Toronto Transit Commission's Wilson subway station.

Since he began making major sculpture in the later 1960s, Roland Brener has worked with standard industrial materials requiring little modification. This has led him to strongly formal struc-

tures like *Sculpture on the Theme of a Portable Monument Using Angle-Iron, Nuts and Bolts* (1979) (fig. 232). He has referred to his work as being "within the Constructivist tradition" and the similarity between his recent work and that of the Russian Constructivist architect Konstantin Melnikov has been noted.[13] Brener seeks a balance between the work's formal structure and the symbolic character of architecture. He has spoken of hoping to let

the work shift between its symbolic quality as a ziggurat and all the historical and cultural significances woven to that form, and a transparent structure, in which the component forms break down and re-assemble themselves as you move through it.[14]

The conceptual precision and structural simplicity of his work is visually complex, offering a baffling profusion of elements both from inside and outside.

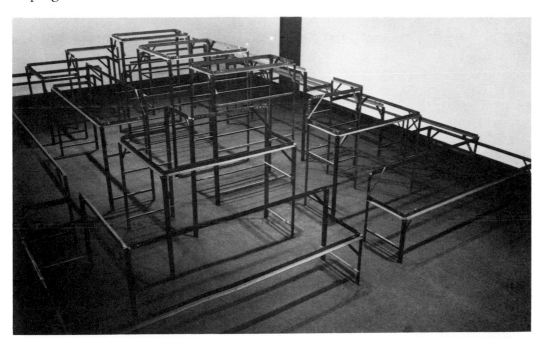

Fig. 232.
Roland Brener.
Sculpture on a Theme of a Portable Monument using Angle-Irons, Nuts and Bolts, 1979. Steel. 9.1 × 6.2 × 1.8 m.

Fig. 233.
Claude Mongrain.
Construction (Méditerranée), 1978. Concrete. Ten sections, 70.0 × 178.0 × 357.0 cm. Canada Council Art Bank.

Fig. 234. Judith Schwarz. *Forest Room*, 1982. Cedar lattice. 365.8 × 213.4 × 213.4 cm. S.L. Simpson Gallery, Toronto.

Fig. 235. Mark Gomes. *Untitled*, 1980. Steel, wood. 2.7 × 1.2 × 2.7 m. The Isaacs Gallery, Toronto.

Mark Gomes and Judith Schwarz draw more emotionally charged relationships between sculpture and architecture. Schwarz's structures (fig. 234) relate both to landscape and interior spaces and imply the notion of both shelter and passage, but of passage into a fantasy. Many of Gomes' sculptural installations are also concerned with the notion of passage. The references to ancient structures—pyramids and ziggurats—draw on the concept that was, in essence, their purpose, passage from finite space and time to the infinite, although in some works, for example, the blocked entrance-like structure of *Untitled* (1980) (fig. 235), the sense of passage can be turned into a prohibition of entrance or an experience of disorientation.

A more severely abstracted relationship to architecture occurs in the work of Delio Fonseca.

Gate (1982) (fig. 236) comprises two equivalent elements, one vertical, the other horizontal. The immediate association of one with a doorway and the other with a floor suggests a certain behavioural response, a reference to known experiences, but the abstraction wrenches the work out of any context and leaves the spectator curiously disoriented.

In all of these relationships between sculpture or installations and architecture, the references have been to architecture as an element of symbolic or metaphoric stability. These interests and associations simply sharpen the statement of the Québecois sculptor Armand Vaillancourt's massive fountain sculpture, *Je me souviens* (1969–71) (fig. 237) made for Embarcadero Plaza, San Francisco. Covering a surface one hundred and forty by two hundred feet it stands up to thirty-six feet

high with fifteen feet below grade. The work is rimmed by an elevated highway, and looks like a result of some massive disaster or a warning of physical or cultural upheaval. In appropriating the structures, the history, or the social and behavioural characteristics of architecture, sculpture has broken open its boundaries.

The notion of the installation that relates to sculpture and painting and architecture, and yet is wholly none of them, is most fully explored in the work of Renée van Halm. Her three-dimensional structures are based on the architecture found in the paintings of the early Italian Renaissance. The structures, built in wood and often with relief elements formed in plaster, are painted with bright clear colours similar to those of early Renaissance paintings. The scale of the structures is crucial. In the old paintings the figures are invariably very large compared to the architecture, which gives the scenes the character of theatrical set pieces marking the crucial moments of a narrative. Van Halm's structures, too, have the character of theatre in their simple establishment of space, open to a range of views but effectively projected frontally. In scale they would supply an adequate support as a setting for figures but still allow the figures to dominate. They seem to anticipate the presence of figures. In her most recent

Fig. 236 (above). Delio Fonseca. *Gate* 1982. Steel, wood. 223.5 × 203.2 × 238.8 cm. Sable-Castelli Gallery, Toronto.

Fig. 237 (right). Armand Vaillancourt. *Je me souviens*, 1969–71. Fountain-sculpture and mural. 10.9 × 42.6 × 60.9 m, 4.5 m below grade. Embarcadero Plaza, San Francisco.

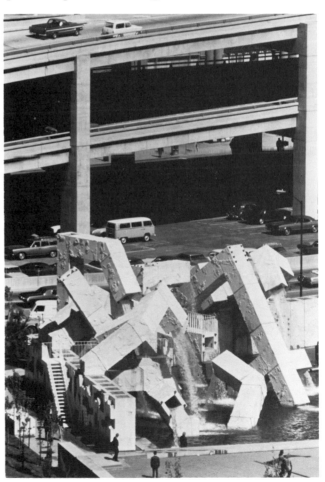

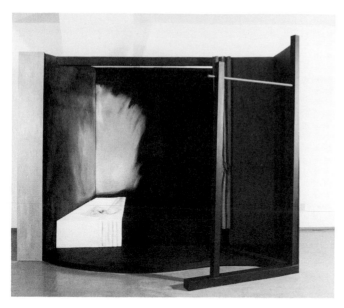

Fig. 238. Renée Van Halm. *Upon Awakening She Becomes Aware*, 1983. Painted wood. 2.4 × 3.2 × 1.9 m. Collection Art Gallery of Ontario, Toronto. Purchase, 1983.

works van Halm has begun to include a human presence, if only as a suggestion in the title or limited to disembodied hands lying on a pillow (fig. 238).

Van Halm's work stands between the implication of the figurative in a conventional context and the real presence of the spectator. The suspension of narrative, and references to the layers of illusion, the illusions of theatre and painting and sculpture, create the tension of the work. Just as painting in recent years has come increasingly to deal directly with the figure, so sculpture has followed a similar course. It has been suggested that the new figurative sculpture owes more to New Realist or Photo-Realist painting than to contemporary sculpture. In other respects, new forms of figurative sculpture, particularly some of those using body-casting, one of the most ancient sculptural practices, have arisen independently of those approaches to painting. Jasper Johns and George Segal, for instance, were working with casts from the figure in the 1950s, well before the

Photo-Realist painters came on the scene. Their interests were more closely related to the multi-media events and happenings of the later 1950s than to painting. And it is in relation to the context of process and even of performance, not painting, that the work of Colette Whiten has arisen.

Whiten had already begun to make castings from the human body before her graduation from the Ontario College of Art in 1972. Up to 1975 the emphasis lies more in the process and the performance of making the work than in the final cast product. The performance centred around the complex structures she made to hold the figures while the fibreglass casts were being made. These structures, although developed to ensure efficiency and comfort, are nevertheless forbidding in the way they trap the body and emphasize its vulnerability. *Structure no. 8* (1972), reminiscent of medieval stocks, is an arrangement to hold four figures with iron belts around their waists; they touch only at the fingertips. The process of the work was recorded by photographs and in a film.

Whiten chooses to use friends or members of her family as models, and the essence of her work, for which the structures are the form and the casts the product, lies in its expression of these relationships. Because of their very strength and power as objects the structures tend to dominate. Instead of being devices made for a specific project, they appear capable (as indeed they are) of being used time and again and so, in a sense, they belie the intimacy and uniqueness of the process.

The resolution of this problem came with *Untitled (February) 1975*. A brick wall was built around the figure, leaving a general but sharply constructed outline of him. The other side of the wall was plastered, giving a more rounded, though still general, silhouette. The structure and the image therefore co-existed, a resolution brilliantly realized later that year in *September 1975* (fig. 239), with the first of the "mummy case" figures. Here the whole figure is cast in two moulds, one for the front, the other for the back,

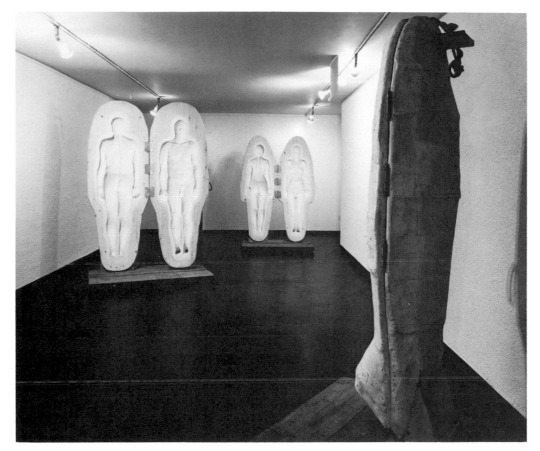

Fig. 239.
Colette Whiten.
September 1975, 1975.
Plaster moulds,
fibreglass, wood, metal.
Three units, each 86.2
× 58.5 × 33.7 cm. The
National Gallery of
Canada, Ottawa.

and the moulds are then enclosed in a hinged case. Instead of the general silhouette of *Untitled (February) 1975* we are presented with precisely detailed impressions of the figures. Although the figures are moulded into the plaster, they appear to project forward in relief. The work hovers between the double negative—the absence of the figure and the recessed mould—and the double positive—the physical structure of the work and the illusion of human presence. Subsequent to this Whiten made a number of works of friends, of herself, and members of her family, in which their plaster impressions are set into a plywood surround and propped up, rather like a canvas on a painter's easel. More recent pieces, like the *Paul* series (1980), cut the outline of the figure free

from any surround; the impressed side is rubbed with graphite which further sharpens the illusion of presence within the negative mould.

Whiten's work, especially prior to 1975, has been compared with the work of the American, George Segal. But the comparison cannot be pressed too far. Segal's figures are invariably elements of a tableau, abstracted presences within an abstracted but everyday context, like a suspended moment. As Segal has said, "My biggest job is to select and freeze the gestures that are most telling so that if I'm successful. . .I hope for a revelation, a perception"[15] In Whiten's work there is no narrative, only an intense focus on the presence and absence of people, on literal and figurative impressions, and the values of relationships.

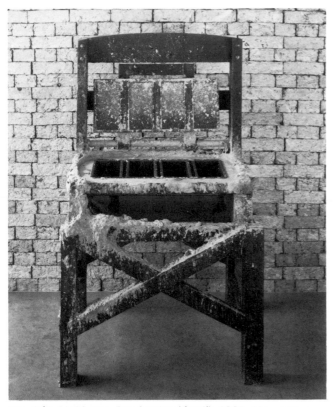

Fig. 240. Liz Magor. *Production* (detail), 1980. Newspaper, wood, steel. Each brick: 20.3 × 10.2 × 5.1 cm; machine: 81.3 × 61.1 × 134.6 cm; wall: 335.3 × 31.8 × 167.6 cm. Courtesy Ydessa Gallery, Toronto.

The notion of the process is also integral to the work of Liz Magor. For *Four Boys and a Girl* (1979), she first constructed a wood and metal structure to compress cloth fibres and grass clippings with glue. She produced five slabs of the compressed material, each different in dimensions but all generally of a human scale. The process of the work engages a complex of metaphoric associations to transformation: a reduction of natural and manufactured fibres to a single form, metaphors of life and death, of figures pressed from the same mould, a reduction of individuality to a generalized equivalence, and the archaeological association of compressed layers transformed by time. In a subsequent work,

Production (1980) (fig. 240) the transformation of materials points to the recording, codifying, and processing of experience. In a moulding device Magor made bricks of soaked and compressed newspaper. From these she constructed two walls, with the mould-maker standing for the absent worker between them. The bricks vary in colour, tone, and individual texture and on them we catch glimpses of the information the papers held, the events to which they referred transformed into the conventions of writing and now transformed again into material with which to build.

Richard Prince has also, in recent years, made sculpture by body-casting. His work has a fine wit, an unexpected combination of forms and associations that are resolved poetically rather than naturalistically. His use of body-casting is abstracted at several levels. First he uses only sections of the body; second, he shows the casts

Fig. 241. Richard Prince. *Casting the Constellations; Monoceros*, 1980. Fibreglass, reinforced plastic, steel, aluminum. 222.0 × 104.0 × 31.0 cm. Collection of the Artist.

236

as shells; and third, he generalizes the forms, simplifying the details so that we are not, as in Whiten's work, made aware of a particular person. In *Casting the Constellations; Monoceros* (1980) (fig. 241), the torso of a woman is attached to a slim metal arc to which are attached small light bulbs. She is casting a constellation, as she herself is cast. The word *Monoceros* is the name of a constellation, but it can also be thought of technically; *cero* (or *Kero*), the Greek word for wax, refers both to the plasticity of the material and the ancient practice of inscribing wax tablets.

Prince's generalization of the human form relates to the classical tradition of figure sculpture. Evan Penny's work also engages the long tradition of figure sculpture, the goddess image of the standing figure isolated on a pedestal. But there the comparison ends, for Penny's figures are wholly unidealized. And the most effective of them, like *Janet* (1979–80) (fig. 242)—modelled, not cast—are scaled down from life-size, thus holding a fine tension between the immediacy of their impact and a sense of distancing that gives them a matter-of-fact confidence, discomforting to the spectator.

There can be no comparison between this mild discomfort and the response raised by the work of Mark Prent. The basis for much of the work is done from body-casts, often of himself, or casts of objects, but they form only the starting point for the imaginative and fantastic process of Prent's work. The process itself, the modelling of the forms in polyester resin and the application of colour, is carried through with striking virtuosity (fig. 243). Prent's work derives from man's long history of fascination with the grotesque, with the details of death and infirmity, with the horror of the recognizably human, grossly victimized or distorted. In Prent's work, as in life, the reactions of humour and of horror often stand close together. The fascination with horror has devel-

Fig. 242. Evan Penny. *Janet*, 1979–80. Polyester and oil paint. 121.9 cm (three-quarters life size). Courtesy Wynick-Tuck Gallery, Toronto.

Fig. 243. Mark Prent. *Bondage* (detail), 1975. Fibreglass and polyester resin. Life size. Canada Council Art Bank.

(fig. 245) it is the relationship between the figures that becomes the subject of the work; the notion of the "gang" with their adoption of personas that cannot, however, conceal the natural ordering of a group into a hierarchy.

The figurative in recent sculpture in the work of ceramic artists, such as Gathie Falk, Joe Fafard, Russell Yuristy, and Glen Lewis, contrasts sharply with that of Prent. In technique and in the choice of his subjects Fafard's work directly reflects folk art traditions. When he went to teach at the University of Regina in 1968, Fafard was working in kinetic sculpture. Becoming dissatisfied with this, he began to make portraits in plaster, satirical

Fig. 244. Joe Fafard. *Maggie Okanee*, 1979. Ceramic. 42.0 × 38.0 × 23.0 cm. Art Gallery of Hamilton. Gift of the Volunteer Committee and Wintario.

oped its own practices and genres; waxworks are one example, and movies have essentially developed it into a sub-culture. It has become increasingly apparent in the work of many recent artists in Europe and North America, most notably in the work of Edward Kienholz—to whom Prent has acknowledged an important debt. "Becoming aware of Kienholz's work gave me a tremendous amount of confidence," he has said.[16]

The disturbing effect in Prent's work is heightened by the acute concentration, in almost every work, on the isolated figure. In Sherry Grauer's sculpture, *Dogface Boys' Picnic* (1973)

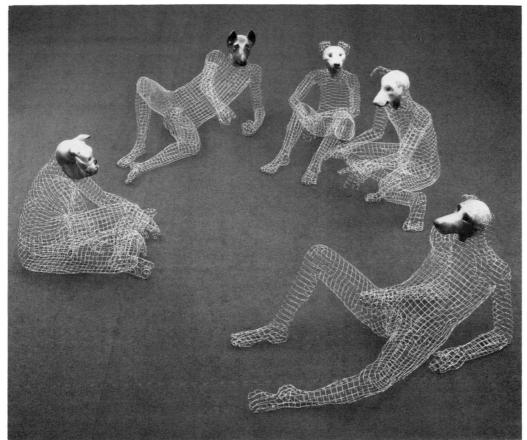

Fig. 245.
Sherry Grauer.
Dogface Boys' Picnic,
1974–75. Wire mesh,
fibreglass, putty,
styrofoam, acrylic. 91.4
× 254.0 × 304.8 cm
overall. The National
Gallery of Canada,
Ottawa.

reflections on the arts, and turned to work in ceramic as a result of his contact with David Gilhooley, the American ceramic sculptor who taught in Regina in 1970-71. The subjects of Fafard's plaster portraits were his colleagues and others associated with the arts. His move to ceramics, however, broadened his range of subjects and his work became a response to the life and people of the community in which he lived, deliberately rejecting the sophisticated concerns of the art world (fig. 244).

Gathie Falk's work defies categorization. Everything she has done, whether in performance, sculpture, or painting, is wholly her own, a personal mixture of fantasy and memory bound into an acute sensitivity to everyday life. She has worked extensively in ceramic, although among her most ambitious sculptural works are two herds of twenty-four carousel-type horses cut from plywood, one painted in dark tones, the other drawn in pencil. Rather than stressing the mechanics and bright colours of the thundering carousel herds, Falk's monotone herds are lightly suspended above the ground, seeming to move (particularly *Herd Two* (fig. 246), the pencil-drawn horses) with a ghost-like presence. Falk's work, though so singular, is presented with the directness of folk art in its invention and literalness. A similar sense of sheer delight in invention and ingeniousness of craft is common to the work of artists like Victor Tolgesy, Alex Wyse (fig. 247), and Claude Luneau, each of whom has developed

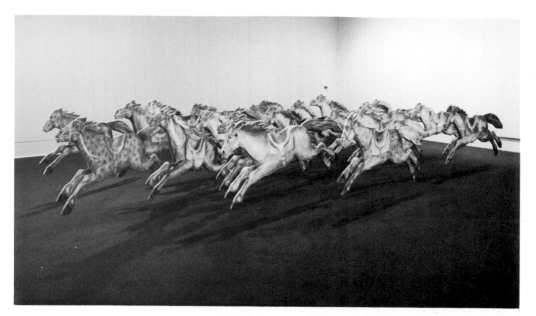

Fig. 246. Gathie Falk. *Herd II*, 1975. Pencil, eraser, white undercoat enamel on plywood. Twenty-four units, each 78.7 × 124.5 × 1.9 cm. The National Gallery of Canada, Ottawa.

Fig. 247. Alex Wyse. Installation view, *Pluralities 1980*. The National Gallery of Canada, Ottawa. Mixed media. Various sizes.

his own cast of fantasy characters, in toy-like sculptures or weird machines.

Artists such as these have deliberately turned from modernism to the universality of folk art. For George Sawchuk there has been no question of turning away from the mainstream traditions of art, but rather of discovering that his interests, values, and means of work were similar to those of others. Sawchuk, born in Kenora in the late 1920s, has lived in British Columbia since 1945. He worked as an itinerant labourer in his early teens and, while working in the forests, began making wooden toys and constructions of found objects—for instance, a door handle screwed into a tree, or a length of lead pipe driven through a tree. Meeting with Iain and Ingrid Baxter radically changed his outlook, as he realized that the things he was doing were a form of artistic expression. He has continued to make pieces with found objects, but in the later 1960s he also began to build movable sculptures, combining carved wood structures and found objects. Moral or political issues are expressed through visual puns that, in pieces like *Treasury Department* (fig. 248), make their point with humour and clarity.

Murray Favro, like Sawchuk, displays a directness of approach and disregard for art as the construction of specialized and internally motivated languages. "There is already," Favro has written, "too much made-to-measure art work, calculated to fit neatly on to the end of art history. This work is caused by having too specialized an interest in art only."[17] But his viewpoint is both subtle and profound, one that unites his desire to invent and the natural forces which invention harnesses.

His major works have taken two principal forms, one of installations and projections, the other the construction of free-standing objects, of which *Sabre Jet* (fig. 209) is the most complex and ambitious. The projections explore the relationship between seeing and understanding, in order to reveal illusion and the creation of illusion. In *Synthetic Lake* (1973) (National Gallery of Can-

Fig. 248. George Sawchuk. *Treasury Department*, 1979. Wood, brass, and plexiglass. 162.5 × 58.4 cm. Courtesy of the Artist.

241

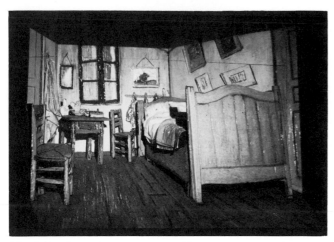

Fig. 249. Murray Favro. *Van Gogh's Room*, 1973–74.
Painted wood, 35 mm slide, projector. 213.4 × 365.8 cm.
Collection Art Gallery of Ontario, Toronto. Purchase, 1975.

ada), a length of canvas, on which a film of lake-shore waves is projected, is laid over a mechanized wooden construction. The mechanism of the structure rhythmically and progressively raises and lowers the canvas, approximating the illusion of movement in the projected film. *Van Gogh's Room* (1973–74) (fig. 249) is a simulation of the painting by van Gogh. The objects in the room are three-dimensional, but are constructed according to the perspectival distortions of the painting, and a slide of the painting is projected onto them. The complex and eccentric nature of the construction is only partly resolved by the illusion of the projection. Favro has said,

> The observation I made after the first few [projection pieces] was the involvement of image and underlying object in everything we look at. By being able to see they are overlapped, it is easy to observe how you involve yourself in making the piece work.[18]

The artist does not attempt to recreate the original exactly, but rather, through the activity of invention, to broaden our understanding of reality and illusion.

Constructions such as *Sabre Jet* are founded on Favro's interest in and admiration for the sheer capacity of invention. But again the issue is not simply the reproduction of something that, in its original form, worked, but rather the celebration of man's capacity for creation.

Favro's impatience with "made-to-measure art work" is paralleled by the concerns of Juan Geuer. Geuer, in seeking to understand the natural world and its forces, equates scientific understanding and aesthetic demonstration (fig. 250). He worked for many years at the Dominion Observatory in Ottawa, and his knowledge of scientific investigation, of the relativity of its certainties, led him to give equal value to systematic scientific knowledge and its revelation as artistic experience. He has written,

> in a technological society one cannot admit the jungle However I had found out that among certain scientists this was different. They . . . knew about . . . nonrationality and about the constant proximity of the jungle. There is always that reference to something else. Each body of knowledge is an "ens ab alio", or as they put it, "No discipline can justify its own existence by its own methodology or systems."[19]

Norman White's interest is in working machinery, and the effects that can be gained from the energy of light and sound. He has described himself as "a tinkerer of philosophical bent," one who in mimicking natural mechanisms tries "to sharpen my own awareness of their profound subtlety. The only results I can look forward to are frustration and wonder."[20]

Artists like Favro and White and Geuer, in their use of technology, have at very different levels forced a recognition of a broader perspective of art's purpose. Other artists have approached art through a more formal use of the manufactured aspects of technology. A number, for instance, Zbigniew Blazeje, Don Jean Louis, and, in particular, Michael Hayden, have made sculpture with fluorescent light and tubes. In many respects, however, the new technologies which from the 1960s onwards many artists have

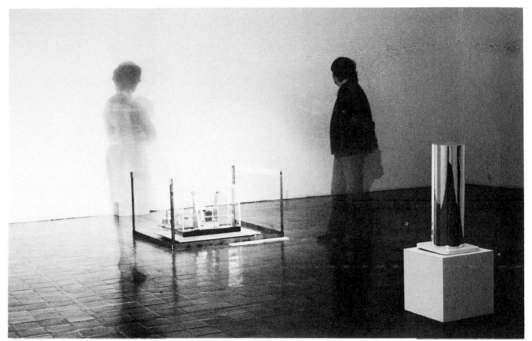

Fig. 250.
Juan Geuer.
A People Participating Seismometer, 1980.
Mixed media installation. Collection of the Artist.

Fig. 251 (below).
Robert Bowers.
Untitled, 1980. Steel, wood, paint. 533.4 × 487.6 × 137.1 cm. Courtesy Grunwald Gallery, Toronto.

enthusiastically taken up, have rarely realized their potential. Artistic ventures in these areas often appear weak reflections of their industrial models. Much more meaningful is the range of perspectives raised by artists like Murray Favro or Noel Harding whose works comment so sharply on human values.

The values of much of the best new sculpture lie in the disjuncture between the physicality of the object and the response of the spectator. The work forces us to contemplate the gap between our innerness and the "innerness" we allow objects, a gap that contrasts the dynamics of our response to the inertness of objects; it makes us recognize the relativity of our position in the world and our understanding of it. This is done with a surreal humour in Robert Bowers' work—disturbing the commonplace and domestic in a way that wrenches objects from our simple use of them (fig. 251).

An open understanding of that relativity is precisely what arises in the work of John Mc-

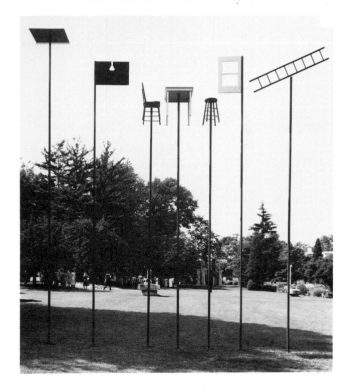

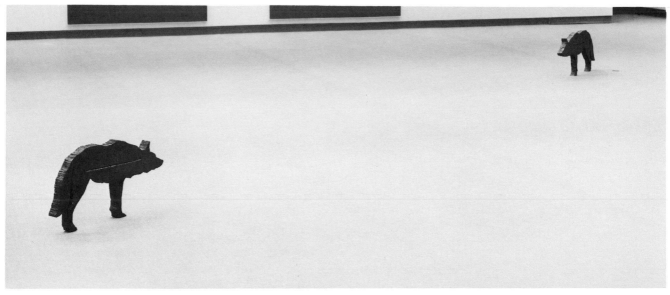

Fig. 252.
John McEwen.
*The Distinctive Line
Between One Subject and
Another*, 1980. Flame-cut
plate steel. One unit, 116.0
× 54.5 × 6.4 cm; one
unit, 116.4 × 55.5 × 6.4
cm. Collection Art Gallery
of Ontario, Toronto.
Purchase, 1981. Courtesy
Ydessa Gallery.

Fig. 253.
Reinhard Reitzenstein.
Sky Cracking, 1982.
Aluminum and steel. 254.0
× 373.3 × 1.3 cm overall.
Collection Art Gallery of
Ontario, Toronto.
Purchase, 1982.

Ewen. In *The Distinctive Line Between One Subject and Another* (1980) (fig. 252) we find, immediately, layers of paradox in the scale, the material, and the image itself. The scale of the wolves is smaller than life, and therefore distances their appearance in our perception. They exist as two objects separated from each other, but related by the distance between them. The forms themselves, flame-cut from steel so as to show how the material has been worked, are emphatically physical, yet they seem like shadows, with no fullness in their bodies and no internal detailing. Only one element breaks that shadow/silhouette; each wolf has a line grooved horizontally along its side. It is like a sign of the distinctive but imaginative line between them, a line built in the imagination and drawn taut by the figures' watchful, testing poses. They are each at the same time a subject projected towards the other, and an object of the other's attention, and both are objects of our attention.

McEwen's first works had been Conceptual in form and approach but he became dissatisfied with the actions and procedures such an approach meant; a point well described by Ian Carr-Harris when he wrote,

> The problem [of meaning] for McEwen lies in the nature of ideas. Their insubstantial facility and their easy manipulation is a familiar dilemma, and one which the artist came to view with considerable suspicion . . .[21]

But, as Carr-Harris goes on to say, McEwen's concern for art is related to seeking knowledge about experience, a "search which irrevocably must be based on ideas."[22] His sculptural works have responded with a simplicity of means but an acute calculation of the tension among the immediacy of the physical world, the associations these offer to the imagination, and the synthesized abstractions that constitute the fullness of experience.

Reinhard Reitzenstein has worked, through a wide variety of media, in ways that bear on the relationship between the natural and the cultural

Fig. 254. John Greer. *TV Idol Time*, 1981. Granite and steel. 187.9 × 66.0 × 35.6 cm. Courtesy The Isaacs Gallery, Toronto.

245

and the development of signs that become the basis for myth. In *Sky Cracking* (1982) (fig. 253) materials from the earth—steel and aluminum—are transformed into heavenly signs—lightning and the moon—that in their reference to the cyclic balance are, in mythic terms, characterized as the male and female principles. In contrast to this level of abstraction, John Greer's work lies in reverses of meaning and mixed metaphors of verbal and visual puns. *TV Idol Time* (1981) (fig. 254), an obvious play on the words "idol time" and "idle time," plays further on the associations of "idol" by raising a stone sculpture of a television on a pedestal. The value of the image lies more in the medium than the message, and the polished screen gives a shadowy reflection of the spectator on its smooth, blank surface. This work, as so many of Greer's pieces, is humorous and sharply ingenious in its switches between words and images, illusions and allusions.

Notes

1. Rosaline E. Krauss, *Passages in Modern Sculpture.* Cambridge, Massachusetts: The MIT Press, 1981.
2. Philip Fry, "Robin Collyer; Event, Description, Narrative," *Parachute* 20 (Fall 1980), p. 44.
3. *John McKinnon: Steel Constructions.* Toronto: Mercer Union Gallery, n.d. [1983]; n.p.
4. Fauteux worked as an assistant to Caro in the fabrication of Caro's York University pieces in 1974 and 1975.
5. *André Fauteux: Ten Years.* Kingston: Agnes Etherington Art Centre, Queen's University, 1982; pp. 9 – 10.
6. Kenworth Moffitt, *Michael Steiner.* Boston: Museum of Fine Arts, 1974; n.p.
7. See Roald Nasgaard, *Structures for Behaviour.* Toronto: Art Gallery of Ontario, 1978; pp. 15 – 18.
8. *10 Canadian Artists in the 1970s.* Toronto: Art Gallery of Ontario, 1980; p. 15.
9. *Ibid.,* p. 87.
10. *Ibid.*
11. *Ibid.,* p. 14.
12. Peter White, "Mia Westerlund's Pictorial Sculpture," *Parachute* 13 (Winter 1978); pp. 36 – 38.
13. *Pluralities 1980.* Ottawa: The National Gallery of Canada, 1980; p. 40.
14. *Roland Brener.* Stratford: The Gallery, 1979; p. 5.
15. Lucy Lippard (ed.), *Pop Art.* London: Thames and Hudson, 1966; p. 102.
16. *Prince, Prent, Whiten: Figurative Sculpture.* Kingston: Agnes Etherington Art Centre, Queen's University, 1981; p. 17.
17. *10 Canadian Artists in the 1970s,* p. 48.
18. *Ibid.*
19. *Fascination Feast. Constructions by Juan Geuer.* London, Ontario: McIntosh Gallery, n.d. [1979]; n.p.
20. Mayo Graham, *Another Dimension.* Ottawa: The National Gallery of Canada, 1977; n.p.
21. Ian Carr-Harris, *John McEwen, Real Sculpture.* Lethbridge: Southern Alberta Art Gallery, 1979.
22. *Ibid.*

Recent Painting

It has been common in recent years to announce the death of painting. Since the late 1960s painting as a practice, with all that that implies of intention, meaning, ambition, and purpose, has been under attack, and the assumption that it was at the leading edge of new art has been challenged. The attack, in particular, has focused on modernist painting's aesthetic and formal preoccupations and the assertion of its determined historical role. The challenge has come in part from painters themselves, but more fully from artists working in Conceptual Art, in video, performance, and installations, in all the practices of art and critical writing described by the term "Post-Modernism." It is a challenge that has displaced style by content, rejected the values and expectations of modernist art, and engaged itself directly with political and social issues, with communication, with self-identity, and the binding and divisive natures of human relationships.

At the extreme, modernist painting and sculpture have been described as a "stupendous marketing accomplishment," one based on collaborations within the art system, of market-place exchange with the support of critical and historical validation:

> Painting and sculpture were reduced to style, which could be changed on schedule and—probably for the first time in history—the so-called art history needed to hype the work's economic value was produced and packaged at nearly the same time and place as the art.[1]

The same writer, John Stocking, goes on to dismiss "pluralism" as a cover-up

> for the obviously repressive nature of the avant garde academy's distribution stranglehold. How could one find anything but a "pluralist" scene, after the deliberate invention and promotion of several dozen "original new styles" in the last twenty-five years?[2]

But from a broader viewpoint the situation is not unusual nor is its solution clear cut. In the later 1950s writers and literary critics frequently announced the death of the novel, but, as one of the would-be executioners has written,

> When God dies, the Death-of-God theologians have been discovering recently, the Gods are reborn—monotheism being replaced not with atheism but polytheism. Similarly, when the novel dies, it leaves behind not a vacuum but a proliferating swarm of competing sub-genres, each clamouring for its right to independence and recognition.[3]

Painting, however, has not only continued, but its parameters have expanded beyond the range of a particular sense of historical precedent. The new painting coming from Europe, especially from Germany and Italy, has had substantial effects on painting in the United States and Canada. This reassertion is by no means free of the brief tyrannies of fashion. And despite the enthusiastic declarations of a "return to painting," there can be no return to a condition that is ignorant of all that has happened in art through the 1960s and 1970s.

This point was firmly underlined by the Royal Academy of Art's 1981 exhibition, *A New Spirit in Painting*, which gathered together work by European and American artists ranging in generation from Picasso (born in 1881) to Julian Schnabel (born in 1951), and in approach from the cool abstraction of Brice Marden to the expressive figurative painting of Mario Merz. The purpose was to "stimulate a new reading. . .[and] once again draw attention to the art of painting."[4] The continued vitality of painting was presented as surviving "the avant-garde of 1970s with its narrow, puritan approach devoid of all joy in the senses, [which] lost its creative impulse and began to stagnate."[5]

The issue, however, cannot simply be one of retrieval or dismissal. In the past fifteen or twenty years the claim for painting as an autonomous and indivisible entity has often been denied. Painting's survival lies in its very eccentricity and openness, rather than in a myth of its inalienable

Fig. 255.
Ron Moppett.
Siren Song 2. Journey from Nowhere to Nowhere, 1980. Oil on canvas. 162.0 × 302.0 cm. Alberta Art Foundation, Edmonton.

progress. Recent painting must be examined not as illustrating critical positions, but in its diversity and contradiction, in order to recognize the values of individual choices.

The dominance of formal abstraction in the 1960s seemed to exclude serious consideration of figurative work. But many painters, for example Claude Breeze, Bruce Parsons, Ron Moppett (fig. 255), and John Hall, whose training in the 1960s had taught them to see abstraction as the epitome of advanced art, began to turn to figurative work. Others, such as John Clark and Charles Pachter, whose work has always been figurative, found that the different perspective afforded them a shift in values.

In 1962–63, Claude Breeze, who studied first with Ernest Lindner in Saskatoon and then with Arthur McKay and Kenneth Lochhead in Regina, turned from abstract painting to making figurative paintings, responding to Pop Art, but also to Willem de Kooning's *Woman* series. In 1964–65 he did a major series of paintings on the theme *Lovers in a Landscape*. Brilliantly coloured, loosely and freely painted, they are explosive pictures

both in manner and subject matter, and disturbingly ambiguous in their position between the natural relationship of human sexuality and landscape, and its distortion in violence and exploitation. In this series, as in others, Breeze drives a deep division between conventional and superficial response to aspects of our world and the reality of its situations. His *Home view (TV series)* (1966–67) criticizes the detachment of the media-informed audience from the actual events of suffering and violence. His most extensive series, the *Canadian Atlas* (fig. 261), parodies man's thoughtless assumptions about the land and his ambiguous or indifferent relationship to the natural environment.

Bruce Parsons' work exemplifies the changes of approach and interests affecting so much art through the 1960s and 1970s. He graduated from the Ontario College of Art in 1961 and from 1963 to 1968 was a curator at the Dunlop Art Gallery in Regina. He attended several of the Emma Lake workshops, notably with Kenneth Noland, Jules Olitski, and Frank Stella, and his work through the 1960s was of large-scale colour-field paintings. But he began to question the dominant hold

of post-painterly abstraction, especially after he joined the faculty of the Nova Scotia College of Art and Design in Halifax in 1969. There he entered "a cultural milieu without interest or support for the kind of modernist painting that had dominated the cities in which he had previously lived."[6] His work became diversified into object pieces, installations, video, and photoworks. And his paintings, though still abstract, stood critically against the catch-phrases of formalist abstraction. He began to use vinyl rather than canvas as a support, in effect sandwiching the design between two sheets of vinyl to obtain a wrinkled and translucent surface. This sort of soft packaging of abstract design countered the principles of painting's autonomous, self-supporting flat surfaces. And he emphasized the point by having some pictures propped up against the wall with a long pole. He explored his interests in myth and dreams and the transformations of symbolic imagery in various media. In 1979, two years after returning to Toronto, he began a series of works done on baskets, in a combined painterly-sculptural form. These works (fig. 256), which have the character of a folk-art craft, deal with the potential of images to evoke the notion of magic, or of ancient beliefs; to raise the private images of dreams; or to express the conflicts in the co-existence of technological and natural societies.

Parsons has responded to the variety of regional interests of the major art in those places where he has lived, as well as reflecting the interests of advanced art, first in its breach with painting and then its re-engagement. The idiosyncrasy of his work is similar to that of many artists through the 1960s and 1970s who refused to restrict the range of their views of the world to the discipline of specialized form. For others, however, the nature of art-making remains wholly bound to continuous pressure on the limits of a particular enterprise. And for an artist like Jacques Hurtubise this has meant an unwavering pursuit of the bonds between self-expression and the personality of style.

Fig. 256. Bruce Parsons. *Black Ladder*, 1980. Painting on basket, wood. 76.2 × 35.5 × 7.6 cm. Private Collection, Toronto.

Fig. 257.
Christian Knudsen.
Diptych #3, 1980. Mixed media on paper and masonite behind plexiglass. Two panels, each 121.9 × 97.8 cm. Collection of the Artist.

After graduating from the Ecole des beaux-arts in Montreal in 1960, Hurtubise spent a year in New York, where he eventually spent much of the decade. His painting immediately reflected the energy, the boldness and the scale of New York Abstract Expressionism. But while accepting the validity of Abstract Expressionism's "accident" of paint drips and spatters, Hurtubise sought to reconcile his desire for full colour and free gesture with a more deliberately structured surface. He experimented with various means: stencils, reversing the negative and positive elements, even for a time using fluorescent tubes and working with fluorescent paint. In the mid 1970s he began to build paintings from square canvas modules as in *Simonne* (1975) (fig. 262), painting them, arranging and rearranging them, and painting over them again, allowing the process of work to determine the final size and format. In the past few years, however, he has concentrated more on the full sweep of gesture and the action of drawing. These works are without compromise, inheritors of Abstract Expressionism, undeniably sensuous and exuberant.

At the other end of the spectrum of abstract painting is Louis Comtois. Although he is now living in New York, the basis of Comtois' work arises from the context of formal abstract colour painting in Montreal. He has had a deep respect for the work of Fernand Leduc, and his own painting depends on strong colour but subtle shifts in light values. Paintings such as *Distortion in Orange* (1979) (fig. 263) actually divide the picture into panels. Changes of colour intensity within the individual panels give overlapping readings of the surface both as abstract structure and as movement through colour-light values.[7]

When through the 1970s many young artists in Montreal began to work on installations, conceptual art, video, and photography, they appeared to some people to be breaking with a Montreal sensibility. A number of the best younger painters—for instance, Leopold Plotek, Christian Knudsen, Christian Kiopini, Jocelyn Jean, and Richard Mill—did however continue with modes of formal abstraction, but they did so while critically re-evaluating the issues on which modern painting in Montreal had been based.

Their work is based on geometric abstraction, but they emphasize the materialness of painting, rather than the smooth, all but textureless surfaces of the more senior painters. Against a uniform geometric structure they actively integrate texture and colour and shape. Against the definition of space by colour they open up a variety of approaches to pictorial illusionism.

Jocelyn Jean's paintings with their layered geometry and their emphatic encaustic surfaces seem to turn back the efforts of painters in the 1950s to gain and seal a flatness of surface. Jean's approach to geometry seems to take on the character of gesture. Christian Knudsen, also working with layered geometric forms (fig. 257), seems more concerned with the conflict between the rationalness of geometry and the intuitive process of painting. The formation of a work comes through successive layers of geometric drawing, fields of paint, and, sometimes, overlays of collage. As one layer suggests continuation to the next, so it may in part be covered over, encouraging a sort of vibration of balance across and into the surface.

In Leopold Plotek's paintings (fig. 267), the

Fig. 258. Christian Kiopini. *Ecran #3*, 1982. Acrylic parlatain on plywood. 2.4 × 3.5 × 1.7 m (installed). Collection Art Gallery of Ontario, Toronto, Purchase, 1983.

shapes emerge from a dark modulated ground, projected forward by their contrasting tones and overlapping. This tension in the projection from the ground is further spread across the surface by the eccentricity and asymmetry of the shapes. The images seem to come to the threshold of figurative identification as if, by an act of will, we could give them precise identities. The emergence in Christian Kiopini's paintings, by contrast, reinforces their determined abstraction. His earlier paintings, large-scale and dark in tone, were subtly articulated by internal geometric divisions. His most recent works have projected their illusionistic structure into three dimensions. At their most radical, as with *Ecran #3*, 1982 (fig. 258) they do not simply stand out from the wall, but are developed in overlapping planes of cutout shapes. Instead of drawing the forms forward as though into real space, the illusion is that of taking them from real space and reconstituting them into the single plane of a picture.

If these painters approach the formal, plastic issues of a certain tradition of painting in Montreal, they do so critically. Louise Robert's work, as related to past painting in Montreal, refers not to Plasticien geometry but to the gestural abstraction of the Automatistes, to their expression of freedom through direct action. The freedom the Automatistes claimed was to break from the rigid structures—pictorially, socially, philosophically—in which they found themselves. The gestures of the work constituted in themselves the authenticity of their freedom. In contrast, Robert's painting in the mid 1970s was like an illegible correspondence, strings of slopes and curves across the canvas and, later, words scrawled, crossed through, or partially erased like writing on a blackboard. It is as if Robert shows painting as a space created for the purpose of carrying significant statements, to be intimidating, a cause of uncertainty, a practice demanding a clarity she cannot reach. In her recent paintings she has ironically stated the conflict between seeing and saying, between the meaning that painting should

251

Fig. 259. Louise Robert. *No. 78–37*, 1980. Acrylic on canvas. 183.0 × 244.0 cm. Collection of the Artist.

carry and how it is presented. In *No. 78-37* (1980) (fig. 259), the surface is richly and freely painted. Divided through the centre, it appears either split apart or like an open book—but on the right are inscribed the words "*A ne pas lire..!*" ("Not to be read"). As the words in her pictures have become legible so she has reduced them to declamatory statements, "*Alors le langage*" in one, in another "*Démarqué*," with its implications of removing marks, marking something down in price, or plagiarizing.

If there is in the painting of these artists a recognition, albeit a negative one, of the modernist tradition in Montreal, it is an aspect in which other painters in the city have little or no direct interest. Abstract painting, whether in Montreal or anywhere else, is not validated simply by its form; value lies only in the responses raised by the character of each work. The work lies open to the experience of the individual spectator.

The work of London, Ontario, artist Ron Martin, for instance, is outside any regional *tradition* of abstract painting, and resists a dependence on stylistic or formal analysis as such. The very appearance of Martin's work, through several quite distinct series, effectively denies discursive de-

Fig. 260. Ron Martin. *Untitled #47*, 1981. Acrylic on canvas. 243.8 × 167.6 cm. Collection Art Gallery of Ontario, Toronto. Purchase, 1981.

scription. We must first recognize the separation in experience between the artist and the viewer. We may *know* that a work is the result of the artist's particular actions in relation to size, material, and so on, but our view of the work is constituted by our particular perceptions. In trying to order our perceptions, especially for an object outside everyday experience, we seek constants against which we can recognise and organize changes. In Martin's black paintings, like *Untitled #47* (1981) (fig. 260), the black colour

Fig. 261. Claude Breeze. *Canadian Atlas: Great Divide*, 1974. Acrylic on canvas. 121.9 × 182.9 cm. Imperial Oil Limited.

Fig. 262. Jacques Hurtubise. *Simonne*, 1975. Acrylic on board. 121.9 × 243.8 cm. Lavalin Inc.

Fig. 263. Louis Comtois. *Distortion in Orange*, 1979. Acrylic on canvas. Four panels, 182.9 × 350.5 cm overall. Collection of the Artist.

and the paint itself are constants, as is the activity of the artist who has spread the paint across the surface. The result of that activity, however, is the formation of a surface of continual change brought about by the fall of light on the paint, by changes in the spectator's position, and by the length of time and intensity of that spectator's concentration. The painting is constituted as a special object for experience, deliberately restricted in its contents and associations but with a complexity and subtlety that is directly related to the intensity of the spectator's attention.

Martin's very recent paintings (fig. 268) have a formal rigour, an apparent regularity of information and suppression of surface detail. But if the terms have changed, the principles have not. In the black paintings, Martin chose the paint for its density, for its response to his actions, and for the effects of light on it. The recent paintings emphasize colour—a vital element, physically, emotionally, and psychologically, of our experience—and how the relationships between constants and changes affect that experience. The grid-like form organizes and clarifies the fact of colour; the smooth application of paint, giving an evenly reflecting light, avoids interference with our perception of the colour. A constant tint and changing tints are so organized that each change is always set next to a rectangle of the constant, yet, as we scan up and down the picture, the constant appears to be modified by the changing tints. The rigorousness of Martin's paintings, their denial of formalism or of expressive intentions have made them appear difficult. Approached however with an openness to one's individual experience, their rigorousness and denial of generalized categories are values which have made Martin's work among the most original of recent years.

Post-painterly Abstraction developed at the beginning of the 1960s, in reaction to the psychologically charged dramas of Abstract Expressionism. The look of the sixties was flat, geometric, strongly coloured, with hard-edge designs that

Fig. 264. Guy Monpetit. *Deux cultures une nation*, 1968. Acrylic on canvas. 121.9 × 137.2 Lavalin Inc.

engaged the whole surface and shape of the canvas. It was a look that became open to a multiplicity of optical effects. The manipulation of hard-edge design in the work of Bodo Pfeifer, for instance, contrasts with the figurative abstraction of Guy Monpetit. In Pfeifer's case, in *Untitled D16* (1967) there is a rigid symmetry and insistent flatness; in Monpetit, as in *Deux cultures, une nation* (1968) (fig. 264), a still-Cubist layering of forms and slight asymmetries give the abstraction an organic sense of movement. For other artists geometric abstraction led to the visual complexities of Op-Art, which, led by artists like Viktor Vasarely, Bridget Riley, and Raphael Soto, enjoyed a bright but brief prominence in the mid and later 1960s. In this country artists such as Ralph Allen (fig. 265), Brian Fisher, and Paul Lacroix made Op-Art works during the decade.

Just as hard-edge abstraction seemed to define the 1960s, there were those like Gary Lee-Nova who broke its premises from within its own style. Minimal art negated the distinctions between painting and sculpture by insisting on the objec-

254

Fig. 265. Ralph Allen. *Blue on Red*, 1964–65. Acrylic on board. 123.0 × 183.0 cm. C·I·L Inc.

Fig. 266. Gerald Ferguson. *Untitled*, 1972. Enamel paint on unprimed canvas. 162.6 × 335.3 cm. Glenbow Museum, Calgary.

255

tive character of the whole work; detached from its audience, the object simply "is." Minimalism seemed to deny work and the processes, both conceptual and physical, by which it was made, appearing despite its banal simplicity remote and insular. In reaction, many artists began to criticize the divisions between the art object, the artist, and the audience; between perceiving, thinking, and the description of experience.

In *Contemporary Canadian Collection— Average Size—Average Colour*, Garry Neill Kennedy structured his analysis on a grid. At least since the Renaissance, the grid has been a device by which painters can transfer their view of the three-dimensional world into two dimensions. For artists like Gerald Ferguson, Daniel Blyth, and Michael Fernandes (all of them, like Kennedy, have lived or are currently living in Halifax) the grid itself has marked the process of a work. In Ferguson's *Untitled*, 1972 (fig. 266), however, the grid is not an indifferent "given," but something that must be constructed by a laborious process, unit by unit—in this case with a hard industrial paint on a raw canvas. Its image of order is not simply achieved but *made*, and in a sense it marks both the beginning and the end of painting. It is

Fig. 267. Léopold Plotek. *Le Neveu de Rameau*, 1979. Oil on linen. 221.0 × 173.0 cm. The Westburn Collection.

Fig. 268. Ron Martin. *9 Tints Alizarin Crimson #3*, 1983. Acrylic on canvas. 243.8 × 365.8 cm. Courtesy Carmen Lamanna Gallery, Toronto.

Fig. 269. Peter Gnass. *Progression sur 2 perspectives*, 1975. Acrylic on board. 87.6 × 228.6 cm. Lavalin Inc.

painting as a means to arrive at an image of its own process. In this sense the image is not one of cool, geometric detachment but of tragic absurdity. In Michael Fernandes' *Untitled* (1977) (fig. 271), we see what seem to be only the fragments of a grid. Five separate panels carry—but cannot contain— the sweeping gestures of the artist's hand, as if we need a different organization and more information to give ordered form to the artist's expression. The grid seems to promise understanding while at the same time restricting it; it rationalizes the intuitive but cannot contain it.

In Ferguson's work the grid is a tautology, in Fernandes' it seems in conflict with the desire for meaning. For Jaan Poldaas, in contrast, the grid determines an intellectually rational order, which is perceived in a totally different form. Here (fig. 272) an arrangement of small, smoothly painted panels presents a series of chosen colour relationships. The colours of the central row are mixed in sequence, and the results of those mixtures and remixtures develop progressively in the rows above and below. The sequence is fixed and the overall shape developed accordingly, but the colours assert an independent structure, perceived and related subjectively by hue and tone.

For other painters, the tensions between for-

mal structure and illusion are addressed in abstract and geometric terms. In Ric Evans' *Aristera (Open)* (1980) (fig. 270), three panels, equal in dimensions and similarly painted in slate grey, are articulated by an equivalent, but subtly changing, geometric structure. In the right side of each panel a triangular wedge is cut. The angle formed

Fig. 270. Ric Evans. *Aristera (Open)*, 1980. Oil, chalk on duraply. Three panels, each 213.3 × 55.9 cm. Art Gallery of Hamilton.

Fig. 271 (above). Michael Fernandes. *Untitled (5 panels)*, 1977. Pencil and latex on masonite. Five panels, each 60.6 × 60.6 cm.

Fig. 272 (below). Jaan Poldaas. *(2,1,3)/5 Colours: Blue, Red, Grey, Purple, Yellow* 1982. Oil on board. 182.7 × 203.0 cm. Collection Art Gallery of Ontario, Toronto. Purchase, 1982.

by the upper edge is slightly less acute as we view the panels from left to right. The lines marked on the surface of the panels take slightly different positions with the changes to the triangular wedge. There are two levels of illusion: first, the illusion that the three panels are simple repetitions of each other, second, the spatial illusion developed by the contrast between the outer shape and the inner linear markings.

The shaping of the panels and the way that they stand slightly but clearly away from the wall brings Evans' work close to the border between painting and sculpture. It has often been pointed out that the closer a medium comes to its "pure" qualities the closer it comes to the "pure" qualities of other media. As the critic John Perreault has described it,

> Paradoxically, the closer an artist gets to the mythological "essence" of his particular medium the faster his medium becomes something else. Frank Stella's shaped-canvases become a kind of flat sculpture for the wall. Cage's "music" becomes theatre. Concretist poems become graphic art Film becomes a kind of projected painting.[8]

A progressive formal reduction, in whatever me-

dium, means simply coming closer to the fundamental relationships between our sense perceptions and the rational descriptions by which we give order to them. The diminishing distinctions between, say, painting and sculpture allow the artist an openness to work in different media with a range of materials, without compromising the essential meaning of his work. Peter Gnass, for one, has worked in painting (fig. 269) and sculpture with wood, acrylic, steel, neon tubes, not in order to solve distinct formal problems but to explore the notion of formation within time and space as a metaphor for life. He has described this as,

> Without beginning or end—everything between the two takes form. . . . Form and volume gathered in ceaseless movement, or in symbiosis, with or without system. . . . Today is no longer dissolved, classified, catalogued; between stop and start in a time-space transforming themselves between these two infinities of life.[9]

The more specific formal tension between painting and sculpture, and the references in illusion that bind them, have been forcefully approached by Peter Hill. In a work like *Untitled* (1980) (fig. 273) the object projects emphatically from the wall, although its shape and drawing, colour and texture, address the issues of painting and painting's illusions. It has, in a pictorial sense, a reference to landscape, to our organization of space around a horizon and the spreading of our field of vision outwards into the world. Milton Jewell's paintings, by contrast, remain set in one plane but their complex geometry seems to suggest not a single, flat configuration but one that seeks resolution in three-dimensional space where, freed from this particular form, a fuller reality would be achieved. Their abstraction is not a matter of style but of procedure, of bringing to form.

The ambiguities between illusion and order appear in a different manner in the work of David Craven. The two-dimensional shape of the canvas and the two-dimensional drawing within it, create

Fig. 273. Peter Hill. *Untitled*, 1980. Oil, wax, varnish on plywood. Courtesy Ydessa Gallery, Toronto.

Fig. 274. Ron Shuebrook. *Plight*, 1982. Acrylic on canvas. 220.9 × 170.2 cm. Courtesy Olga Korper Gallery, Toronto.

Fig. 275 (opposite left). Joseph Drapell. *Haydn's Advantage*, 1980. Acrylic on canvas. 170.2 × 109.2 cm. Mr. and Mrs. A. Silverberg, Toronto.

Fig. 276 (opposite right). Doug Haynes. *Rocky Mountain Red*, 1982. Acrylic on canvas. 195.6 × 85.2 cm. Courtesy Gallery One, Toronto.

a formal structure which defines the shapes re-
leased by scraping away the black paint that cov-
ers the surface (fig. 277). The process is purely
pictorial, but the illusion it produces seems to
return the forms to the three-dimensional world.
It was a process that Craven developed further—
though with some loss of tension between two
and three dimensions—in a series of wall reliefs.
This relationship of flatness and illusion is made
more complex in his most recent paintings where
the emphatic, painterly forms, which at first sight
appear to be wholly abstract, describe—or per-

Fig. 277.
David Craven.
Passodoble 1977.
Acrylic on canvas.
172.7 × 325.1 cm.
Edwin L. Stringer, Q.C.,
Toronto.

haps more properly reveal—human figures, as if they had been born within the painting process.

For Ron Shuebrook, however, the demand of expression remains wholly formal (fig. 274). His paintings stand metaphorically for his acceptance of "the fleeting and the changing. . . [which is] closer to the way life appears to me." Like many other artists of his generation, he worked from Abstract Expressionism to a more geometric structure developed in the dynamic tension between two and three dimensions. His work remains, in essence, humanist, somewhat uncomfortable and anxious and yet uncompromising in its conviction that the business of painting still lies in the vital struggle of personal expression:

> My own intention is to make work that evokes, through working process and image, a sense of my own doubt and ambivalence about this world. Perhaps, these works can function as metaphors for the experience of others. I cannot be certain.[10]

This openness in Shuebrook's formalism con-trasts with that development in the modernist tradition whose immediate roots are found in American abstract colour-field painting of the 1960s. More than any other painting in recent years, the colour-field approach has most sharply polarized critical opinion. To some, colour-field holds the essential values of painting's history and is the source of a continued investigation of those issues that properly belong to painting. To others colour-field abstraction proves the disintegration of the modernist tradition.

Opposition, whether moderate or extreme, has isolated colour-field painting as a purely aesthetic movement, one of art for art's sake, separated from an engagement with broader issues of social and historical concern. Radical opposition has dismissed it as a focus for an establishment system of commercial, curatorial, and critical interests, and in this sense its critics are unconcerned with opinions on this or that particular work. The fragmentation of the avant-garde through the 1970s, disclaiming the privileged position of any particular approach to art, revealed

colour-field abstraction as one direction among many. The claims for this direction, to the extent that they seek to disregard the shiftings of perspectives in art in the past fifteen years, have weakened the case for the best of this approach. And, in consequence, much of the work has been lessened by a lack of the self-criticism that recognizes the difference between painting as a function of expression and painting as a manipulation of style and technique.

The fact remains that abstract colour-field painting still constitutes a substantial part of contemporary painting, its practice most firmly established on the Prairies and in Toronto. When painting is reduced to a structure of colour, quality lies in the sense of unity between form and colour. The work of Joseph Drapell of Toronto offers this indivisibility between a strong and clear formal structure and the colour by which it is made. Since the early seventies he has invariably developed his paintings through a circular motif, as in *Haydn's Advantage* (1980) (fig. 275). Drapell rotates a scraper across the canvas through layers of paint and then works further colours into the painting. The result has been many series of paintings of consistent quality, with a formal dynamic between the action of painting and its relationship to the shape of the field which seems bound only by the release of colour sensations.

In Edmonton more than in any other city, painting has meant colour-field painting, an approach accepted by successive generations of painters. Too often the results have been wan stretches of stained canvas or, more recently, attempts to revitalize the surfaces with swatches or encrustations of acrylic gel. Yet some good painting is being done—Doug Haynes, a senior painter, is one of the most accomplished. Haynes moved to Edmonton in 1969 to teach at the University of Alberta. His work in the early and mid 1970s was characterized by strongly textured surfaces and a tension between the image and the field. The *From the Interior* series developed its images from the centre out towards forms that acted like internal framing devices, both fulfilling the images and returning attention to their starting points. In 1977 he began to use thinner paint and to develop a stronger optical tension between image and ground, an approach for which the example of Jack Bush seems to have been the catalyst. The recent paintings, like *Rocky Mountain Red* (1982) (fig. 276), have taken this a stage further. The surfaces are opaque and textured, and opened to reveal layers of colour beneath.

Fig. 278. Robert Christie. *Pink and White Spaces*, 1979. Acrylic and chalk pastel on canvas. 195.6 × 137.2 cm. Collection of Alcan Smelters and Chemicals Ltd., Montreal.

Fig. 279. Ann Clarke. *Ament Her Girdle*, 1978. Acrylic on canvas. 147.3 × 190.5 cm. The Westburn Collection.

But rather than using the formal device of a diamond or window-like form, as in the earlier paintings, in these paintings Haynes unites form and colour through an elegant, almost calligraphic drawing.

Amongst other colour abstractionists in the West, particular mention must be made of Robert Christie in Saskatoon, Bruce O'Neil in Calgary, and Ann Clarke in Edmonton. At several points in his career, Christie (fig. 278) benefited from the advice of Jack Bush as well as the working atmosphere of the Emma Lake workshops. His painting contrasts open and closed forms, colour and ground, negative and positive spaces, and he often uses forms or a sense of atmosphere that refers to landscape. In 1975 Michael Greenwood wrote in *artscanada* of Clarke and O'Neil that they "appear to be reacting against the over-refinement of sensibility that often signals the final

Fig. 280. Harold Feist. *Good Suit (for Aaron)*, 1980. Acrylic on canvas. 123.2 × 168.2 cm. Mr. and Mrs. Aaron Milrad, Toronto.

stages of etiolation of a purely aesthetic movement."[11] Greenwood's assessment then has been borne out by Clarke's continuing work, strong in colour and dynamic in painterly action (fig. 279).

Although Vancouver has not for some time been known as a "painter's town," a number of painters there are making abstract and, more recently, figurative paintings. Among the abstract painters, Ranjan Sen is of particular note (fig. 283). He works on large-scale, unstretched canvases contrasting strong geometric organization with a depth of colour and the soft, rippling effects of freely hanging canvas.

In Toronto the issues of abstract colour painting appear more complex in that the number and range of working artists prevents the dominance of a single mode of painting. Harold Feist is one of the most accomplished of the purely abstract colour-field painters. As Joseph Drapell's work is

Fig. 281 (above).
Milly Ristvedt-Handerek.
Pacific Salt, 1978.
Acrylic on canvas.
198.2 × 198.2 cm.
Gerald W. Schwartz.

Fig. 282.
Paul Hutner.
Outpost, 1982. Acrylic and graphite on canvas.
198.1 × 278.2 cm.
Private Collection,
Toronto.

265

Fig. 283.
Ranjan Sen.
Butterfly, 1983. Acrylic
on unstretched canvas.
182.9 × 383.5 cm.
Courtesy of the Artist.

identified with a particular image, so Feist's is characterized by a form, characteristically a sunburst or hub-and-spoke arrangement, in which the colour radiates out from the centre towards the edges. Sometimes the textured atmosphere of the ground dominates the pictures; at other times, as in *Good Suit (for Aaron)* (1980) (fig. 280), the spokes are feathered into the ground, the colours modified by the grey tone but moving, like a scattered spectrum, towards a pure white. Carol

Sutton's paintings (fig. 284) are made with broad asymmetrical sweeps of colour, flowing in linked gestures diagonally across the canvas, emerging from and dissolving into the brushed grounds. The dynamics of colour given in elegant drawing are characteristic of the paintings of Milly Ristvedt-Handerek, Joan Frick, and Rose Lindzon. Between Lindzon's dense and complex weaving of colour and Frick's spare relationships of form and gesture (fig. 285), Ristvedt-Handerek (fig. 281) develops lively contrasts between strongly coloured flat grounds and contrasting patches and strokes of colour.

The works of K. M. Graham and Paul Fournier, although they also hover between colour-field atmosphere and colour drawing, do not decisively hold apart distinctions between abstraction and representation. Some of Graham's best pictures, like *Arctic Sovereignty in Pink* (1971) (fig. 287), are abstractions of the Arctic landscape, in a sense abstract impressions of the special delicacy of light and colour. In other pictures she magnifies the surprising brilliance of Arctic flowers in an atmosphere of coloured light. Paul Fournier's career has been one of a series of oscillations between the abstract and the representational: landscape paintings followed by "all-over" textured coloured fields, large-scale

Fig. 284. Carol Sutton. *Third Studio*, 1981. Acrylic on canvas. 170.1 x 243.8 cm. Mrs. and Mrs. H. Konopny, Toronto.

266

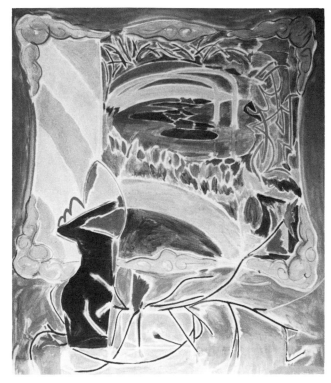

"stormy" abstractions by images of sea-shells and fish. Between these a whole range of variations has moved between abstraction and representation. In one particularly successful series of paintings, *The Florida Mirrors*, images, like those in *The Water Garden* (1976) (fig. 286), appear as if viewed through a window or seen reflected in a mirror. The image seems ambiguously placed between immediate representation and a recall in memory. In much of his work Fournier takes up

Fig. 285 (above left). Joan Frick. *Duello*, 1980. Mixed media on paper. 194.9 × 303.5 cm. Courtesy Wynick-Tuck Gallery, Toronto.

Fig. 286 (above right). Paul Fournier. *The Water Garden*, 1976. Acrylic on canvas. 170.1 × 152.4 cm. Private Collection, Toronto.

Fig. 287 (below). K.M. Graham. *Arctic Sovereignty in Pink*, 1971. Acrylic on canvas. 101.6 × 181.6 cm. Courtesy Klonaridis Gallery Inc., Toronto.

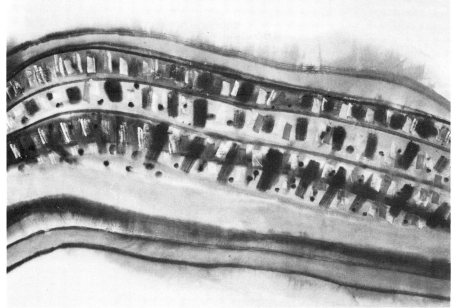

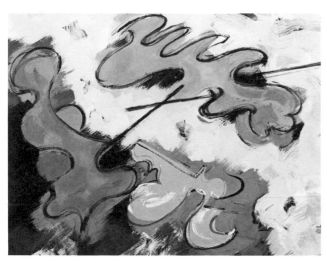

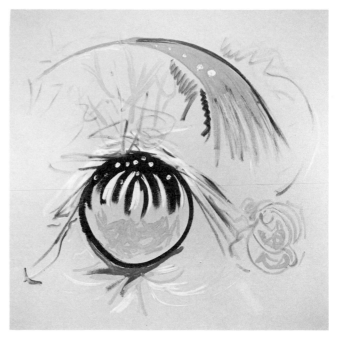

Fig. 288 (above). John MacGregor. *Three Blue Shapes*, 1976. Acrylic on canvas. 187.9 × 245.1 cm. Private Collection, Toronto.

Fig. 289 (right). Alex Cameron. *Blue Strawberry*, 1976. Acrylic on canvas. 167.5 x 167.5 cm. Mr. and Mrs. S. Stupp.

the heritage of Matisse, with its relationship between a flowing draughtsmanship and rich colour balanced between the surface and an illusion of depth.

Many painters in Toronto whose careers began to develop in the 1970s have a distinct attachment to painterliness and figuration. In this they reflect that aspect of the modernist tradition that had developed in Toronto from the later 1950s. As well, they give support to the notion of a Toronto "look" identified by Barrie Hale in his discussions of Toronto painting of the 1960s.[12] That "look" often displayed a sort of zany humour, to which, in their different ways, John MacGregor (fig. 288) and Alex Cameron seem heirs, with paintings that deflate pomposity and prudishness. Cameron's paintings of the later 1970s (fig. 289), often on a very large scale, are brilliantly coloured, with a sort of wild rococo drawing bursting across the canvas. His recent paintings, while they retain a brilliance of colour, are more formally structured, reminiscent of Paul Klee's paintings of around 1930.

Vibrant colour and breadth of gesture also mark the paintings of Paul Hutner (fig. 282). References to maps and flags, and writing, become the starting points for layer on layer of painterly activity; the original images are all but concealed beneath the explosive energy of the work. Even more than with the paintings of Cameron and McGregor, Hutner's paintings play with the dynamic tension between the associations and references that can be drawn out of them and the lively activity of the surfaces. This tension is given quite different terms by Eric Gamble (fig. 290). His paintings, strong in colour and forceful in design, draw on a broad repertoire of images which seem deliberately to challenge the notion of tasteful balance and unity. Daringly referring to the great image-makers of modern art, whether Kandinsky or Matisse, Picasso or Japanese woodblock prints, he confidently asserts the individuality of his own images.

Paul Sloggett, Howard Simkins, and Dan Solomon (fig. 291), in contrast, have worked without evident representational references; their images

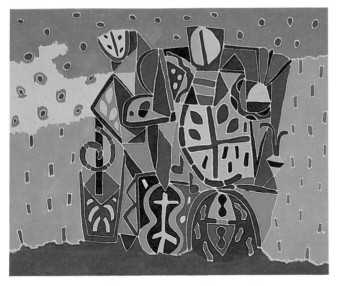

Fig. 290. Eric Gamble. *Vera Cruz*, 1981. Acrylic on canvas. 167.6 × 208.2 cm. Heather Reisman, Toronto.

Fig. 291. Daniel Solomon. *Crossways*, 1976. Acrylic on canvas. 231.1 × 350.5 cm. Courtesy Klonaridis Gallery Inc., Toronto.

Fig. 293. David Bolduc. *1-2-3*, 1977. Acrylic on canvas. 137.2 × 213.4 cm. Edwin L. Stringer, Q.C., Toronto.

Fig. 292. Harold Klunder. *Full Torque*, 1977. Acrylic on canvas. 243.8 × 213.4 cm. Private Collection, Toronto.

Fig. 295 (above). Howard Simkins. *Marble Cow*, 1980. Mixed media on canvas. 129.5 × 134.6 cm. David P. Silcox.

Fig. 294 (left). Paul Sloggett. *Serafa Tikit*, 1978. Acrylic on canvas. Courtesy Klonaridis Gallery Inc., Toronto.

reflect the structures of their paintings. This is most evident with Sloggett's asymmetrically shaped canvases and constuctivist approach to form and colour. The rigorous structuring of his recent work stands in contrast to his earlier paintings which seemed to extend the illusionist potential of Bush's work of the early 1970s with their "brush-stroke" shapes on mottled atmospheric grounds (fig. 294). Simkins' break from his earlier work has been more radical. After working in a strictly abstract manner, he began to introduce figurative images into his painting in 1975–76 (fig. 295). At first this was simply to get a fresh perspective on his formal painting but he found these images becoming the compelling aspect of his painting, and he began gradually to

work towards particular themes that intrigued him—the circus, magic, and myth. The themes, developed as formal devices, stand often as metaphors for the activity of painting: the magic of transformation, the tension between the inner and outer world symbolized by the image of the cave, and a personal mythology as a mediation between the individual and the world.

David Bolduc and Harold Klunder (along with Joseph Drapell) are to date perhaps the most resolved painters of their generation in Toronto. In the mid 1970s, Bolduc was working with imposed forms on thinly painted grounds in a wholly abstract manner. Then in 1974 he began to inscribe an image, even as simple as a single stroke, onto the painted ground. From here he

has developed a variety of images, sometimes a single central form, sometimes a form repeated at intervals across the surface, like the fan-shape in *1–2–3* (1977) (fig. 293). The forms are associative rather than directly referential; the images which he has described as "carriers for...colour" are the occasions for and not the meanings of the painting.

In Bolduc's work the image becomes a focal point for the activity of painting and the experience of looking. It becomes a way of drawing out the painting's construction, of extending it, with the associations the images suggest, beyond the circularity of formal painting's demonstrations of its own existence. In Klunder's recent paintings elements suggestive of figures and landscape emerge. His earlier paintings were structured quite differently; a process of form and formation revealed the character of the colour energy of paint through the character of the material itself. In *Full Torque* (1977) (fig. 292) a sturdily painted, interlocked geometric structure appears threatened by the loose splashes of paint from the lower left. It is as if one form of painterly energy, its looseness and freedom, seeks to cancel out the artist's attempt to build order and structure.

Describing a personal sensibility he found in the range of recent painting in Toronto the American critic Donald Kuspit wrote of an "exotic modernism."[13] There is a history of expressionist-type and image-oriented painting in Toronto reaching back some thirty years, but a glance at almost every major centre in North America reveals a comparable explosion of directions. These directions spread not only into the mainstreams of western art, but into non-western cultures, into folk art, into crafts, as well as reflecting an engagement with our immediate technological, urban environments, and to a substantial degree criticism is at a loss to cope with what is occurring, left to bark at its own shadow.

With Bolduc and Klunder there can be no separation between the images they use and the proce-

Fig. 296. Katja Jacobs. *For Tanja Jacobs (Knife Piece)*. Oil and enamel on canvas. 213.4 × 165.1 cm. Courtesy Gallery One, Toronto.

dures by which their paintings are made. Their paintings are not *about* fans or figures, they are about picture-making, about the challenge of the past—whether their particular references are to Matisse, or to oriental rugs, or to de Kooning—about opening the potential that painting still holds. Their modernism does not narrow options but opens them in visionary ways, showing painting as creating new ways of looking, new ways of interpreting the store of past images, showing through painting individual reactions to the pressures to make something.

This very openness leads in much current painting not to a pluralism of styles, but to the vitality of individual options. For Katja Jacobs (fig. 296), for instance, that option lies in painting as an

Fig. 297. Christopher Broadhurst. *Osaka Tea*, 1983. Oil on canvas. 91.4 × 182.9 cm. Collection of the Artist.

activity which gathers up immediate experiences, images seen, people admired, objects used, and time passing. The images are often buried or split apart by the very energy of the painting process. A predominance of white separates and covers the images, as if in an attempt to make a beginning, as if the artist could absorb experience to a point where she could start with everything in place. In contrast, Chris Broadhurst, a young painter working in Kingston, Ontario, affirms images of simple domesticity. He gives particular emphasis to the decorative character of the things with which we surround ourselves, plates and vases, fabric patterns and pieces of furniture (fig. 297). His work springs from the heritage of Bonnard and Matisse, recasting the commonplace into an image of delight.

Broadhurst's images express a settled familiarity in a particular but stable tradition of modern painting. For Jacobs, an attempt to affirm the reality of the moment can only succeed by encompassing the complexity of personal experience. Two young Vancouver artists, Roz Marshall and Nora Blanck, recast the traditions of the past to assert values of stability and the succession of generations. Nora Blanck works with the traditions of abstract decoration, patterns that throughout history have appeared in architecture, rugs, and fabric designs. The patterns are easily transmittable, affirming the succession of the past, and in their stability they mediate between

Fig. 298 (left). Ivan Eyre. *Sky Terrace*, 1971–72. Acrylic and oil on canvas. 205.7 × 157.5 cm. Robert McLaughlin Gallery, Oshawa. Purchase, 1980.

Fig. 298a (opposite). Ivan Eyre. *Highwater*, 1978. Acrylic and oil on canvas. 179.3 × 169.2 cm. Norcen Energy Resources Limited.

the ephemeral world and a transcendent order. Roz Marshall has linked her work to craft traditions, particularly quilt-making, a craft that has existed not simply as an embellishment of a functional object, but as an expression of pride and affection.

The work of Blanck and Marshall, at very different levels, relates to the stability of traditions. The work of Catharine MacTavish, who has recently moved from Vancouver to Toronto, relates not only to orderly patterns in art, but to the order we seek in the visible and microscopic worlds and their reflection of the cosmos. MacTavish's *Cetacean Constellations (Bathers #2)* (1976) is covered with a swarm of swimming

Fig. 299. Catharine MacTavish. (Left) *A Landscape in the Obsessional Style (Night Vision #14)*, (Right) *The Pure Gold Baby That Melts To A Shriek*. (Photographed in progress.) Mixed media on canvas. Collection of the Artist.

stick-like figures. The painting is divided into several sections, in the largest of which the figures swim about in hopeless confusion. Towards the bottom they take up a more ordered direction, flowing in horizontal lines, while at the edges they cling to and define the field of the picture. From a distance we see only a pattern, close up we recognize its constitution as thousands of individuals, swarming, disoriented, seeking a form and order.

In another series of pictures, MacTavish transfers the search for order to the fixed relationships of the stars. A remarkable two-sided work, *Both Sides* (1983), has *A Landscape in the Obsessional Style (Night Vision #14)* on one side and *The Pure Gold Baby That Melts to a Shriek* on the other (fig. 299). *Night Vision #14*, painted with acrylic, glitter, and glass beads, is an obsessional *tour de force* in its complexity of lines and dots and stars, in its mapping of the constellations. The sheer complexity of the work and its metaphoric description of the infinite and the unbounded, seems to give order to that which defies order because we

cannot hope to describe its limits. The painting is quiet, deep and awe-inspiring. On the other side (*The Pure Gold. . .*) we are confronted with ugliness, formless splashes of paint, metallic fragments, dead insects, beads. It is like a body pierced and slashed with its fluids smeared across the canvas. The two sides seem to show two levels in our search for understanding our existence, *A Landscape in the Obsessional Style. . .* an attempt to trace the cosmic, *The Pure Gold. . .* the remains of a ritual that seeks to find the measure of everything from within our bodies.

One of the most persistent forms of pictorial representation derives from the vocabulary of figurative Surrealism. A group of young Vancouver artists formed themselves into The West Coast Surrealists and, through their work, refer openly to the tradition of European Surrealism. Greg Simpson (fig. 300) and Robert Davidson, for instance, are interested in the work of Max Ernst; David Mayrs and Robert Carmichael in that of

274

René Magritte and Salvador Dali. The force of Surrealism lies not only in its historical status but in its ability to open poetic imaginative worlds, the pictorial worlds, for instance, of Esther Warkov, Carol Fraser, and Florence Vale.

Fraser's imagery, as in *The Couple II* (1973–76) (fig. 301), is Surrealist in its sexual currents, its intertwining of human and natural forms, and its breakdown of the distinctions between inside and outside appearance; figure and tree, arteries, roots, and stems become interchangeable. Esther Warkov's work is more subtly and more privately poetic (fig. 302). Her pictures are divided into clearly separated compartments but the pale tones of her images give the paintings a sense of insubstantial mistiness. Her shaped canvases break away from the customary expectations of illusion in a painting to recreate the sensations of curious divisions and associations that come in memories and dream images.

Fig. 300 (above). Greg Simpson. *Flight to Tangiers*, 1977. Oil and acrylic on canvas. Courtesy of the Artist.

Fig. 301 (below). Carol Fraser. *The Couple II*, 1973–76. Oil on linen. 128.3 × 204.5 cm.

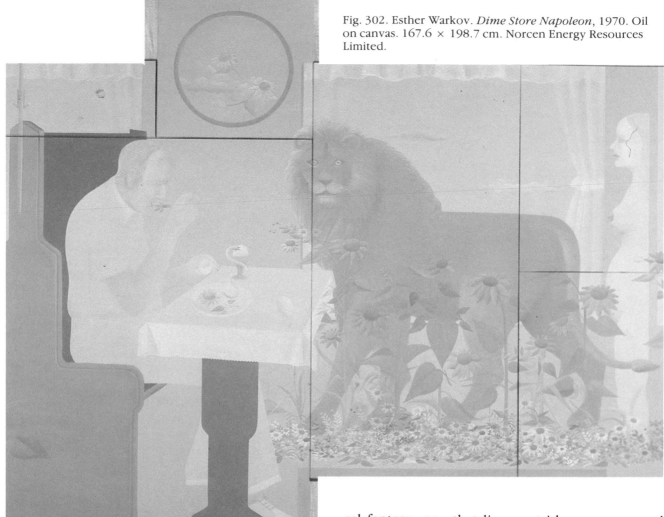

Fig. 302. Esther Warkov. *Dime Store Napoleon*, 1970. Oil on canvas. 167.6 × 198.7 cm. Norcen Energy Resources Limited.

cal fantasy, one that lives outside programs and theories, but, for all its personal imagery, strikes intimate chords in us (fig. 303).

Fraser, Warkov, and Vale construct in their own ways alternative worlds, somehow just beneath the surface of the everyday with a freedom to combine images and transform context. In Art Green's work (fig. 304) the surrealist image appears literally as a breakthrough, an opening, and a promise of freedom from the binding restrictions of the everyday world. For Derek Michael Besant (fig. 305), the power of dream images places objects within a possible space and a possi-

There is a wonderful, human charm to the visual surrealist poetry of Florence Vale. It is a poetry of life and death, humour and eroticism, memories and fantasies. Vale, married to Albert Franck and at the centre of the small Bohemian art circle in Toronto in the years after the war, was around forty when she began to paint. She has worked with collage and mixed media, paint and watercolours, to build a special world of whimsi-

Fig. 303. Florence Vale. *Virgin's Dream*, 1973. Pen and pencil on paper, 20.3 × 27.9 cm. Collection of the Artist.

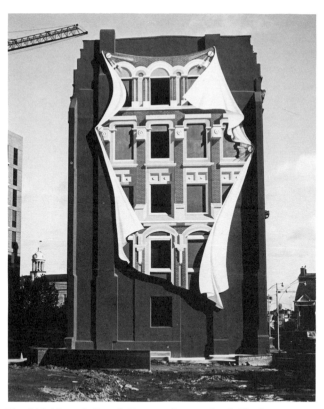

Fig. 305 (above). Derek Besant. *Berczy Park Flatiron Mural*, 1980. Polyurethane on alucobond. 49 panels, 185.8 m² overall. Gift to the City of Toronto from A.E. Lepage Co., Ltd., Lavalin Inc., Royal Insurance Company of Canada, and the Ontario Ministry of Culture and Recreation.

Fig. 304 (left). Art Green. *Double Bind*, 1975. Oil on canvas. 173.0 × 122.0 cm. C·I·L Inc.

ble moment, but a moment divided from the continuum of time by an unbridgeable gulf, separated from the operations of cause and effect.

Ivan Eyre's surrealism, a personal vision, rests on a respect for the art of the past and rejects modernist reductivism. Through the late 1960s and early 1970s Eyre's paintings were principally still lifes reminiscent of the painting of Giorgio di Chirico and the Pittura Metafisica, the early twentieth-century Italian "metaphysical" school of painting. Eyre's simplification of objects transforms them from things with particular identities

into cryptic abstractions. He places the still-life elements close to the picture plane so that beyond them space opens up, perhaps through a window (or a painting of a window) to the sky or into the landscape (fig. 298). Through the mid 1970s Eyre separated the foreground and background elements, and made it increasingly difficult to sustain the illusion of space gradually developing from front to rear. The distant landscape with trees and hills painted in fine detail lured the eye from the entangled confusion of the foreground. Our expectations are disturbingly inverted; the clarity and detail of what is distant is clear and precise, while what is immediately in front of us is dark and indistinct. By 1973, in fact, this disjuncture was made explicit; some pictures of the landscape alone, for all their clarity, have a curious sense of detachment; it is rather like looking through a telephoto lens (fig. 298a). Eyre has written,

> . . .as Joseph Conrad knew, . . .there is a darkness in every human heart. In my recent work, particularly, the darkness has moved underground, but there are some who still see it lurking behind the membrane of subject matter.[14]

Landscape continues to be, it seems, a vital aspect of Canadian painting. Gordon Smith, Takao Tanabe, Toni Onley have each made their particular abstractions of the landscape. In the work of the Saskatoon artists Wynona Mulcaster, Reta Cowley, and Dorothy Knowles formalist colour painting has radically altered the approach to landscape. Landscape painting, particularly in the West, has been taken up by a younger generation of artists, by Barbara Ballachey and Ken Christopher (fig. 306) in Calgary; by Joan Willsher-Martel, born in British Columbia and now living in Toronto, and by David Alexander (fig. 307), who moved from Vancouver to Saskatoon and found in the move a freedom to paint that the very richness of the west coast landscape had stifled. In contrast, since moving to Vancouver in 1974, Alan Wood has immersed himself through his painting in that very richness. In particular, he has taken the ranchlands of interior British Columbia as the subject of his paintings and of three-dimensional installations with paintings. He is attracted to the landscape for, at least in part, the way it is steeped in the mythology of the Hollywood West.

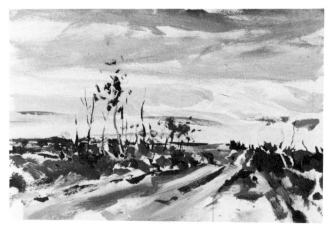

Fig. 306 (above). Ken Christopher. *Sunset East of Saskatoon*, 1981. Acrylic on canvas. 60.9 × 91.4 cm. Security Pacific Bank.

Fig. 307 (right). David Alexander. *Lowland*, 1982. Acrylic on canvas. 122.0 × 122.0 cm. Private Collection, Toronto.

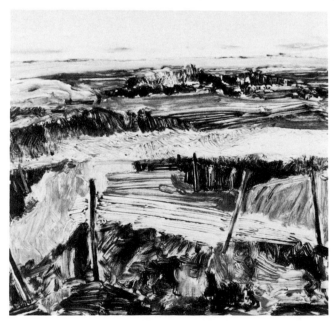

Its grandeur of scale has inspired him to undertake a massive work, *Ranch*, of paintings (some sixty thousand square metres of canvas) and three-dimensional structures (fifty thousand metres of wood) for a 320 acre site near Calgary.

In Tim Zuck's work, the image of the landscape appears in a totally different vein and with very different motives. In the late 1960s, when the properties traditionally associated with painting were being appropriated by performance art, video, installations, and sculpture, Zuck's work seemed to be moving in the opposite direction, that is, out of conceptual work into painting. His *Performance Piece No. 1* (1971), which occupied one working day, was in effect a critical statement on the relationship between the expectations of an audience and the vulnerability that those expectations cast on the artist. Through the day, Zuck, enclosed in a wooden box with a plexiglass front, painted the inside of the box black, gradually concealing himself behind the layer of paint. The painting literally stood between the artist and the audience. In this way Zuck commented ironically on the assumptions that we see the artist through his work, and that the artist conceals himself behind his work.

In 1974 he began to move away from performance works towards work in two-dimensional surfaces, first with masking tape on plexiglass and soon after to painting. The first paintings were without representational imagery. For instance a square, inscribed inside a square panel, was joined to the picture edge by painted tubes or paths, making a reference to hiding, to life-support systems, to the umbilical links between the inner and external worlds, that had occurred in some of his performance works. Gradually the images became more explicit. In *Untitled* (1976) (fig. 308) a house like a child's drawing, set on the horizon, is joined to the picture's corner by a path. The image of the house retains the duality of inside and outside, of concealment as well as of stability and security. Two years later in *Untitled #86* (1978) (fig. 308a), the red house, the image of

Fig. 308. Tim Zuck. *Untitled*, 1976. Oil and pencil on canvas. 60.9 × 60.9 cm. Private Collection.

Fig. 308a. Tim Zuck. *Untitled #86*. 50.8 × 50.8 cm. Private Collection, Toronto.

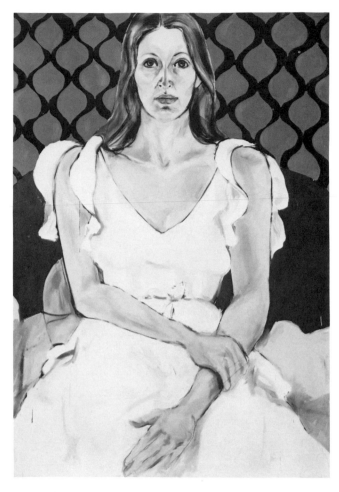

Fig. 310 (above). Tony Scherman. *Her Stool*, 1983. Encaustic on canvas. 152.4 × 121.9 cm. The Westburn Collection.

Fig. 309 (left). Lynn Donoghue. *Portrait of Sharon*. Acrylic on canvas. 203.2 × 149.9 cm. Private Collection, Toronto.

warmth and security, featureless but uncompromised, stands adjacent to a cold blue box filled with a tangle of lines, as if to contrast the desire for enclosure and security against the anxiety and difficulty of painting. The paintings are reduced to a few emblematic elements—house, ground, box, horizon, sky—of universal references. The paintings, apparently so simple and made without expressive "personality," have nevertheless a compelling sense of deep intimacy. The physical concealment of the artist in his work in performance pieces could not hide his psychological vulnerability. In his paintings it is as if Zuck stands beside us; our focus is no longer on each other but on a common image inseparable from our common cause.

Much recent painting has broken away from the circles of abstract modernism. The changes cannot be seen simply as shifts in style, nor as a consensus in approach; they result from individual choices made in response to the desire to paint. The impressive frontal portraits of Lynn Donoghue (fig. 309) and the dream-related images of Shirley Wiitasalo (fig. 311), the isolated objects of Tony Scherman (fig. 310) and the aggressive and unsettling representation of Andy Fabo can-

not be seen simply as a recapturing of a "joy in the senses." The images, both in what they represent and how they are represented, are charged with references and associations that address each spectator rather than defining a subject with fixed points of reference. And the further we extend our view the more we are confronted with choices; choices familiar and yet disturbing because they do not take their assumed patterns, the codes and conventions that we have grown used to attaching to them. Joanne Tod's *Self Portrait* (1982) (fig. 312), for instance, draws on the image of nostalgic elegance issued by the grand illusions of the movies, appropriated by advertising techniques for their own versions of reality. Tod gathers these up but then ripostes with the politically charged text "neath my arm is the color of Russell's Subaru," breaking all illusions by creating her own illusion: a Washington, D.C., hostess speaking the poetry of advertising to push a Japanese product.

Judith Allsopp uses figurative images in reaction to the procedures of her own earlier work. In the later 1960s she was working in a gestural Abstract Expressionist manner, but by the end of the 1970s she questioned her own actions as they were contained in modernism's self-referential procedure. The redirection of her art has been a combination of two apparently diverse sources. She has gone both to the figuration of past modern masters like Picasso and Lyuba Popova, and to images of popular cultures from Latin America, from North America, in response to political events and social conditions. Her response to the immediate view reconciles an apparently arbitrary art-historical eclecticism. She re-uses the revolutionary aspects of early twentieth-century art which have been settled into the established language of western art, but she draws a parallel with the expressions of repressed cultures, the vitality of instability. In contrast, the witty, swift images of John Scott, who works with large cartoon-like drawings and scrawled captions, are taken from high technology: lunar landing craft,

Fig. 311. Shirley Wiitasalo. *Desiring*, 1978. Oil on canvas. 167.8 × 228.8 cm. Collection Art Gallery of Ontario, Toronto. Purchase with assistance from Wintario, 1978.

Fig. 312. Joanne Tod. *Self Portrait*, 1982. Acrylic on canvas. 140.3 × 153.4 cm. Mr. and Mrs. R. Hallisey, Toronto.

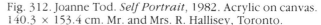

Fig. 313.
John Scott.
Carnivore #2, 1981.
Graphite and Varsol on
paper. 152.4 × 320.0 cm.
Courtesy Carmen
Lamanna Gallery,
Toronto.

Fig. 314 (below).
Doug Kirton.
Cutting out the Steps,
1981. Oil on canvas.
183.0 × 183.0 cm.
David P. Silcox.

high speed bombers (fig. 313). The loose, almost scribbled style of his drawings counters the sheer finesse of technical accomplishment represented by his subjects, just as the wit of the drawings underlines the image of power through technological domination.

Tim Zuck's images, time and again, suggest a notion of passage, of journeys undertaken or journeys desired. The images of Doug Kirton (fig. 314) though equally simplified, are static. They state a condition of objects—a bed, a curtain, an acetylene torch, a set of steps—suspended in the field of the painting. It is a condition that abstracts objects from their natural context—abstracts them from their context of use, which we understand as reality, and places them in a pictorial world of illusion and perspectival ambiguity. They exist in the painting alone, and yet they are inseparable from our attempts to place them in our understanding of the real world. The hard, glossy surfaces of the pictures hold the images in conflict with their illusion. But the power of the images is such that their ambiguities will not settle, their objectivity is inseparable from the subjective contexts in which we seek to place them.

In the precision of his images, David Thauberger presents yet another option in subject matter and its representation. He began his career as a ceramicist, building "imaginary landscapes, small monuments to popular fantasy" from local scenes and people.[15] When in the mid 1970s he started to concentrate on painting, he repeated single images across the canvas. The specific meaning of

Fig. 315. David Thauberger. *Yellow Church*, 1981. Acrylic and glitter on canvas. 167.0 × 229.0 cm. Collection Art Gallery of Ontario, Toronto. Purchase, 1982.

the image, whether a bird or a fish or a rabbit, was broken down by repetition into a formal pattern of negative and positive spaces, as the repetition of a word submerges its meaning in the rhythm of sound and silence. In 1978 Thauberger shifted his attention more to the actual subject matter with references to folk-art traditions, styles, and techniques. His paintings become portraits of the life and environment of his surroundings—houses, churches, the Legion Hall, the landscape, farming scenes, and animals—rendered in bright clear colours (fig. 315).

In contrast to the concentrated image shown with precision and clarity in the paintings of Zuck and Kirton and Thauberger, other painters, such as Ed Radford, David Elliot, and Ron Moppett scatter the elements of their images across the canvas, and John Clark (fig. 316) displaces the associations attached to the images through their context in the painting. Clark has written of his work,

> By submitting the disparate objects to the form of the pile and absorbing them into the surface, I hope to prevent a conventional narrative reading. Rather, I would like the object's arrangement to resemble the result of some directional force such as a landslide or an explosion....[16]

Elliot, Radford, and Moppett strain the classical expectations that painting be balanced and unified. Disjointed elements, like pictograms, are set into the field of the picture so that its narrative depends on the spectator supplying the connectors between objects, as in speech or writing we join nouns with qualifying adjectives and motivating verbs. Radford's pictures (fig. 317) are reminiscent of drawings illustrating word definitions in dictionaries and encyclopedias. The images, presented in a sort of neutral style, are given a

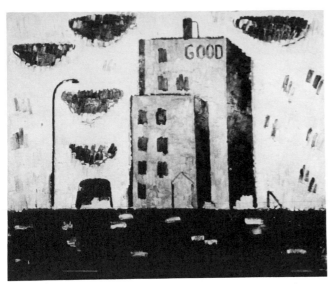

Fig. 316. John Clark. *The Good Warehouse*, 1981. Acrylic on canvas. Courtesy Wynick-Tuck Gallery, Toronto.

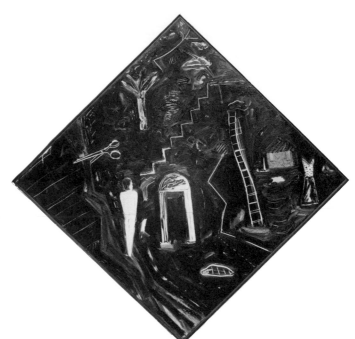

Fig. 317 (above). Ed Radford. *The Immigrant*, 1981. Oil on canvas. 127.0 × 127.0 cm. Courtesy The Isaacs Gallery, Toronto.

Fig. 318 (left). David Elliot. *License*, 1981. Oil on canvas. 91.4 × 127.0 cm. Collection of the Artist.

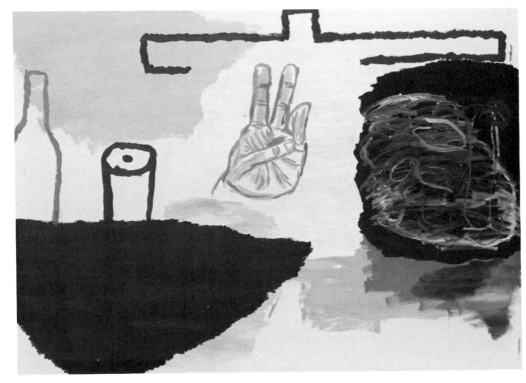

sense of flow and mood by abstracted patches of colour. Elliot's paintings (fig. 318) are rough, crudely drawn, and display childlike perspectival tricks. Their very rawness is like a blow against painting's sophistications, against its culture of skills, and its endless, often tedious concern with its own integrity.

Painting of this sort brings us to one of the most recent, and hence one of the most contentious, issues of current painting, that of "new expressionism." Much has been made of this style's apparent recapitulation of early twentieth-century German Expressionism, of *der Brücke* and *der blaue Reiter* and *Neue Sachlichkeit* movements that had deep repercussions in European painting between the wars. Its effects were felt in the United States, particularly with the 1930s immigration of artists fleeing Nazi oppression, but in Canada it was was taken up after the war by only a few individuals, among them Maxwell Bates and Bruno Bobak. But a new influx of European painting, particularly from Germany and Italy, and led by artists such as Georg Baselitz, Mario Merz, A. R. Penck, Sigmar Polke, and Janis Kounellis, has introduced a new expressionism. With the possible exception of the new knowledge of the early twentieth-century Russian avant-garde, it is the first time in nearly forty years that a movement of new art from Europe has deeply influenced the direction of painting in North America.

The character of the painting is broad, raw, and crude and its subject matter focuses on destruction, anxiety, and violence. Its effect on younger painters in North America has been rapid and pervasive, but the situation is complex. The German and Italian painters, for instance, are working directly out of their history and in response to the current political and social debates in those countries. Such things cannot simply be transposed from one culture to another; the attempt to do so is naïve, a sort of baseless stylism. Furthermore such a disjuncture, in adopting the very rawness and attack of the new painting, can also lead to bad painting and bad drawing. But

because we are so used to change and so unshockable, we have many ways to draw off the vitality of the new. The aggressiveness of the new style is excused as a sign of its uncertainty, and experience can show how the course of any new direction is littered with the detritus of ideas that lead nowhere and careers that are never realized. Nevertheless, the work, both good and bad, is being done by young artists who, in their rejection of existing forms, must state their own terms. And those terms must be presented to an audience not just resistant to change, but one as often concerned with exercising the fashion of resisting fashion, categorizing and historicizing rather than with looking at the work.

For many younger painters figuration has set new terms for the relationship between painting and content. In their rejection of style as content,

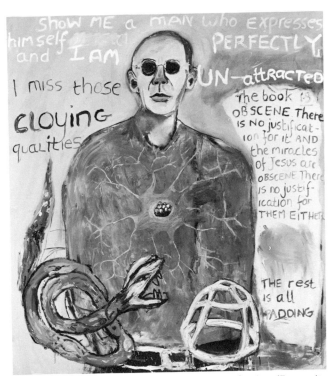

Fig. 319. Lynn Hughes. *Painting about Perfection (Portrait of Henry Miller)*, 1982. Oil on canvas. 152.4 × 137.2 cm. Courtesy Grunwald Gallery, Toronto.

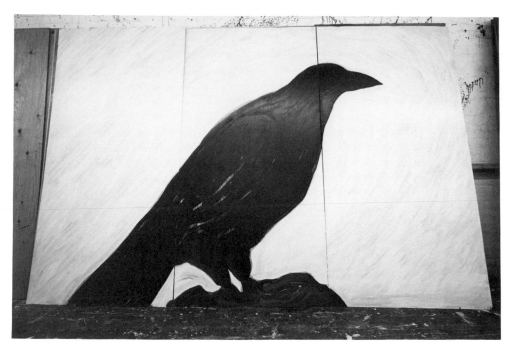

Fig. 320. Wanda Koop. *Raven*, 1982. Acrylic and rhoplex on plywood. 243.8 × 365.8 cm. Collection of the Artist.

and process as subject matter, they are responding to issues raised through the 1970s by artists working in video and performance. These media forced a breach in the traditional relationships of form and content, and broke away from modernism's patterns of self-generation and detachment from events outside its own concerns. The new painting re-engages painting's history but rejects subtlety, rejects reality as existing in the pure contemplation of the spectator's perceptions, and replaces it with images of immediate attention to the context of the world.

Lynn Hughes' *Painting about Perfection (Portrait of Henry Miller)* (1982) (fig. 319) is raw and aggressive, a graffiti-like challenge to the fabric of intellectual and moral assumptions. The Winnipeg artist Wanda Koop's criticism differs but is still aggressively stated. She has made large-scale paintings on plywood, isolating single images drawn from the landscape as signs of the tenuous and often destructive relationships between people and their environments. She has described the bird in *Raven* (fig. 320), as

bright and beautiful . . . it evokes fear, it destroys to survive just as man does; it is the most human animal.[17]

Luc Béland's paintings emit a sense of barely contained violence; the elements are separated from one another by cage-like compartments and surrounded by slashes of brilliant colour (fig. 321). His earlier work, grid-like in form, was a reductivist type of colour abstraction. The attack of the new paintings can be read, in part, as one on the authority of abstract painting in Quebec and its history of ideological debate. Béland's most recent paintings break away from formalism and its metaphors of reality to deal directly, through a personal mythology, with the states of anxiety that surround us.

Michael Jolliffe moved from Vancouver to Montreal, where he works with religious themes, a simple expressive iconography abstracted from religious narrative (fig. 323). Although Landon MacKenzie's paintings do not have specific religious themes there is a certain similarity to Jolliffe's work in their reduction of profound

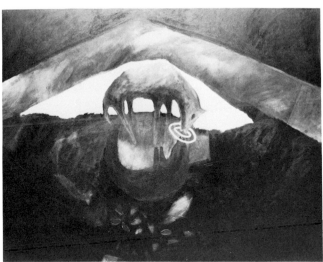

meaning to simple images. In dark landscape spaces she paints animals drawn with a child-like simplicity. Despite the darkness of the pictures, there is a unity between the animals and their environment, a fundamental relationship of provision and acceptance, a relationship given miraculous form in *Lost River Series #12* (1981) (fig. 322) where the ripples on the water radiate from the animal's mouth as bright circles. The work of John Brown (fig. 324) and Marc de Guerre (fig. 325) approach religious subjects very differently; their dark and tortured images of eschatalogical themes comment directly on the contemporary world.

The new figurative painting was given particular focus in Toronto with the founding of the artist-run space ChromaZone in 1981. The initiative arose as a result of the difficulty some young artists found in showing their work, and Chroma-

Fig. 321 (upper). Luc Beland. *Hypermnésie. . . vous n'avez pas compris les choses*, 1983. Serigraph, collage, mixed media on canvas. 183 × 183 cm.

Fig. 322 (lower left). Landon MacKenzie. *Lost Horizon Series #12*, 1981. Acrylic on canvas. 198.7 × 228.5 cm. Collection Art Gallery of Ontario, Toronto. Purchase, 1982.

Fig. 323 (lower right). Michael Jolliffe. *Babylonian Nightmare—Part II*, 1982. Oil on canvas. 234.8 × 193 cm. Courtesy Grunwald Gallery, Toronto.

Fig. 324.
John Brown.
The Mocking of Christ,
1982. Egg and oil
emulsion on plywood.
Six panels, 243.8 ×
375.9 cm overall.
Private Collection,
Toronto.

Fig. 325 (below).
Marc de Guerre.
*I Saw God Wash the
World* (View 2), 1982.
Egg and oil emulsion on
plywood. 181.6 ×
548.0 cm. Private
Collection, Toronto.

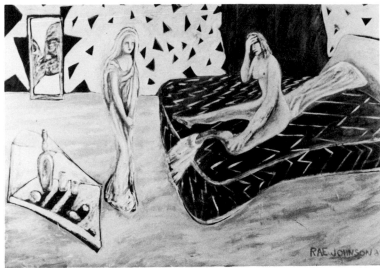

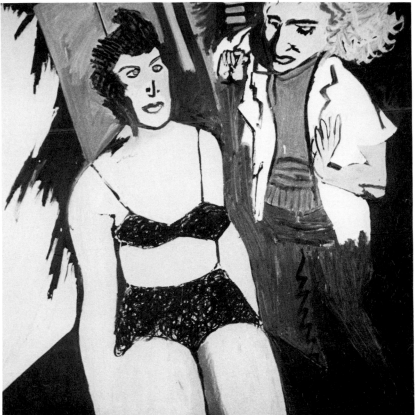

Fig. 326 (above left). Brian Burnett. *Mint Cakes*, 1983. Acrylic on canvas. 175.3 × 167.6 cm. Collection The Isaacs Gallery, Toronto.

Fig. 327 (above right). Rae Johnson. *Anima-Animus*, 1981. Acrylic on canvas. 167.6 × 259.1 cm. Courtesy Carmen Lamanna Gallery, Toronto.

Fig. 328 (left). Oliver Girling. *Sculpted in a Daze*, 1982. Acrylic on canvas. 182.9 × 182.9 cm. Collection of the Artist.

Getting close to the outside option.

Fig. 330. Sandra Meigs. *Getting Close To the Outside Option* (from the film installation *Semi Wind-Up Bout*), 1982. Conté on paper, 50.0 × 65.0 cm. Courtesy Ydessa Gallery, Toronto.

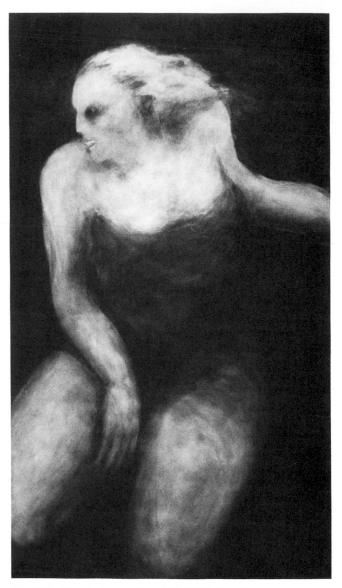

Fig. 329. Wendy Coad. *PYA 994*, 1983. Acrylic on paper. 186.7 × 106.7 cm. Collection of the Artist.

Zone quickly became a forum for the new painting. Among the painters who are or have been associated with this group, such as Brian Burnett (fig. 326), Rae Johnson (fig. 327), Oliver Girling (fig. 328), and Andy Fabo, are some of the strongest artists working in the new figurative painting.

The range of their work, though similar in its raw directness, attacking imagery and narrative content, is broad—broader still, if we look towards the work of Wendy Coad (fig. 329), Sandra Meigs (fig. 330), and Chrisanne Stathacos, to Carol Wainio in Halifax (fig. 331) and Suzanne Funnell in Winnipeg (fig. 332), to David Elliott, Lynn Hughes, Joanne Tod, Marc de Guerre, and so on. And these artists are representative of so many more, representative of a new generation of artists which, through each individual, seeks its own voice.

It is, with the expansion of critical writing and reviewing and the opportunities to exhibit, a generation more closely scrutinized than others have been at a similar stage of development. The pressures for performance are greater and with this, inevitably, will come the impatience of those people who can only view art and the careers of artists as events within the changes of fashion. But the fact that we can now look back on forty years of unprecedented growth and richness in the arts in Canada, is due to the strength and commitment of individual artists. Each generation of artists must set its own terms and these can never be divorced from the context of society as a whole.

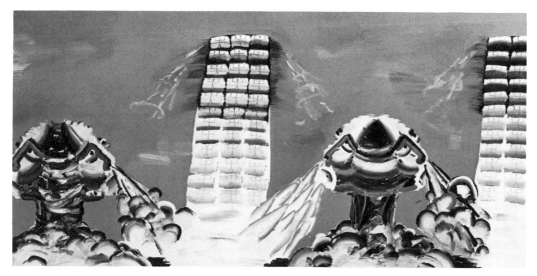

Fig. 331.
Carol Wainio.
Breathing and History,
1982. Acrylic on
masonite. 121.9 ×
243.8 cm. Courtesy
Yarlow/Salzman
Gallery, Toronto.

Fig. 332. (below).
Suzanne Funnell. *James
G. Neufeld, Earle J.
Keeley, A.J. Meehan*,
1981. Oil on plywood.
275.0 × 124.0; 300.0
× 227.0; 282.0 ×
133.0 cm. Courtesy
Ydessa Gallery,
Toronto.

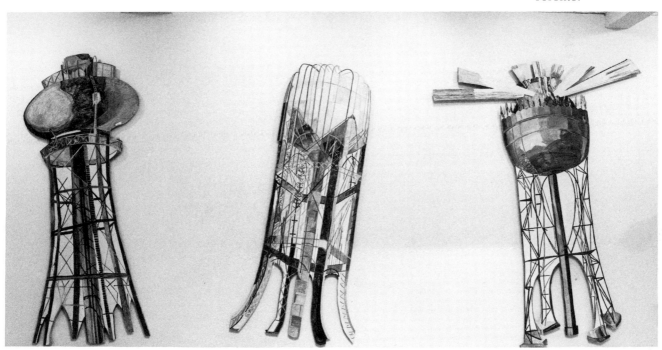

Notes

1. John R. Stocking, "Promotional Art History and the Iconography of Style," *Parachute* 16 (Autumn 1979); p. 12.
2. *Ibid.*
3. Leslie A. Fiedler, "The Death and Rebirths of the Novel," *Salmagundi* (Fall 1980 – Winter 1981); p. 150.
4. *A New Spirit in Painting.* London: Royal Academy of Arts, 1981; p. 13.
5. *Ibid.,* p. 15.
6. Ron Shuebrook, "From Emma Lake to Mother Earth. Bruce Parsons," *Vanguard,* Vol. 11 (February 1982); p. 27.
7. It must be noted with this picture, as with so many other works of this type, that colour reproduction is, by its very technique, unable to reproduce the optical effects contained within the painting.
8. John Perrault, "Minimal Abstracts," in Gregory Battcock (ed.), *Minimal Art.* New York: E.P. Dutton Co., Inc., 1968; p. 262.
9. *Progressions. Peter Gnass.* Montreal: Musée d'art contemporain, 1977; n.p.
10. *Ron Shuebrook. Black and White Drawings 1965 – 1982.* Halifax: St. Mary's University Art Gallery, 1982; n.p.
11. Michael Greenwood, "The Canadian Canvas," *artscanada,* Vol. 32 (March 1975); p. 11.
12. *Toronto Painting: 1953 – 1965.* Ottawa: National Gallery of Canada, 1972; pp. 20 – 31.
13. Donald B. Kuspit, "Exotic Modernism: Toronto," *Vanguard,* Vol. 9 (November 1980); pp. 18 – 25.
14. Joan Murray, *Ivan Eyre Exposition.* Oshawa: Robert McLaughlin Gallery, 1980; p. 35.
15. Philip Fry. "David Thauberger," *Pluralities 1980.* Ottawa: National Gallery of Canada, 1980; p. 110.
16. *John Clark Paintings 1978 – 81.* Halifax: Art Gallery Mount St. Vincent University, 1981; p. 2.
17. *Nine Signs: Wanda Koop.* Calgary: Glenbow Museum, 1983; n.p.

Selected Bibliography

Many of the books and catalogues listed here contain more extensive bibliographic and biographic references to individual artists, to groups and movements. There is also a wide range of periodical literature. The principal magazines are: *Artmagazine, artscanada, Parachute, Vanguard,* and *Vie des Arts.*

General

Berlin, Akademie der Kunste, *OKanada,* Berlin/Ottawa: Akademie der Kunste/Canada Council, 1982.

Fenton, Terry and Wilkin, Karen, *Modern Painting in Canada,* Edmonton: Edmonton Art Gallery/Hurtig Publishers Ltd., 1978.

Harper, J. Russell, *Painting in Canada: A History* (Second edition), Toronto: University of Toronto Press, 1977.

Lord, Barry, *The History of Painting in Canada: Towards a Peoples' Art,* Toronto: NC Press, 1974.

Ottawa, National Gallery of Canada, *Pluralities/1980/Pluralités,* Ottawa: National Gallery of Canada, 1980.

Regina, Norman Mackenzie Art Gallery, *Statements: 18 Canadian Artists,* Regina: Norman Mackenzie Art Gallery, 1967.

Reid, Dennis, *A Concise History of Canadian Painting,* Toronto: Oxford University Press, 1973.

Toronto, Art Gallery of Ontario, *10 Canadian Artists in the 1970s,* Toronto: Art Gallery of Ontario, 1980.

Townsend, W. (ed.), *Canadian Art Today,* London: Studio International, 1970.

Various authors, *Focus on Montreal, artscanada,* Volume 33 (July/August, 1976 — entire issue).

Various authors, *Art and Nationalism, artscanada,* Volume 37 (December 1979/January 1980 — entire issue).

Withrow, William, *Contemporary Canadian Painting,* Toronto: McClelland and Stewart, 1972.

Painting in Quebec: Change and Revolution

Bourassa, André, *Surréalisme et litterature québecoise,* Montreal: Etincelle, 1977.

Davis, Ann, *Frontiers of our Dreams: Quebec Painting in the 1940s and 1950s,* Winnipeg: Winnipeg Art Gallery, 1979.

Gagnon, François-Marc, *Paul-Emile Borduas: Biographie Critique & Analyse de l'oeuvre,* Montreal: Fides, 1978.

Gagnon, François-Marc (ed.), *Borduas: Ecrits/Writings 1942–58,* Halifax: Nova Scotia College of Art and Design, 1978.

Lefebvre, G., *Pellan,* Toronto: McClelland & Stewart, 1973.

Luckyj, Natalie, *Other Realities: The Legacy of Surrealism in Canadian Art,* Kingston: Agnes Etherington Art Centre, Queen's University, 1978.

Saint-Martin, Fernande, *Structures de l'espace pictural: essai,* Montreal: Editions Hurtubise HMH Ltée, 1968.

Schneider, Pierre, *Jean Paul Riopelle,* Paris: Musée National d'art moderne, Centre Georges Pompidou, 1981.

Various authors, *The Presence of Borduas, artscanada,* Volume 35 (December 1978/January 1979 — entire issue).

Varley, Christopher, *The Contemporary Arts Society, Montreal, 1939–1948,* Edmonton: Edmonton Art Gallery, 1980.

Wilkin, Karen, *The Collective Unconscious: American and Canadian Art, 1940–1950,* Edmonton: Edmonton Art Gallery, 1975.

Wilkin, Karen, *Pierre Gauvreau: The First Decade,* Kingston, Agnes Etherington Art Centre, Queen's University, 1981.

Toronto: Breaking the Mould

Edinburgh University, Talbot Rice Art Centre, *Jack Bush: paintings and drawings 1955–1976,* Edinburgh University: Talbot Rice Art Centre, 1980.

Fenton, Terry, *Jack Bush: A Retrospective,* Toronto, Art Gallery of Ontario, 1976.

Hale, Barrie, *Toronto Painting 1953–1965,* Ottawa: National Gallery of Canada, 1972.

Murray, J. and Watson, J., *Alexandra Luke: A tribute,* Oshawa: Robert McLaughlin Gallery, 1979.

Murray, Joan, *Painters Eleven in Retrospect,* Oshawa: Robert McLaughlin Gallery, 1979.

Murray, Joan, *Two Decades: Ray Mead,* Oshawa: Robert McLaughlin Gallery, 1982.

Windsor, Art Gallery of Windsor, *Indications: Harold Town 1944–1975,* Windsor: Art Gallery of Windsor, 1975.

Windsor, Art Gallery of Windsor, *Poets and Other People: Drawings by Harold Town,* Windsor: Art Gallery of Windsor, 1980.

Woods, Kay, *Painters 11: 1953–1959,* Oshawa: Robert McLaughlin Gallery, 1973.

Woods, Kay, *Kazuo Nakamura,* Oshawa: Robert McLaughlin Gallery, 1974.

Zemans, Joyce, *Jock Macdonald: The Inner Landscape,* Toronto: Art Gallery of Ontario, 1981.

Abstraction in Montreal

Bradley, Jessica, *Paterson Ewen,* Ottawa: National Gallery of Canada, 1982.

Burnett, David, *Guido Molinari: Works on Paper,* Kingston: Agnes Etherington Art Centre, Queen's University, 1981.

Corbeil, Danielle, *Claude Tousignant,* Ottawa: National Gallery of Canada, 1973.

Duquette, Jean-Pierre, *Fernand Leduc,* Montreal: Editions Hurtubise HMH Ltée, 1980.

Fry, Philip, *Charles Gagnon,* Montreal: Musée des beaux-arts, 1978.

Gascon, France, *Claude Tousignant: Diptyques: 1978–1980,* Montreal: Musée d'art contemporain, 1980.

Molinari, Guido, *Guido Molinari: Ecrits sur l'art (1954–1975),* Pierre Théberge (ed.), Ottawa: National Gallery of Canada, 1976.

Montreal, Musée d'art contemporain, *Ulysse Comtois 1952–1982,* Montreal: Musée d'art contemporain, 1983.

Montreal, Musée d'art contemporain, *Jauran et les premiers Plasticiens,* Montreal: Musée d'art contemporain, 1977.

Nasgaard, Roald, *Yves Gaucher: A Fifteen-Year Perspective 1963–1978,* Toronto: Art Gallery of Ontario, 1979.

Pepin, Yves, *Jean McEwen,* Paris: Centre culturel canadien, 1970.

Théberge, Pierre, *Guido Molinari,* Ottawa: National Gallery of Canada, 1976.

Thériault, Normand, *Claude Tousignant: Sculptures,* Montreal: Musée des beaux-arts, 1982.

A Broadening Scene: Toronto and London

Burnett, David, *Gershon Iskowitz,* Toronto: Art Gallery of Ontario, 1982.

Cornwell, Regina, *Snow Seen: The Films and Photographs of Michael Snow,* Toronto: Peter Martin Associates, 1980.

Hale, Barrie, *Graham Coughtry Retrospective,* Oshawa: Robert McLaughlin Gallery, 1976.

Oshawa, Robert McLaughlin Gallery, *Louis de Niverville Retrospective,* Oshawa: Robert McLaughlin Gallery, 1978.

Oshawa, Robert McLaughlin Gallery, *Gordon Rayner Retrospective,* Oshawa: Robert McLaughlin Gallery, 1978.

Oshawa, Robert McLaughlin Gallery, *Dennis Burton Retrospective,* Oshawa: Robert McLaughlin Gallery, 1977.

Théberge, Pierre, *Greg Curnoe,* Ottawa: National Gallery of Canada, 1982.

Toronto, Art Gallery of Ontario, *John Meredith: Fifteen Years,* Toronto: Art Gallery of Ontario, 1974.

Town, Harold, *Albert Franck: Keeper of the Lanes,* Toronto: McClelland & Stewart, 1974.

The Maritimes, Modernism and the West

Andrus, D.F.P., *Bruno Bobak, Selected Works 1943–1980,* Montreal: Sir George Williams Art Galleries, Concordia University, 1983.

Emery, Anthony, *Jack Shadbolt,* Vancouver: Vancouver Art Gallery and National Gallery of Canada, 1969.

Fredericton, Beaverbrook Art Gallery, *Miller G. Brittain: Drawings and Pastels: c. 1930–1967,* Fredericton: Beaverbrook Art Gallery, 1968.

Harper, Russell, *Jack Humphrey: A Painter in the Maritimes,* Fredericton: Beaverbrook Art Gallery, 1966.

Lindberg, Ted, *Jack Shadbolt: Seven Years,* Vancouver: Vancouver Art Gallery, 1978.

Malkin, Peter, *Gordon Smith,* Vancouver: Vancouver Art Gallery, 1976.

Moppett, George and Zepp, Norman, *Otto Rogers: A Survey 1973–1982,* Saskatoon: Mendel Art Gallery, 1982.

Ottawa, National Gallery of Canada, *Five Painters from Regina/Cinq Peintres de Regina,* Ottawa: National Gallery of Canada, 1961.

Regina, Norman Mackenzie Art Gallery, *Emma Lake Workshops 1953–73,* Regina: Norman Mackenzie Art Gallery, 1973.

Shadbolt, Jack, *In Search of Form,* Toronto: McClelland & Stewart, 1968.

Thom, Ian, *Maxwell Bates: A Retrospective,* Victoria: Art Gallery of Greater Victoria, 1982.

Vancouver, Vancouver Art Gallery, *Toni Onley: A Retrospective Exhibition,* Vancouver: Vancouver Art Gallery, 1977.

Wilkin, Karen, *William Perehudoff: Ten Years 1970–1980,* Saskatoon: Mendel Art Gallery, 1981.

Winnipeg, Winnipeg Art Gallery, *Takao Tanabe 1972–1976: The Land,* Winnipeg: Winnipeg Art Gallery, 1976.

Sculpture in the Sixties

Cameron, Dorothy, *Sculpture 67 Toronto City Hall,* Ottawa: National Gallery of Canada, 1967.

Gibson, Michael, *Louis Archambault: Sculpteur,* Paris: Centre culturel canadien, 1980.

Henault, Gilles (foreword), *Panorama de la sculpture au Québec 1945–70,* Montreal: Musée d'art contemporain, 1970.

Marshall, Neil, *Robert Murray: a sculpture exhibition,* Dayton, Ohio: The Dayton Art Institute, 1979.

Montreal, Musée d'art contemporain, *Françoise Sullivan: Retrospective,* Montreal: Musée d'art contemporain, 1981.

Saltmarche, Kenneth, *David Partridge,* Windsor: Art Gallery of Windsor, 1975.

Shadbolt, Doris, *Ronald Bladen/Robert Murray,* Vancouver: Vancouver Art Gallery, 1970.

Withrow, William, *Sorel Etrog: Sculpture,* Toronto: Wilfeld Publishing Co. Ltd., 1967.

Representational Painting

Burnett, David, *Colville,* Toronto: Art Gallery of Ontario and McClelland & Stewart, 1983.

Calgary, Alberta College of Art Gallery, *John Hall: Paintings and Auxiliary Works 1969–1978,* 1978.

Davis, Ann, *The Drawings of Christiane Pflug,* Winnipeg: Winnipeg Art Gallery, 1979.

Duval, Paul, *High Realism in Canada,* Toronto: Clarke, Irwin & Co. Ltd., 1974.

London, London Regional Art Gallery, *Jack Chambers: The Last Decade,* London: London Regional Art Gallery, 1980.

London, London Regional Art Gallery, *Mary Pratt,* London: London Regional Art Gallery, 1981.

Murray, Joan, *Kurelek's Vision of Canada,* Oshawa: Robert McLaughlin Gallery, 1982, Hurtig Publishers Ltd., 1983.

Sackville, Owens Art Gallery, *Tom Forrestall: A Retrospective Exhibition: 1957–1978,* Sackville: Owens Art Gallery, 1978.

Silcox, David P., *Christopher Pratt,* Toronto: Prentice-Hall Canada Inc., 1983.

Alternative Modes

Bronson, A. A. and Gale, Peggy, (eds.), *Performance by Artists,* Toronto: Art Metropole, 1979.

Burnett, David, *Serge Tousignant: Géometrisations,* Montreal, 1980.

Cornwell, Regina, *Michael Snow,* Berkeley: University of California Art Museum, 1979.

Ferguson, Bruce, *Canada Video Biennale de Venezia,* Ottawa: National Gallery of Canada, 1980.

Ferguson, Bruce, *Suzy Lake: Are you talking to me?,* Saskatoon: Mendel Art Gallery, 1980.

Fleming, Marie L., *Baxter²: Any Choice Works,* Toronto: Art Gallery of Ontario, 1982.

Fry, Jacqueline, *Irene Whittome 1975–1980,* Montreal: Montreal Museum of Fine Arts, 1980.

Gale, P., Falk, L., and Frenkel, V., *Noel Harding: Enclosure for Conventional Habit,* Banff: Walter Phillips Gallery, 1980.

Gale, Peggy, *Video by Artists,* Toronto: Art Metropole, 1976.

Galerie Optica, *Camerart,* Montreal: Galerie Optica, 1974.

Graham, Mayo, *Another Dimension,* Ottawa: National Gallery of Canada, 1977.

Montreal, Musée d'art contemporain, *Pierre Boogaerts: coins de rues (pyramides) — NY 1978–79 — Street Corners,* Montreal: Musée d'art contemporain, 1980.

Montreal, Musée d'art contemporain, *Bill Vazan,* Montreal: Musée d'art contemporain, 1980.

Nasgaard, Roald, *Garry Neill Kennedy: Recent Works,* Toronto: Art Gallery of Ontario, 1978.

Neils, Christian, *For Suzy Lake, Chris Knudsen, Robert Walker: An Exhibition,* Vancouver: Vancouver Art Gallery, 1978.

Parent, Alain, *Betty Goodwin,* Montreal: Musée d'art contemporain, 1976.

Paris, Centre national d'art et culture, *Michael Snow,* (English/German Edition), Lucerne, Bonn, München: Kunstmuseum, Rheinisches Landesmuseum, Städtische Galerie im Lenbachhaus, 1979.

Pollock, Ann, *Confrontations: Ian Carr-Harris, John McEwen, John Massey,* Vancouver: Vancouver Art Gallery, 1980.

Racine, Rober, *Rober Racine: Dictionnaires A,* Montreal: Musée des beaux-arts, 1982.

Shapiro, Barbara (ed.), *Parallelogramme Retrospective,* Montreal: The Association of Non-Profit Artists Centres, 1977.

Shapiro, Barbara (ed.), *Parallelogramme Retrospective 2,* Montreal: The Association of Non-Profit Artists Centres, 1978.

Stuttgart, Württembergischer Kunstverein, *Kunstler aus Kanada Raume und Instaliationen,* Stuttgart: Württembergischer Kunstverein, 1983.

Swain, Robert, *Sorel Cohen,* Kingston: Agnes Etherington Art Centre, Queen's University, 1981.

Toronto, Art Gallery of Ontario, *Hurlbut, Martin, Massey, Singleton,* Toronto: Art Gallery of Ontario, 1981.

Town, Elke, *Fiction,* Toronto: Art Gallery of Ontario, 1982.

Vancouver, Vancouver Art Gallery, *Eric Cameron/ Noel Harding: Two Audio-Visual Constructions,* Vancouver: Vancouver Art Gallery, 1978.

Recent Sculpture

Amsterdam, Stedelijk Museum, *Mark Prent,* Amsterdam: Stedelijk Museum, 1978.

Banff, Peter Whyte Gallery, *Catherine Burgess, Recent Sculpture,* Banff: Peter Whyte Gallery, 1982.

Carr-Harris, Ian, *John McEwen/Recent Work,* Lethbridge: Southern Alberta Art Gallery, 1979.

Chandler, John, *Mia Westerlund: Recent Work/ Sculpture and Drawing,* Vancouver: Vancouver Art Gallery, 1978.

Ferguson, Bruce, *George Sawchuk,* Saskatoon: Mendel Art Gallery, 1980.

Godmer, Gilles, *Sculptures et dessins de Gunther Nolte,* Montreal: Musée d'art contemporain, 1979.

Graham, Mayo, *1 × 2: Liz Magor, John McEwen,* Calgary: Glenbow Museum, 1983.

Halifax, Art Gallery of Nova Scotia, *John Greer, sculptural objective 1968-1981,* Halifax: Art Gallery of Nova Scotia, 1981.

Heath, Terrence, *Joe Fafard: Recent Sculpture,* Edmonton: Edmonton Art Gallery, 1979.

Holmes, Willard, *Claude Mongrain, Roland Poulin,* Victoria: Art Gallery of Greater Victoria, 1980.

Ihrig, Bob, *Tony Urquhart. Twenty-five years: Retrospective,* Kitchener: Kitchener-Waterloo Art Gallery, 1979.

Krefeld, Museum Haus Lange, *David Rabinowitch: 25 sculptures from 1968–1978,* Krefeld: Museum Haus Lange, 1978.

Luckyj, Natalie, *Prince, Prent, Whiten: Figurative Sculpture,* Kingston: Agnes Etherington Art Centre, Queen's University, 1981.

Melançon, Robert, *Roland Poulin,* New York: 49th Parallel, Centre for Contemporary Canadian Art, 1981.

Milrod, Linda, *Mark Gomes: Recent Work,* Halifax: Dalhousie Art Gallery, 1981.

Nasgaard, Roald, *Structures for Behaviour,* Toronto: Art Gallery of Ontario, 1978.

Ottawa, National Gallery of Canada, *Canada. Ron Martin. Henry Saxe,* Ottawa: National Gallery of Canada, 1978.

Phillips, Carol, *Douglas Bentham: Getting to Now,* Regina: Norman Mackenzie Art Gallery, 1980.

Restany, Pierre, *Peter Gnass: Installation,* Paris, 1980.

Saskatoon, Mendel Art Gallery, *Eli Bornstein: Selected Works 1957–1982,* Saskatoon: Mendel Art Gallery, 1982.

Stratford, The Gallery, *Roland Brener,* Stratford: The Gallery/Stratford, 1979.

Vancouver, Vancouver Art Gallery, *Mise en Scene,* Vancouver: Vancouver Art Gallery, 1982.

Vancouver, Vancouver Art Gallery, *Production/ Reproduction,* Vancouver: Vancouver Art Gallery, 1980.

Wilkin, Karen, *André Fauteux Ten Years 1972–1982,* Kingston: Agnes Etherington Art Centre, Queen's University 1982.

Recent Painting

Banff, Walter Phillips Gallery, *Ron Moppett,* Banff: Walter Phillips Gallery, Banff Centre School of Fine Arts, 1982.

Baster, Victoria, *David Craven,* Lethbridge: University of Lethbridge Art Gallery, 1982.

Calgary, Glenbow Museum, *Nine Signs: Wanda Koop,* Calgary: Glenbow Museum, 1983.

Carpenter, Ken, *Robert Christie/Five Years,* Saskatoon: Mendel Art Gallery, 1982.

Elder, Alan C., *The Discernable Image,* Burlington, Ontario: Burlington Cultural Centre, 1982.

Luckyj, Natalie, *Metamorphosis: Memories, Dreams and Reflections: The Work of Florence Vale,* Kingston: Agnes Etherington Art Centre, Queen's University, 1980.

Montreal, Musée d'art contemporain, *Louise Robert et Michel Goulet,* Montreal: Musée d'art contemporain, 1980.

Montreal, Sir George Williams Art Galleries, *Montreal Painting Now,* Montreal: Sir George Williams Art Galleries, Concordia University, 1982.

Oshawa, Robert McLaughlin Gallery, *Ivan Eyre Exposition,* Oshawa: Robert McLaughlin Gallery, 1980.

Paikowsky, Sandra, *David Bolduc: Recent Work,* Montreal: Sir George Williams Art Galleries, Concordia University, 1981.

Payant, Réné, *Louis Comtois, Painting 1974–1979,* Toronto: Art Gallery of Ontario, 1980.

Sackville, Owens Art Gallery, *Claude Breeze,* Sackville: Owens Art Gallery, 1978.

Vancouver, Vancouver Art Gallery, *Jacques Hurtubise,* Vancouver: Vancouver Art Gallery, 1981.

White, Peter *Tim Zuck Paintings,* Calgary: Glenbow Museum, 1980.

Wilkin, Karen, *Milly Ristvedt-Handerek: Paintings of a Decade,* Kingston: Agnes Etherington Art Centre, Queen's University, 1979.

Winnipeg, Winnipeg Art Gallery, *David Craven/ Harold Klunder,* Winnipeg: Winnipeg Art Gallery, 1980.

Index

In parentheses after the names of Canadian artists are their dates of birth and (if appropriate) death, and their current place of residence.

A Space 182
Abeloos, Pierre 96
Abstracts at Home 42, 54
Agnes Lefort Gallery 73
Alexander, David (1947) (Saskatoon) **278**
Allen, Ralph (1926) (Kingston) 254, **255**
Alleyn, Edmund (1931) (Montreal) 74
Allsopp, Judith (1943) (New York) 280
American Abstract Artists, 44, 54
Archambault, Louis (1915) (St. Lambert, Quebec) **144**, 149
Artists' Jazz Band 83, 84
Association des artistes non-figuratifs de Montreal 35, 38, 63, 76, 142, 145
Astman, Barbara (1950) (Toronto) 207, **208**
Automatistes 21, 22, 23, 30, 35, 38, 41, 46, 47, 63, 65, 71, 74, 76, 81, 251

Baden, Mowry (1936) (Victoria) **215**
Ballachey, Barbara (1949) (Calgary) 278
Barbeau, Marcel (1925) (Montreal) 21, 26, **28**, 71
Barnet, Will 126, 127
Bates, Maxwell (1906–1980) 123, 124, **125**, 126, 285
Battcock, Gregory 159
Baxter, Iain (1936) (Toronto) **180**, 183, **184**, 185, 186, 202, 241
Baxter, Ingrid (1938) (Vancouver) 183, 241
Beaver Hall Hill Group 14, 16
Beckmann, Max 125, 165
Beland, Luc (1951) (Montreal) 286, **287**
Bellefleur, Leon (1910) (Paris) 23, 30, 35, 42
Belzile, Louis (1929) (Montreal) **35**, 36
Bentham, Douglas (1947) (Saskatoon) 219, **220**, 222
Besant, Derek Michael (1950) (Calgary) 276, **277**
Bieler, André (1896) (Kingston) 14
Bieler, Ted (1938) (Toronto) **230**
Binning, B.C. (1909–1976) 115, **116**, 119
Blackwood, David (1941) (Port Credit, Ontario) 175
Blanck, Nora (1947) (Vancouver) 272
Blazeje, Zbigniew (1942) (Toronto) 242
Bloore, Ronald (1925) (Toronto) 127, 128, **129**, **130**, 132, 142
Blyth, Daniel (1946) (Toronto) 256
Bobak, Bruno (1923) (Fredericton) 113, 114, 285
Bobak, Molly Lamb (1922) (Fredericton) 113, **114**, 115
Bolduc, David (1945) (Toronto) **269**, 270, 271
Bonham, Don (1940) (Toronto) 143
Boogaerts, Pierre (1946) (Montreal) 202, 203, **204**
Borduas, Paul-Emile (1905–1960) 13, 16, 19, 20, 21, 22, **23**, 24, **25**, 26, 31, 34, 35, 38, 42, 46, 63, 66, 71, 74, 81, 136, 142
Bornstein, Eli (1922) (Saskatoon) 136, 153, **154**
Bowers, Robert (1943) (Toronto) **243**
Boyle, John (1941) (Elsinore, Ontario) 107, **108–109**
Brandtner, Fritz (1896–1969) 15, **16**, 111
Breeze, Claude (1938) (Toronto) 248, **253**
Brener, Roland (1942) (Victoria) 230, **231**

Breton, André 21
Brittain, Miller (1912–1968) 111, **112**, 113, 114
Broadhurst, Christopher (1953) (Kingston) **272**
Bronson, A.A. (*See* General Idea)
Brooker, Bertram (1888–1955) 111
Brown, D.P. (1939) (Collingwood, Ontario) 160
Brown, John (1953) (Toronto) 287, **288**
Burgess, Catherine (1953) (Edmonton) 219, **221**, 222
Burnett, Brian (1952) (Toronto) **289**, 290
Burton, Dennis (1933) (Vancouver) 83, 84, 85, 88, **89**, **90**, 91, 102
Bush, Jack (1909–1977) 41, 42, 43, 44, **45**, 46, 47, 48, **49**, 50, **52**, 57, 90, 102, 136, 263, 264, 270

Cadieux, Genevieve (1955) (Montreal) 205, **206**
Cage, John 83, 84, 258
Cahén, Oscar (1916–1956) 42, 43, **44**, 47, 48, 49, 58
Calgary Group 125, 126
Cameron, Alex (1947) (Toronto) **268**
Cameron, Eric (1935) (Halifax) 193, **194**
Cameron, Dorothy (Gallery) 42, 82, 121, 141, 142
Canada Council 175, 182
Canada Council Art Bank 182
Canadian Artists Representation (CAR) 99, 104, 107, 175
Canadian Group of Painters 14, 15, 41, 46
Canadian Society of Painters in Watercolour 41
Carmichael, Robert (1937) (Vancouver) 275
Caro, Anthony 219, 221, 222
Carr, Emily (1871–1945) 111
Carr-Harris, Ian (1941) (Toronto) **191**, **192**, 245
Chambers, Jack (1931–1978) 104, 107, 159, **173**, **174**, **175**, 202
Charney, Mel (1935) (Montreal) 229, 230
Christie, Robert (1946) (Saskatoon) **263**, 264
Christopher, Ken (1942) (Calgary) **278**
Clark, John (1943) (Halifax) 248, **284**
Clarke, Ann (1944) (Edmonton) **264**, 265
Coad, Wendy (1951) (Toronto) **290**
Cohen, Sorel (1936) (Montreal) 205, **206**
Collyer, Robin (1949) (Toronto) **215**, 216
Colville, Alex (1920) (Wolfville, Nova Scotia) 113, 114, 159, 160, 161, **162**, **163**, **164**, 165, 173
Comtois, Louis (1945) (New York) 250, **253**
Comtois, Ulysse (1931) (Granby, Quebec) **70**, 71, 74, 142, 145, 147, **148**
Contemporary Arts Society 15, 19, 20, 21, 30, 31, 41, 111, 113
Cormier, Bruno 21
Coughtry, Graham (1931) (Claremont, Ontario) 82, 83, 84, 85, 86, **87**, 88, 90, 91, 93, 102, 104
Couturier, Père Alain-Marie 19
Cowley, Reta (1910) (Saskatoon) 136, **138**, 139, 278
Craig, Kate (Vancouver) 186
Craven, David (1946) (New York) 259, 261, **262**
Cruise, Stephen (1949) (Toronto) 192, 193, **194**
Curnoe, Greg (1936) (London, Ontario) 104, **105**, **106**, **107**, 108

Dallaire, Jean (1916–1965) **31**
Danby, Ken (1940) (near Guelph, Ontario) 159, 169, **170**
Davidson, Robert (1947) (Vancouver) 275
Davies, Haydn (1921) (Toronto) 153
de Guerre, Marc (1959) (Toronto) 287, **288**, 290
de Kooning, Willem 85, 88, 90, 133, 271
de Niverville, Louis (1933) (Toronto) 99, 100, **101**
de Tonnancour, Jacques (1917) (St. Lambert, Quebec) 23, **29**, 30, 42

Dean, Max (1949) (Ottawa) 192, **193**
Delrue, Denyse (Gallery) 38
Donoghue, Lynn (1953) (Toronto) **280**
Downing, Robert (1935) (Toronto) 153
Drapell, Joseph (1940) (Toronto) **261**, 263, 266, 270
Duchamp, Marcel 82, 105, 108, 196, 202
Dumouchel, Albert (1916–1971) 23, 30, 76
Duncan, Douglas 41, 42, 58

Eastern Group of Painters 15, 111
Elliot, David (1953) (Montreal) 283, **284**, 290
Ellis, Clay (1955) (Edmonton) 219
Eloul, Kosso (1920) (Toronto) 153, **155**, 156
Emma Lake Workshops 126, 127, 128, 132, 133, 136, 219, 248, 264
Espace dynamique 38, 41, 46, 142
Etrog, Sorel (1933) (Toronto) 150, **152**, 156
Evans, Ric (1946) (Toronto) **257**, 258
Ewart, Elizabeth (1949) (New York) **229**
Ewen, Paterson (1925) (London, Ontario) 71, 74, **75**, **76**, 81, 149
Eyre, Ivan (1935) (Winnipeg) **273**, 277, 278

Fabo, Andy (1953) (Toronto) 280, 290
Fafard, Joe (1942) (Pense, Saskatchewan) **238**, 239
Falk, Gathie (1928) (Vancouver) 185, 238, 239, **240**
Fauteux, André (1946) (Toronto) **218**, 219, 227
Fauteux, Roger 21
Favro, Murray (1940) (London, Ontario) 107, 213, **214**, 215, 241, **242**
Feist, Harold (1945) (Toronto) **264**, 265, 266
Ferguson, Gerald (1937) (Halifax) **255**, 256, 257
Fernandes, Michael (1944) (Halifax) 256, 257, **258**
Ferron, John 133
Ferron, Marcelle (1924) (Montreal) **26**, 71
Filion, Armand (1931) (St. Louis de Terrebonne, Quebec) 143
Fisher, Brian (1939) (Vancouver) 254
Fisher, Orville (1911) (Vancouver) 119
FitzGerald, Lionel LeMoine (1890–1956) 111, 120, 123
Fonseca, Delio (1955) (Toronto) 232, **233**
Forrestall, Tom (1936) (Dartmouth, Nova Scotia) 159, 160, 169, **170**
Fortin, Marc-Aurèle (1888–1970) 14
Fournier, Paul (1939) (Toronto) 266, **267**, 268
Fox, John (1927) (Montreal) **31**
Franck, Albert (1899–1973) 42, **102**, 276
Fraser, Carol (1931) (Halifax) **275**
Freifeld, Eric (1919) (Toronto) 101, 102
Frick, Joan (1942) (Toronto) 266, **267**
Frinck, Elizabeth 143
Fulford, Robert 46, 111, 141
Funnell, Suzanne (1946) (Winnipeg) 290, **291**

Gagnon, Charles (1934) (Montreal) 76, 78, **79**, **80**, 81, 202
Gagnon, Clarence (1881–1942) 13
Gagnon, Maurice 21
Galerie Optica 202
Galerie Dresdnere 82
Gallery Moos 82, 150
Gallery of Contemporary Art 42, 58, 82, 85
Gallery Pascal 82
Gamble, Eric (1950) (Toronto) 268, **269**
Gaucher, Yves (1934) (Montreal) 53, 76, **77**, **78**, 79, 81
Gauvreau, Claude 21, 65

Gauvreau, Pierre (1922) (Montreal) 21, 26, **27**, 38
General Idea **185**, **186**, 187
Geuer, Juan (1917) (Almonte, Ontario) 242, **243**
Gilhooly, David 239
Girling, Oliver (1953) (Toronto) **289**, 290
Gladstone, Gerald (1929) (Caledon, Ontario) 142, 145, **146**, 147
Gnass, Peter (1936) (Montreal) **257**, 259
Godwin, Ted (1933) (Calgary) 126, 128, 133, **134**
Goguen, Jean (1928) (Montreal) 38
Goodwin, Betty (1923) (Montreal) 196, **197**, 229
Goranson, Paul (1911) (New York) 119
Gordon, Hortense (1887–1961) 43, 46, 48
Gorman, Richard (1935) (Ottawa) 84, **85**, 102
Gould, John (1929) (Waubaushene, Ontario) 101
Graham, K.M. (1913) (Toronto) 266, **267**
Grauer, Sherry (1939) (Vancouver) 238, **239**
Green, Art (1941) (Stratford, Ontario) 276, **277**
Greenberg, Clement 44, 50, 54, 90, 128, 133, 136, 137, 139
Greenwich Gallery 42, 82, 93, 111, 150
Greer, John (1944) (Halifax) **245**, 246
Group of Seven 13, 14, 41, 46, 47, 48, 49, 50, 99, 111

Hale, Barrie 83, 84, 268
Hall, John (1943) (Calgary) 171, **172**, 202
Handy, Arthur (1933) (London, Ontario) 150, **151**
Harding, Noel (1945) (Toronto) **195**, **196**, 243
Harper, J. Russell 112, 141
Harris, Lawren P. (1910) (Ottawa) 42, 113, 114, **115**
Harris, Lawren S. (1885–1970) 111, 116
Hayden, Michael (1943) (Los Angeles) 242
Hedrick, Robert (1930) (Toronto) 149, **150**
Henault, Gilles 21, 22
Here and Now Gallery 42, 82, 141
Heward, Prudence (1896–1947) 14, 16
Hide, Peter (1944) (Edmonton) 219, **220**
Hill, Peter (1948) (Toronto) **259**
Hodgson, Tom (1924) (Toronto) 42, 47, 48, 50, **52**, 53, 84
Hofmann, Hans 48, 111, 123
Holgate, Edwin (1892–1977) 14
Hughes E.J. (1913) (Shawnigan Lake, B.C.) **119**, 120
Hughes, Lynn (1951) (Montreal) **285**, 286, 290
Hughes, Robert 181
Humphrey, Jack (1901–1967) 15, **110**, 111, 113
Hurtubise, Jacques (1939) (Montreal) 249, 250, **253**
Hutner, Paul (1948) (Toronto) **265**, 268

Intermedia 185
Isaacs, Avrom (Isaacs Gallery) 42, 82, 83, 84, 102, 149, 178
Iskowitz, Gershon (1921) (Toronto) 88, **99**, **100**, 101

Jacobs, Katja (1939) (Toronto) **271**
Jarvis, Alan 114
Jauran (*See* Repentigny, R.)
Jean, Jocelyn 250, 251
Jean Louis, Don (1937) (Toronto) 242
Jérôme, Jean-Paul (1928) (Montreal) 35, **36**
Jewell, Milton (1938) (Toronto) 259
Johns, Jasper 83, 234
Johnson, Rae (1953) (Toronto) **289**, 290
Jolliffe, Michael (1945) (New York) 286, **287**
Juneau, Denis (1925) (Montreal) **38**

Kahane, Anne (1924) (Montreal) 143
Kantaroff, Maryon (1933) (Toronto) 150
Kaprow, Alan 84
Kasamets, Udo 84
Kelly, Beverley Lambert (1943) (London) 107
Kenderdine, Augustus (1870–1947) 111, 127, 136
Kennedy, Garry Neill (1935) (Halifax) 182, **183**, 256
Kerneman, Barry 42, 82
Kerr, Illingworth (1905) (Calgary) 124
Kienholz, Edward 238
Kiopini, Christian (1949) (Montreal) 250, **251**
Kirton, Doug (1955) (Toronto) **282**, 283
Kiyooka, Roy (1926) (Vancouver) 125, 128, 133, **134**, **135**
Klee, Paul 30, 93, 117, 268
Kline, Franz 24, 50, 53, 56, 133
Klunder, Harold (1943) (Toronto) **269**, 270, 271
Knowles, Dorothy (1927) (Saskatoon) 136, **139**, 278
Knudsen, Christian (1945) (Montreal) 250, 251
Kolisnyk, Peter (1934) (Cobourg, Ontario) 142, 213, **214**, 215
Koop, Wanda (1951) (Winnipeg) **286**
Kootz Gallery 44, 54
Kostyniuk, Ronald (1941) (Calgary) 153
Kritzwiser, Kay 89
Kubota, Nabuo (1932) (Toronto) 83, 153
Kurelek, William (1927–1977) 102, **177**, **178**, 179

L'actuelle (Galerie) 67
Lacroix, Paul (1929) (Montreal) 254
Laing Galleries 42, 82
Lake, Suzy (1947) (Toronto) 202, **207**
Lamanna, Carmen (Gallery) 82
Leduc, Fernand (1916) (Champseru, France) 20, 21, **26**, 35, 38, **62**, 63, **64**, 65, 66, 250
Leduc, Ozias (1864–1955) 13, 19, 20
Lee-Nova, Gary (1943) (Halifax) 254
Leighton, A.C. (1901–1965) 111, 136
Lemieux, Jean Paul (1904) (Sillery, Quebec) 13, 31, **33**, **34**
Lemyre, Marcel 197
Leroy, Hugh (1939) (Toronto) 153, **226**, 227
Letendre, Rita (1928) (Toronto) **71**, **72**, 73, 74
Levine, Les (1935) (New York) 181, **202**
Lewis, Glenn (1935) (Vancouver) 238
Lindner, Ernest (1897) (Saskatoon) 136, **137**, 159, 248
Lindzon, Rose (Toronto) 266
Lismer, Arthur (1885–1969) 74
Lochhead, Kenneth (1926) (Ottawa) 46, 126, 127, 128, **131**, **133**
Lorcini, Gino (1923) (London, Ontario) 153
Lord, Barry 132
Luke, Alexandra (1901–1967) 42, 43, 44, 47, **48**, 124
Luneau, Claude (1935) (Toronto) 239
Lyman, John (1886–1967) 13, **14**, 15, 16, 20

Macdonald, J.W.G. (Jock) (1897–1960) **40**, 42, **43**, 44, 46, **47**, 48, 51, 53, 54, 85, 111, 119, 124, 126
MacGregor, John (1944) (Toronto) **268**
Mackay, Donald C. (1906–1979) 113
Mackenzie, Hugh (1928) (Toronto) 160
Mackenzie, Landon (1954) (Montreal) 286, **287**
Macklin, Ken (1955) (Edmonton) 219, **220**
MacTavish, Catharine (1952) (Toronto) 272, **274**
Magor, Liz (1948) (Toronto) **236**
Maillard, Charles 19, 20, 46
Marcil, Tancrède 21
Markle, Robert (1936) (Toronto) 83, 84, 102, **103**

Marshall, Roz (1947) (Vancouver) 272
Martin, Ron (1943) (London, Ontario) 107, **252**, 254, **256**
Massey, John (1950) (Toronto) **198**, **199**, 200, 202
Matisse, Henri 14, 19, 100, 117, 268, 271, 272
Mayrs, David (1935) (Vancouver) 275
Mazelow Gallery 82
McCarthy, Pearl 82
McElcheran, William (1927) (Toronto) **143**
McEwen, Jean (1923) (Montreal) 53, **73**, **74**, 79
McEwen, John (1945) (Toronto) **244**, 245
McKay, Arthur (1926) (Regina) 46, 126, 128, **130**, **132**, 133, 136
McKinnon, John (1953) (Toronto) **216**
Mead, Ray (1921) (Montreal) 42, 43, 44, 48, 50, 53, **54**
Meigs, Sandra (1953) (Toronto) **290**
Meredith, John (1933) (Toronto) 84, 85, **86**, 102
Metcalfe, Eric (1940) (Vancouver) 186
Mill, Richard (1949) (Montreal) 250
Milne, David (1882–1953) 41
Mirvish, David (Gallery) 55, 82
Molinari, Guido (1933) (Montreal) 38, 53, **62**, 63, **65**, **66**, 67, 68, 70, 74, 76, 78, 84, 142, 144
Mondrian, Piet 35, 65, 66, 67, 82
Mongrain, Claude (1948) (Montreal) 227, 228, 229, **231**
Monpetit, Guy (1938) (Val David, Quebec) **254**
Moppett, Ron (1945) (Calgary) **248**, 283
Morrice, James Wilson (1865–1924) 13
Morris, Michael (1942) (Vancouver) 202
Morris, Jerrold (Gallery) 42, 82
Morton, Douglas (1926) (Victoria) 126, 128, 133, **134**, 135
Motherwell, Robert 24, 50, 56, 88, 90
Mousseau, Jean-Paul (1927) (Montreal) 21, 26, **27**
Mulcaster, Wynona (1915) (Saskatoon) 136, **137**, 139, 278
Murray, Robert (1936) (Coatesville, Pennsylvania) 128, 153, **156**, **157** 218

N.E. Thing Co. Ltd. 183, 184, 186
Nakamura, Kazuo (1926) (Toronto) 42, 46, 50, **51**, 53
National Museums Corporation 182
New Design Gallery 121
Newman, Barnett 68, 73, 78, 128, 132, 133, 135, 156
Nicoll, Jim (1893) (Calgary) 124, 125
Nicoll, Marion (1909) (Calgary) 124, 125, **126**
Nihilist Spasm Band 107, 108
Noestheden, John (1945) (Toronto) **217**
Noland, Kenneth 38, 50, 78, 128, 136, 139, 219, 248
Nolte, Gunther (1938) (Ottawa) 202, **203**

O'Neil, Bruce (1942) (Calgary) 264
Olitski, Jules 50, 128, 136, 137, 139, 248
Olson, Gary (1946) (Calgary) 172, **173**
Onley, Toni (1928) (Vancouver) 120, **121**, **122**, 278
Ontario Society of Artists 41
Ouspensky, P.D. 47, 48, 115

Pachter, Charles (1942) (Toronto) **176**, 177, 248
Painters 11 46, 47, 48, 50, 53, 54, 57, 58, 83, 88, 90, 102, 142, 144
Park Gallery 42, 43, 44
Parsons, Bruce (1937) (Toronto) 248, **249**

Partridge, David (1919) (Toronto) 142, 144, 145, **146–147**
Partz, Felix (*See* General Idea)
Pellan, Alfred (1906) (Quebec City) 13, 16, 18, 19, 20, 23, 29, **30**, 31, **32**, **33**, 35
Penny, Evan (1953) (Toronto) **237**
Perciballi 38
Perehudoff, William (1919) (Saskatoon) 136, **138**
Pfeifer, Bodo (1936) (Toronto) 254
Pflug, Christiane (1936–1972) 102, 175, **176**
Phillips, Walter J. (1884–1963) 136
Plaskett, Joseph (1918) (Paris) 122, **127**
Plasticiens 34, 35, 36, 38, 41, 46, 63, 76, 79, 251
Plotek, Leopold (1948) (Montreal) 250, 251, **256**
Poldaas, Jaan (1948) (Toronto) 257, **258**
Pollock, Jackson 24, 66, 88, 132
Pollock Gallery 82
Poulin, Roland (1940) (Montreal) 227, **228**
Pratt, Christopher (1935) (St. Mary's Bay, Newfoundland) 159, 160, **165**, 166, **167**
Pratt, Mary (1935) (St. Mary's Bay, Newfoundland) 159, 160, 166, 167, **168**, 202
Prent, Mark (1947) (Montreal) 143, 237, **238**
Prince, Richard (1949) (Vancouver) **236**, 237
Prisme d'yeux 23, 29, 30, 41
Proch, Don (1944) (Winnipeg) **190**, 191

Rabinowitch, David (1943) (New York) 107, **222**, **223**
Rabinowitch, Royden (1943) (New York) 107, 222, **224**, **225**
Racine, Rober (1956) (Montreal) **200**, 201
Radford, Ed (1953) (Toronto) 283, **284**
Rauschenberg, Robert 83
Rayner, Gordon (1935) (Toronto) 83, 84, 85, 88, 90, **91**, 102
Redinger, Walter (1940) (West Lorne, Ontario) 107, 225, 226, **227**
Refus global 21, 22, 23, 30, 35, 46, 147
Regina Five 128
Reid, Dennis 132, 141
Reid, Leslie (1947) (Ottawa) 170, 171, **172**
Reitzenstein, Reinhard (1949) (Grimsby, Ontario) **244**, 245
Repentigny, Rodolphe de (1926–1959) 35, **36**
Reppen, Jack (1933–1964) 102, **104**
Reynolds, Al (1947) (Edmonton) 219, **221**, 222
Riopelle, Jean-Paul (1923) (Paris) 20, 21, 22, 23, 26, **27**, **28**, 29, 63
Ristvedt-Handereck, Milly (1942) (Tamworth, Ontario) **265**, 266
Robert, Louise (1941) (Montreal) 251, **252**
Roberts, Goodridge (1904–1974) 14, **15**, 23, 30, 74
Roberts Gallery 42, 43, 82
Robertson Gallery 43
Robertson, Richard (1948) (Toronto) 160, **161**
Robertson, Sarah (1891–1948) 14
Robinson, Albert H. (1881–1956) 14
Rogers, Otto (1935) (Saskatoon) 136, **138**
Ronald, William (1926) (Toronto) 42, 43, 44, 46, 47, 50, **52**, **53**, **54**, 55, 56, 57, 58, 85
Rothko, Mark 73, 88

Royal Canadian Academy 41

Sanouillet, Michel 104, 108
Savage, Anne (1896–1971) 14, 16
Sawchuk, George (1927) (Vancouver Island) **241**
Saxe, Henry (1937) (Tamworth, Ontario) 142, 217, **218**
Schaeffer, Carl (1903) (Toronto) 41, 113, 121
Scherman, Tony (1950) (Toronto) **280**
School of Paris 14, 15, 34
Schwarz, Judith (1944) (Toronto) **232**
Scott, John (1950) (Toronto) 281, **282**
Scott, Marian (1906) (Montreal) 15, **16**, 42, 65, 74
Segal, George 234, 235
Sen, Ranjan (1941) (Vancouver) 265, **266**
Shadbolt, Jack (1909) (Vancouver) 42, 113, 115, **116**, **117**, 118, 119, 120, 127
Sheldon-Williams, Inglis (1870–1940) 136
Shuebrook, Ron (1943) (Halifax) **260**, 262
Simkins, Howard (1948) (Toronto) 268, **270**
Simmins, Richard 128, 132
Simpson, Greg (1947) (Vancouver) 274, **275**
Singleton, Becky (1952) (London, Ontario) **209**
Sloggett, Paul (1950) (Toronto) 268, **270**
Smith, David 142
Smith, Gordon (1919) (Vancouver) **119**, **120**, 121, 122, 278
Smith, Jeremy (1946) (Ottawa) 160, **161**
Smith, John Ivor (1927) (Montreal) 143
Snow, John (1911) (Calgary) 125
Snow, Michael (1929) (Toronto) 78, 82, 83, 84, 92, **93**, **94**, **95**, 96, 202
Solomon, Daniel (1945) (Toronto) 268, **269**
Spencer, James (1940) (Toronto) 167, **169**
Spickett, Ron (1926) (Calgary) **125**
Stathacos, Chrisanne (1951) (Toronto) 290
Steiner, Michael 219, 221, 222
Stella, Frank, 38, 248, 258
Stern, Dr. Max 21
Still, Clyfford 50, 73, 88
Stocking, John 247
Sullivan, Françoise (1925) (Montreal) 21, 142, **147**, **149**
Surrey, Philip (1910) (Montreal) 15, **17**
Sutton, Carol (1945) (Toronto) **266**
Swinton, George (1917) (Morrisburg, Ontario) 127

Tanabe, Takao (1926) (Vancouver) 122, **123**, 278
Tangredi, Vincent (1950) (Toronto) 201
Teitlebaum, Mashel (1921) (Toronto) 101
Thauberger, David (1948) (Regina) **283**
Théberge, Pierre 99, 107
Thibert, Patrick (1943) (Lambeth, Ontario) 218, **219**, 227
Thompson, Michael (1954) (Port Credit, Ontario) 170, **171**
Thomson, Tom (1877–1917) 99, 108
Tod, Joanne (1953) (Toronto) 280, **281**, 290
Tolgesy, Victor (1928–1980) 239
Toupin, Fernand (1930) (Montreal) 35, 36, **37**, 38

Tousignant, Claude (1932) (Montreal) 38, 53, 63, 65, 67, **68**, **69**, 70, 74, 76, 84, 142
Tousignant, Serge (1942) (Montreal) 202, 203, 204, **205**
Town, Harold (1924) (Toronto) 42, 43, 44, 46, 47, 48, 49, 50, 54, **56**, **57**, 58, 59, 82, 83, 84, 142
Trasov, Vincent (1947) (Vancouver) 186, 202

Urquhart, Tony (1934) (Waterloo, Ontario) 84, 104, 107, 150, 152, **153**

Vaillancourt, Armand (1929) (Montreal) 149, 232, **233**
Vale, Florence (1909) (Toronto) 42, 101, 275, 276, **277**
van Halm, Renée (1949) (Toronto) 233, **234**
Varley, Frederick (1881–1969) 47, 111, 119
Vazan, Bill (1933) (Montreal) **187**, **188**, 202
Véhicule 182, 202
Video Inn 185

Wainio, Carol (1955) (Halifax) 290, **291**
Walker, Robert (1945) (New York) 202
Wall, Jeff (1946) (Vancouver) **210**, **211**
Wallace, George (1920) (Hamilton, Ontario) 143
Wallace, Ian (1943) (Vancouver) **209**, 210
Warkov, Esther (1941) (Winnipeg) 275, **276**
Webber, Gordon (1909–1965) 30, 65
Westerlund, Mia (1942) (New York) **227**, 228
Western Front 185
White, Norman (1938) 242
Whiten, Colette (1945) (Toronto) 142, 234, **235**, 237
Whitlock, An (1944) (Toronto) **217**
Whittome, Irene (1942) (Montreal) 188, **189**, 190, 191
Wieland, Joyce (1931) (Toronto) 79, 84, 94, **97**, **98**, 99
Wiens, Clifford 127, 128
Wiitasalo, Shirley (1949) (Toronto) 280, **281**
Willsher-Martel, Joan (1935) (Toronto) 278
Wood, Alan (1935) (Vancouver) 278
Wyse, Alex (1938) (Ottawa) 239, **240**

Yarwood, Walter (1917) (Toronto) 43, 44, 48, 49, 50, 53, **55**, 59, 84, 142, **145**, 147
Young, Dennis.96
Young, Robert (1938) (Vancouver) 170
Yuristy, Russell (1936) (Silton, Saskatchewan) 238

Zelenak, Ed (1940) (West Lorne, Ontario) 107, 226, **227**
Zontal, Jorge (*See* General Idea)
Zuck, Tim (1947) (Kingston) **279**, 280, 282, 283